THE INVISIBLE GOD

THE
INVISIBLE
GOD
The Earliest Christians
on Art

Paul Corby Finney

New York Oxford
OXFORD UNIVERSITY PRESS
1994

Oxford University Press

Oxford New York Toronto
Delhi Bombay Calcutta Madras Karachi
Kuala Lumpur Singapore Hong Kong Tokyo
Nairobi Dar es Salaam Cape Town
Melbourne Auckland Madrid
and associated companies in
Berlin Ibadan

Published by Oxford University Press, Inc.
200 Madison Avenue, New York, New York 10016

Library of Congress Cataloging-in-Publication Data
Finney, Paul Corby.
The invisible God : the earliest Christians on art /
Paul Corby Finney.
p. cm.
Includes bibliographical references and index.
ISBN 0-19-508252-4
1. Christian art and symbolism—To 500.
2. Christianity and culture—History—Early church, ca. 30–600.
3. God—Knowableness—History of doctrines—Early church, ca. 30–600.
4. Art, Early Christian. 5. Fathers of the church.
I. Title. BV150.F56 1994 246'.2—dc20 93–10129

2 4 6 8 9 7 5 3 1

Printed in the United States of America
on acid-free paper

carissimae coniugi benemerenti

Preface

This is a study of early Christian attitudes toward art. As to chronological limits, I have set the upper end (*terminus ad quem*) at the late third century, roughly the period of Tetrarchy (285–305). Occasionally, as the subject required, I have exceeded this limit, but on principle this study concerns pre-Constantinian evidence. I have left the lower limit (*terminus a quo*) open-ended because it seems to me the primary evidence demands this. In both its literary and material cultures, pre-Constantinian Christianity continuously reflects the formative influence of earlier thought and behavior. Thus, the chronological point of departure for a study such as the present one must be left open-ended, because it is impossible to isolate and analyze this subject apart from its pre-Christian antecedents.

Obviously a subject and its origins are not the same thing, and I have made every effort to avoid committing yet another version of what some have called the "genetic fallacy," confusing the becoming of a thing for that which it has become. Moses is not Jesus, nor is Plato Paul. But both the legendary Israelite and the Athenian sage are relevant to our subject for the simple reason that the early Christians who wrote about art-related matters thought that Moses and Plato were just as important for this subject as the Palestinian rabbi who founded their religion and considerably more important than the Cilician Jew who promulgated the new religion among gentiles. Homer and Hesiod are also relevant, and for the same reason, as are Xenophanes, Zeno, Antisthenes, and the second Isaiah—indeed there is a large cast of pre-Christian characters who figure prominently in the study of this subject. A few of them are Israelites, a larger number Jews (the Hellenistic successors of the Israelites), but most are Greeks. In short, one must follow the evidence wherever it leads, and on that principle most of the following discussion, insofar as it concerns sources and origins, will focus on Hellenic and Hellenistic precedents.

In setting the *terminus ad quem* I have adopted a considerably more restrictive point of view. In doing so my main purpose is to focus on the primary evidence, not on the later history of its interpretation. Our subject is controversial: it has been debated continuously from antiquity to the present. Byzantine polemicists, Carolingian court theologians, Reformers

and Counterreformers have argued about our subject and have made significant contributions to its scope and definition. In addition, nineteenth- and twentieth-century historical scholarship has had a great deal to say on the subject, much of it valuable. It would be foolish to think one can ignore the history of interpretation surrounding this subject, as if one could separate a subject from its ongoing interpretation. In fairness, however, one must admit that much of what medieval and modern interpreters have said on our subject simply distorts the issue by imposing retrojections, later categories of thought that are foreign to the original evidence as we have it. *Sensu stricto*, Moses is foreign also, but the early Christians did not think so.

Judged from the perspective of pre-Constantinian Christianity, what Eusebius, Epiphanius, the Cappadocians, Ephrem, and Augustine had to say on our subject is irrelevant. The same is true for Karlstadt, Calvin and Zwingli, Eck and Molanus, and other Reformers and Counterreformers. The complicating factor is that our subject is charged with what the French call *actualité*, immediate significance in the present, and thus there is a constant temptation to draw analogies between the past and the present. The history of interpretation surrounding our subject attests the considerable force of that temptation. But I have tried to resist it here and to limit inferences to what can be known based on the ancient evidence judged by its own proximate world of meaning, namely Greco-Roman society in the first three centuries of the present era. In the end it may be naïve to undertake this study on the premise that one can separate the primary evidence from its later interpretation. I think within limits it is possible, and I am convinced it is worth the effort. Readers must judge for themselves.

On the idea of seeing divinity and representing visually what is seen, early Christianity was shaped by three ancient concepts: first, that humans could have a direct vision of God; second, that they could not; and, third, that although humans could see God they were best advised not to look and were strictly forbidden to represent what they had seen. The first of these three, the iconic view of divinity, came to early Christianity over a long route from early Indo-European religions in the Aegean and from their Semitic counterparts in the ancient Near East. The classic Western expression is found in the eighth and seventh centuries, within the circle of Homeric/Hesiodic mythopoesis, a tradition that was very much alive in both the Greco-Roman and the Greco-Semitic worlds that played host to the earliest Christians.

In large degree the earliest Christians rejected the iconic view of divinity. The idea that humans could see divinity appearing in either anthropomorphic or theriomorphic (for example, the Cretan Zeus: a bull) guise is a concept the early Christians (especially the apologists) found absurd. Christian writers ridiculed the people who upheld this notion, and likewise they impugned the idea itself, often in elaborately constructed rhetorical conceits. The second- and third-century apologists treated the

iconic view of divinity as a literary foil, which gave them leave to propound a different and—they thought better—concept of divinity. Most of the new religionists' rejection of this iconic view appears within the pages of early Christian apology.

The second of the three ancient concepts, that humans cannot see God because God is invisible, also has a long pedigree, though slightly shorter than the first. In the West this concept is linked to philosophy, and the earliest identifiable traces are located in the east Aegean during the sixth century B.C., among the pre-Socratics, notably Xenophanes. This concept involves the definition of an abstract divinity who is unlike anything or anybody we encounter in the world of daily experience. Indeed it is precisely the imperfections of this world, its contingent and transitory nature, together with our habit of relying on sensorial experience to interpret life in this world, which provide the building blocks for the construction of a negative theological paradigm that defines the God of philosophy. This is a God of apophatic predicates, a divinity who, for example, cannot be known or contained or represented or defined or seen.

On the last-named point, namely God's invisibility, excepting one or two troubling passages in the Platonic corpus, Greek philosophers did not deny that God had a form (εἶδος), but they did insist that the divine *eidos* was not human and that this form was beyond the sight of humans. Thus when Cicero's expositor of Stoic theology, Balbus, declares that "nothing is more difficult than to divert the mind from the habit of reliance on the eyes" ("nihil est difficilius quam a consuetudine oculorum aciem mentis abducere," *ND* 2.45), this is a statement designed to wean humans, educated and uneduated alike, from the erroneous habit of theological anthropomorphism—that is, imagining divinity in human form. Xenophon's Socrates (*Mem.* 4.3.13ff.), Tat in the Hermetic corpus (Logos 5.1–6), Jesus instructing Philip (Jn 14:8ff.), and Theophilus (*Autol.* II.1ff.) writing to Autolycus all share the same message: God is invisible, and it is an exercise in futility for humans either to imagine God in human form or to seek an unmediated vision of the divine *eidos*.

The third of the three ancient concepts involves the proposition that humans can see God but should avert their gaze and are forbidden to represent what they see. This evokes the idea of sacred taboo, and of three ancient concepts on seeing and representing divinity this is very likely the oldest. Power, authority, and boundaries are at issue. In the symbol system that defined the tribal society of ancient Israel, for example, Yahweh was at the center as the object of cult and belief. To all persons who counted themselves members of the tribe, Yahweh represented absolute power and absolute authority, and his unlimited exercise of both attributes included his right to draw boundaries between himself and his subjects.

On pain of instant death, Yahweh forbade tribal members to see him face-to-face. In like manner, Zeus forbade "lightning-married" Semele (Eur., *Bacch.* 7), Dionysus's human mother, to see him in his true form,

and when with Hera's avenging assistance Semele violated this boundary, the reluctant Zeus came to Semele as her lover-murderer, annihilating her with his thunderbolts (Ov., *Met.* 259ff.) At Ex 3:6, 1 Kings 19:13 and Isa 6:2, Yahweh appears respectively to Moses, Elijah, and the Seraphim. They respond by covering their faces. The rationale for this peculiar response is given several times throughout the Hebrew Bible, notably at Ex 19:21 and 33:20, where we are told that the person who looks upon God face-to-face must die. Furthermore, in the Sinai theophany at Ex 20:4a, Yahweh stipulates apodictically to Moses that the making of his image (and in the interpolated expansion at Ex 20:4b: the making of all representational images regardless of their subject) is prohibited. The boundaries are clearly demarcated: Israelites who look upon God do so to their own destruction, and they are strictly forbidden to represent him in a visual form.

At the same time, because he exercised limitless power and authority, the Hebrew God was free to disregard boundaries. Occasionally he did just that and granted selected tribal members a direct vision of himself. He always exercised this prerogative, we are told, by way of exception, and the beneficiaries of this unmediated vision constituted a kind of inner circle, the select few, beginning first and foremost with Moses who spoke directly to God and saw him face-to-face (Ex 24:9–11 [with other notables], 33:11; Deut 34:10; Num 12:8). Other privileged persons were allowed to look upon God's angel, for example, Aaron and Miriam (Num 12:7–8), Gideon (Judg 6:21–22), Samson's parents (Judg 13:8–25), Elijah (1 Kings 19:9–14), and Isaiah (Isa 6:1, 5; but cf. *Mart. Is.* 3.8, 9). In short, the Hebrew God remained invisible to the majority but visible to the select few, his favorites—preeminent among the latter group was Moses. In a similar manner, Athena granted Odysseus (and his dogs) a direct vision of herself, but denied it to Penelope and Telemachus (*Od.* 16.160–62). Unlike Athena, however, Yahweh never permitted his subjects to represent what they had seen. For the earliest Christians, Yahweh's boundaries remained substantially intact, with the notable substitution of Jesus for Moses: Jesus alone talked to the Father as his equal and saw him face-to-face (Jn 6:46).

But by and large, for early Christianity the most important of these three ancient concepts for seeing and representing God was the second. John, Paul, and Luke (as author of Acts, especially the Areopagus speech, 17:16–34) are the first-century witnesses, and for the rest of the pre-Constantinian period the testimonies, particularly in the apologetic realm, are too numerous to mention here. The earliest Christians were convinced that God was invisible and could not be represented. No one could see God or had ever seen God or ever would see God, because God was an immaterial and spiritual being. The only exception they allowed was their Moses antitype, namely Jesus, the one person who enjoyed the direct vision of God. Thus Jesus rebukes Philip (Jn 14:8–21) as does Theophilus Autolycus (*Autol.* II.1ff.) for asking to be shown God. "Lord, let us see the

Father" (Philip) and "Show me your God" (Autolycus) are requests for the impossible, literary paradigms uttered by ignorant men who have no knowledge of God's true nature.

The Israelite prohibition of images, which was a prephilosophical, aniconic taboo, influenced early Christianity less than is commonly presumed. First and foremost the apologists represented themselves and their constituents as philosophers and exponents of a Greek philosophical form of aniconism. They were committed, they said, to the invisibility of divinity and to all that this doctrine entailed and implied, including zealous opposition to iconic forms of superstition. The apologists exploited the Israelite taboo only as a kind of secondary corroboration. Furthermore, they reshaped the taboo in philosophical language and concepts. Following their Jewish-Hellenistic predecessors, Philo for example, the apologists were able to convince themselves that the taboo and philosophy were integral parts of the same tradition, that Moses had been the archetypal philosopher and primeval precursor of Hellenic wisdom, and that the early Israelite tribes had lived out their lives philosophically in a kind of aniconic utopia. There is no doubt that this notion played a role in the apologists' portrayal of Christians as exemplars of philosophical aniconism, but overall Israel's aversion to sacred images influenced early Christianity considerably less than the Greek philosophical tradition of invisible divinity apophatically defined.

In all of early patristic literature, Origen (*Princ.* I.1.8) gives the most uncompromising and principled Christian statement of God's essential invisibility: he is not visible to some yet invisible to others (as implied in the Hebrew Bible and in various Greek religious traditions) but is invisible to all persons, because given the nature of God's invisible being it is impossible for any human to see God. This represents the extreme form of what is I think a near-universal early Christian conviction: no human being can see God, Jesus alone excepted. In referring to this viewpoint I have used the term *theologoumenon*, meaning a widespread and deep-rooted theological conviction, more than just a theologian's opinion, but perhaps less than a synodically defined dogma. Although this theologoumenon is clearly derived from Greek philosophical tradition, belief in God's invisibility was not the exclusive property of philosophers, theologians, and bishops. In my view the conviction ran just as deep among the common people as it did among the eggheads.

Much of the study that follows concerns the analysis of evidence in two kinds, literature and material culture. On the subject of God's invisibility there is a common presumption that these two kinds of evidence are in conflict: literature is supposed to support the theologoumenon, and archaeology contradict it—the apologists, we are told, pronounce the inviolacy of the theologoumenon, and the earliest generations of catacomb Christians wilfully disregard it. Theodor Klauser adds a social or sociological dimension to this putative conflict: as exponents of strict opposition to iconic theology, the apologists speak for the educated clergy, whereas the

people of the catacombs with their simple pictures represent the deviant inclinations of an uneducated laity.

On the subject of this study (as on several others within the field of Christian origins) I find myself in disagreement with Klauser. The presumption of a conflict in evidence between literary and archaeological sources, a conflict which is supposed to reflect an opposition between anti-image clerics and image-loving laypersons, strikes me as unconvincing. In the one place where the evidence is sufficient to judge this issue, namely in the earliest painted chambers of the Callistus catacomb, this putative opposition makes little or no historical sense. In my view, the conflict between the apologists' advocacy of philosophical aniconism and the Callistus paintings is more apparent than real. The two are better characterized as different expressions by different people of a communal commitment to certain commonly held principles, including belief in an invisible God. The apologists I think would have had no quarrel with the paintings in the Callistus catacomb, and the people of the Callistus catacomb would have been surprised to learn that generations later they would be accused of compromising God's invisibility along with violating the supposedly early Christian commitment to strict aniconism in the Jewish mode.

To summarize, the conflict between our two evidentiary sources, literature and material culture, is a smoke screen. Scholars have exploited this as a pretext to justify a larger, synthetic picture of early Christianity as a fundamentally and irrevocably aniconic form of religiosity. As the following chapters will reveal, this picture has little or no basis in the primary sources that have come down to us. This is a picture of early Christianity created by Byzantine and Reformation polemicists, and a picture carried forth into the modern period by Ritschlian Liberals. This picture no longer serves any useful historical purpose (I doubt that it ever did), and hence it deserves to be put to rest, respectfully but definitively, in the mausoleum of obsolete historiographies.

Princeton, N.J. P. C. F.
April 1993

Acknowledgments

My first acknowledgment goes to Hugo Koch (1869–1940), who, though no longer with us, lives on in his work. His *Bilderfrage* provides the initial point of departure for this study. Quite by accident, in 1957 while a student at the Theodor Heuss Gymnasium in Heilbronn am Neckar, I discovered Koch's little monograph on early Christian attitudes toward art, and from then to the present Koch has been with me, at once my vade mecum and thorn in the side, a helpful companion and a nagging reminder of unfinished business. *Bilderfrage* portrays pre-Constantinian Christianity as a religion opposed on principle to the visual arts. The present book is my response to Koch and to the venerable tradition of interpretation that his monograph represents. Although my purpose here is to plead a different construal of the early Christian evidence, I have no doubt that *Bilderfrage* will continue to be a useful introduction to the subject as viewed by an older school of interpretation. But it is now time to move the discussion forward. A new historical perspective is needed, and that is what I provide here.

In 1962–1963 in Munich under the direction of Klaus Wessel, I produced my first written essay on the subject of this book. And in 1967 I began my formal study of early Christian art under Ernst Kitzinger, who directed my doctoral thesis (Harvard, 1972; cf. *HTR* 66[1973], 505) and to whom I am immensely indebted for the care with which he oversaw my initial project. The other colleagues to whom I want to express my thanks for help at the dissertation stage include Hans Belting, Beat Brenk, Frank Cross, William Frend, Helmut Köster, Cyril Mango, Bezalel Narkiss, Pieter van der Nat(†), Johannes Quasten(†), Patrick Skehan(†), and George Williams. I also want to record my debt to Ganse Williams and Howard Kee, both of whom made formal recommendations for the publication of my dissertation in its unrevised form.

In the postdissertation stage I read widely, rethought my subject several times over, and finally abandoned all pretense to revising the dissertation. The present book is a new study altogether—only occasional bits and pieces of the dissertation have been carried over here. For more recent research into the literary side of this subject, I am grateful to Glen

Bowersock and Fergus Millar, both of whom offered useful criticisms of my Chapter 4. I also profited from discussions of first-century materials with David Adams and Christian Beker. Roland Frye, John Gager, Daniel Hardy, and Van Reidhead made helpful suggestions concerning Chapter 5, as did George Kennedy for Chapter 2. As critic and editor, Peter Brown performed yeomanly for Chapters 2 and 3—his slash-and-burn admonitions helped me eliminate much of the dross. And on virtually all subjects that occupy the pages of this study, Morton Smith (D·M·) generously shared with me his enormous erudition.

On the archaeological–art-historical side I have benefitted greatly from personal associations and correspondence with Donald Bailey, Hugo Brandenburg, David Buckton, Arne Effenberger, Umberto Fasola, Antonio Ferrua, Paul-Albert Février (†), Joseph Gutmann, Martin Henig, Irving Lavin, Phillipe Pergola, Arnold Provoost, and Louis Reekmans (†). Among my esteemed University of Missouri–St. Louis colleagues (past and present), I want to single out for special thanks Howard Miller, Thomas Pickrel, Neal Primm, and John Works. To all of these persons I extend my sincere thanks. For all errors, both of fact and judgment, I assume full responsibility.

Generous support from library personnel has come from the Andover-Harvard, Widener, and Dumbarton Oaks libraries, from the libraries of the Hebrew University, the École Biblique, the Roman and Berlin branches of the German Archaeological Institute, the Pontifical Institute of Christian Archaeology, from Speer, Marquand, and the Institute for Advanced Study libraries and from the American School of Classical Studies Library in Athens. I am particularly indebted to Mary Zettwoch and Lucinda Williams and the accommodating Interlibrary Loan Staff at Thomas Jefferson Library, University of Missouri–St. Louis, as I am to Suor' Maria Francesca who responded promptly and with unfailing competence to my many requests for photographs from the archive of the Pontificia Commissione di Archeologia Sacra.

Material support came from Harvard University, the American Council of Learned Societies, the American Philosophical Society, the American Schools of Oriental Research, the German Archaeological Institute (Berlin), the Center of Theological Inquiry (Princeton), and University of Missouri–St. Louis.

I owe a considerable debt to my editors, Cynthia Read, Peter Ohlin, and Paul Schlotthauer at Oxford University Press. To them and to their colleagues I extend my warmest thanks. And to Brian MacDonald, "homo sollers subtilisque," many thanks, for the fine work copyediting a rather daunting text.

My last and greatest expression of gratitude goes to my colleague and wife, Kathleen McVey, to whom I dedicate this book. She has discussed the subject with me at length, has graciously read its many drafts, and has criticized this study with an unfailing eye to content as to form. It is much the better book thanks to her intelligence, insight, and encouragement.

Contents

Abbreviations

Academies, catalogues, congresses, epigraphic corpora, encyclopedias, journals, serials, lexica, text series

AA	*Archäologischer Anzeiger*
AAA	*Athens Annals of Archaeology*
AB	*Art Bulletin*
ABD	*The Anchor Bible Dictionary*
AbhBerl	*Abhandlungen der Preussischen Akademie der Wissenschaften. Phil.-hist. Kl.*
AbhGött	*Abhandlungen der Akademie der Wissenschaften in Göttingen. Phil.-hist. Kl.*
AbhMainz	*Mainz. Akademie der Wissenschaften und der Literatur. Abhandlungen der Geistes- und Sozialwissenschaftlichen Klasse*
AbhRh-Westf.Akad	*Abhandlungen der Rheinisch-Westfälische Akademie der Wissenschaften. Geisteswissenschaften*
AC	*Antike und Christentum*
AcA	*Acta Archaeologica*
AccadLincei	*Accademia Nazionale dei Lincei*
ACW	*Ancient Christian Writers*
AE	*L'Année Épigraphique*
AGDS	*Antike Gemmen in Deutschen Sammlungen*, 4 vols. (Munich, 1968–1975)
AIBL	*Académie des Inscriptions et Belles Lettres*
AIRF	*Acta Instituti Romani Finlandiae*
AJA	*American Journal of Archaeology*
AJP	*American Journal of Philology*
AkadGött	*Akademie der Wissenschaften in Göttingen*
ANS	American Numismatic Society
ANRW	*Aufstieg und Niedergang der römischen Welt*, ed. H. Temporini and W. Haase (Berlin, 1972–)
APA.Papers	*American Philological Association. Papers*
APA.Philological Monographs	*American Philological Association. Philological Monographs*
ArchCl	*Archeologia Classica*

ARW	*Archiv für Religionswissenschaft*
ASR	*Die Antiken Sarkophagreliefs*
AW	*Antike Welt*
BA	*Biblical Archaeologist*
Bailey, *Cat.*	D. M. Bailey, *A Catalogue of the Lamps in the British Museum 2. Roman Lamps Made in Italy* (London, 1980)
BAR	*British Archaeological Reports*
BAR Suppl.	*British Archaeological Reports. Supplementary Series*
Bardenhewer, *Gesch.*	O. Bardenhewer, *Geschichte der altkirchlichen Literatur*, 5 vols. (Freiburg, 1913–1932)
BASOR	*Bulletin of the American Schools of Oriental Research*
BBB	*Bonner Biblische Beiträge* (Cologne and Bonn)
BJbb	*Bonner Jahrbücher*
BKV	*Bibliothek der Kirchenväter*, ed. F. X. Reitmayr and V. Thalhofer
BM.MLA	London. The British Museum. Department of Mediaeval and Later Antiquities
Bonner, *SMA*	Campbell Bonner, *Studies in Magical Amulets* . . . (Ann Arbor, Mich., 1950)
Bosio, *RS*	A. Bosio, *Roma sotteranea* (Rome, 1632)
BSRAA	*Bulletin de la Société (Royale) Archéologique d'Alexandrie*
BullAC	*Bulletino di Archeologia Cristiana*
BullJRy	*Bulletin of the John Rylands Library*
BZ	*Byzantinische Zeitschrift*
CBQ	*Catholic Biblical Quarterly*
CH	*Church History*
ChicSCP	*University of Chicago Studies in Classical Philology*
Christ, Schmid, Stählin	W. Christ, W. Schmid, and O. Stählin, *Geschichte der griechischen Literatur* . . . , *HAW* 7 (Munich, 1908–)
CIAC	*Congresso Internazionale di Archeologia Cristiana* (Vatican City)
CIG	*Corpus Inscriptionum Graecorum*
CMH	*Cambridge Medieval History*
CP	*Classical Philology*
CQ	*Classical Quarterly*
CR	*The Classical Review*
CRINT	*Compendia Rerum Iudiacarum ad Novum Testamentum*, ed. M. de Jonge and S. Safrai (Assen/Maastricht, 1974–)
DACL	F. Cabrol and H. Leclercq, *Dictionnaire d'Archéologie Chrétienne et de Liturgie* (Paris, 1907–1953)
Dalton (1901)	O. M. Dalton, *Catalogue of the Early Christian Antiquities . . . in the . . . British Museum* (London, 1901)
Dar./Sag.	C. H. Daremberg and E. Saglio, *Dictionnaire des antiquités greques et romaines* (Paris, 1877–1919)
DHGE	*Dictionnaire d'Histoire et Géographie Ecclésiastique*
Dölger, ΙΧΘΥΣ	F. J. Dölger, ΙΧΘΥΣ, 5 vols. (Münster, 1910–1957)
DOP	*Dumbarton Oaks Papers*

EAA	*Enciclopedia dell'Arte Antica, Classica e Orientale*
EC	*Enciclopedia Cattolica*
EEC	*Encyclopedia of Early Christianity*, ed. E. Ferguson, M. P. McHugh, F. W. Norris, and D. M. Scholer (New York, 1990)
EJ	*Encyclopaedia Judaïca*, 2d ed. (Jerusalem, 1971)
ER	*The Encyclopedia of Religion*, ed. M. Eliade (New York, 1987)
ÉtTrav	*Études et Travaux (Studia i prace). Polski Academia Nauk. Zakład archaeologii*
FRLANT	Forschungen zur Religion und Literatur des Alten und Neuen Testaments
FS	*Frühmittelalterliche Studien*
GCS	*Die griechischen christlichen Schriftsteller der ersten [drei] Jahrhunderte*
Gibbon, *Decline*	E. Gibbon, *The History of the Decline and Fall of the Roman Empire*, 7 vols., ed. J. B. Bury (London, 1896–1900)
Goodenough, *Symbols*	*Jewish Symbols in the Greco-Roman Period*, 13 vols., ed. E. R. Goodenough (New York, 1953–1968)
GöGN	*Göttingen Gelehrten Nachrichten*
GöO	*Göttingen Orientforschungen. Reihe II: Studien zur spätantiken und frühchristlichen Kunst*
GRBS	*Greek, Roman, and Byzantine Studies*
Guthrie, *GkPhil*	W. K. C. Guthrie, *A History of Greek Philosophy*, 6 vols. (Cambridge, 1962–1981)
Harnack, *Gesch.*	A. von Harnack, *Geschichte der altchristlichen Literatur bis Eusebius*, 2d ed. (Leipzig, 1924)
HAW	*Handbuch der [klassischen] Altertumwissenschaft*, ed. I. von Müller, W. Otto, and H. Bengtson (Munich, 1892–)
HbO	*Handbuch der Orientalistik*
HeidAkad	*Heidelberger Akademie der Wissenschaften*
HSCP	*Harvard Studies in Classical Philology*
HTR	*Harvard Theological Review*
HTS	*Harvard Theological Studies*
HUCA	*Hebrew Union College Annual*
HZ	*Historische Zeitschrift*
IEJ	*Israel Exploration Journal*
IWWKT	*Internationale Wochenschrift für Wissenschaft, Kunst und Technik*
JAAR	*Journal of the American Academy of Religion*
JARCE	*Journal of the American Research Center in Egypt*
JbAC	*Jahrbuch für Antike und Christentum*
JbL	*Jahrbuch für Liturgiewissenschaft*
JBL	*Journal of Biblical Literature*
JbÖAI	*Jahrbuch des Österreichischen Archäologischen Instituts*
JdI	*Jahrbuch des deutschen archäologischen Instituts*
JEA	*Journal of Egyptian Archaeology*
JGS	*Journal of Glass Studies*
JJA	*Journal of Jewish Art*

JQR	*Jewish Quarterly Review*
JRS	*Journal of Roman Studies*
JSJ	*Journal for the Study of Judaism in the Persian, Hellenistic and Roman Periods*
JSP	*Journal for the Study of the Pseudepigrapha*
JThS	*Journal of Theological Studies*
Koch, *Bilderfrage*	H. Koch, *Die altchristliche Bilderfrage nach den literarischen Quellen*, FRLANT 27 (Göttingen, 1917)
KlPauly	*Der kleine Pauly*, ed. K. Ziegler and W. Southeimer (Munich, 1979)
LB	*Linguistica Biblica*
LCC	*Library of Christian Classics* (Philadelphia)
LCL	Loeb Classical Library
LCP	*Latinitas Christianorum Primaeva*
LQF	*Liturgiegeschichtliche Quellen und Forschungen*
MAAR	*Memoirs of the American Academy in Rome*
Magie, *RRAM*	D. Magie, *Roman Rule in Asia Minor* 1 and 2 (Princeton, N.J., 1950
MarbJb	*Marburger Jahrbuch für Kunstwissenschaft*
MarbThSt	*Marburger Theologische Studien*
MÉFRA	*Mélanges d'Archéologie de d'Histoire, publiés par l'École Française de Rome*
MémBrux	*Mémoires de l'Académie Royale de Belgique/Bruxelles*
MFA	Boston Museum of Fine Arts
MGH	*Monumenta Germaniae Historica*
MM	*Madrider Mitteilungen*
Mnem	*Mnemosyne*
Mommsen, *Straf.*	Th. Mommsen, *Römisches Strafecht* (Leipzig, 1899)
MonAnt	*Monumenti Antichi*, Accademia Nazionale dei Lincei
MPAI	*Monumenti della pittura antica scoperti in Italia*
MQR	*Mennonite Quarterly Review*
MüJb	*Müncher Jahrbuch der bildenden Kunst*
NHeidJbb	*Neue Heidelberger Jahrbücher*
Nilsson, *GGR* 1, 2	M. Nilsson, *Geschichte der griechischen Religion, HAW* Abt. 5.2.1 and 2, 2d and 3d eds. (Munich, 1961 and 1967)
NJbb	*Neue Jahrbücher für das klassische Altertum*
NovT	*Novum Testamentum*
NSc	*Notizie degli Scavi di Antichità*, Accad Lincei
NTS	*New Testament Studies*
OC	*Oriens Christianus*
OCD²	*Oxford Classical Dictionary*, ed. H. G. L. Hammond and H. H. Scullard, 2d ed. (Oxford, 1970)
OCT	Oxford Classical Texts
OECT	Oxford Early Christian Texts
OLD	*Oxford Latin Dictionary*, ed. P. G. W. Glare (Oxford, 1982)
PARA	*Pontificia Accademia Romana de Archeologia*
PBSR	Papers of the British School at Rome
PCAS	Pontificio commissione di archeologia sacra

PEQ	*Palestine Exploration Quarterly*
PIAC	Pontificio Istituto di Archeologia Cristiana
PP	*Past and Present*
Preisigke, *Sammelbuch*	F. Preisigke, F. Bilabel, and E. Kissling, *Sammelbuch griechischer Urkunden aus Ägypten* (Berlin, 1915–1958)
PTS	Patristische Texte und Studien
RA	*Revue Archéologique*
RAC	*Reallexikon für Antike und Christentum*
RB	*Revue Biblique*
RE	*Realenzykopädie der klassischen Altertumswissenschaft*, ed. A. Pauly, G. Wissowa, and W. Kroll (Stuttgart, 1893–1970)
RÉAug	*Revue des Études Augustiniennes*
RÉJ	*Revue des Études Juives*
RendPontAcc	*Atti della Pontificia Accademia Romana de Archeologia, Rendiconti*
Rep	*Repertorium der christlich-antiken Sarkophage I: Rom u. Ostia*, ed. F. W. Deichmann (Weisbaden, 1967)
RepKu	*Repertorium für Kunstwissenschaft*
REprot	*Realencyclopaedia für protestantische Theologie und Kirche*, ed. J. Herzog and A. Hauck (Leipzig, 1897–1913)
RHE	*Revue d'Historie Ecclésiastique*
RhM	*Rheinisches Museum für Philologie*
Rh-Westf.Akad.Vort	*Rheinische-Westfälische Akademie der Wissenschaften. Geisteswissenschaften. Vorträge*
RivAC	*Rivista di Archeologia Cristiana*
RivIstArch	*Rivista dell'Istituto Nazionale di Archeologia e Storia dell'Arte*
RKW	*Repertorium für Kunstwissenschaft*
RM	*Mitteilungen des deutschen archäologischen Instituts. Römische Abteilung*
Roscher, *Lex.*	W. Roscher, *Ausfürliches Lexikon der griechischen und römischen Mythologie* (Leipzig, 1884–1937)
Rossi, *RS*	G. B. de Rossi, *La Roma sotteranea cristiana descritta e illustrata*, 3 vols. (Rome, 1864–1877)
RQ	*Römische Quartalschift*
SbBerl	*Sitzungberichte der Akademie der Wissenschaften zu Berlin. Phil.-hist. Kl.*
SC	*The Second Century*
SCD	*Studien über christliche Denkmäler*, ed. Johannes Ficker
Schanz and Hosius	M. Schanz and C. Hosius, *Geschichte der römischen Literatur*, 4 vols. 4th ed. (Munich, 1914–1935)
SCHNT	*Studia ad Corpus Hellenisticum Novi Testamenti*
SChr	Sources Chrétiennes (Paris)
SCP	*Studies in Classical Philology*
ST	*Studi e Test*
StudPalPap	*Studien zur Palaeographie und Papyruskunde*, ed. C. Wessely (Leipzig, 1904–1924)
SussSACr	*Sussidi allo studio delle antichità cristiane*

TAPA	*Transactions [and Proceedings] of the American Philological Association*
TDNT	*Theological Dictionary of the New Testament*, ed. G. Kittel and G. Friedrich, trans. G. W. Bromily (Grand Rapids, Mich., 1964)
ThLZ	*Theologische Literaturzeitung*
TLL	*Thesaurus Linguae Latinae*
TQ	*Theologische Quartalschrift*
TRev	*Theologishe Revue*
TS	*Texts and Studies* (Cambridge)
TSAJ	*Texte und Studien zum Antiken Judentum*
TU	*Texte und Untersuchungen zur Geschichte der altchristlichen Literatur*
VC	*Vigiliae Christianae*
VetChr	*Vetera Christianorum*
ZAW	*Zeitschrift für die alttestamentliche Wissenschaft*
ZDMG	*Zeitschift der deutschen morgenländischen Gesellschaft*
ZKG	*Zeitschrift für Kirchengeschichte*
ZKT	*Zeitschrift für katholische Theologie*
ZNW	*Zeitschrift für die neutestamentliche Wissenschaft*
ZPE	*Zeitschrift für Papyrologie und Epigraphik*
ZSav	*Zeitschrift der Savigny-Stiftung für Rechtsgeschichte. Romanistische Abteilung*
ZTK	*Zeitschrift für Theologie und Kirche*

Texts, translations, commentaries, short titles of monographs

NB: Abbreviations of books in the Hebrew Bible, the New Testament, and their respective Apocrypha/Pseudepigrapha are given according to the conventions of the *NRSV*.

Ael., *VH*	Claudius Aelianus, *Varia Historia*, ed. R. Hercher (Leipzig, 1857)
Aët.	Aëtius (eclectic compiler; fl. ca. A.D. 100); frags. apud Diels, *DoxGr.*, 273–444
Alb., *Didas*	Albinus, *Didaskalikos*, ed. P. Louis (Paris, 1945)
Anthisth., *Frag.*	*Anthisthenis Fragmenta*, ed. F. C. Caizzi (Milan, 1966)
Apsines, *Rhet. Gr.*	Valerius Apsines of Gardara (*PIR*² A978); apud L. Spengel, ed., *Rhetores Graeci* I (Leipzig, 1853–1856), 331ff.
Apul., *Apol.*	Apuleius, *Apologia*, ed. R. Helm (Leipzig, 1905)
Arist., *An*	Aristotle, *De Anima*, ed. W. D. Ross, OCT (Oxford, 1961)
Arist., *Phys.*	Aristotle, *Physica*, ed. W. D. Ross, OCT (Oxford, 1900)
Arist., *Rhet.*	Aristotle, *Ars Rhetorica*, ed. W. D. Ross, OCT (Oxford, 1969)
Aristid., *Apol.*	Aristides, *Die Apologie . . .* , ed. E. Hennecke, *TU* 4.3 (Leipzig, 1893)

Arn., *Pag.*	Arnobius, *Contra Paganos*, ed. A. Reifferscheid, *CSEL* 4 (Vienna, 1875)
Athen., *Deip.*	Athenaeus, *Deipnosophistae*, ed. G. Kaibel (Leipzig, 1887–1890)
Athenag., *Leg.*	Athenagoras, *Legatio and De Resurrectione*, ed. W. Schoedel, OECT (Oxford, 1972)
Aug., *CD*	Augustine, *De Civitate Dei*, ed. B. Dombart and A. Kalb, 4th ed. (Leipzig, 1928–1929) = *CCL* 47–48 (Turnhout and Paris, 1955)
Aug., *Conf.*	Augustine, *Confessions*, ed. P. Knöll, *CSEL* 33.1 (Vienna, 1896)
Aus., *Epita.*	Ausonius, *Epitaphia heroun*, ed. S. Prete (Leipzig, 1978)
B.M. Pap. Inv. No.	London. The British Museum. Papyrus Inventory Number
CCL	*Corpus Christianorum. Series Latina* (Turnhout and Paris)
Cic., *Acad. Post.*	Cicero, *Academica Posteriora*, ed. M. Ruch (Paris, 1970)
Cic., *Att.*	Cicero, *Epistulae ad Atticum*, ed. D. R. Shackleton Bailey (Stuttgart, 1987)
Cic., *Div.*	Cicero, *De Divinatione*, ed. A. S. Pease (Urbana, Ill., 1920)
Cic., *Inv.*	Cicero, *De Inuentione*, ed. E. Stroebel (Stuttgart, 1965)
Cic., *ND*	Cicero, *De Natura Deorum*, ed. A. S. Pease (Cambridge, Mass., 1955–1958)
Cic., *Or.*	Cicero, *Orator ad M. Brutum*, ed. A. S. Wilkins, OCT (Oxford, 1903)
Cic., *Part.*	Cicero, *Partitiones Oratoriae*, ed. A. S. Wilkins, OCT (Oxford, 1903)
CIJ	*Corpus Inscriptionum Judaicarum*, ed. J.-B. Frey and B. Lifshitz, *SussSACr* 1 (New York, 1975)
CIL	*Corpus Inscriptionum Latininarum*
Clem., *Prot.*	Clemens Alexandrinus, *Protrepticus u. Paidagogos*, 3d ed., ed. O. Stählin, *GCS* 36 (Berlin, 1972)
Clem., *Strom.*	Clemens Alexandrinus, *Stromata* I–IV, 3d ed., ed. O. Stählin and L. Früchtel, *GCS* 52 (Berlin, 1960)
Clem., *Strom.*	Clemens Alexandrinus, *Stromata VII & VIII. Excerpta ex Theodoto. Eclogae Propheticae. Quis Dives Salvetur. Fragmente*, 2d ed., *GCS* 17 (Berlin, 1970)
Col., *Re Rustica*	L. Iunius Moderatus Columella, *De Re Rustica*, ed. H. B. Ash, E. S. Forster, and E. Heffner, LCL (1948–1955)
CSEL	*Corpus Scriptorum Ecclesiasticorum Latinorum* (Vienna, 1866–)
CSHB	*Corpus Scriptorum Historiae Byzantinae* (Bonn)
Cyprian, *Epp.*	Cyprian, *Epistulae*, ed. W. Hartel, *CSEL* 3.2 (Vienna, 1871)
D. Chr., *Orat.*	Dio Cocceianus [Chrysostom], *Orationes*, ed. L. Dindorf (Leipzig, 1857)

Denis, *FPG*

A.-M. Denis, *Fragmenta Pseudepigraphorum Quae Supersunt Graeca Una Cum Historicorum et Auctorum Judaeorum Hellenistarum Fragmentis* (Leiden, 1970)

Diels., *DoxGr.*

Doxographi Graeci, ed. H. Diels (Berlin, 1879)

Diels and Kranz, *Vorsokr.*

Fragmente der Vorsokratiker, 3d ed., ed. H. Diels and W. Kranz (Oxford, 1966)

Dig.

Iustiniani Digesta, ed. Th. Mommsem (Berlin, 1900–1904)

Diod. Sic.

Diodorus Siculus, ed. L. Dindorf (Leipzig, 1866–1868)

Diogn. Epis.

Anonymous, *À Diognète*, ed. H. Marrou, SChr (Paris, 1951)

Epict., *Diss.*

Epictetus, *Epicteti Dissertationes . . .* , ed. H. Schenkl (Stuttgart, 1965)

Epiphan., *Haer.*

Epiphanius, *Panarion* 1–80, ed. K. Holl, *GCS* 25, 31, and 37 (Leipzig, 1915–1933)

Eur., *Bacch.*

Euripides, *Bacchae*, 2d ed., ed. A. H. Cruickshank (Oxford, 1921)

Eus., *Chron.*

Eusebius, *Die Chronik*, ed. J. Karst, *GCS* 20 (Leipzig, 1911)

Eus., *HE*

Eusebius, *Die Kirchengeschichte*, ed. E. Schwartz, *GCS* 9.1 and 9.2 (Leipzig, 1903 and 1908)

Eus., *PE*

Eusebius, *Praeparatio Evangelica*, 2d ed., ed. K. Mras and É. des Places, *GCS* 43.1 and 2 (Berlin, 1982, 1983)

FGrHist

F. Jacoby, ed., *Die Fragmente der griechischen Historiker* (Berlin and Leiden, 1923–)

Gaius, *Inst.*

Gaius [jurist; fl. 2d century A.D.], *Gai Institutiones*, 2d ed., ed. E. Seckel and B. Kubler (Berlin, 1935)

HA

Scriptores Historiae Augustae, ed. E. Hohl (Leipzig, 1965)

Herm., *Mand.*

Anonymous, *Shepherd of Hermas* (*Mandates*), ed. M. Whittaker, *GCS* 48 (Berlin, 1956)

Hermog., *Progym.*

Hermongenis Opera (*Progymnasmata*), ed. H. Rabe, *RhetGr* 3.3ff. (Leipzig, 1913)

Hipp., *Dan.*

Hippolytus, *Commentary on Daniel*, ed. G. N. Bonwetsch, *GCS* 1.1 (Leipzig, 1897)

Hipp., *Ref.*

Hippolytus, *Refutation Omnium Haeresium*, ed. M. Markovich, PTS 25 (Berlin, 1986)

Hor., *Sat.*

Horace, *Satirae* (*sermones*), ed. F. Klinger (Leipzig, 1950)

ICVR

Inscriptiones Christianae Urbis Romae

Ign., *Eph.*

Ignatius of Antioch, *Epistle to the Ephesians*, 2d ed., ed. F. X. Funk, K. Bihmeyer, and W. Schneemelcher (Tübingen, 1956)

ILCV

Inscriptiones Latinae Christianae Veteres, ed. E. Diehl (Dublin, 1925–1970)

ILS

Inscriptiones Latinae Selectae, ed. H. Dessau, 3 vols. (Berlin, 1892–1916)

Iren., *Haer.*

Sancti Irenaei ep. Lugdunensis Libros Quinque Adversus Haereses, ed. W. W. Harvey (Cambridge, 1857)

Iust., *Inst.*

Justinian, *Institutiones*, ed. P. Krüger (Berlin, 1900–1904)

Jer., *Vir.*	Jerome, *De Viris Inlustribus*, ed. E. C. Richardson (Leipzig, 1896)
Jos., *Ap.*	Josephus, *Against Apion*, 2d ed., ed. B. Niese (Berlin, 1955)
Jos., *JW*	Josephus, *The Jewish War*, 2d ed., ed. B. Niese (Berlin, 1955)
Just., I *Apol.*	Justin, *Apolgia* I, ed. J. C. Th. Otto, Corp. Apol. I.1, 3d ed. (1876)
Just., II *Apol.*	Justin, *Apopogia* II, ed. Otto, *Corp. Apol.* I.1, 3d ed. (1876)
KP	*Kerygma Petri* (Fragments in Clem., *Strom.* 1 and 6)
LP	*Le Liber Pontificalis*, ed. L. Duchesne (Paris, 1886–1892); rpt. with additions and corrections by C. Vogel (Paris, 1955–1957)
Luc., *J. Conf.*	Lucian, *Juppiter Confutatus*, ed. C. Jacobitz (Leipzig, 1896–1897)
Luc., *J. Tr.*	Lucian, *Juppiter Tragoedus*, ed. C. Jacobitz (Leipzig. 1896–1897)
Luc., *Pereg.*	Lucian, *De Morte Peregrini*, ed. M. D. MacLeod, OCT (Oxford, 1980)
Luc., *Philops.*	Lucian, *Philopseudes*, ed. M. D. MacLeod, OCT (Oxford, 1974)
Luc., *Somn.*	Lucian, *Somnium Sive Vita Luciani*, ed. M. D. MacLeod, OCT (Oxford, 1974)
LXX	*Septuaginta. Vetus Testamentum Graecum*, ed. A. Rahlfs (Stuttgart, 1935)
Macer	Aemilius Macer [jurist; fl. late Severan period: cf. Schanz and Hosius III.213]; frags. apud *Dig.*
Marc. Aur., *Med.*	Marcus Aurelius, *Meditations*, 2d ed., ed. A. S. L. Farquharson (Oxford, 1952)
Mart. Is.	*Martyrdom of Isaiah* (alt. title: *Testament of Hezekiah*), trans. M. A. Knibb, *OTPseud* 2.143–76
Mart. Polyc.	*Martyrdom of Polycarp*, 4th ed., ed. G. Krüger and G. Ruhbach (Tübingen, 1965)
Math.	Sextus Empiricus, *Adversus Mathematicos*, 2d ed., ed. H. Mutschmann, J. Mau, and K. Janáček (Leipzig, 1954–1957)
Men., *Frag.*	*Menandri Quae Supersunt* I and II, ed. H. Körte and A. Thierfelder (Leipzig, 1953–1955)
Men. Rhet., *Diaer.*	Menander (apud *Suda*: "M" 590). *Treatises* I and II, ed. D. A. Russell and N. G. Wilson (Oxford, 1981)
Met.	Apuleius, *Metamorphoses*, 3d ed., ed. T. Helm (Leipzig, 1950)
Min., *Oct.*	*Minucius Felix Octavius*, ed. J. Beaujeu, SChr (Paris, 1974)
Nat.	Ephrem the Syrian, *Hymns on the Nativity*, in *Ephrem the Syrian Hymns*, trans. K. E. McVey (New York and Mahwah, N.J., 1989)
NRSV	*The New Oxford Annotated Bible*, New Revised Standard Version, ed. B. M. Metzger and R. E. Murphy (New York, 1991)

Od.	Homer, *Odyssea*, ed. D. B. Monro and T. W. Allen, OCT (Oxford, 1902–1912)
Orac. Sib.	Anonymous, *Oracula Sibyllina*, ed. J. Geffcken, *GCS* 8 (Leipzig. 1902)
Orig., *Cels.*	Origen, *Contra Celsum*, ed. P. Koetschau, *GCS* 2–3 (Leipzig, 1899)
Orig., *Princ.*	Origen, *De Principiis*, ed. P. Koetschau, *GCS* 22 (Leipzig, 1913)
OTPseud	*Old Testament Pseudepigrapha* 1 and 2, ed. J. Charlesworth (Garden City, N.Y., 1983–1987)
Otto, *Corp. Apol.*	*Corpus Apologetarum Christianorum Saeculi Secundi*, 3d ed., 9 vols., ed. J. K. Th. Otto (Jena, 1876–1881)
Ov., *Met*	P. Ovidii Nasonis, *Metamorphoses*, ed. W. S. Anderson (Leipzig. 1985)
OxyPap	Oxyrhynchus Papyri
Paul.	Julius Paulus [jurist; fl. ca. A.D. 210]; frags. apud *Dig.*
Paus.	Pausanius, *Graeciae Descriptio*, ed. M. H. Rocha-Pereira (Leipzig, 1973)
PG	J. Migne, Patrologia graeca (Paris)
PGM	*Papyri Graecae Magicae*, 2 vols., 2d ed., ed. K. Preisendanz and A. Henrichs (Stuttgart, 1973–1974)
Phaed.	Plato, *Phaedrus*, ed. J. Burnet, OCT (Oxford, 1901)
Philo, *Ap.*	*Contra Apionem in Philonis Alexandrini Opera Quae Supersunt*, ed. I. Cohn and P. Wendland (Berlin, 1896–1930)
Philod., *Rhet.*	Philodemus, *Philodemi Volumina Rhetorica*, 2 vols., and Suppl., ed. S. Sudhaus (Leipzig, 1892–1896)
Philod., *Sign.*	Philodemus, *De Signis* (Περὶ Σημείων καὶ Σημειώσεων), ed. P. H. de Lacy and E. A. de Lacy (Naples, 1978)
Philostr., *VS*	Philostratus, *Lives of the Sophists*, ed. C. L. Kayser (Leipzig, 1870–1871)
PIR	*Prosopographia Imperii Romani*, 2d ed., ed. E. Groag and A. Stein, (Berlin and Leipzig, 1933–1970)
PL	J. Migne, *Patrologia Latina* (Paris)
Pl., *Rep.*	Plato, *Republic*, ed. J. Burnet, OCT (Oxford, 1902)
Pl., *Tht.*	Plato, *Theatetus*, ed. J. Burnet, OCT (Oxford, 1900)
Pl., *Ti.*	Plato, *Timaeus*, ed. J. Burnet, OCT (Oxford, 1902)
Plin., *Ep.*	C. Plinius Caecilius Secundus, *Epistulae*, ed. R. A. B. Mynors, OCT (Oxford, 1963)
Plin., *Nat.*	C. Plinius Caecilius Secundus, *Naturalis Historia*, ed. L. von Jan and C. Mayhoff (Leipzig, 1875–1906)
Plut., *De E*	Plutarch, *De E apud Delphos* (*Mor.* 384D–394C), ed. W. R. Paton, M. Pohlenz, and W. Sieveking (Leipzig, 1972)
Plut., *Def. Orac.*	Plutarch, *De Defectu Oraculorum* (*Mor.* 409E–483E), ed. W. R. Paton, M. Pohlenz, and W. Sieveking (Leipzig, 1972)
Plut., *Deis.*	Plutarch, *De Superstitione* (*Mor.* 164E–171E), ed. G. N. Bernardakis, 7 vols. (Leipzig, 1888–1896)

Plut., *Is. Osir.*	Plutarch, *De Iside et Osiride* (*Mor.* 351C–384C), ed. G. N. Bernardakis, 7 vols. (Leipzig, 1888–1896)
Plut., *Mor.*	Plutarch, *Moralia*, ed. G. N. Bernardakis (Leipzig, 1888–1896)
Plut., *Per.*	Plutarch, *Pericles*, in *Vita Parallelae*, ed. Cl. Lindskog and K. Ziegler, 3d ed. (Leipzig, 1964–)
Posidon., *Frag.*	Posidonius, *Die Fragmente*, ed. W. Theiler, E. Chambry, and M. Juneaux (Berlin and New York, 1982)
Prud., *Cath.*	Prudentius, *Cathemerinon*, ed. J. Bergman, *CSEL* (Vienna, 1926)
Quint., *Inst.*	Quintilian, *Institutio Oratoria*, ed. M. Winterbotton (Oxford, 1970)
Rhet. Gr.	*Rhetores Graeci*, ed. L. Spengel, 3 vols. (Leipzig, 1853–1856)
Schürer, *Hist.*	E. Schürer, G. Vermes, F. Millar, and M. Goodman, *The History of the Jewish People in the Age of Jesus Christ*, 3 vols. (Edinburgh, 1973–1987)
Sen., *Ep.*	Seneca, *Epistulae*, 2d ed., ed. A. Beltrami (Rome, 1937)
Sen., *Sup.*	Seneca, *L. Annaei Senecae Opera* 3 (fragments), ed. F. Haase (Leipzig, 1878)
Stern, *GLAJJ*	*Greek and Latin Authors on Jews and Judaism*, 3 vols., ed. M. Stern (Jerusalem, 1974–1984)
Suda	*Suidiae Lexicon*, 5 vols., ed. A. Adler (Leipzig, 1928–1938)
Suet., *Nero*	Suetonius, *De Vita Caesarum: Nero*, ed. M. Ihm (Leipzig, 1933)
SVF	*Stoicorum Veterum Fragmenta*, 4 vols., ed. J. von Arnim and M. Adler (Leipzig, 1903–1924)
Tac., *Ann.*	Tacitus, *Annalium . . . Libri*, ed. C. D. Fisher, OCT (Oxford, 1906)
Tac., *Hist.*	Tacitus, *Historiae*, ed. C. D. Fisher and H. Furneaux, OCT (Oxford, 1910)
Tat., *Or.*	Tatian, *Oration ad Graecos and Fragments*, ed. M. Whittaker, OECT (Oxford, 1982)
Tert., *Apol.*	Tertullian, *Apologeticum*, ed. C. Becker (Munich, 1961)
Tert., *Bap.*	Tertullian, *De Baptismo*, ed. A. Reifferscheid and G. Wissowa, *CSEL* 20 (Vienna, 1890)
Tert., *Cult. Fem.*	Tertullian, *De Cultu Feminarum*, ed. A. Kroymann (1942) = *CSEL* 70 = *CCL*1 (Turnhout and Paris, 1954)
Tert., *Exhort. Cast.*	Tertullian, *De Exhortatione Castitatis*, ed. A. Kroymann (1942) = *CSEL* 70 = *CCL* 1 (Turnhout and Paris, 1954)
Tert., *Fug.*	Tertullian, *De Fuga in Persecutione*, ed. J. J. Thierry (Thesis, Free University, Amsterdam; Hilversum, 1944)
Tert., *Idol.*	Tertullian, *De Idololatria*, ed. J. H. Waszink and J. C. M. van Winden (Leiden, 1987)
Tert., *Marc.*	Tertullian, *Adversus Marcionem*, ed. E. Evans, OECT (Oxford, 1972)

Tert., *Nat.*	Tertullian, *Ad Nationes*, ed. J. W. Ph. Borleffs (Leiden, 1929) = *CCL* 1 (Turnhout and Paris, 1954)
Tert., *Pud.*	Tertullian, *De Pudicitia*, ed. A. Reofferscheid and G. Wissowa, *CSEL* 20 (Vienna, 1890)
Tert., *Scap.*	Tertullian, *Ad Scapulam*, ed. E. Dekkers, *CCL* 2 (Turnhout and Paris, 1954)
Tert., *Scorp.*	Tertullian, *Scorpiace*, ed. A. Reifferscheid and G. Wissowa, *CSEL* 20 (Vienna, 1890) = *CCL* 2 (Turnhout and Paris, 1954)
Tert., *Spect.*	Tertullian, *De Spectaculis*, ed. A. Reifferscheid and G. Wissowa. *CSEL* 20 (Vienna, 1890)
Thdt., *Graec.*	Theodoret of Cyrus, *Graecarum Affectionum Curatio*, ed. P. Canivet, SChr 58 (Paris, 1958)
Thdt., *HE*	Theodoret of Cyrus, *Historia Ecclesiastica*, ed. L. Parmentier and F. Scheidweiler, *GCS*, 2d ed. (Berlin 1954)
Theophil., *Autol.*	Theophilus, *Ad Autolycum*, ed. R. M. Grant, OECT (Oxford, 1970)
Ulp.	Domitius Ulpianus [jurist; d. A.D. 223]; frags. pud *Dig.*
Var., *Ant.*	M. Terentius Varro, *Antiquitates Rerum Humanarum et Divinarum*. Teil I: *Die Fragmente*, ed. B. Cardauns, *AbhMainz* (Mainz, 1976)
Var., *R.*	M. Terentius Varro, *Rerum Rusticarum libri tres*, ed. G. Götz (Leipzig, 1912)
Virg.	Ephrem the Syrian, *Hymns on Virginity*, in *Ephrem the Syrian Hymns*, trans. K. E. McVey (New York and Mahwah, N.J., 1989)
Vitr.	Vitruvius Pollio, *De Architectura*, ed. F. Krohn (Leipzig, 1912)
Xen., *Mem.*	Xenophon, *Memorabilia*, ed. C. Hude (Leipzig, 1934)

THE INVISIBLE GOD

1

The History of Interpretation

In a sense this study has two subjects: what the earliest Christians thought about art and what later interpreters (the present writer included) said they thought. The two are not easily disentangled. In fact any separation of the primary subject from the history of its interpretation is bound to be arbitrary—after all, even the earliest second-century apologists thought they were interpreting first-century tradition; hence they too belong to the history of interpretation. But one must draw the line somewhere, and I have done so here at the Tetrarchy. Thus, for this study developments in the fourth and subsequent centuries will be construed as belonging to the history of interpretation. The primary subject of this study is located in the pre-Tetrarchic period.

Although there have been multiple beginnings in the ongoing interpretations of our subject, one can distinguish three watersheds along the way. The first occurred in the eighth century, the second and third in the sixteenth and nineteenth centuries respectively. These three I think provide a useful and workable framework for the discussion of interpretative traditions. Admittedly, these three rubrics do not exhaust the complex history of interpretation that surrounds our subject, but they do have the virtue of underscoring a set of continuities that extend from the fourth century to the present.

Byzantine Precedents

During the Iconoclastic controversy[1] (726–843), the opposing parties argued their respective positions from two vantage points, the one dogmatic

3

(with analogies to Christology), the other traditional and quasi-historical (with appeals to Scripture and other real or invented precedents). The latter, the so-called historical argument, concerns us here. Both of the disputing parties, Iconoclasts and Iconophiles, created anthologies (*florilegia*) of quotations excerpted from the Bible and from the Fathers, and these anthologies became the foundation of all subsequent interpretation based on appeals to tradition and historical precedent (whether real or imagined).

In Byzantium, both the pro- and anti-image factions culled their quotations from the same patristic sources, and both did so with equal disregard for the original literary and historical contexts that defined their materials. Both arranged their excerpted materials polemically, and for both the goal was the same, namely to prove that the authoritative testimony of a given excerpt represented the true historical line of Christian tradition, both in thought and in practice. The quarreling parties strung together quotations within their respective anthologies in the manner of loosely assembled catenae constructed around proof texts. Overall these polemical florilegia constituted an important part of the Byzantine disputants' literary arsenals, assembled and deployed for the primary purpose of demolishing the enemy's defense.

Within the Iconoclastic camp, Emperor Constantine V (741–775) played a central role in creating the anti-image florilegium tradition. Prior to convening the Iconoclastic Council of Hiereia (10 February to 8 August 754), he drafted a document entitled the *Inquiries*[2] (πευσεῖς), which then served as the focus of the Council's deliberations. This document, subsequently incorporated into the Council's final *Definition*[3] (Ὅρος), did contain the argument from tradition replete with excerpted testimonies, but it was set forth here in a provisional and rudimentary form.

We have better evidence of Constantine's reliance on arguments from history and tradition in Patriarch Nicephorus' so-called *Against Eusebius and pseudo-Epiphanius*[4] where Nicephorus tells us that Constantine had drafted an anthology of patristic quotations (χρησεῖς), which he intended to deploy against his iconophilic enemies. According to the patriarch, Constantine had excerpted primarily from the writings of Eusebius of Caesarea and Epiphanius of Salamis, but we are told he also adduced quoted materials from Gregory of Nyssa, Gregory of Nazianzen, Athanasius, Cyril of Alexandria, Nilus of Ancyra, John Chrysostom, Amphilocius of Iconium, and Methodius of Myra. On Nicephorus' testimony it appears the Emperor went to considerable lengths to establish that his and his fellow Iconoclasts' position of uncompromising opposition to religious pictures was in the true line of Christian tradition. In short, the Iconoclasts sought to vindicate their views and practices by associating with a venerable line of authorities reaching back into the early church.

On 6 October 787 the sixth session of the second Council of Nicea was called to order. Its business was to read aloud verbatim and to condemn the *Definition* of 754. Gregory of Neo-Caesarea (in the Euphrates Di-

ocese), himself an Iconoclast manqué and signatory at Hiereia, was chosen to read the offending document, which contained quotations lifted from both Testaments and from Patristic sources, most of them well known. About one-third of the way through the session Gregory pronounced a statement that summarized well the Iconoclastic sense of the early Christian past, "the foul name of images, falsely so-called, cannot be justified by the tradition of Christ, nor can it be justified by the tradition of the Apostles and the Fathers."[5]

This blanket declaration of the Iconoclastic position is short and effective. It represents the Iconoclasts' claim that there is nothing in early Christian tradition to justify the Christian use of religious pictures, an argument from silence that their Iconophile opponents had a hard time refuting. But in addition to this negative claim, the statement also implies a positive assertion, namely that there existed a tradition (attested in written form, although Gregory does not say so) that condemned the Christian use of images. With these few words the Iconoclasts had thrown down the gauntlet, and their Iconophile opponents strained under the challenge.

Indeed the pro-image faction was so hard put and so tendentious in its reply that modern scholarship has tried to settle the dispute once for all in favor of the Iconoclasts. As one distinguished contemporary Byzantinist has put it, "the Iconoclasts were closer to historical truth than their opponents in affirming that the early Christians had been opposed to figurative arts."[6] Mango's assessment of this issue represents a kind of modern critical consensus: the Iconoclastic view of the early church is said to be more historically accurate, a more faithful reconstruction of the "historical truth" than the opposing position. In short, we are supposed to believe that early Christianity was a religion that opposed the use of religious images.

The Sixteenth Century

In sixteenth-century western Europe we encounter continuations of the anti-image florilegium tradition begun in Byzantium. A well-known German example, at once iconoclastic and antimendicant, comes from the pen of Andreas Bodenstein von Carolstatt (Karlstadt): it carries the intriguing title *Von Abtuhung der Bilder vnd das keyn Bedtler vnther der Christen seyn sollen* (On the abolition of pictures and why there should be no beggars among Christians).[7]

Karlstadt published this little pamphlet at Wittenberg on 27 January 1522, and in the fall of the following year Ludwig Hätzer brought out an anti-image tractate[8] based on Karlstadt's. In 1525 Huldreich Zwingli published his well-known *Answer to Valentin Compar*,[9] based directly on Hätzer's work, indirectly on Karlstadt's. In other words, Karlstadt's modest little pamphlet exercised considerable influence in the creation of the Reformation anti-image argument based on tradition and history.

Karlstadt omits altogether the Byzantine method of argument based on Christological analogies. Instead he relies entirely on arguments rooted in tradition, to wit, biblical and patristic testimonies understood as proof texts. In omitting proofs based on analogies with dogmatic-theological arguments and in underscoring tradition, especially biblical precedents, Karlstadt's treatise represents the course followed by most of the sixteenth-century pamphleteers and controversialists who argued either for or against the Christian use of images.

Karlstadt quoted extensively from both Testaments, the majority of the excerpts having to do with the evils of idolatry and the desirability of a pure Christian worship, free of externals such as pictures. He culled Old Testament quotations, nearly seventy in number, from the Pentateuch, the historical books, and the prophets. He based New Testament proofs primarily on John[10] and the Pauline corpus; he took four quotations from the synoptic Gospels and one each from Hebrews, 1 Peter, and 1 Timothy.

As for patristic tradition, which he knew very imperfectly, Karlstadt classified Pope Gregory's famous defense[11] of religious images (that as a *biblia pauperum* they provide a substitute for the illiterate) under the category of papist obfuscations inspired by Satan. Karlstadt also alluded to a *Letter*[12] (written perhaps 393 or 394), attributed to Epiphanius and addressed to John of Jerusalem. Karlstadt must have known Jerome's translation (published by Erasmus in 1516) of this problematic document in which Epiphanius tells John he had discovered a curtain (evidently embroidered or dyed) bearing the image of Christ or one of the saints and hanging over the doorway of a Palestinian church. Epiphanius writes that straightaway he tore down the offending curtain and gave instructions that it be used as a burial wrap for an indigent person.

In the early 1520s the Wittenberg burghers were reeling with the headiness of iconoclastic zeal, as evidenced by Gabriel Zwilling[13] and his monastic confrères, the Augustinian hermits who purged the Wittenberg cloister church of its idolatrous images on 10 January 1522.[14] The latter is the first recorded instance of Reformation iconoclasm that survives, but many[15] more followed. And no doubt an example of iconoclastic behavior such as that provided by the enthusiastic Bishop of Salamis was well timed and fed the flames of Reformation indignation at the idolatrous use of images.

Later in the sixteenth century John Calvin brought out his *Institutes*, and within this impressive monument of Reformed theology he set forth a primitivist version of ecclesiastical history, one that contrasted a pristine primeval beginning with successive stages of decay and degeneration. Not coincidentally, Calvin (like Israel's judges and prophets: a mighty enemy of idolaters) made aniconism one of the hallmarks of Christianity's golden era—in Calvin's view, it was only after early medieval corruptions had begun to creep into the church that Christians had adopted the use of religious images:

For about the first five hundred years, during which religion was still flourishing, and a purer doctrine thriving, Christian churches were commonly empty of images [Christiana templa fuisse communiter ab imaginibus uacua]. Thus, it was when the purity of the ministry had somewhat degenerated that they were first introduced for the adornment of churches [in ornamentum templorum]. . . .[16]

Of all the sixteenth-century Reformers, Calvin had the best grasp of patristic literature. He possessed a firsthand acquaintance with the writings of Tertullian, Cyprian, Justin, Irenaeus, Eusebius, Hilary, Augustine, the Cappadocians, and Chrysostom. He also inclined to accept the authority of the first four ecumenical councils, although not without certain reservations. He represented his reform program as a return to the apostolic and the patristic periods—both in his view constituted a seamless robe of unsullied and uncompromised tradition.

For Calvin it was simply unthinkable that pictures could have cluttered up this pristine spiritual commonwealth. And so he concluded there had been none, no pictures in Christian churches before Chalcedon (451). Primitive Christianity had been an aniconic form of religiosity. Karlstadt and Zwingli had also uncovered patristic expressions of hostility to images, but Calvin knew all that they knew and a great deal more—indeed he assembled more art-related testimonia than any of his predecessors or contemporaries, both Protestant and Catholic.[17] It is clear, especially from his exegetical work, that Calvin was immensely impressed by the Second Commandment, which he linked, often habitually, with the anti-idolatry pronouncements of the Fathers. He was eager to uphold the unsullied purity of the apostolic and early patristic church. These convictions were so real to Calvin that they evidently prompted him to conclude (on the evidence of the words just quoted) that there had been no early Christian art "for about the first five hundred years [quingentis circiter annis], . . ."

In short, Calvin linked theoretical iconophobia with aniconism in practice, that is, religion without pictures. He seems to have inferred the latter from the former, as one would a conclusion from a premise. The resulting equation purports to describe the historical condition of the apostolic and early patristic church: hostile to pictures in theory, without pictures in fact. This sixteenth-century view of the early church is quintessentially a product of the Calvinist branch of the Reformation. And it has exercised a profound influence on all later historical reconstructions of the early Christian attitudes toward art, not least in our own century.

Modern Interpretations

When we turn to more recent reconstructions, one publication towers over all others, namely Hugo Koch's *Die altchristliche Bilderfrage nach den literarischen Quellen.*[18] As the title indicates, *Bilderfrage* concerns literary and documentary evidence. Koch gave a few paragraphs to art and archaeol-

ogy, but his treatment of these subjects is not noteworthy. The quantity of Koch's documentation is impressive. Within a modest format (104 pages cover to cover) he managed to assemble a wide range of pre-Gregorian, patristic testimonies in Latin and Greek along with occasional pronouncements lifted from church orders and from synodical and conciliar decrees. His purpose, to vindicate a modern anti-image reading of early Christianity, is a goal realized in exemplary fashion, with clarity and an elegant economy of words. Although a small masterpiece, Koch's monograph is largely ignored today, and this is unfortunate because all modern study of our subject owes its immediate origins to *Bilderfrage*.

Koch was a man bound by a time and a place, and both belonged to Adolf von Harnack. Koch was a loyal Harnackian and proud to acknowledge his debt to the master. He framed *Bilderfrage* from beginning to end in concepts that were pure Harnackian. The premise, an inheritance of Ritschlian[19] theology, required the existence of historical essences.[20] Harnack viewed the earliest form of Christianity as in essence (*wesentlich*) a religion of simple Semites living lives of high moral purpose. Their paradigm: the life and death of Jesus.

Harnack believed that primitive Christianity was undermined and thrown off track by Greeks who introduced new ideas and practices hostile to the primitive integrity of the new religion. In Harnack's view one of these intrusive Hellenic elements was the manufacture of religious pictures, another their veneration. Harnack never wrote a book on early Christian attitudes toward art (Koch spared him this task), but it is clear from his correspondence (unpublished),[21] from his occasional reviews[22] on early Christian archaeological subjects, and from the few lines he devoted to this subject in his monographs[23] that he viewed picture making and the veneration of pictures as prime examples of Christianity Hellenized. Thus on the Harnack-Koch model, picture making should be construed as a late (that is, postapostolic), Hellenic intrusion (one of many) that enervated the primitive vitality of the new religionists and directed their attention away from the center to peripheral matters that were morally and spiritually unproductive.

In scholarship since the end of the Second World War, due especially to the discovery of the Qumran scrolls, Harnack's Hellenization theory has undergone substantial modifications. Much of the theory has been discarded, and rightly so. It would be anachronistic to fault Koch for applying to *Bilderfrage* a historical-theoretical framework that he could not know was inadequate. On the other hand, there are things Koch did know, lessons he had learned, and these he ought to have applied.

After all, *Bilderfrage* (like its Byzantine precedents, the Iconoclastic florilegia) is yet another anthology of quotations lifted out of their original literary-historical contexts and strung together in a narrative that is indifferent to the qualifying force of context. It is true that Koch assembled more sources (many more) than any of his predecessors, and he also

dressed them up in a more scholarly format consistent with modern historical-critical standards, but even these improvements cannot disguise the underlying barrenness of literary and historical evidence cut free of defining environments and contexts.

An anthology is not a history. Throughout Greek and Roman antiquity, for example, the anthologized creation of sayings attributed to wise men was a popular literary exercise, one that was carried forward conspicuously in the Hellenistic period by the so-called doxographic[24] compilers. But as any historian who has dealt with this material knows, it is difficult to penetrate the bare bones of doxography and to evaluate the historical worth of these attributed sayings. Given his time and place, his education and his intellectual setting, Koch can scarcely have been ignorant of the inadequacies inherent in anthologizing literature, but evidently because he had other agenda, in composing *Bilderfrage* he simply ignored these problems. In the end, *Bilderfrage* is a modern doxography, a catena of authoritative patristic testimonies carefully selected and arranged to illustrate Harnack's Hellenization theory.

Over time *Bilderfrage* became an influential and well-received monograph. Several prominent scholars accepted Koch's reconstruction— among them were Walter Elliger,[25] Edwin Bevan[26] (who politely expressed mild reservations), Hans von Campenhausen,[27] Ernst Kitzinger,[28] and Norman Baynes.[29] Repeated approval by even these respected scholars did not make Koch's thesis any more correct, but it did endow his work with the authority of a scholarly tradition.

One of the persons who allowed himself to be impressed with the weight of this tradition was Theodor Klauser, who from 1958 to 1968 published serial installments of a study[30] devoted to archaeological and art-historical subjects, all of them early Christian, most of them third and fourth century in date. Klauser began where Koch left off. He accepted as authoritative Koch's anthology of excerpts together with the claims advanced in their name that they represented the true historical mood of the early church.

Klauser then set about to provide archaeological "proof" of early Christian opposition to art. In the first instance he based his argument on surviving third- and fourth-century Christian archaeological sources, especially those exhibiting figural subjects. He also drew attention to the well-known fact that we have nothing that is material and demonstrably Christian (papyri excepted) that can be dated before the third century. Klauser was prompted to conclude that archaeology confirmed Koch's theory: at the beginning of the movement Christianity had been essentially an iconophobic-aniconic form of religiosity.

Only in the early third century did the situation begin to change. Aniconism, which had been a hallmark of the primitive community, began to give way to new (external) forces. In fact, the theoretical framework with which Klauser introduced and illustrated his materials contained few

surprises: he resumed nineteenth-century historiography in its familiar Ritschlian-Harnackian form, and in matters more closely tied to art-related questions, his constructions closely followed *Bilderfrage.*

The following three rubrics summarize Klauser's interpretative framework:

1. As the child of Judaism, primitive Christianity was a religion simultaneously hostile to pictures in theory (iconophobic) and opposed to their use in practice (aniconic). This was the normative position. On the official (clerical) level this point of view was maintained well into the fourth century, and in some places much later.

2. Gradually this official view, upheld by educated bishops, priests, and theologians (that is, the carriers of the primitive tradition), gave way to pressures from below, namely pressures exerted by an uneducated, iconophilic laity, men and especially women who did not understand the essence of the tradition, who demanded pictures and got them. Over time these simpleminded undoers of the hoary past prevailed, but not without resistance from the educated clergy.

3. The introduction of pictures into the early church meant a compromise of the original and essential anti-image attitudes and practices that typify the earliest stage of Christian history.

In summary, there is really not much in Klauser's construction that can be called new or innovative. He simply repeats Harnackian orthodoxy in the very same manner already set forth by Koch. In fact, particularly in his interpretative framework and conclusions, Klauser exhibits remarkably little critical distance from the prototypes. His major innovation is the attribution of distinctive roles to clergy and laity, but as we shall see in Chapter 5, this attribution raises more questions than it answers. In addition, Klauser introduces archaeological materials into the discussion of attitudes toward art, and on principle this is a real step forward, but due to his interpretative framework, much of what he has to say about these materials is either problematic or demonstrably false.

The matter stands where Klauser left it in 1968. Since that time numerous scholars—among them Bernard Kötting,[31] James Breckenridge,[32] Robert Grigg,[33] Uwe Süssenbach[34]—have repeated the received opinion. Expressions of disagreement are rare. During the Congresso Internazionale di Archeologia Cristiana in 1962 at Ravenna, Lucien de Bruyne[35] (characterizing Klauser's views as "un peu trop rigoristes") executed a short Gallic riposte, and in 1977 Sister Charles Murray published a brief but promising article[36] challenging the consensus. Murray's article has clearly made an impression on the historical theologian Margaret Miles,[37] but it is equally obvious that mainstream scholars working in the period of later antiquity, both archaeologists and historians, are content to repeat the ancient pieties,[38] first and best enunciated in modern historiography by Hugo Koch.

Notes

Throughout the notes, the titles of some journal articles are quoted while others are omitted. The former represent works essential to the understanding of our subject.

1. Introduction: E. J. Martin, *A History of the Iconoclastic Controversy* (London, n.d.); G. Ostrogorsky, *Studien zur Geschichte des byzantinischen Bilderstreites* (Breslau, 1929).

2. G. Ostrogorsky, "Les débuts de la querelle des images," in *Mélanges Charles Diehl*, vol. 1 (Paris, 1930), 8–11; also H. Hennephof, *Textus Byzantinos* [sic] *ad Iconomachiam Pertinentes* (Leiden, 1969), 52.

3. J. D. Mansi, *Sacrorum Conciliorum Nova et Amplissima Collectio*, vol. 13 (Florence, 1767), cols. 205–6.

4. *Contra Eusebium et Epiphanidem* is one treatise published as two in J. B. Pitra, *Spicilegium Solesmense* (Paris, 1852), 1:371–72: "Eusebii Caesariensis Confutatio," and ibid., 4:292–93: "Pseudo Epiphanii sive Epiphanidis Confutatio"; also cf. P. Alexander, *The Patriarch Nicephorus of Constantinople* (Oxford, 1958), 173–72.

5. Mansi, *Sacrorum Conciliorum*, col. 267B/C; the Iconoclastic argument from tradition: Martin, *Iconoclastic Controversy*, 85–86; used again in A.D. 815: P. Alexander, "The Iconoclastic Council of St. Sophia (815) and Its Definition," *DOP* 7 (1953), 35–36.

6. C. Mango, *The Art of the Byzantine Empire 312–1453* (Englewood Cliffs, N.J., 1972), 150; also M. Anastos, "Iconoclasm and Imperial Rule 717–842," *CMH* 4.1 (1966), 85–86, and E. Kitzinger, "The Cult of Images in the Age before Iconoclasm," *DOP* 8 (1954), 87–89.

7. Edited by Hans Lietzmann in *Kleine Texte* . . . (Bonn, 1911). Imprints: E. Freys and H. Barge, *Verzeichnis der gedruckten Schriften des Andreas Bodenstein von Karlstadt* (Niewkoop, 1965), 226–27 = *Zentralblatt für Bibliothekwesen* 21 (1904), 153–54. Discussion: H. Barge, *Andreas Bodenstein von Karlstadt*, vol. 1 (Leipzig, 1905), 386–87, and J. S. Preus, *Carlstadt's Ordinaciones and Luther's Liberty: A Study of the Wittenberg Movement 1521–1522* (Cambridge, Mass., 1974), 35–36; also S. Ozment, "Pamphlet Literature of the German Reformation," in *Reformation Europe: A Guide to Research*, ed. S. Ozment (St. Louis, Mo., 1982), 85–105.

8. *Ein urteil gottes unsers eegemahels wie man sich mit allen gotzen und Bildnussen halte soll uss der heiligen geschrifft gezoge* (Zurich, 24 September 1523); cf. Charles Garside, "Ludwig Hätzer's Pamphlet against Images: A Critical Study," *MQR* 34 (1960), 20ff.

9. *Ein antwort Huldrychen Zwinglis Valentino Compar* . . . *Von den bildern, und wie an denen die schirmer und sturmer misleerend* . . . , in *Huldreich Zwinglis Werke*, vol. 2.1, ed. M. Schuler and J. Schulthess (Zurich, 1830), 1ff. Literature on Reformation opposition to images: C. C. Christensen, *Art and the Reformation in Germany* (Athens, Ohio, 1979); P. M. Crew, *Calvinist Preaching and Iconoclasm in the Netherlands 1544–1569* (Cambridge, 1978); J. Phillips, *The Reformation of Images: Destruction of Art in England 1535–1660* (Berkeley, Calif., 1973); M. Stirm, *Die Bilderfrage in der Reformation* (Gütersloh, 1977).

10. Jn 4:23, 24 was an Iconoclastic locus classicus: "But the hour will come—in fact it is already here—when true worshipers will worship the Father in spirit and truth—God is spirit, and those who worship him must worship him in spirit and truth."

11. Epistle IX in *PL* 77, cols. 1128–29: "in ipsa (i.e. a picture) legunt qui litteras nesciunt. . . ." Karlstadt's opinion of this teaching: "Gregorius der Bapst / hat . . . den bildern die ehere geben / die got seinem wort geben hat / und spricht / das bildnis / den Leyhen bucher seind. Ist nit das eyn recht Bepstlich laher. und teuffelisch tzugebung?"

12. Karlstadt knew the Latin version of the *Letter* (attributed to Epiphanius) from Erasmus's 1516 edition of Jerome; cf. *CSEL* 54, ed. I. Hilberg (Vienna, 1910), 395–96 = *Epistula* 51, also in *Libri Carolini* 4.25 = *Opus Caroli, MGH* Concilia II, Suppl., ed. H. Bastgen (Hannover and Leipzig, 1924). In his *Detectio et Eversio* (Ἔλεγχος καὶ Ἀνατροπή) contained in Paris Graecus 1250B and Cosilinianus 93C (both in the Bibliothèque Nationale), Nicephorus calls the *Letter* a forgery. Literature: Alexander, "Iconoclastic Council," 65; P. Maase, "Die ikonoklastische Episode in dem Brief des Epiphanius an Johannes," *BZ* 30 (1929–30), 279–80; Ostrogorsky, Studien, 73–74; K. Holl, "Die Schriften des Epiphanius gegen die Bilderverehrung," *SbBerl* (1916), 828–68 = *Gesammelte Aufsätze . . .* 2 (Tübingen, 1928), 351–52.

13. On Zwilling: Th. Kolde, in *REprot*, vol. 4 (Leipzig, 1898), s.v. General introduction: Preus, *Carlstadt's Ordinaciones and Luther's Liberty.*

14. Ernst Fabian, *Mitteilungen des Altertumsvereins für Zwickau und Umgebung* 9 (1914), 30 (from a letter of Johann Pfab to Hermann Mühlpfort, written early in 1522): "hat er [Zwilling] folgends freitags [10 January 1522] mit etzlichen monchen ein fewer jns Augustiner closter hof gemacht, jst jn die kirche mit jnen gangen, hat die holtzern altaria zu grund abgebrochen, dieselbigen mit jren und sonst allen andern tafeln, gemalten und geschnitzten bildern, Crucifixen, fannen, kerzen, leuchtern, usw. allezumal dem fewer zu getragen, dorein geworfen und vorbrandt."

15. For modern histories of Reformation iconoclasm, see n. 9.

16. *Institutio Christianae Religionis 1559* I.XI.13, ed. P. Barth and G. Niesel (Munich, 1957) = Joannis Calvini, *Opera Selecta* III; Eng. trans.: F. L. Battles in *LCC* 20; H. Berger, *Calvins Geschichtsauffassung* (Zurich, 1955), 47–48.

17. On the Catholic reaction to sixteenth-century iconophobia and aniconism: John Eck, *De non tollendis Christi et sanctorum imaginibus . . . decisio* (Ingolstadt, 8 July 1522); *Enchiridion locorum communum adversus Lutteranos Article 15: De imaginibus sanctorum* (Landshut, April 1525); *Secunda pars operum Iohan. Eckii contra Ludrum Article 4: de imaginibus* (Ingolstadt, 1530); cf. Th. Wiedemann, *Dr. Johann Eck* (Regensburg, 1865), 185, 440, 520–21. Also important: J. Molanus (Jan van der Meulen), *De picturis et imaginibus sacris* (Louvain, 1570). Cf. W. Klaiber and R. Baumer, *Katholische Kontroverstheologen und Reformer des 16. Jhdts.* (Münster, 1978), entries under Konrad Braun, Michael Buechinger, N. Harpsfield (pseud. Alan Cope), Hieronymus Emser, Hugo von der Hohenlaudenberg, Jacopo Nac(c)chianti, Ambrosius Pelargus (Storch), and Nicholas Sander; also H. Jedin, "Entstehung und Tragweite des Trienter Dekrets über die Bilderverehrung," *TQ* 116 (1935), 143–88, 404–29; idem, *ZKG* 68 (1957), 96–128, and 74 (1963), 321–39; Myron Gilmore, "Italian Reactions to Erasmian Humanism," in *Itinerarium Italicum*, ed. H. A. Oberman and T. A. Brady, Jr. (Leiden, 1975), 61–115.

18. Published in Göttingen, 1917 (FRLANT 27). Reviews: K. Bihlmeyer, *TQ* 101 (1920), 328ff.; W. Neuss, *TRev* 17 (1918), 157ff.

19. Decisive for Ritschlian (or Liberal) historiography: A. Ritschl, *Die Entstehung der altkatholischen Kirche* (Bonn, 1850, 1857). Ritschl's influence on Harnack: G. W. Glick, *The Reality of Christianity* (New York, 1967), 82–83.

20. D. H. Fischer, *Historians' Fallacies* (New York, 1970), 68–69. A. von Harnack's classic statement of essentialism: *Das Wesen des Christentums* (Leipzig, 1900).

21. For Harnack's correspondence with Rudolph Sohm, see G. Lease, *ZSav* (Kanonische Abt.; Festschrift für Karl Bader) 92 (61) (1975) 348–76; on Harnack and Heiler, cf. idem, *JAAR* 45 (1977) 1135–45; but the correspondence in the Harnack Nachlass (Berlin, Deutsche Staatsbibliothek, Preussicher Kulturbesitz) between Harnack and his contemporaries in the field of early Christian archaeology remains unpublished.

22. *ThLZ* 2 (1877), 546–47; 4 (1879), 97–98, 384–85; 5 (1880), 301; 6 (1881), 140; 7 (1882), 368–69, 607–8.

23. Art understood as a syncretistic, Hellenistic intrusion upon the Christian fold: A. von Harnack, *Lehrbuch der Dogmengeschichte* 2 (Tübingen, 1931), 478, n. 2, 479; also *Die Mission und Ausbreitung des Christentums*, vol. 1 (Leipzig, 1925), 300–331.

24. Introduction and commentary: Diels, *DoxGr*.

25. *Die Stellung der alten Christen zu den Bildern in den ersten vier Jahrhundert*, *SCD*, n.s. 20 (Leipzig, 1930).

26. *Holy Images* (London, 1940).

27. "Die Bilderfrage als theologisches Problem der alten Kirche," *ZTK* 49 (1952), 33.

28. Kitzinger, "The cult of images," 83; also *Byzantine Art in the Making* (Cambridge, Mass., 1977), 3: "the taboo against religious images which obtained in the early Church until about A.D. 200 . . ."

29. "Idolatry and the Early Church," a lecture delivered November 1930 in Birmingham (Aytoun Memorial Lecture), published in *Byzantine Studies and Other Essays* (London, 1955), 120.

30. "Studien zur Entstehungsgeschichte der christlichen Kunst," *JbAC* 1 (1958), 20–51; 2 (1959), 115–45; 3 (1960), 112–33; 4 (1961), 128–45; 5 (1962), 113–24; 6 (1963), 71–100; 7 (1964), 67–76; 8–9 (1965–1966), 126–70; 10 (1967), 82–120. Informative brief reviews: J. M. C. Toynbee, *JThS*, n.s., 10.2 (1959), 393; 12.1 (1961), 96; 13.1 (1962), 159; 14.2 (1963), 490; 15.2 (1964), 392; 17.1 (1966), 150; 17.2 (1966), 466; 19.1 (1968), 321; 20.1 (1969), 290. Also Vinzenz Buchheit, "Tertullian und die Anfänge der christlichen Kunst," *RQ* 69 (1974), 133–42. Klauser summarized his series "Entstehungsgeschichte" at *ZKG* 76 (1965), 1–11 and *CIAC.Atti* 6 (1965), 223–42.

31. B. Kötting, "Die religiösen Grundlagen der Volksfrömmigkeit als Quelle kirchlich-religiöser Kunst," *Schwarz auf Weiss* 9 (1977), 3ff., reprinted in *Ecclesia peregrinans. Das Gottesvolk unterwegs. Gesammelte Aufsätze*, vol. 2 (Münster, 1988), 9–22.

32. J. D. Breckenridge, "The Reception of Art into the Early Church," *CIAC.Atti* 9.1 (1978), 364: "Everything now seems quite simple: an absolutely monolithic opposition to imagery existed among responsible ecclesiastics from the earliest days of the Christian era through at least the reign of Constantine."

33. R. Grigg, "Aniconic Worship and Apologetic Tradition: A Note on Canon 36 of the Council of Elvira," *CH* 45 (1976), 428–29; also "Constantine the Great and Cult without Images," *Viator* 8 (1977), 1–2.

34. U. Süssenbach, *Christuskult und kaiserliche Baupolitik bei Konstantin* (Bonn, 1977), 83–107; discussion: P. C. Finney, *HTR* 81 (1988), 319ff.

35. *CIAC.Atti* 6 (1965), 239–42.

36. "Art and the Early Church," *JThS*, n.s., 28.2 (1977), 304–45.

37. M. R. Miles, *Image as Insight* (Boston, 1985), 43–46.

38. Thus Beat Brenk, in *Propyläen Kunstgeschichte* Suppl. 1 (Frankfurt, 1977, 1980), 16: "Dieses Gebot (Exod. 20.4) gelt im gleichen Masse für Juden und Christen. . . . Im Urchristentum scheint es noch streng befolgt worden zu sein . . ."; Arne Effenberger, *Frühchristliche Kunst und Kultur* (Leipzig, 1986), 14–15: "Die christliche Haltung [toward images] wurzelt gänzlich in der jüdischen Tradition des zweiten göttlichen Gebots. . . ." Similar misguided ideas are propounded by Guntram Koch in W. A. Bienert and G. Koch, *Kirchengeschichte I. Christliche Archäologie* (Stuttgart, 1989), 90.

2

The Apologists' Attack on Greek Art: History and Literature

Two environments define our subject, one history, the other literature. It is pointless to discuss early Christian attitudes toward art in the abstract, apart from these two defining environments. In short, context is the key to understanding this subject. Unless it is put in context, the consensus[1] view—namely that early Christian attitudes toward art were essentially negative and rooted first and foremost in Jewish precedents, notably 20:4,[2] the Israelite taboo against idol worship—is really little more than a vague generalization. Without a knowledge of who invoked the taboo, where and when and why, we cannot draw any conclusions that have meaning for history. In fact, as I have already suggested, the consensus is misleading— Greek precedents are of much greater importance for our subject than Jewish models. Given the overall historical context, this is exactly as it should be. After all, the Christian apologists were writing to Greeks and Romans, not to Jews. Hence it is to be expected that they allowed themselves to be more impressed by Xenophanes and Heraclitus than by the second Isaiah or the Jewish-Hellenistic Pseudepigrapha. Considering the setting, we get exactly what we should expect.

Apology is the primary literary setting in which we find most of the early Christian discussions of art-related matters. This distinct genre commenced sometime in the early second century,[3] although its literary roots, both pagan[4] and Jewish,[5] are much earlier. Admittedly, we have fragments of art-related subject matter in other early Christian literary envi-

15

ronments (Chapter 4), but clearly the bulk of the testimonies is embedded in the apologetic genre.

Art on its own is never the subject, hence I use the term "art-related." The apologists always subordinate art-related subject matter to concerns and issues that loom larger in their horizon, issues such as the nature of God, true worship, and the ethical life. These latter three represent the kinds of subjects that truly exercised the apologists' imagination—they drew art (painting and sculpture) into the discussion only to illustrate these primary concerns.

Since apology is the literary setting, interpretations of art-related material must first establish the character of the genre. In practical terms, what this means is that one must attempt to demarcate the boundaries between literary apology and real life. Is the attack on Greek art just a literary exercise, or is there some implied purpose that extends beyond the confines of literature, a purpose perhaps designed to affect the real-life conditions of the apologists and their cohorts? This is the major interpretative crux. Many have assumed that everything the apologists said on art-related matters should be taken at face value, as if the apologists were faithfully reproducing the real-life conditions that obtained both for themselves and their enemies in the second and third centuries. This is naïve and misleading. On the other end of the interpretative spectrum there is Geffcken's[6] hypercritical attitude, suggesting that everything the apologists said on art-related matters (and on most other issues) was specious and bore little or no relationship to real-life conditions. But this view trivializes early Christian apology and, in my view, completely misses the point of what the apologists were trying to achieve.

There is an unquestionable link between apology and the real-life conditions of Christians living in the second and third centuries. But this connection is indirect, as it must be, because apology is literature, and literature is not the real world. The degree of indirect correlation between the apologists' literary efforts and the world in which they lived is substantial, certainly much greater than Geffcken was willing to grant. Overall the mood of apology is serious. The authors in question wrote about subjects that, for them and their constituents, possessed a kind of life-and-death urgency. Geffcken missed this most fundamental fact of early Christian apology.

The reason for writing apology was not "literary" in the common sense of the term, as if apology were conceived and composed primarily with a view to satisfying literary palates. It is true the apologists were rhetoricians, and in that capacity they were certainly attached to the production of literary conceits, many of them (as Geffcken stressed) tired, derivative, and lifeless. They followed the rhetorical conventions of the Second Sophistic closely, perhaps slavishly and uncritically (*pace* Geffcken), and there is little doubt that the apologists committed all the same epideictic sins that were commonplace in early and especially middle

Imperial literature. They spun out faded purple passages and indulged themselves with infatuations for the bon mot.

But even so the apologists were serious writers. Their purposes were political in character—they had a strong sense of the Roman judicial scene and were keenly aware of Greco-Roman social prejudice. A great deal more is at stake in early Christian apology than just "pure" literature; one needs to distinguish carefully between the literary form of the genre and the purposes its authors envisaged. Unfortunately, in the wake of Geffcken's damning criticism of the apologists' literary style and philosophical[7] content, this distinction is too often overlooked. It is obvious that much of Antonine-Severan literature (Greek and Latin) is supercilious fluff designed to titillate literary palates, but this is not what early Christian apology is about.

Apology is rooted in a real-life struggle for survival. Its purposes are to guarantee the survival of the new religionists. Thus, as least judged by its intentions, early Christian apology is about as "serious" a genre of literature as one can imagine: it concerns life and death. On the other hand, its purposes and importance as "pure" literature add up to very little indeed—the literary world, then and now, can function quite nicely without the malapropisms of this genre. For this reason, the idea of judging early Christian apology primarily (*pace* Geffcken) or exclusively on literary grounds makes no sense whatsoever.

What the apologists were attempting was nothing less than a complete turnaround of the political, legal, and social conditions that defined their lives. Thus it is impossible to understand the genre without first identifying these historical factors, the setting that impelled the apologists to put pen to paper. Whatever the apologists had to say about art-related matters is a function of both literature and history, and any intelligent assessment of our subject requires at least some rudimentary knowledge of their interrelated character.

The earliest Christian apologists constructed an elaborate literary attack on Greek religious art. Within this attack we get most of the earliest Christian written pronouncements on art-related matters. We shall consider the contents of the attack in the following chapter. Our present concern is to set the context and outline the historical setting and the literary connectors that give meaning to the apologists' attack on Greek art.

The Historical Setting

At least by the early second century (and possibly earlier)[8] Greek- and Latin-speaking subjects of Rome (both pagan and Jew) had begun to express open disapproval of Christians and their religion. Based on New Testament evidence, on Celsus' *True Word*, and on early rabbinic traditions, it seems possible that Tannaic[9] authorities had commenced their

anti-Christian campaign in Palestine even earlier, perhaps even during Jesus' lifetime. A few disaffected, anti-Christian gentiles writing in the second century are known by name. Most are not. Accusations (consisting of rumors, gossip, slurs, and occasional formal complaints) against the new religionists probably began to circulate in the public sphere at the beginning of the century, and by its end a long and impressive list had been put together. The majority (but not all)[10] of these complaints and accusations can be classified under three rubrics: atheism, superstition, and sexual misconduct.

— Atheism was a legitimate complaint. Exactly how it arose we do not know, but Mommsen[11] was probably right to explain it as an inference based on matters of observed behavior: the new religionists refused to worship the gods and caesar, a fact that was evident to all who had eyes to see. Outsiders who observed this behavior might well infer that, practically speaking, Christians were atheists. Jews also refused to worship, and anti-Jewish pagans—Apollonius Molon,[12] Posidonius,[13] the elder Pliny,[14] Tacitus[15]—had already dubbed them atheists;[16] thus the anti-Christian version of the charge was both precedented and predictable.

— Superstition and sexual misbehavior are more difficult to assess. Both were evidently based on a mixture of fact and fiction, probably more of the latter than the former. So far as we can tell, taken together these three anti-Christian accusations (along with the several slurs they subsume) are best described as informal charges, meaning they were not judicially actionable. To the best of our knowledge, before Decius (249–251) no Roman magistrate sitting formally in a judicial inquiry took any of these three charges seriously—again, so far as we can tell, Christian defendants were not tried on any of these three bases. In short, before the mid-third century anti-Christian charges of atheism, superstition, and sexual misconduct did not have judicial status, but after Decius atheism became judicially actionable, although superstition and sexual misbehavior continued to be accusations that the courts ignored.

Of course, there were trials of Christians long before the government became an official persecutor. From the early second century onward, Roman subjects (probably private persons functioning as delators)[17] submitted anti-Christian complaints to Roman magistrates. On Pliny's example (*Ep.* X.96, 97) together with other correlative bits of evidence, some[18] of the magistrates who received anti-Christian delations apparently felt compelled to respond and so acted accordingly. Early in the century Pliny had convened a judicial investigation (*cognitio*)[19] in which he interrogated defendants accused of being Christians, and he executed those who confessed to the charge—on what judicial basis, we do not know. Schulz's famous dictum[20] "nullum crimen sine lege, nulla poena sine lege" (intended to describe Roman judicial practice) evidently did not apply. The Roman execution of Christians on the grounds of their confessing the *nomen Christianus* is without question a judicial anomaly, but it comes as no great surprise—criminal jurisprudence in the Empire, especially in the

provinces, failed to achieve the "rule of law," despite the advances accorded by the *quaestiones*.[21] Students of Roman law have acknowledged (and lamented) the fact for decades.

That Christians ran afoul of the government in the second and third centuries is beyond question. Admittedly, the impulse to accuse them before courts was initiated at some level other than that of government, presumably in the private sector among Rome's subjects, both citizen and noncitizen. But even so, after delations had been formulated, submitted in the proper form, and accepted, the ball was then in the public court, and although one must admit the evidence is thin, there is enough to assert as a matter of fact that at least some of the princeps' judicial representatives took the position (following Pliny, Trajan, and perhaps Pilate[?]) that defendants who confessed the "nomen" should be punished by capital means.

In the realms of distress and real-life troubles visited upon the new religionists, in addition to the two categories just described, namely informal complaints and formal delations, there is yet a third, namely popular uprisings. These occurred sporadically from the principates of Trajan to Decius. The government neither intervened nor sanctioned these mob outbursts. They amounted to pogroms.[22] The elderly bishop Polycarp[23] of Smyrna was the victim of one at the middle of the second century (circa 156), and under Marcus[24] there were anti-Christian incidents in Rome, Athens, Laodicea, and probably in Gaul[25] (Lugdunum: 177[26] or earlier [?]). Under Commodus[27] and Septimius Severus,[28] other examples are attested. There was virulent, anti-Christian mob violence in Cappadocia around the year 235.[29]

Thus the evidence survives in three kinds, informal and formal complaints plus mob violence. Given the apparent extent of this evidence, which is considerable, one is tempted to follow the Eusebian view of the second and third centuries as an "age of persecution." Barnes[30] has cautioned I think convincingly against this temptation, but at the same time one must be careful not to minimize or dismiss the real difficulties that Christians confronted before the outbreak (winter 249/250) of the first official persecution under Decius.

For Christians living in the period from Trajan to Decius it seems likely that the moods and attitudes of their non-Christian neighbors varied from place to place. The environment was unfriendly in some places, hostile in others, and probably indifferent or even friendly in still other places. It is difficult to generalize on this subject since we have so little evidence. Hostility to the new religionists was clearly not present in equal degree in all places at all times. Christians got on well with their neighbors in some places, less well in other places, and not at all in some. Unfortunately, our sources of information are few, fragmentary, and episodic, a fact that makes it impossible to write a narrative history of pagan-Christian relations before the mid-third century. But there is certainly enough pre-Decian anti-Christian sentiment and action to suggest that the road

for the new religionists was rocky in several places, even impassable in others.

Cumulatively the evidence demands this modest conclusion: Christians were an unpopular minority in several places and times and at more than one social and political level during the period extending from Trajan to Decius. Many people disliked them. A few went to considerable lengths in expressing their scorn. Different constituences are represented: bureaucrats and magistrates (Pliny, Trajan, Hadrian, Marcus), philosophers (Celsus, Epictetus, Galen, Marcus, Porphyry), and rhetoricians (Fronto, Suetonius, Tacitus, Lucian). But Christian bashing was not limited to these three groups.

Jews also played a role. Whoever invented the Jesus ben Pantera[31] slur (and its variants, including ben Stada) evidently had little love for their upstart competitors, and although the Christian identity of their targets (*minim*),[32] the heretics whom they cursed thrice daily in synagogues, is now strongly challenged,[33] it is still possible that the curse (*birkat ha-minim*) that originated at Jamnia (Berakoth 28b) toward the end of the first century (85–100/115) had some reference to Christians.[34]

Last but not least, there is the witness of an anonymous and, I suspect, large group of working-class enemies[35] of Christianity, the wage laborers who subsisted at roughly the same economic and social levels as the new religionists and who had good reasons to fear and hate them as competitors for jobs and resources. In sum, the earliest apologists did not concoct out of thin air their beleagured condition. They were not paranoids. The fact is that they and their cohorts had real enemies.

Individuals under attack responded to their problematic status in different ways. On one end of the spectrum were the apostates,[36] on the other end, the martyrs: how many there were in these two categories we do not know. At the middle of the spectrum were the Christians who chose to remain inconspicuous. Probably the majority falls into this category. Unobtrusive behavior would have been a prudent choice and was no doubt a course that worked for many, although we know it is precisely demeanor of this sort that earned the new religionists the caricature of skulkers, people who lurked about "in angulis,"[37] in nooks and crannies, as if they had some terrible secret to hide. The apologists clearly had more in common with martyrs than with apostates, although neither of these comparisons is very apt. Inconspicuous and unobtrusive they were not, but, on the other hand, excepting Justin and judging them by what they did rather than what they said, most of the apologists did not embrace the dramatic forms of resistance and noncooperation exhibited by the martyrs.

Tertullian is a good example of the tack that the apologists took. In approaching his pagan addressees he might use language that was confrontational, aggressive, and rude. At the same time he could (and did) lick their boots. Both are part and parcel of his approach to his pagan addressees. So far as we know, Tertullian did not die a martyr's death, although as Barnes[38] pointed out, there may be good reason to suppose

this was his lot. Given his exceedingly intemperate tongue and the virulence of his attacks, his enemies certainly would have been justified in seeking his head.

Much to their detriment (and ours), the earliest Christian apologists did not have their own Philostratus,[39] the biographer of the sophists. Eusebius and Jerome give a few miserable biographical details,[40] most of them invented, and we are left with a very incomplete picture. The best evidence we have is internal, and on that basis it is indisputable that the apologists were educated men—thus they must have been men of privilege (although how much is debatable). Perhaps because from early childhood onward they had become inured to benefits and privileges, in later life these men chose to fight and refused to submit to the half-truths and slurs perpetrated by anti-Christian propagandists. In fact the precise reason why they responded the way they did is not known. We may presume, I think, that they were offended and threatened and probably outraged by the anti-Christian accusations that they must have run up against with continuously greater frequency as the second century unfolded.

The apologists identified themselves openly as advocates for the Christian cause. We have numerous parallels among their pagan counterparts, for example the second- and third-century rhetoricians and sophists who represented special interest groups. There are also Jewish parallels, both of formal embassies or legations[41] (representing the Jewish *ethnos* or *politeuma* such as the Jewish jurisdiction within Alexandria) and of informal apologies[42] written on behalf of both Palestinian and especially diaspora Jews.

By contrast with their pagan and Jewish counterparts, however, the earliest Christian apologists represented constituencies that lacked distinct political, social, economic, and ethnic identities. This fact had both advantages and disadvantages. As to the latter, although the apologists represented constituents who were real flesh-and-blood people, it was often difficult to communicate to outsiders what it was that held these people together and gave them their special identity. Judged by secular standards, being a Christian had a somewhat ephemeral character, consisting as it did in little more than certain obscure and evidently irrational beliefs and habits of mind, joined to behavior (particularly nonparticipation in public cult) that Greeks and Romans found hard to comprehend.

The apologists sought to defend their own interests and those of their constitutents. They sought intercession from persons in high places. They wanted government protection and judicial relief. In a sense, like their pagan and Jewish counterparts, they even sought a kind of immunity (ἀτέλεια), but not like the sophists from the performance of civic duties and liturgies and not like the Jews from the payment of certain taxes or the obligation of military service. Instead the apologists sought *ateleia* from the wrath of popular opinion and from a government, which, when put to the test, judged Christians unjustly (or so it appeared to the victims). They did not seek special economic benefactions or exemptions. Nor did

they seek political appointments or other special privileges. But they did seek intercession and protection from people at the top; indeed they demanded judicial relief, including immunity from prosecution on the mere grounds of confessing the *nomen*. How they came to play this advocacy role, whether self-appointed or, like the second-century sophists and the Jewish legates to Rome, appointed by their constituents, we do not know. The important point is that they took up the cause of defending the new religionists. In my view, as advocates for the Christian cause the apologists were very effective.

To summarize, second- and third-century Christians constituted an unpopular minority in several places within the empire. Selected Greeks, Romans, and Jews evidently disliked them. Hatred is probably not too strong a term, given the way they were treated in some parts of the Empire. Christians were slandered and accused of a wide range of faults, crimes, and misdemeanors. Both informal and formal complaints were brought against them. In a few attested examples, they were made victims of mob violence. The government acted (it appears selectively, based no doubt on local conditions) on some anti-Christian delations and executed Christians who admitted to being current and active participants. The apologists responded by composing written defenses that openly advocated the Christian cause. They not only promoted their own cause but they also attacked their enemies, in some cases (Tatian and Tertullian are the best examples) putting into play language that was abusive and inflammatory. These advocates for the Christian cause sought intercession and protection from their superiors. They demanded judicial relief. In short, there can be no doubt that the goals which the apologists envisaged went considerably beyond "pure" literature. To what degree they achieved those goals is as much a matter for debate today as it was two centuries ago in Gibbon's day. As I have already indicated, I believe they were a good deal more successful than is commonly acknowledged.

Literary Connectors

Dramatis Personae and Their Roles

All Christian apologies envisage three parties, the speaker/writer/advocate (or apologist) for Christianity, the addressee, and the enemy. In the first instance, the apologist's role as a practitioner of epideictic[43] rhetoric was to rehearse the praise (ἔπαινος/*laus*)[44] of himself (and by extension of his constituents), the apologetic equivalent of *ethopoeia*.[45] In the second, his role was to flatter the addressee, the apologetic equivalent of *logos basilikos*[46] (or *prosphonetikos*): an encomiastic speech directed to a king. Occasionally the speaker also remonstrated[47] with the addressee: Tertullian is a conspicuous practitioner of this art. Third, drawing on a well-stocked arsenal, consisting of arguments in various kinds, all of them based on blame-censure (ψόγος/*uituperatio*)[48] mixed with other forms of abuse, no-

tably slander (διαβολή/*calumnia*),[49] invective,[50] and sarcasm, the Christian speaker assaulted his enemy.

The addressee typically has no speaking role. He is present, as it were, onstage as object of the addressee's *epainos* or *psogos*. He is also the recipient of the speaker's petitions and entreaties, but his presence is a silent one. In fact, with the exceptions of Trajan and Hadrian, we do not know how (or even if) the addressees of Christian apology responded. The addressee is frequently identified by name, and in that scenario he is inevitably a notable,[51] either the princeps or one of his agents. Autolycus is the only exception: he was evidently Theophilus' friend (ὦ ἑταῖρε: *Autol.* I.1.5) and a pagan (*Autol.* I.9.12), but otherwise he is an *ignotus*. In other cases, which are commonly classified as examples of the "open-letter"[52] tradition, the apologists address a collectivity. Tatian writes "PROS HELLENAS." So does Clement. Minucius' apology is structured in the form of philosophical dialogue (modeled on Cicero's lost *Hortensius*)—hence, it lacks an addressee. Finally, there is the *Contra Celsum:* Origen does not identify its intended recipient.

In those examples where the addressee is identified as a notable, it is common for the speaker to indulge the addressee with various rhetorical forms of flattery, all of them part of epideictic tradition and all of them technically classified under the panegyric-encomium rubric. Addressing Marcus and Commodus, Athenagoras[53] provides the clearest example of a Christian apologist following the encomiastic prescriptions set forth in the rhetorical handbooks that circulated in the early and middle Empire. His method of addressing the corulers (176–180) is particularly close to Menander Rhetor's[54] second treatise entitled the *Imperial Oration* (*basilikos logos*) and composed in the Tetrarchic period. Menander's recipe for flattering an emperor has parallels in the so-called *Rhetorica ad Alexandrum*, in Cicero and Quintilian, and in the progymnasmatic tradition represented by Theon, Hermogenes, Aphthonius, and Nicolaus. At various places in his apologetic writings, Tertullian indulged his addressees in similar forms of flattery. In his first apologetic effort (*Nat.*) he did not stipulate an addressee(s), but in his second (*Apol.*) he addressed high priests or protectors (*Romani imperii antistites*), perhaps the City Fathers gathered on Byrsa hill, or the chief magistrates of Carthage. The apologists' purposes in using encomiastic forms of address are transparent: they are designed to ingratiate the addressee so that he would look favorably on the petitioner and his cause.

In the examples just cited, where the addressee is either a named notable or an assembly of dignitaries, the Christian rhetor must walk a fine line between praise and blame: too much of the latter could have a chilling effect, indeed it could trigger exactly the opposite response of the one that the apologists envisaged. But in the so-called open-letter tradition where the addressees are often identified as an amorphous collectivity, the extent of abuse directed at the addressee can (and does) become quite considerable: Tatian is the best single example of an early Christian

apologist lashing his addressee with verbal abuse. Tertullian is a close second.

The only addressee who is given an onstage, speaking role is Caecilius, the pagan philosopher who is the Christian Octavius' opponent in Minucius' apology. In this respect, as in the form of the *Octavius* (a philosophical dialogue),[55] this Latin-Christian apology is unusual. Minucius represents himself solely as the narrator of the dialogue: he is neither participant nor adjudicator.[56] He merely introduces the two antagonists and concludes with words of praise for the winner and his God.

The third of the three dramatis personae is the enemy. He is a straw man. He has no speaking role and is thus denied the opportunity to defend himself. Again Caecilius who is at once addressee and adversary is an exception; however, even here the real enemies are the unfortunate dupes[57] of superstition, the fools who demean themselves by membership in Nilsson's[58] throwaway rubric: *die niedere Glaube*. The latter designation was this great historian's *omnium gatherum* (like gnosticism for students of early Christian iconography), a convenient dumping ground for magicians, occultists, superstitious hoi polloi, and the other like-minded late-antique undesirables whose existence Nilsson deplored—it is no coincidence that the apologists pigeonholed their enemies in the same manner. The only real exception to the rule of silence that the apologists imposed on their enemies is the *Contra Celsum:* Origen lets Celsus speak but only in a very truncated manner. Otherwise the apologists' enemies (like their addressees) are present but silent. The enemy is in fact a caricature, a straw man, the Greco-Roman *Jedermann*, a common lout conspicuous for his unphilosophical life-style in which he mixes large doses of stupidity with superstition and depravity. In literature as in real life, boors are known by the company they keep, and it is no accident that this one is found haunting temples and precincts where images are worshiped.

The relationship between the parties involved in Christian apology is best described as triangular. The Christian *rhetor* and his pagan addressee make up the two strong sides of the triangle. The enemy occupies the weak third side. The apologist cajoles his addressee in an effort to gain his support and sympathy. In flattering the addressee the speaker uses the very same epithets[59] (philosophical, sagacious, peace-loving, philanthropic, righteous, and just) that he applies to himself and his coreligionists. Clearly this is no accident. Of the three parties, the conceit portrays two (*rhetor* and addressee) as birds of a feather. The third (the enemy) is the *auis praua*, a vulgar outsider, nasty and contemptible. The apologists portray themselves and their constituents as paradigms of all the virtues that they attribute to their addressees—they come across as fierce opponents of the vices that plagued Greco-Roman society, especially the common man's depraved groveling in superstition and image worship.

The Christian and his addressee—philosophers, men of incomparable wisdom and impeccable morals—these are the twin heroes of apology. They come together as it were naturally, bonding in the common cause of

defending wisdom, justice, goodness, of upholding everything that is wise and decent and rational. And they stand united against the common enemy who represents the forces of superstition, ignorance, and evil. All things foolish, degrading, and indecent mark the character of the enemy—image worship is one of his most conspicuous and pernicious hallmarks.

Literary Characteristics of the Genre and the Attack on Art

As was inevitable, the literary character of early Christian apologetic genre influenced the attack on Greek religious art. Geffcken sensed the relationship between these two, but he never managed to articulate anything beyond a vague sense of their interdependence. One must distinguish between the literary character of the genre and its authors' intents and purposes: the two are distinct—Geffcken habitually blurred the distinction. Because early Christian apology was second-rate qua literature proves nothing about its authors intentions. I believe they were nothing less than dead serious in the goals that they pursued. To my knowledge, Geffcken was the first and last scholar to explore the way in which the literary form of early Christian apology may have affected the attack on Greek art; no one seems to have picked up on this subject. Five of apology's literary characteristics directly affected the attack on Greek art—three are essential, two incidental.

The first in the former category is the appeal to precedents. This is one of the most important literary characteristics of the apologetic genre overall, and it had a direct bearing on the attack. It would be difficult to overestimate the importance that the apologists attributed to the testimonies that they culled from a broad range of late Hellenistic and Greco-Roman collections. They built up their arguments on a foundation of largely Greek philosophical precedents, ancient authorities whom they either quoted verbatim or paraphrased and whom they invoked as precursors of Christian wisdom. In some instances the apologists cited sayings (*logoi*) attributed to Greek wise men, in others they rehearsed actions (*praxeis*) that were said to exemplify these same sages putting their wisdom into action.

As for the form in which precedents were presented, the apologists shared the Antonine-Severan preference for pithy, aphoristic dicta. Christian apologists were evidently impressed with literature that served up lessons in the form of popular maxims (*chreiai*)[60]—these had to be brief, witty, easy to comprehend, and preferably satirical. The entire exercise has a conspicuously anecdotal quality, not unlike much of the quasi-philosophical, pagan literature that circulated in the early Empire and reflected, for example, the influence of Cynic diatribes.[61] The apologists' purpose in adducing precedents and presenting them in an aphoristic manner was to persuade the addressee in the clearest possible form that Christians were the true philosophical heirs and successors of giants like Xenophanes and Heraclitus.

In their attack on Greek art, the apologists also invoked Israelite precedents, but for obvious reasons this part of the argument was destined to play a secondary role. Since the apologists were addressing their arguments to pagans, it makes sense that they would fish for precedents that would impress their addressees. Their purposes, lest one forget, were deliberative[62] in the technical rhetorical sense (Arist., *Rhet.* 1459a30 ff.): they wanted to persuade their addressees to adopt a new course of action, to intervene and provide relief for their beleagured constituents. Clearly, the most persuasive arguments were bound to be those with which their addressees were already familiar and with which they were already in substantial agreement. Under circumstances such as these, it makes sense that Israelite precedents counted for less.

Insofar as the apologists invoked Hebrew precedents to support the attack on Greek art, the ideal scenario was the one Jews had already developed in their own defense. For example, Philo[63] together with the Jewish-Hellenistic historians (Demetrius, Eupolemus, Artapanus, Aristeas, Cleodamas, Philo, Theodotus, Ezechiel) excerpted by Alexander Polyhistor[64] had created an *interpretatio judaïca* of Hellenism, an apologetic exercise in which Greek wisdom was subordinated to and fictitiously derived from Israelite models. Hellenistic Jews advanced their cause through the forgery and interpolation of Greek literature in virtually all of its forms, including the Orphic materials (e.g. Aristobulus),[65] the oracular literature (Sibyllines), Greek tragedy (Aeschylus, Sophocles) and comedy (Menander, Philemon), early Greek geography and ethnography (Hecataeus), along with early Greek ethical writings (Phokylides).

The point was to show how all of Greek tradition derived from Hebrew models. The ancient Hellenic sages, Homer, Solon, and Plato, were said to have descended from Moses. A bogus filiation of Orpheus from David was part of the exercise. Before Eusebius' *Praeparatio Evangelica*, most of the Christian apologists, Clement excepted, knew this Jewish Hellenistic appropriation of Hellenic tradition very imperfectly, but even the Latins who knew it least could recite some of the commonplaces in support of their own cause. After all, since Christians fancied themselves as the new Israel, Jewish Hellenistic apology provided a useful building block by which the new religionists could assert their own filiation from Hellenic wisemen, who in turn were descended from Israelite sages. If nothing else, Jewish Hellenistic apology was a convenient clearinghouse for the earliest Christian apologists. As for the Christian version of an attack on Greek art, since Ex 20:4–5 (along with its several derivatives)[66] was presumed to be Mosaic and pre-Hellenic in origin, Greek philosophical aniconism (said to be carried forward by the new religionists) could be shown to descend ultimately from early Hebrew wisdom.

Clement, for example, constructed a little-known paradigm[67] based on the prophet of the Babylonian Exile, the Second Isaiah, who is noteworthy in the present context for his brilliant satires[68] of idols and idol worshipers. In an antianthropomorphic sequence that opposed the idea

that divinity can be visually represented, Clement juxtaposed the prophet and Antisthenes in such a manner that the so-called founder of the Cynic school complemented the sixth-century prophet's attack on idolatry. This was Clement's own special invention, otherwise unattested.

By the time that Christian apology began to develop in the early second century, the harmonization of Greek rationalistic, anti-idolatry sentiment with traditional Israelite opposition to image worship had gone rather far. In other words, the Christian apologists were provided with a ready-made literary tradition from which they could quarry their excerpts and proof texts.

Among Jewish documents represented as carrying biblical or quasi-biblical authority and important as background to the apologists' attack on art were the Judaized *Sibyllines*,[69] the pseudonymous Letter of Jeremiah,[70] the Wisdom of Solomon[71] and the *Book of Jubilees*.[72] The famous *Letter of Aristeas to Philocrates*[73] may be added to these four. All of these writings were guided in greater or lesser degree by Jewish apologetic intentions, and all of them underscored the importance of opposition to gentile religious art. All of them also presented a Judaized version of philosophical aniconism. In short, these five are examples of the already-existing stockpile from which the Christian apologists could draw their weapons.

The apologists' extensive reliance on the use of precedents, both real and fictive, is a sign of the times in which they lived and wrote. The literature of the early Empire was heavily weighted to antiquarian and bookish invocations of ancient authorities.[74] The apologists did not read these authorities in the original but instead relied on secondary compilations, gnomic collections (doxographies) of sayings attributed to famous wisemen, collected anecdotes and episodic narrations, epitomes, compendia, and florilegia concerning early Greek philosophers, their teachings, and their exploits. The apologists not only relied on doxographies for their knowledge of the pre-Socratics, but (despite the availability of the LXX) they also consulted secondary collections of testimonies even for their recitation of Pentateuchal traditions. This is simply a sign of the literary environment in which they lived and wrote—this literature of attributed *logoi*, *chreiai*, and *praxeis* gathered in an anthologized form represents a type of predigested *aides-mémoire* in an age of diminished literary vitality and creativity. A great deal more could be said in detail about the apologists' use of precedents to sustain their attack on Greek art, but for the present the major goal is simply to have recorded the fact.

The second literary characteristic of Christian apology that had a direct effect on art-related subject matter is apology's heterogenous and highly eclectic quality, often noted and much lamented by Johannes Geffcken,[75] who, though a rigid and somewhat dyspeptic Hellenist, was (surprisingly) also one of the all-time great cognoscenti of the Christian apologetic genre. This literary tradition exhibits a strong preference for diversity in language (epideictic is the dominant mode), in the arrangement (τάξις)[76] of subject matter (στάσις),[77] and in the choice of common-

places (τόποι)[78] to illustrate subjects. For the attack on Greek art, the most important of these three is the last, namely the wide-ranging *topoi*, which the apologists introduced to support their negative and highly critical portrayal of Greek religious art. Many of these commonplaces are philosophical in the broadest sense of the term. Some are historical. Others are drawn from natural history, from ethnography, from mythology or religion, and a few are based on the world of Greco-Roman manners and mores. Several are obscure.

This farrago of commonplaces is a fitting expression of a period in literature history given to an archaizing and encyclopedic turn of mind. Favorinus' *Pantodape Historia*, Telephos' *Poikile Philomatheia*, and Alexander of Kotyaeion's *Pantodapos Hyle* are signs of the time. So is Clement's *Stromateis*. In both Greek and Latin letters this was a period given to pedantry, especially the pedantic recitation of authorities culled from earlier tradition. Lexicographers, epitomizers, paradoxographers, and doxographers played a prominent role in defining the literary ethos of the early and middle Empire, much of that ethos consisting in learning that was superficial but impressive in its encyclopedic pretentions, learning that was inevitably presented in epideictic mannerisms.

This is an era in literature history noteworthy for the production of numerous forgettable curiosities, and were it not for the religious subject matter and for the subsequent triumph of the new religion, early Christian apology (which Geffcken likened to an "Urwald der Wissenschaft")[79] might also have fallen prey to posterity's collective amnesia. The truth is that early Christian apology is a literary hodgepodge, an indiscriminate mix of commonplaces drawn from a wide range of secondary compilations and abridgments, superficially impressive, but on closer inspection a scissors-and-paste job, uncritically conceived and hastily executed. For the reader who is unfamiliar with the apologetic genre, the attack on Greek art is bewildering in its complexity and in its evidently random, formless character. Within the many pages of the apologetic corpus, parts of this attack are strewn about as so many *disiecta membra*, and attention to such literary virtues as economy of words, clarity of expression, order, and arrangement is conspicuous by its absence. Geffcken gave a rather damning indictment of the formal aspects both of Christian apology in general and of the attack on Greek art in particular—with regard to the latter I think he was very much on target.

The third literary characteristic that directly affects the attack on Greek art is the apologists' commitment to popular expressions of philosophy as their argument of choice. I have already mentioned the diatribe parallel, and I agree with Geffcken that there is clearly more at stake here than just a casual relationship with Cynic literary tradition. Christian apology is an explicitly exoteric literature in both senses of the term: addressed to outsiders and conducted at an elementary level, indeed so elementary that even a self-made imbecile like Commodus might have been able to comprehend the drift of Athenagoras' argument. Early Christian apology

in general and the attack on Greek art in particular clearly owe a considerable debt to the Cynic-Stoic diatribe,[80] not in its original Hellenistic (dialogic) form, but in its Greco-Roman derivatives, which were made available to the earliest apologists in the writings of Dio Chrysostom, Epictetus, Favorinus, Musonius, Philo, Philodemus, and Plutarch. For the early Latin apologists, Seneca and Cicero were the decisive models. Though propounded in the name of philosophy, in fact the apologists' attack on Greek art exhibits a highly anecdotal, episodic, and only quasi-philosophical character. This is really popular literature. The intellectual demands put on the reader or auditor are kept to a minimum. And quite clearly, the attack on Greek art (like apology overall) was meant to appeal to an audience that had philosophical pretenses but was in fact inured to the popular intellectual worlds of Greco-Roman satire and diatribe.

The fourth and fifth literary characteristics of Christian apology overall that had a direct effect on the way that art-related subject matter was treated are both self-explanatory. The fourth is the lack of coherent arrangement (*taxis*)[81] in the presentation of subjects. Most of the the apologists (Tertullian excepted)[82] paid relatively little attention to the overall structure of their arguments. The attack on Greek art richly illustrates this fact: it is disordered and confused in both Greek and Latin renditions. The fifth characteristic, namely the apology's redundancy, is patently related to the question of arrangement. Instead of making their point in a logical sequence and fully at one time, the apologists repeat the same argument in different parts several times over, adding an occasional exemplum, deleting another, but in the end repeating the selfsame argument often verbatim within the same treatise. Both literary characteristics, lack of arrangement and redundancy, Geffcken[83] found particularly annoying, no doubt with justification.

This brings us to the conclusion of our brief discussion centering the historical setting and the literary connectors that help to make sense of the apologists' attack on Greek art. As for the former, which is not at all well documented in early Christian apology, our sources of reliable information are very fragmentary. But despite this fact, it is clear I think that written (and possibly spoken) apologies came into being as a response to real-life struggles and conflicts. Christians were an unpopular minority in several recorded places and times over the course of the second and early third centuries. Admittedly, as Barnes has cautioned, one should not over-dramatize their lot. The persecution of Christians did not really reach crisis proportions until the mid-third century, and even then persecution was enforced with considerable unevenness from one jurisdiction to the next. But it is also evident that many second- and third-century Christians were confronted with real expressions of bigotry, discrimination, slander, injustice, and even violent persecution.

The apologists represent one very small group of individuals who responded openly and aggressively to their problematic status. They vigorously defended themselves and their coreligionists. They also counter-

attacked. Judged by the evidence as it happens to survive, their response seems to have been unusual. Excepting the martyrs, most Christians seem to have suffered their condition somewhat passively. Certainly most did not respond by taking pen in hand. The apologists addressed people in high places. They petitioned for help, judicial relief, and an unbiased evaluation of their merits and faults (of the latter, of course, they had none)—in short they asked their addressees to intervene. The apologists responded to a real-life conflict by constructing written defenses of themselves and of their constituents. However one judges the success or failure of their efforts, it would be a mistake to follow Geffcken in minimizing or dismissing the urgency of the real historical setting in which this genre took root—it would be equally inaccurate in my view to deny that the apologists sought the real-life solutions to their dilemma. Early Christian apology represents the written expression of real people seeking real solutions to a real-life conflict.

As for the apologists' attack on Greek art, its purposes are virtually identical with those of genre overall. The attack is not a superfluous addendum. Nor is it a literary curiosity. The attack on Greek art is instead an integral and essential part of the overall apologetic tactic. One should not detach the attack on art from the rest of apologetic corpus, as if this part of the exercise had some significance outside of or apart from its own immediate literary environment. The truth is, it has none.[84] Whatever meaning one can legitimately read out of the apologists' attack on Greek art must be a meaning that is consistent with purposes of the genre overall. The attack is an apologetic stratagem, pure and simple—its purposes are to advance the argument, to persuade the addressee, hence to foster the Christian cause. All other putative intentions are either secondary or irrelevant.

In the first instance, the attack serves apologetic *ethopoeia*, the *rhetor*'s self-portrayal (and, by extension, his representation of his constitutents), and in the second it buttresses the apologists' caricature of the enemy. Curiously, the attack has no direct bearing on the apologists' portrayal of the addressee, although an inference is implied. As I have already indicated, *rhetor* and addressee are made to stand over against a common enemy; hence, whatever the speaker advocates is presumed to be met with sympathy on the addressee's part. Thus when the speaker praises himself and his coreligionists for their philosophical aniconism, by association and by inference he is also praising his addressee, who, we must presume, shares the same set of values. In other words, we are led to believe that philosophical, theological, and cultic forms of aniconism would have struck an auspicious chord among the apologists' addressees.

In conclusion, although the attack was meant to throw direct light on only two of the three involved parties, the speaker and the enemy, indirectly it also accentuated propensities and prejudices that were firmly entrenched among the educated Greeks and Romans whom the apologists identified as their addressees. In simple language, by attacking Greek

religious art, the apologists perceived and attempted to exploit the widespread Greco-Roman intolerance of Nilsson's *niedere Glaube*—this was a historian who had a profound and lifelong interest in primitive religion but who also had little tolerance of superstition and magic "out of context," namely in the setting of a highly evolved civilization such as that presented by second- and third-century Rome. Nilsson reflected an ancient prejudice—like Pliny, Marcus, and a host of other Roman bureaucrats, he could not stomach and would not tolerate the superstitions of the common people. The apologists exploited this prejudice. They sensed their addressees' disdain of popular religion and capitalized on it, to their own and their constituents' advantage. The attack on Greek art was their most potent and effective vehicle for putting this apologetic stratagem to work.

Notes

1. The consensus view, that Ex 20:4par. was the starting point and sine qua non for early Christian attitudes toward art, was one of the three foundations on which Th. Klauser (discussed in Chapter 1) constructed his theory of the origins of early Christian art; thus *CIAC.Atti* 6 (1965), 223: "Das zweite Gebot des Dekalogs . . . hat auch im frühen Christentum lange als Richtschnur gegolten"; Klauser, *ZKG* 76 (1965), 1, 2: "Aber hat die Kirche dieses Gebot (*Exod.* 20.4) nicht noch lange respektiert? Sicher ist jedenfalls, dass christliche Kunst nur entstanden sein kann in einem Bereich, in dem man das zweite Gebot aufgegeben hatte oder doch wenigstens nicht mehr ernst nahm." In other words, Klauser convinced himself that as a precondition the early Christians had to throw Ex 20:4 "über Bord" before they could develop their own artistic tradition.

2. Thus W. Elliger, *Die Stellung der alten Christen zu den Bildern in den ersten vier Jahrhunderten*, SCD, n.s. 20 (Leipzig, 1930), 4, 5: "Das Christentum hatte vom Judentum, wo das göttliche Verbot (Ex. 20,4) in einem Gegensatz von unerbittlicher und imponierender Schärfe allem Bilderdienst entgegentrat, die reine Geistigkeit des Gottesdienstes überkommen und als einen Faktor von ausschlaggebender Bedeutung neben mannigfachen anderen Elementen auch die Verwerfung religiöser menschlich-figürlicher Darstellungen zu werten und gewertet, nicht nur solange seine Anhänger auch räumlich fast ganz in der Einflusssphäre jüdischer oder jüdisch orientierter Frömmigkeit lebten, sondern noch weit in die Zeit hinein, als die Heiden bereits das Übergewicht in der jungen Gemeinschaft erhalten hatten." A recent revisionist reading: W. B. Tatum, "The LXX Version of the Second Commandment (Ex. 20,3–6 = Deut. 5,7–10): A Polemic against Idols, not Images," *JSJ* 17.2 (1986), 177–95: this is an attempt to reconcile Jewish and Greco-Roman archaeological and art-historical evidence with the biblical prohibition of images—the author's most important insight is that the Septuagint version of the text is not just a translation but an interpretation; he fails, however, in my view to distinguish between idol and image.

3. More precision in dating is not possible. Eus., *HE* 4.3.2–3 writes (also *Chron.* 220) that Quadratus and Aristides addressed apologies to Hadrian. In the latter entry, he associates the delivery of both apologies with the Emperor's visit to Athens where he was inducted (fall 125 to spring of the following year) into the Eleusinian mysteries. Testimonia: Harnack, *Gesch.* 1:1, 95ff.; 2:1, 269ff. But the

original Aristides was a Jew, not a Christian; see G. C. O'Ceallaigh, *HTR* 51 (1958), 227–54. And the association of Quadratus with Athens (and hence with Hadrian in that City, 125/126) is problematic. Jerome (*Vir.* 19) makes Quadratus the bishop of Athens, thus confusing the apologist Quadratus (*HE* 4.3) with the Athenian bishop Quadratus (*HE* 4.23.3). If the lost *Kerygma Petri* (frags.: Clem., *Strom.* 1.182.3; 6.39.1–41.7; 6.43.3; 6.48.1–2; 6.128.1–3; not to be confused with the *Gospel of Peter*) was an apology, then the Christian form of the genre probably commenced under Trajan, not Hadrian. But the original form of the *KP* is a matter for speculation; see P. Nautin, *JThS*, n.s., 25 (1974), 98–105. On the *Gospel of Peter:* H. Koester, *Ancient Christian Gospels* (London, 1990), 216–30.

4. From the fifth and fourth centuries (Antiphon, Lysias, Thucydides, Hyperides), apologia (*apologeomai*) has the sense of a defense-speech, e.g. Preisigke, *Sammelbuch* 4658.18, 4747.1, 4765.1, 4823.1, 8248.53, 9387.7, 9396.2, 9397.5, 6. Not to be confused with *apologos* which has the sense of legend or story, esp. one that is long and tedious, e.g. Pl., *Rep.* 614b; Arist., *Rhet.* 1417a13. The paroemiographers made Odysseus's story (*Od.* 23.263–84, 305–43) to Alcinous the proverbial *apologos*.

5. A big subject. Older literature: M. Friedländer, *Geschichte der jüdischen Apologetik als Vorgeschichte des Christentums* (Zurich, 1903); also V. A. Tcherikover, "Jewish Apologetic Literature Reconsidered," *Eos* 48.3 (1956), 169–93; J. Gutman, *Ha-Sifrut ha-Yehudit ha-Hellenistit*, vols. 1–2 (Jerusalem 1958–1963); N. Walter, *Der Thoraausleger Aristobulos*, *TU* 86 (Berlin, 1964); J. Schwartz, "Philo et l'apologétique chrétienne du second siècle," in *Hommages à André Dupont Sommer* (Paris, 1971), 497–507; M. Hengel, *Judentum und Hellenismus*, 2d ed. (Tübingen, 1973), 129ff.; further bibl.: *TU* 106 (1969), esp. 229, 235, 241. More recent: J.-D. Gauger, *Beiträge zur judischen Apologetik*, *BBB* 49 (1977), and *JSJ* 13 (1982), 6–46. A new comprehensive study is much needed.

6. J. Geffcken, "Die altchristliche Apologetik," *NJbb* 15 (1905), 625ff.; idem, "Der Bilderstreit des heidnischen Altertums," *ARW* 19 (1919), 286ff.; idem, *Zwei griechische Apologeten* (Leipzig, 1907), Sachregister: Götterbilder; also p. 99, n. 1: Justin's two Apologies and Athenagoras' Legatio are "reine Buchliteratur ohne praktische Zwecke." He stressed this interpretation throughout his publications.

7. Geffcken's critique began in his "Altchristliche Apologetik und griechische Philosophie," *Zeitschrift für Gymnasialwesen* 60 (1906), 1–13, and continued unabated until his *Der Ausgang des griechisch-römischen Heidentums* (Heideleberg, 1929). The message: the Christian apologists were half-educated, pseudo-Sophists whose knowledge of Greek philosophy was superficial and completely undigested.

8. At *Ann.* 15.44 (Suet., *Nero* 16.2; Tert., *Apol.* 5.3; Eus., *Chron.* 216; *HE* 2.25) Tacitus reports that Christians were persecuted under Nero. Tacitus knew Pliny's *Ep.* X.96 (H. Fuchs, *VC* 4 [1950] 72), and in my view the report is very likely a retrojection. Other reports of Christian persecutions under Tiberius (Tert., *Apol.* 5.2; Eus., *Chron.* 214) and Domitian (Eus., *HE* 3.19ff., 4.26.9) are fictions; cf. T. D. Barnes, *JRS* 58 (1968), 32ff. Thus the earliest positive confirmation we have of pagans disapproving of Christians is Pliny's *Ep.* X.96, dated ca. 110–112; see A. N. Sherwin-White, *The Letters of Pliny* (Oxford, 1966), 691: written between 18 September and 3 January, second year (as "legatus Augusti pro praetore consulari potestate" in Bithynia-Pontus).

9. Tannaim (tanna): rabbinic sages (70–200), authorities of the Mishnah. On Jewish *diabole/psogos/uituperatio* of Jesus: H. Strack, *Jesus, die Häretiker und die Christen, nach den ältesten jüdischen Angaben* (Leipzig, 1910): a useful collection

of sources. For discussion: M. Smith, *Jesus the Magician* (San Francisco, 1978), 21–67.

10. The charge that Christians were bad for business (Acts 19:23–40; Pl., *Ep.* X.96.10; Luc., *Pereg.* 16; Tert., *Apol.* 42.1–43.2) does not fall under any of these three headings. For discussion, see Chapter 3. Perhaps, the *maiestas* charge (Min., *Oct.* 8.3, 31.6) should be put under atheism. Mommsen (*Straf.* 595) thought it was a *Staatsverbrechen*, although it could equally be considered on its own separate merits (or faults). The charge (Orig., *Cels.* 2.4) that Christians were apostates from Judaism should probably be considered separately, although this could also be considered an expression of their atheism. As for the charge (Orig., *Cels.* 3.55, 6.1, 6.14; Min., *Oct.* 8.4, 12.7; Just. I *Apol.* 60, II *Apol.* 10; Athenag., *Leg.* 11.4; Tat., *Or.* 32.1; Luc., *Pereg.* 13) that they were uneducated and ignorant yokels, people of no account, this is related both to atheism and superstition, but it stands on its own merits and probably should be considered separately.

11. Mommsen, *Straf.*, 575, approaches this conclusion; idem, *HZ* 64 (1890), 419: "Die Regierung [i.e., Rome] konnte einerseits sich dem nicht verschliessen, dass das Christenthum politisch mindestens ungefährlich war, andrerseits im Hinblick auf die Reste des alten Nationalgefühls und den Fanatismus der Massen es nicht wagen den 'Atheismus' offen zu- und den Staatsglauben fallen zu lassen." Following Tert., *Apol.* 24–35, Mommsen argued that Christian refusal to worship the gods and caesar must have been construed (by Roman magistrates) as a delictum against the majesty of the princeps and of the *populus Romanus*. Christian refusal to worship was an unjustifiable "Staatsverbrechen," an offense against the state. Part of the rationale for allowing Jewish refusal to worship consisted in the fact that Jews were an *ethnos*, a nation with their own national god; cf. A. von Harnack, *Der Vorwurf des Atheismus in den drei ersten Jahrhunderten*, *TU* 13 (Leipzig, 1905).

12. Jos., *Ap.* 148 = Stern, *GLAJJ* no. 49 (*atheous kai misanthropous*, along with other complaints, including the charge that Jews had contributed no useful invention to civilization. Celsus repeated this latter charge; Orig., *Cels.* 4.31).

13. Posidon, *Frag.* 128, 131a (apud Diodorus Siculus).

14. *Nat.* 13.4.46: "gens contumelia numinum insignis."

15. *Hist.* 5.5: "contemnere deos."

16. Schürer, *Hist.* 3.1, 612. For the full list with texts of anti-Jewish accusations of atheism, see Stern, *GLAJJ* 3: s.v. "Atheoi."

17. Delatio (Ulp., *Dig.* 49.14.25; Paul., *Dig.* 49.14.44) as a form of denunciatio is part of the summons procedure in *cognitio extraordinaria;* cf. Mommsen, *Straf.*, Sachliches Register, s.v. "Denuntiation"; also R. Kipp, *Die Litisdenuntiantion* (Leipzig, 1887). It appears that Eusebius rendered *delatio nominis* (formal denunciation of a defendant by name) into an awkward Greek paraphrase at *HE* 4.9.3 (Hadrian's rescript to Minucius Fundanus). Accuser (*delator*) should not be confused with informer (*index*); on the latter: Mommsen, *Straf.*, 504ff.

18. Notably Q. Junius Rusticus (*PIR²* J814) perhaps City prefect from 162–167; Rusticus interrogated and condemned Justin and his friends. Discussion of others who may have acted on delations against Christians: T. D. Barnes, *JThS*, n.s., 19 (1968), 509ff.

19. H. F. Jolowicz and B. Nicholas, *Historical Introduction to the Study of Roman Law*, 3d ed. (Cambridge, 1972), 397ff. The *cognitio* procedure was inquisitorial, not accusatory (contra G. E. M. de Ste. Croix, *PP* 26 [1963], 15, mistakenly asserting the opposite).

20. F. Schulz, *Principles of Roman Law* (Oxford, 1936), 173.

21. Jolowicz and Nicholas, *Roman Law.*, 401ff.

22. Hadrian's *Letter* (Eus., *HE* 4.9.1–3) to Minucius Fundanus, proconsul of Asia 121/122, seems to be a response to strong popular sentiment (*boai*) against Christianity; the princeps ruled (presuming the *Letter* is authentic) that delations made unjustly (as harassment, as blackmail, as the work of *sycophantiai*) should be punished.

23. Eus., *HE* 3.36.1, 4.14.1, 5.20.4–8; date: Barnes, *JThS*, n.s, 19 (1968), 510–14.

24. A. Birley, *Marcus Aurelius* (Boston, 1966) 328–31; also M. Sordi, "I nuovi decreti di Marco Aurelio contro i Cristianai," *Studi Romani* (1961), 365ff. Tert., *Apol.* 5.6, calls Marcus a "protector" of Christians, a bald fiction.

25. Eus., *HE* 5.1–3.

26. On the date, a *non liquet*, from Barnes, *JThS*, n.s., 19 (1968), 517–19.

27. Eus., *HE* 5.21.1ff.; Tert., *Scap.* (written ca. September 212) 3.4, 5.1.

28. Eus., *HE* 6.2.2, puts the outbreak of persecution in Alexandria to the Emperor's tenth year: either August 201–August 202 or April 202–April 203.

29. Cyprian, *Epp.* 75.10.

30. T. D. Barnes, *Tertullian: A Historical and Literary Study* (Oxford, 1971), 143–63: on the persecution of Christians, the extent and nature of the evidence.

31. Strack, *Jesus;* the earliest evidence is associated with Rabbi Eliezer (ca. 70–100) who is said to have heard about "Jesus, son of Panteri" in Galilean Sepphoris; cf. Smith, *Jesus the Magician*, 46, 47. Celsus (author of the *True Word*, ca. 177–180) knew a version of the story, probably not based on rabbinic sources; he calls Jesus' father "a soldier named Panthera" (Orig., *Cels.* 1.32). Tert., *Spect.* 30.5–6 (196/97), cites part of the story but does not mention Pantera—he may be citing Tannaic tradition known to him from contemporary North African Jewry, but his source is disputed; cf. W. Horbury, *JThS*, n.s., 23 (1972), 455–59.

32. D. Sperber, in *EJ*, s.v. "Min."

33. R. Kimelman, "Birkat Ha-Minim and the Lack of Evidence for an Anti-Christian Jewish Prayer in Late Antiquity," in *Jewish and Christian Self-Definition* 2, ed. E. P. Sanders, A. I. Baumgarten, and A. Mendelson (Philadelphia, 1981), 226–44.

34. On being "excluded from the synagogue" (*aposynagogos:* Jn 9:22, 12:42, 16:2) and *birkat ha-minim*, see J. L. Martyn, *History and Theology in the Fourth Gospel*, 2d ed. (Nashville, Tenn., 1979), 37–62; also A. Segal, *Two Powers in Heaven* (Leiden, 1977).

35. Demetrius and the silversmiths (Acts 19:23–41) are the paradigm (possibly invented); for discussion, see Chapter 3.

36. *Arnesis* (apostasy): Eus., *HE* 5.1.33–50: the Lugdunum massacre.

37. Min., *Oct.* 8.4; also Orig., *Cels.* 3.55: Celsus portrays Christians as purveyors of pious gibberish, but only in private places away from their (non-Christian) superiors. On claims that the new religionists maintained intentional secrecy (O. Perler, in *RAC* 1 (1950), s.v. "Arkandisziplin"), see discussion in Chapters 5 and 7.

38. Barnes, *Tertullian*, 59.

39. On the difficulty of identifying and distinguishing the author of *VS* from the other Philostrati, see G. Bowersock, *Greek Sophists in the Roman Empire* (Oxford, 1969), 1–16.

40. Testimonia: A. von Harnack, *TU* 1.3 (1883), 1ff.

41. E. M. Smallwood, ed. *Philo, Legatio ad Gaium* (1961); Schürer, *Hist.* 3.2, 859ff.; also cf. F. Millar, *The Emperor in the Roman World 31BC–337AD* (Ithaca, N.Y., 1977) index I, s.v. "Embassies."

42. As observed by V. Tcherikover (*Eos* 48.3 [1956], 169–93), a considerable percentage of Greek Jewish literature in the Hellenistic and Greco-Roman periods is guided by apologetic intentions; for an informative introduction, see J.-D. Gauger, *Beiträge;* also D. Mendels, *The Land of Israel as a Political Concept in Hasmonean Literature, TSAJ* 15 (Tübingen, 1987).

43. Epideictic, virtuoso rhetoric, or speeches of display: Th. C. Burgess, "Epideictic Literature," *SCP* 3 (1902), 89ff.; also V. Buchheit, *Untersuchungen zur Theorie des Genos epideiktikon von Gorgias bis Aristoteles* (Munich, 1960); M. L. Clarke, *Rhetoric at Rome* (London, 1953), 130ff.: Antonine Rome as an epideictic era. Also G. Anderson, "The Second Sophistic: Some Problems of Perspective," in *Antonine Literature,* ed. D. A. Russell (Oxford, 1990), 91–110: urging a more nuanced view of second-century history and literature.

44. Rhetorical *epainos/laus* (along with its opposite, *psogos/uituperatio*) is a standard part of epideictic speeches, especially of the panegyric-encomium (which subsumes *basilikos logos, genethliakos logos,* and *epitaphios logos*). *Epainos* normally has two major topoi: *eugeneia* and *praxeis.* See Burgess, "Epideictic Literature, 147ff., and Quint., *Inst.* 3.7.1–2. Theon's progymnasmatic treatment of encomium and *psogos* is an excellent background to the early Christian apologists' use of both devices; see *Rhetores Graeci,* vol. 2, ed. L. Spengel (Leipzig, 1854), 57–130, esp. 109–112. On Aelius Theon (second century A.D.): *Suda,* s.v.

45. Ethos: Men., Frag. 407, line 7: Τρόπος ἔ͂θ' ὁ πείθων τοῦ λέγοντος, οὐ λόγος (it is the character of the speaker that persuades, not the speech). Arist., *Rhet.* 1366a8–12, 1377b21: the speaker must not only make the speech convincing, but he must also convey a positive impression of himself, a sense of his own moral character. Aristotle continues by defining the content of the speaker's ethos as consisting in *phronesis, arete, and eunoia;* see G. Kennedy, *The Art of Persuasion in Greece* (Princeton, N.J., 1963), index, s.v. "ethos." On the power of *ethopoeia:* Arist. *Rhet.* 1356a1–2, 4–13. Some rhetorical theorists considered *ethopoeia* to constitute artificial and indirect proof; others (Lysias, Antiphon, Isocrates) considered it inartificial and direct. *Ethopoeia* was originally used in judicial oratory, but in the Imperial period it was widely applied in epideictic contexts. Quint., *Inst.* 6.2.8ff.: on ethos. Hermogenes on character portrayal: *Hermogenis Opera,* ed. H. Rabe (Stuttgart, 1969), 20–22; and Aphthonius on the same subject: *Apthonii Progymnasmata,* ed. H. Rabe (Leipzig, 1926), 34–36.

46. Burgess, "Epideictic Literature," index, s.v.; also Men. Rhet., *Diaer.,* Treatise II, 76ff. *Prosphonetikos logos* (discussed by Menander Rhetor and Dionysus of Halicarnassus) is really a variant of the speech to a king.

47. Thereby distancing early Christian apology from classical epideictic form on the example of the panegyric-encomium: Isocrates, Theon, and Nicolaus agree that an encomium should not be contaminated with apologetic themes. Quint., *Inst.* 3.7.6, however allows the possibility of apology and defense in an encomiastic setting: Athen., *Leg.* fulfills this exception; cf. Burgess, "Epideictic Literature," 118.

48. Ciceronian *psogos: M. Tulli Ciceronis in L. Calpurnium Pisonem,* ed. R. G. M. Nisbet (Oxford 1961), esp. 192–97, and on Piso's response, *Invectiva in Ciceronem* (falsely attributed to Sallust), ibid., 197–98; also P. DeLacy, *TAPA* 72 (1941), 49–58. On the distinction in Claudian between rhetorically patterned *psogos*

and vituperative material: H. L. Levy, *TAPA* 77 (1946), 57–65. Aphthonius on *psogos* and a *psogos* of Phillip: *Aphthonii Progymnasmata*, ed. H. Rabe (Leipzig, 1926), 27–31. The best example of rhetorical *psogos* in early Latin-Christian literature is Tert., *Marc.* I.1.3–6: to the ruination of humankind, a sub-anthropoid ("mus ponticus") named Marcion slithers forth from the frigid bowels of the Euxine.

49. On the classical models: W. Voegelin, *Die Diabole bei Lysias* (Basel, 1943). On *calumnia*, cf. *OLD*. On rabbinic *diabole* of Jesus, see n. 9. In all periods of history a common feature of slander is to equate the target with an animal, on which see E. Leach, "Anthropological Aspects of Language: Animal Categories and Verbal Abuse," in *New Directions in the Study of Language*, ed. E. H. Lenneberg (Cambridge, Mass., 1964), 23–63.

50. Commonly conveyed in Latin by *inueho:* Cic., *Or.* 2.301, 304. *Psogos* and invective are synonyms.

51. Quadratus and Aristides addressed Hadrian; Justin addressed Antoninus Pius, his two adopted sons, and the Senate and People of Rome; Apollinaris and Melito addressed Marcus and Lucius Verus; Athenagoras addressed Marcus and Commodus; an anonymous Severan addressed Ti. Claudius Diognetus (imperial procurator of Egypt A.D. 204: *PIR²* 2:852); Tertullian (*Apol.* I.1) addressed the "chief magistrates" of Rome (. . . Romani imperii antistites . . .)

52. The examples include Tat., *Or.*, Clem., *Prot.*, Tert., *Nat.*, Apollinaris apud Eus., *HE* 4.27; Justin at *HE* 4.18.3 and Miltiades at *HE* 5.17.5. Also ps.-Justin's *Oratio ad Graecos*, Otto, *Corp. Apol.* 3.2–18 and idem, *Cohortatio ad Graecos, ibid.*, 3.19–126. Hippolytus' lost Πρὸς ῞Ελληνας καὶ πρὸς πλατώνα ἢ περὶ τοῦ παντός (at *Ref.* 10.32.17: Περὶ τῆς τοῦ παντὸς οὐσίας) may have been an apology in the open-letter tradition, but it sounds more like a philosophical compendium, no doubt one that rehearsed doxographic commonplaces.

53. For an informative study: W. Schoedel, "In Praise of the King: A Rhetorical Pattern in Athenagoras," in *Disciplina Nostra: Essays in Memory of Robert F. Evans*, ed. D. Winslow (Cambridge, Mass., 1979), 69ff.

54. Men. Rhet., *Diaer.*, Treatise II, 76–94.

55. Modeled on Cicero's lost *Hortensius;* see G. W. Clarke, *ACW* 39.164–65.

56. As suggested incorrectly by Clarke, *ACW* 39.28; at Min., *Oct.* 40.3. Minucius expressly disavows that role: "At ego" inquam "prolixius omnium nostrum uice gaudeo, quod etiam mihi Octauius uicerit, eum maxima iudicandi mihi inuidia detracta sit."

57. Min., *Oct.* 24.5.

58. Nilsson, *GGR* 2.498ff.: magic, the occult, *daimones;* also sec. IV. 175ff.: personal religion in the Hellenistic period.

59. Thus Athenag. (*Leg.* 1.2, 2.1–6) uses τὸ πρᾶου το ἥμερον τὸ πρὸς ἅπαντα εἰρηνικὸν καὶ φιλάνθρωπον. These are all Menandrian topoi, on which cf. Schoedel, "In Praise of the King," 77. Athenagoras, Marcus and Commodus are gentle, mild, peaceable, philanthropic, sagacious (1.2), mighty, humane, and learned benefactors (2.1), men exhibiting δικαιοσύνη (2.3), superior even to scholars who have spent a lifetime mastering a discipline (6.2). They surpass all other men in their wisdom and reverence for godly things (7.3). They are even masters of Hebrew scriptures (9.1)! These great men of wisdom (10.3), these philosopher-kings (11.3) are also deeply versed in pagan scriptures (Orpheus, Homer, Hesiod: 17.1). They are wiser than all men (23.1, 31.3), well versed in everything (24.1), good moderate, philanthropic, and worthy of royal office (37.1).

With respect to Marcus some of this adulation is justified, although his Danubian campaigns were certainly not very wise, peace-loving, or moderate, and his knowledge of Hebrew was nonexistent. Applied to Commodus the entire litany of praise is hollow—the man was a fool and achieved nothing but his own disgrace. On *dikaiosyne* in Menander (along with courage, temperance, and wisdom), see Men. Rhet., *Diaer.*, Treatise II, 84ff. and again in his Logos Prosphonetikos, Treatise II, 164ff.

60. Hermog., *Progym.* 3 (Peri Chreias): Greek text = *Rhet. Gr.* II.iiiff.

61. W. Capelle and H. I. Marrou, in *RAC* 3 (1957), s.v. "Diatribe."

62. *Genus deliberativum/symbouleutikos logos/protreptikos logos* (sometimes called *parainetikos logos*): R. Volkmann, *Die Rhetorik der Griechen und Römer* (Leipzig, 1885; rpt., Hildesheim, 1963), 294–314: "Die berathende Redsamkeit."

63. Esp. in his lost *Hypothetica* (Apologia pro Iudaeis) apud Eus., *PE* 8.6–7, but many of his works have an apologetic intention; see Schürer, *Hist.* 3.2, 809ff.

64. *FrGrHist* III A; also Schürer, *Hist.* 3.1, 510–12.

65. Greek frags.: Denis, *FPG*, 217–18. Eng. trans.: A. Yarbro Collins, *OTPseud* 2, 831–42; cf. Schürer, *Hist.* 3.1, 579–87.

66. Deut. 5:8–9 is no doubt the most important single Deuteronomic passage, but there are many others, as there are in numerous other parts of the Hebrew Bible (Ps 115:3–8, 135:15–18, and the second Isaiah were esp. important for the Patristic writers); see R. H. Pfeiffer, *JBL* 43 (1924), 229–40; C. R. North, *ZAW*, Beiheft 77 (1958), 151–60; J. Ouellette, *RB* 74 (1967), 504–16; J. Gutmann, "The 'Second Commandment' and the Image in Judaism," in *No Graven Images*, ed. J. Gutmann (New York, 1971), 3–18; J. Faur, *JQR* 69 (1978), 1–15. The literature on this subject is vast; a new "state of the question" survey would be extremely helpful.

67. ὅτε Σωκρατικὸς Ἀντισθένης παραφράζων τὴν προφητικὴν ἐκείνην φωνὴν "τίνι με ὡμοιώσατε; λέγει κύριος", "<θεὸν> οὐδενὶ εοικέναι" φησί· "διόπερ αὐτὸν οὐδεὶς εκμαθεῖν ἐξ εἰκόνος δύναται·"

68. Vss. 41:21–29; 42:8–9; 43:8–15; 44:6–8, 21–22; 46:1–4 are from the prophet. Other anti-idolatry verses in 40–48 are disputed and may be secondary. Vss. 49–55 are not at issue; see H. C. Spykerboer, *The Structure and Composition of Deutero-Isaiah with Special Reference to the Polemics against Idolatry* (Groningen, 1976).

69. Passages important for the early Christian attack on Greek art: *OracSib.* 3.3–45, 545–72; 4.6–23; 8.359–428. Eng. trans. J. J. Collins, *OTPseud* 317ff.

70. Greek text: *Septuaginta* 15, ed. J. Ziegler (Göttingen, 1957), 494ff. Let Jer survives only in Greek, but the original may have been in either Hebrew or Aramaic. Eng. trans.: *NRSV* (Apocryphal Books) 169ff.; vss. 8–73: anti-idolatry diatribe. Second-century Christians considered Let Jer canonical, and it was presumably one of Aristides' most important sources (as it may have been later for Jacob of Serug). Tert., *Scorp.* 8.5–6, quotes it, as does Cyprian, *De Dominica Oratione* 5; cf. Schürer, *Hist.* 3.2, 743–45.

71. *NRSV* (Apocryphal Books) 57ff.; vss. 13:1–15, 17: an extended anti-idolatry diatribe. Paul, Clement of Rome, Tatian, Irenaeus, Clement of Alexandria, Tertullian, and Origen used Wis; see Schürer, *Hist.* 3.1, 568–79.

72. Eng. trans.: O. S. Wintermute in *OTPseud* 2.35ff. Date: 160–140 B.C. (D. Mendels, *The Land of Israel as a Political Concept in Hasmonean Literature* [Tübingen, 1987], 58: 125 B.C.). Anti-idolatry passages: 12.1–8, 20.7–8, 21.3,5, 36.5. Testimonia in early Christian contexts: Denis, *FPG*, 150–72; also Schürer, *Hist.* 3.1, 308–18.

73. Vss. 134–37 (Euhemeristic and *Prodikean chreiai*), e.g. line 135: "they [gentiles] make images of stone and wood, and they declare that they are like-nesses of those who have made some beneficial discovery [= shades of Prodicus] for their living. . . ." Eng. trans.: R. J. H. Schutt, *OTPseud* 2.7–34; cf. Schürer, *Hist.* 3.1, 677–87.

74. Thus Christ, Schmid, Stählin 2.2 (= *HAW* 7.2.2 [1913]), 507–760; B. P. Reardon, *Courants littéraires grecs des IIe et IIIe siècles après J.-C.* (Paris, 1971), esp. 237–74: paradoxography, pseudoscience, and religion; for an up-to-date and read-able survey, cf. G. W. Bowersock, D. C. Innes, E. L. Bowie, P. E. Easterling, and B. M. W. Knox, "The Literature of the Empire," in *The Cambridge History of Classical Literature I: Greek Literature*, ed. P. E. Easterling and B. M. W. Knox (Cambridge, 1985), 642–718; also B. A. van Groningen, *Mnem* 18 (1965), 41–56.

75. For Geffcken's publications on early Christian apology, see n. 6, 7.

76. On τάξις: J. Martin, *Antike Rhetorik*, *HAW* 2.3 (Munich, 1974), Register (Griechisch) s.v.

77. R. Nadeau, *GRBS* 2 (1959), 53–71; on stasis in Tertullian, see R. D. Sider, *Ancient Rhetoric and the Art of Tertullian* (Oxford, 1971); also J. Martin, *Antike Rhetorik*, 28–52; on ethos in Aristotle's *Poetics*, see J. T. Kirby, *Arethusa* 24 (1991), 200–203.

78. τόπος (locus): J. Martin, *Antike Rhetorik*, Register Griechisch, s.v.

79. *NJbb* 15 (1905), 626.

80. Still informative: R. Bultmann, *Der Stil der paulinischen Predigt und die kynisch-stoische Diatribe*, FRLANT 13 (Göttingen, 1910); also J. Geffcken, *Kynika und Verwandtes* (Leipzig, 1909); cf. W. Capelle and H.-I. Marrou, in *RAC* 3 (1957), s.v.

81. τάξις: Arist., *Rhet.* 1414a30ff. Latin *contextus orationis:* Cic., *Part.* 1.4, 8.27–17.60; Quint., *Inst.* 8.1.1–62, 9.4.19; cf. Kennedy, Index, *Art of Persuasion*, index, s.v. "Arrangement."

82. Sider, *Ancient Rhetoric;* also idem, *VC* 23 (1969), 177ff.; idem, *JThS*, n.s., 24 (1973), 405ff.; idem, *JThS*, n.s., 29 (1978), 339ff.

83. Geffcken attributed lack of *taxis* to the "Unfreiheit der Halbgebildeten": for lack of a decent education the apologists possessed no powers of discrimination and hence artlessly threw together everything they found in their "miserable" sources; thus, *NJbb* 15 (1905), 645. On Tatian (Geffcken's favorite whipping boy), the "wild Oriental," the enemy "systematischer Darstellung," the "Assyrian Ter-tullian," the ignoramus who philosophized from his anus and whose work exhib-ited total lack of *taxis:* ibid., 639–40. Throughout this essay Geffcken continuously carps at the redundancy and lack of order in early Christian apology.

84. For example efforts to extract information about individual artists and works of art from the apologists (especially Tatian, Athenagoras, and Clement) are conspicuous in modern scholarship; e.g., A. Kalkmann, "Tatians Nachrichten über Kunstwerke," *RhM*, n.s., 42 (1887), 489–524; G. Botti, "Atenagora quale fonte per la storia dell'arte," *Didaskaleion* 4 (1915), 396–417. This is largely a thankless undertaking, because the apologists were apologists, not art historians.

3

The Content of the Attack on Greek Art

This is a complicated subject. For clarity's sake, two preliminary points need to be noted: first, the attack was in word only, and second, the menu was extremely rich and variegated. As to the former, nothing in the record as we have it supports the view that the earliest apologists (or any of their coreligionists) engaged in iconoclastic[1] actions directed against pagan religious art. Admittedly, several apologists employed inflammatory language—it requires little imagination to conjure up a picture of Tertullian smashing statues or Tatian torching temples—but the step from inflammatory rhetoric to acts of violence is one of moment, indeed one that is fraught with consequences (notably reprisals), and it seems unlikely that any Christians took this step before the late fourth century. For several generations after the beginnings in Palestine, the new religionists were politically and economically impotent and their numbers negligible; hence, Christians who carried out acts of violence directed at pagan religious art in the pre-Constantinian period would have been inviting disaster. None did before 300,[2] at least not so far as we can tell.

As for the second point, concerning the richness and variegation of subject matter in the attack on art, it is easy to miss the forest for the trees. Simply put, the attack is a literary hodgepodge. Cheek by jowl it mixes sublimity with bathos. Our authors regale us with stories of kings, wise men, and moral giants, but they also parade forth a long list of fools, felons, and garden-variety degenerates. Within their attack on art the

apologists discourse at length on lofty subjects—the nature of the divine, the meaning of truth—but they also exhibit curious attachments to subjects that are low, banal, and ludicrous, including a king who worshiped his pisspot, a philosopher who cooked his pot of beans over a fire fueled by a wooden agalma, and a lady who bedded an elephant. The tone of the attack is just as uneven as its subject matter, and this fact makes it easy to lose sight of the overall purpose.

The attack is its own kind of παντοδαπὸς ὕλη,[3] a mini-*stromateis*, a farrago of myth, theology, philosophy, poetry, politics, legal arguments, invective, Kafkaesque tales, gossip, and humor. Readers who undertake to absorb and comprehend this bizarre mix of subjects must be ever mindful of the continuities. As I mentioned in the previous chapter, first and foremost the attack on Greek art is an apologetic conceit, a literary stratagem: it is intended and should be read (in all its many parts) as a counterargument to three primary charges brought against the new religionists—namely, atheism, superstition, and sexual misconduct.

Atheism

As suggested in the previous chapter, this common anti-Christian complaint was probably an inference based on observed behavior and may have been prompted by the association of the new religion with its parent stock, Judaism. The complaint was reasonable: the new religionists refused to worship the gods and caesar, hence outsiders concluded correctly that they were *asebeis* and *atheoi*. It was their behavior, not their beliefs, that earned Christians these epithets, hence qua atheists they should be classified under the practical[4] rather than the philosophical[5] wing. Outsiders must have found the public behavior (nonconformity) of the new religionists queer and unsettling. By their nonparticipation in public cults, Christians offended ancient and highly revered customs deeply rooted in Greco-Roman society. Whatever beliefs they held in private was their business—government or socially imposed thought control in this realm was nonexistent. But, like everyone else, Christians were expected to conform in public, and their refusal to do so naturally enkindled speculations and ignited suspicions of various sorts, atheism included.

Cult

One of the ways the apologists responded to the charge of atheism was to appropriate the Stoic notion of God's indwelling[6] (*quod intus habitat*) the mind and heart of the truly religious person. As a kind of negative paradigm, art (temples and cult images) played an important role in this commonplace, an evocative reminder of what God is not. In order to impress their addressees, the apologists construed Christian refusal to participate in public cult as a sign that they enjoyed a rational and spiritual awareness of God's indwelling. Refusal to worship did not mean that Christians were

atheists but that their concept of divinity was internalized and hence more spiritual than that of the common man. Their religious sense was pure and unsullied by contact with the external paraphernalia of cult.

The apologists drew liberally from Stoic exegetical tradition, specifically Stoic allegorization[7] of cult. The latter promoted the systematic transmutation of all public and external acts, persons, and things into language and concepts that belong to the worlds of cosmology, philosophical theology, personal piety (in Seneca's case combining sentimentalism with cosmic mysticism), and personal ethics. Chrysippus' definition (apud Plut., *Mor.* 34B) of allegory as the transfer (μετάγειν) of a useful thing (τὸ χρήσιμον) from one context (in this case poetry) to another has equal application to allegorization of cult in late Stoic sources such as Seneca, Epictetus, Musonius, and Marcus. The primary cult action allegorized was sacrifice, and the main cult persons allegorized were priests. Art (τέχνη) falls under the category of things, cult *realia:* temples, altars, statues, pictures, and miscellaneous cult furnishings. From Zeno onward, but with particular emphasis in the post-Posidonian period, under the *realia* rubric, temples[8] and images[9] became the twin allegorical foci. By invoking allegories of temples and images, the apologists were able to represent themselves and their coreligionists as persons who had transcended the common need for *materia vilissima*[10] the vulgar artifices of a materialistic cult. Christians, they argued, worshiped spiritually and rationally, hence for the new religionists temples and statues were just so much pious claptrap.

Of all the early apologists, both Greeks and Latins, Minucius (*Oct.* 32.1–9) gives the fullest, arguably the most artful, and without question the most transparent (Seneca[11] *redivivus*) version of this *topos*. First (10.2), he makes his pagan interlocutor (Caecilius) accuse Christians of promoting a superstition that lacked the external marks of traditional religion: "Why do they [the Christians] have no altars, no temples, no public images [*nota simulacra*]?" The question is a rhetorical foil—it gives Caecilius leave to pronounce a much larger indictment. He interprets his own question, which he represents as a matter of fact, to mean that the new superstition is private and clandestine by intention. Why? Because its deluded devotees engage in cult acts that are shameful (9.2, 7: random copulation), deviant (9.4: phallus worship), and even criminal (9.2 and 5: incest and cannibalism). Naturally, it is important for them to maintain secrecy lest they be found out.

Secondary discussions of this well-known passage, especially of Caecilius' accusation put forward as a question, have been marked by considerable confusion.[12] It is best to restate[13] the obvious: Minucius' Caecilius is a literary invention, conceived solely for apologetic purposes, and the portrayal of Christianity that Minucius attributes to him is a factoid and a caricature. Lest we forget, Severan Latin Christians who were Minucius' contemporaries ate their agape and eucharistic meals off of some kind of material surfaces (probably wooden tables); furthermore, they had ac-

cess[14] to interior spaces where they worshiped, and at the very least in their funerary hypogea, they had their own images. It is true that they generally avoided pagan nomenclature in describing the tables used in their ritual meals and the places where they worshiped: hence, βωμός/ara and ναός/templum intended to denote Christian cult *realia* are mostly absent from the pages of early patristic literature, although exceptions[15] do occur. As for Christian *simulacra,* their existence around the year 200 is a simple matter of fact. In short, the anti-Christian accusation that Minucius gives to Caecilius does not square with the real-life condition of Christians living in Minucius' world.

Minucius makes Octavius respond to Caecilius' accusation with a litany of Stoic commonplaces. Against the charge that Christianity lacked external forms on purpose (because the new religionists had something to hide), Octavius responds (18.8, 32.4) that Christians believed in a God who is invisible. Of course they had no images (32.1)—God had already created his true *simulacrum* in the form of the human person (*homo*). The same is true for temples (32.1) designed to house divinities: how absurd to imagine that humans could contain God within their temples when this very same God had constructed the entire universe (*mundus*), and even it was too small to contain him (that is, the maker is *a posteriori* greater than the thing made).[16] Altars and victims are equally superfluous (32.2–3). The best and purest sacrifice (32.2) involves the offering of one's heart and mind and conscience. Innocence, justice, and care for one's neighbor: these are the spiritual and ethical sacrifices Christians make.

In short, Octavius does away with cult *realia.* His concept of cult is essentially noncultic. It eliminates the necessity of material props to support worship, including one of the central cult objects within traditional Greek religion, namely the sacred image. The interior disposition of the worshiper is all that counts. God lives (32.7)[17] in the mind and heart of the individual and what matters to God is an honest heart (*bonus animus*), a pure mind (*pura mens*), and a clear conscience (*sincera sententia*).[18] To these interior states Octavius joins (32.3) the typically Stoic ethical concerns for justice, the avoidance of evil, and care for one's neighbor—in short, a life of virtue. Thus what emerges is an idealized picture of the perfect Christian who has no need for the traditional external appurtenances of cult.

Mimesis(Μίμησις)

Clement is the only apologist who applies the Platonic doctrine of representation within the attack on Greek art. He does so in order to refute the charge of atheism. He acknowledges the basic Platonic division[19] between a higher world of pure cognition (*noesis*) and a lower world of knowledge based on links to the phenomenal and material universe. Clement puts artistic representation, which he calls the art of visual representation (the *techne* of *mimesis*), at the lower end of the phenomenal world (*ta aistheta*)[20]

corresponding to Plato's realm of shadowy illusions (*eikasia, skiai, phantasmata eikones*).

For Clement the art of visual representation falls under the rubric of *plane:* error, falsehood, fraud, deceit. Art is a lie, a deluding and deceiving *techne*, and in the nonapologetic setting of the *Stromateis* (6.17.147,3) under his discussion of the Eighth Commandment (Ex 20:15) against theft, he even classifies art as a form of thievery, because the sculptor and the painter steal the truth (*aletheia*) from God. Using their mimetic skills, they pretend to make animals and plants, but this false and deceptive appropriation is nothing more than robbery. Within the apologetic setting of the *Protreptikos* Book 4, where Clement attacks Greek art at length, he explicitly equates mimetic *techne* with *plane*, which in his Middle Platonic system belongs to the lower world of *logos doxastikos*,[21] or mere opinion. Truth, by contrast, belongs to the upper world, the noetic realm, which Middle Platonists denominated under *logos epistemikos*,[22] pure or true knowledge.[23]

Clement gives several familiar examples of mimetic error in artistic form: Pygmalion (*Prot.* 4.57.3), who became the victim of his own skill at sculptural representation; birds and horses (*Prot.* 4.57.4), painted in such a lifelike manner that the real animals were deceived (shades of Zeuxis[24] and Apelles);[25] Daedalus's wooden sculpture[26] of a cow (*Prot.* 4.57.6), which infatuated and deceived bullish Zeus and caused the disgrace of both the god and his human mate, Pasiphae. Lastly, he gives the example of monkeys (*Prot.* 4.58.1) too clever to allow themselves to be duped by *agalmata* and *graphai*, and then he asks his reader: do you really want to let it be known that you are inferior to an ape? But it is interesting to note that Clement does not follow his apologetic purposes with consistency: at one place[27] he says that art should be praised, in another[28] he admits the existence of "the form of the beautiful," and in still another passage he concedes that Lysippus and Apelles had succeeded in enveloping mere matter (ὕλη) in the "form of godly glory."[29]

But overall, like Origen,[30] Clement follows the Platonic model, and both Alexandrians deliver a message that is clear and transparently Platonic: mimetic art, especially art purporting to represent divinity, can only reproduce the phenomenal and material world of appearances, shadows, illusions, deception. *Mimesis* of this world is necessarily a lie. It distorts the truth, hence it is evil. People who worship *techne* of this sort become so engrossed in it that it can cause their own ruination: Pygmalion is the classic example, that hapless sculptor who did such a good job of deceptive *mimesis* that he ended up eternally frustrated, wanting to make love to a piece of stone. Men like Pygmalion only perpetuate the lie—they distort and calumniate[31] the truth. But Christians refuse to be seduced; they recognize artistic *mimesis* for what it really is and, in doing so, they reveal themselves as the superiors of those pagan fools who worship representational images. In sum, for refusing to submit to the blandishments, the meretricious power of visual *mimesis*, Christians should not be condemned as atheists but instead commended as sages.

Antianthropomorphisms (and Euhemerism)

In responding to the charge of atheism, the apologists invoked both anti-anthropomorphic and Euhemeristic arguments, but of the two only the former appears within the literary context of their attack on art. Both arguments relate thematically to Platonic *mimesis* doctrine. The anti-anthropomorphic[32] argument had a long pedigree—its origins are to be found in the east Aegean during the sixth century. Xenophanes is the major spokesperson. Proponents of the antianthropomorphic point of view insisted that God's *morphe* or form was not like that of humans. And Euhemerism,[33] named after a late fourth-century Peloponnesian novelist, promoted the idea that the gods were nothing more than great men, typically kings and benefactors, whom posterity had deified.

The significance of both arguments for art is clear. Hellenic sculpture and painting habitually represented gods and goddesses as men and women, a conception that antianthropomorphic critics found naïve, morally offensive, undignified, and epistemologically wrongheaded. As for Euhemerism, if the gods are nothing more than deified humans, then it follows that their representations in sculpture and painting amount to little more than fanciful mementos of dead men. But this latter argument plays a very minor role in the earliest Greek apologists' attack on Hellenic religious art as a response to the charge of atheism. Antianthropomorphisms, by contrast, are given an important role both in Clement and in Origen.

Clement knew the famous Xenophanic antianthromomophisms, about the mythographers[34] (Homer and Hesiod) who attributed unethical behavior to divinity, about animals[35] who if they could draw would represent animal-like gods, and about Aethiopians[36] and Thracians who represent their gods respectively with flat noses and black hair or grey eyes and red hair. The first imputes to image worshipers an endorsement of immorality; the second and third allege reductionism. But the most important single antianthropomorphic dictum explicitly condemning the visual representation of divinity in human form is the saying that Clement attributes to the Cynic Antisthenes: "God is like no one, and on account of this fact no one can know him through an image [ἐξ εἰκόνος].[37] In this context *ex eikonos* must mean not just any image, but a figural image, one intended to represent a god or goddess in human form.

At the beginning of his long attack on Greek art in book 4 of the *Protreptikos*, Clement illustrates what consequences this antianthropomorphic theory has for history. He sketches a familiar primitivistic[38] notion of cultural evolution: at the beginning of human time, certain cultures worshiped divinity in nonfigural images (*xoana*);[39] the transition to the worship of figural images (*brete*),[40] which involved the introduction of an outwardly pleasant (specious) but malicious art (*techne*), brought the onslaught of error (*plane*).[41] Statues resembling humans (*agalmata andreikela*) falsify[42] the truth.

Celsus, who was Clement's pagan contemporary and shared his world view, also opposed the anthropomorphic representation of divinity. He rejected the notion (Gen 1:26 and 27) that God made man in his image on the grounds that this implies a formal similarity between God and humans: "Nor did he make man his image; for God is not like that, nor does he resemble any other form at all."[43] In order to stress God's transcendence Celsus confirms a very un-Hellenic notion preserved at *Phaed.* 247C, namely that God (whom Plato calls οὐσία ὄντως ὄυσα, "really real being") has no form (or color)[44] whatsoever. As to consequences for real life, one would expect opposition to all sacred images, figural or otherwise, but if we are to believe Origen, this is evidently not the position Celsus took. As an accommodation to popular piety and public perceptions, and in the interests of maintaining traditional public cults, many pagans who like Celsus believed that God could not be represented in human form also were convinced it was a person's civic and public duty to worship anthropomorphic cult images. The Stoics[45] in particular upheld the legitimacy of participating in outward acts of public piety performed in the name of traditional religion, even if one's interior attitudes and spiritual disposition were in conflict.

In responding to Celsus, Origen[46] rejected the legitimacy of this distinction if and when it involved a real conflict of values. And it was clear to Origen that image worship was precisely such an occasion. It was wrong, he argued, for the philosophical person who knew God's form was not anthropomorphic to pretend that he was addressing God in prayer by venerating a statue formed in the image of a man or a woman. This kind of accommodation to public perceptions and popular piety amounted to the endorsement of a lie, and Origen argued there was no room in the soul of the truly religious person for sham and deception. Those who granted an external or outer semblance of reverence to images while simultaneously on the inside withholding honor were pious liars. In public they conveyed one idea of divinity, whereas in private they held another. Unlike Celsus and his duplicitous comrades, Origen insisted that Christians refuse outright all worship of statues of gods and goddesses in human form because they conveyed a false idea of divinity.

Aniconic Societies

Yet another dimension of the apologists' response to the charge of atheism involved their self-portrayal under the umbrella of a familiar primitivistic[47] commonplace that was widespread in antiquity. This involved the proposition that many cultures had once been aniconic, meaning that in their pristine state of infancy they lacked visual images (both nonfigural and figural) of divinity. Clement, for example, embraced a version of primitivism that subscribed to three traditional criteria: chronology, culture, and nature. Under the latter two he propounded the familiar Stoic antithesis between nature (*physis*) and culture or art (*techne*). Aristotle (*Phys.* 194a 21)

gave the *topos* its classic definition: nature is something that exists without human effort or contrivance, whereas its opposite, culture or *techne*, is artificial and made by humans. The underlying primitivist presumption, promoted in antiquity especially by Cynics and Stoics, is that all civilized cultures were once better off in their original simplicity, their unevolved and natural state, than they are enmeshed within the complexities of civilization and its myriad discontents. To many Greeks and Romans aniconism was one of the unmistakable signposts heralding a better time and place in the distant past.

Varro[48] thought, for example, that for more than 170 years after the founding of the Roman state the Romans had worshiped their gods "sine simulacro." This he believed was Rome's golden age, a time when life was simpler, purer, and more natural, a time when Romans were able to approach divinity directly without recourse to the artificial contrivances that had come to clutter up Roman religion in Varro's day. Sacred images, statues, and paintings of divinities, he thought, were prime examples of cultic obfuscation, religious clutter, and claptrap.

The earliest Christian apologists simply appropriated this common-place and did so, once again, in response to the charge of atheism. In so appropriating these traditional materials they were able to represent themselves and their cohorts as reformers and paradigms of old-time religion, pure and unsullied, simple and natural. Christians worshiped God in a direct and natural manner, hence they had no need for the cultic tinsel that encumbered traditional Greco-Roman religion. Christianity represented a return to an earlier and better time, a more natural and pristine state of human evolution, a time and place free of the artificial and muddled contrivances that cluttered up Greco-Roman culture. Naturally, cult images constituted one of the mainstays of this apologetic appropriation.

Clement, Tertullian, and Origen are the major early apologetic proponents of this primitivist *topos*, but of the three Clement is clearly the most important. For Near Eastern culture he repeats the familiar (Herodotean) aniconic portrayal of the early Achaemenids,[49] and he portrays the Lydians in Anatolian Sardis and the early Syrians in Damascus within the same light. Among nomadic cultures (a favorite Sophistic *topos:* the merits of the desert versus those of the city)[50] he mentions Arabs[51] who worshiped an unworked stone (*lithos*/βαίτυλος)[52] and Scythians[53] who supposedly once worshiped a dagger. Clement also knew the Varronian (Stoic) tradition that represented the early Romans[54] as worshiping aniconically.

In addition to these examples which draw on the more exotic ethnographies, Clement also recounted Indo-Europeans closer to home. He mentions by name the existence of aniconic cults at three early Greek[55] sites: Ikaria, Thespiae, and Samos. Like Origen, he also knew the anti-banausic saying[56] attributed to Zeno concerning his ideal commonwealth (a natural place) in which there were neither temples nor *agalmata*, but unlike Origen Clement did not rehearse this tradition in an apologetic setting. At *Cels.* 7.62–67 Origen added traditions concerning Libyan no-

mads, Seres, and Persians, all of them primitivist exemplars of aniconic worship.

In its intention the *topos* is transparent—it amounts to a kind of "nostalgie de la primitivité," and there is little more that needs to be said about the apologists' appropriation of this commonplace. For refusing to worship cult images, Christians had been accused of being atheists. A ready-made, primitivistic commonplace exalting the virtue of aniconism provided the apologists with an ideal and indeed an obvious response: the new religionists refused iconic worship not as a sign of their atheism but as proof of their primitive religious vitality. It is as if Christianity represented a kind of atavistic resurgence of aniconic natural religion, which had been temporarily smothered by the artificial contrivances of Greco-Roman religiosity. Belief in an aniconic state of innocence was deeply rooted in the culture to which the apologists made their appeal, and hence their appropriation of this *topos* is best described as a clever ploy.

Hylotheism

The term denotes an epistemological error: the mistaken identity of God with *hyle*,[57] or matter. In their response to the charge of atheism, the apologists also imputed hylotheism to their enemies. Art (especially statuary) occupied the center of their argument. "Hylotheism" is purposely critical and patronizing—it was popular, for example, among Victorian churchmen who felt the urge to missionize among the savages. The Lord Bishop of Calcutta, Reginald Heber, etched the hylotheistic concept indelibly into the European popular imagination with the last stanza of his famous hymn:[58]

> In vain, with lavish kindness
> The gifts of God are strown;[59]
> The heathen[60] in his blindness
> Bows down to wood and stone.

A hylotheist might be described as a person who lacks the capacity for abstraction, a person who either cannot or will not distinguish between divinity and its embodiment in matter. Roughly the ancient equivalent of hylotheism is Prodicus'[61] theory of the origins of religion, whereby early humans were said to have first worshiped the things of nature that were beneficial to their survival. Precisely because it is critical and patronizing, hylotheism is, I think, the right term to describe the apologists' caricature of their enemies as fools worshiping sticks and stones. Of the apologists' five art-related responses to the charge of atheism, this one is the most widely attested. Furthermore, this argument provides a strong theoretical justification for iconoclastic behavior, in this case defined as the Christian destruction of pagan art; hence it had long-term historical implications.

The apologists used hylotheistic arguments illustrated by statues and paintings exclusively in a relational and definitional sense—namely, to

contrast what God is with what God is not. This point needs to be underscored. Unlike Numenius, Valentinus, Basilides, the anonymous compilers of the *Hermetica*, Plotinus, and Iamblichus, the apologists exhibited little interest in exploring the popular second/third century dualism that pitted a good God against evil *hyle*. The apologetic exposé of statues as sticks and stones was not an antimaterialistic argument per se, and the philosophy of matter as well as the problem of embodiment in matter were not their concerns, as least not in the context where they were attacking Greek art. In this latter setting they used hyle as a relational epithet to describe things, like statues and pictures, that are dissimilar to God.

The first of the apologists' hylotheistic "proofs" concerned King Amasis of Egypt (Ahmose II, 570–526 B.C.) who according to Herodotus (2.172) made a dramatic career change, from court chamberlain to king. In telling Amasis' story, Herodotus singled out for special attention the king's golden basin in which he and his men "washed their feet, pissed, and vomited." Amasis ordered the basin to be recast as a statue of one of the gods, and this became Herodotus' vehicle for allegorizing the king's rise from obscurity to preeminence.

Several early Christian apologists[62] either recited the tale verbatim or alluded to it, but all of them drew a lesson very different from Herodotus'. What the apologists saw in this story was an exposé of hylotheism: the worship of befouled matter, Seneca's[63] "materia vilissima" in one of its nastiest incarnations. Literarily what is at stake in this Herodotean tale is a transformation story, an allegory based on a metamorphosis: from slop basin to sacred statue, from chamberlain to king.

Theophilus[64] flatly rejects the literary premise: the essential character of sacred images remains identical before, during, and after the transforming event. Nothing changes. The statue continues to be a lump of stone, metal, or wood, mere matter (*psilos hyle*), inert and dead, worthless as a vehicle intended to disclose divinity. Metamorphosis[65] is chimerical. Stupid workmen lavish elaborate *techne* on inert matter, but in Athenagoras' words[66] this is much ado about nothing, futile and superfluous workmanship, which says nothing about God. The entire religious art of Hellas is so many piles of dead and inert matter, "stone, metal, wood, pigment, or some other material" (*Autol.* II.2).

Relying on an unknown doxographic source (perhaps Philodemus), Athenagoras[67] and Clement[68] also invoke the example of Diagoras,[69] a famous fifth-century philosopher from Melos. Diagoras wrote lyric and dithyrambic verse,[70] but posterity remembered him primarily as *atheos* and *theomachos*. Greeks viewed him with the same suspicion and disdain as they did Alcibiades, and for the same reason: the Melian had not only the audacity to reveal parts of the Eleusinian mysteries but also the irreverence to satirize what he revealed. Apollodorus dates the psephism[71] outlawing Diagoras to 415–414, and in later Hellenistic catalogues[72] of famous atheists (for example, the *Peri atheotetos*[73] of Clitomachus-Hasdrubal of Carthage), Diagoras's name occupies a prominent place. Greeks remem-

bered Diagoras as a skeptic, a scoffer, an impious man, an atheist. But the Christian apologists viewed him in a different light.

One of the tales associated with Diagoras a story that comes to us in variant fragments but is rendered in its most plausible reading[74] by a twelfth-century scoliast to Aristophanes' *Clouds*, represents Diagoras as a guest at a banquet prepared by another philosopher. The host steps out to attend the call of nature, and in his absence Diagoras sees the fire going out under the evening's meal, a pot of beans (lentils: the host is a Cynic). Diagoras then picks up a wooden statue (*agalma*) of Herakles, smashes it to pieces, and tosses it on the fire, adding these words of wisdom: "the godlike Herakles now has completed the thirteenth in addition to the twelve other labors."[75] On the face of it, this anecdote was designed to underscore what everyone already knew about Diagoras: he was an impious, impertinent fellow who deserved all the nasty epithets posterity had heaped upon him. He treated the statue with the same irreverence as he did the Eleusinian mysteries, as if the former were nothing more than a lowly piece of wood to be tossed on the fire and forgotten.

Naturally, the earliest Christian apologists interpreted the story as evidence of Diagoras' good sense. Far from being a villain, he should be commemorated as a hero. Diagoras recognized the statue for what it was, a mere piece of wood, and he had the good sense not to confuse divinity, which is uncreated and eternal with *hyle*, which is created and perishable.[76] This is the apologists' revisionist reading of the Diagoras anecdote. They rehabilitated him from the status of miscreant to hero—he becomes one of their own kind, a precursor of Christian wisdom, the man who refused to succumb to the hylotheistic nonsense of Greek image worship.

Prodicus[77] of Keos is yet another Greek authority whose ideas the apologists appropriated in their effort to refute the charge of atheism and to countercharge with hylotheism. As noted previously, he is credited with the invention of a naturalistic theory (not unlike the so-called *Naturmythologie*[78] of Schwartz and Müller) concerning the origin of religion. According to Sextus (*Math.* 9.18), Prodicus wrote that "The ancients considered as gods the sun and moon, rivers, springs, and in general also the things that assist our life, on account of the help they give, just as the Egyptians deify the Nile."

Sextus included in his paraphrase of Prodicean theory the claim that worship of Demeter, Dionysus, Poseidon, and Hephaestus was really nothing more than the worship of bread, wine, water, and fire. In other words the gods were simply invented personifications corresponding to benefits conferred by mother nature. For the apologists the recitation of this Prodicean teaching became a convenient tactic for using Greek tradition against itself. It was a method for demonstrating that traditional Greek religion was really nothing more than a version of hylotheism, the worship of grain personified in the Demeter cult, of wine in the Dionysus cult, and so on.

Several of the earliest apologists capitalized on Prodicean teaching,

but only Clement[79] in the *Protreptikos* put this *reductio ad materiam* to work in the literary setting of the attack on Greek art and for the purpose of exposing pagans as hylotheists. To the charge that Christians were guilty of atheism, Clement[80] snaps back that the real atheists are the ones who first worshiped earth and water. From the former arose the worship of gods imaged in stone and wooden statuary, and from the latter came images of the god Poseidon, whose name (based on a lame Stoic etymology) Clement derives from the Greek *posis*.

In support of their hylotheistic argument, Clement[81] and Origen (quoting Celsus)[82] also enlisted the famous *logos*[83] attributed to Heraclitus:

> They [homicides] cleanse themselves by staining themselves with fresh blood [a pig was the common sacrificial victim] as if a man who had fallen into a dung heap were to cleanse himself with manure; he [the homicide] must seem a madman to anyone who understands what he is doing.[84] And they [priests] pray to such images of gods as these, as if a person were to talk to a building. They have no idea what gods and heroes are [really] like.

The *logos* has two subjects, sacrificial purification of blood guilt and prayer to statues. Both are cult acts, but beyond that fact they have little in common. Heraclitus joins them in order to expose the foolishness of popular religion. The person who submits to a purification rite of this sort should be compared to a pig rolling about in its droppings, and the one who imagines he can communicate with God by praying to images is like a lunatic babbling to the bare walls of a room. Neither has the foggiest idea of God's true nature. Clement comments[85] sarcastically on the second half of the Heraclitean *logos:* are they not amazing, these stone worshipers, these people who put their trust in insensate, inert, motionless, dead *hyle?* Origen responds[86] that Christians refuse to worship what are purported to be divine images because God is invisible and incorporeal, and in another place[87] he exhibits a strong aversion to what he regards as the degrading practice of reducing divinity to *hyle:* here he specifically mentions altars and images (*agalmata*).

Clement[88] also draws the comparison between Niobe[89] and Lot's wife (Gen 19:26): two unfortunate wretches noteworthy for having been metamorphosed, Tantalus' daughter on Sipylon into stone, the Sodomite woman at the south end of the Dead Sea into a pillar of salt (Clement instead turns her into stone, which underscores the congruity of Hellenic and Sodomite error). Both women, writes Clement, were transformed into a state of insensibility (*anaisthesia*), which is the inevitable condition of those impious and hardhearted persons who worship *hyle* rather than God. Sodomites and Hellenes who worship dead and stony statues run the risk of becoming like the things they worship—a theme that is richly attested not only in Greek but also in Jewish[90] tradition, a theme the apologists found ripe for the plucking. Clement exploited it extensively, as did in

lesser degree Theophilus[91] and the anonymous epistolographer who addressed Diognetos.[92]

This message is a familiar one, particularly to students of exilic and postexilic Judaism:

> Yahweh, your name endures for ever!
> Yahweh, your memory is always fresh!
> Since Yahweh indicates his people,
> and cares for those who serve him;
>
> whereas pagans' idols, in silver and gold,
> products of human skill,
> have mouths, but never speak
> eyes, but never see,
>
> ears but never hear,
> and not a breath in their mouths.
> Their makers will end up like them
> and so will anyone who relies on them.
> (Ps. 135:13–18)[93]

By comparison with God, who is a powerful, living being and who gives life to all things, the pagan gods are puny nonentities—they are dead and lifeless things, inert matter, and persons who worship them are bound to become like them.

Clement[94] reminds his reader that Pheidias, Polyclitus, Praxiteles, and Apelles were vulgar mortals and "mere earthly workers in earthly things" (γηίνοι γῆς ὄντες ἐργάται), and that the things they made, their images, were also of earth, hence dead, insensate, and lifeless. God is the only real artist, indeed he is the "master artist" (ἀριστοτέχνας)[95] writes Clement, and God alone is capable of bringing forth a living image, which he has done in the Logos and in the creation of humans who are in the image of the Logos. By contrast, Olympian Zeus, also the image of an image, was deaf and dumb, senseless and dead. Clement plays this theme with numerous refrains throughout the *Protreptikos*: Greek gods are ψιλὸς ὕλη, and people who, like Niobe and Lot's wife, worship these gods or their equivalents put their lives at risk—they are in danger of being metamorphosed into stony-hearted silence.

Finally, the last and without question the most charming of the apologists' hylotheistic commonplaces: the comparison of great works of art with tiny animals, Pheidias' Zeus contrasted with an oyster. This too is traditional material. The sources of the *topos* are two: Aristotelian-Peripatetic zoology[96] and Menippean-Lucianic satire. The little bit that Clement knew about oysters[97] came from the former. The mollusk is a relatively simple organism—its sensory apparatus is unevolved, and it occupies a relatively humble place within the phylogenetic tree. Clement reports correctly that it cannot see, hear, or make sounds. And he adds to these matters of fact the commonly held belief[98] (derived from Stoic

"cosmozoology")[99] that the bodies of mollusks swell and shrink in sympathy with the phases of the moon.

But Clement is quick to point out that for all its simplicity, the oyster is still a living organism. It grows and moves and even undergoes bodily change in relation to lunar mensual cycles. This he writes is a great deal more than can be said for the art that pagans worship. It is nothing more than dead and inert matter. In a contest to find symbols that exhibit a positive and sympathetic relationship to divinity—symbols that, however inadequate (or inappropriate: ἀπρεπής) they may be, still bear some positive relationship to God—Clement (closely paralleling Plutarch)[100] informs his reader that even on a moonless night the lowly oyster beats Pheidias' Zeus hands down.

The apologists compare mollusks, annelids, arthropods, rodents, and birds with Greek art. It is not zoological taxonomy but popular perception that holds together this motley menagerie—what these organisms are supposed to have in common is their lowly status as phyla. The literary precedents for drawing the comparison were well established. The best-known examples were the late Hellenistic, pseudo-Homeric *Battle of the Frogs and the Mice* along with the Lucianic exposé[101] of Olympian Zeus as an ineffectual weakling. For the Latin apologists, Horace[102] provided churlish hexameters (Menippean in inspiration) celebrating the impotence of a wooden Priapus incapable of defending itself against a squadron of bombarding ravens. The apologists repeat this conceit in variant forms, and the message remains constant: sacred images are dead and inert matter. They can do nothing even in their own defense. They must be kept under lock and key.[103] Even the lowliest organisms—oysters, worms, and insects—resemble divinity, whereas the most exalted and celebrated Greek statue bears no resemblance whatsoever.

Parenthetically and by way of conclusion, a brief defense of pagan practice is apposite. From start to finish the apologists' hylotheistic argument amounts to a *reductio ad materiam*, as if a statue were nothing more than the material from which it was made. This is absurd. The argument completely ignores the long-standing Greek exegetical tradition of interpreting images symbolically. It does not follow that the pious Greek or Roman who prayed to a statue was worshiping its stone or metal or wood. At the end of the period under discussion, Porphyry put it best:

> It is no wonder that those who are complete ignoramuses regard statues [ξόανα] as mere wood and stone, just as those who are ignorant of letters look upon inscribed markers [στήλας] as nothing more than stones or upon writing tablets [δέλτους] as nothing more than pieces of wood or upon books [βίβλους] as nothing more than papyrus woven together.[104]

In short, those who look at a statue and can see nothing more than a lump of stone are like the illiterates who look at writing and see nothing more than the wood or papyrus surface. Those who cannot "read" an image are just as ignorant and stupid as those who cannot read letters. The

earliest apologists knew full well that pagan cult images were intended as symbols[105] and that those who worshiped such images saw more in them than just their material properties. But in order to pursue their argument exposing the stupidity and perversity of their enemies, it was important that the apologists suppress the symbolic character of pagan religious art. And suppress it they did.

Superstition

Pliny,[106] Suetonius,[107] and Tacitus[108] labelled Christianity a *superstitio*[109]—they would not dignify it with the name *religio*.[110] We do not know the precise content of their meaning, but probably they meant to imply that Christianity was built on a combination of empty-headed fear (*timor inanis*) and irrationality, mental and emotional instability (Plutarch's *pathos*),[111] credulity,[112] and stupidity. The accusation rankled and endured: the apologists took it seriously, which perhaps means they feared there was some truth in it. They responded in the characteristic manner, on the one hand praising themselves and their coreligionists for practicing a philosophical and rational brand of *religio*, on the other hand satirizing their enemies for their blatant and gross *superstitio*, evidenced especially in cultic contexts. Art plays a role in both parts of this response, but it is central to the second, the apologists' satirical exposé of pagan cult. Religious statues constitute the literary centerpiece that sustains this half of the argument.

As for the first half of the apologists' response, the previous discussion in the section on cult applies equally to the charge of superstition as to atheism. By enlisting Stoic allegory of cult the apologists were able to show that their refusal to participate in public worship was something other than what it appeared to be, namely an expression of atheistic belief. Octavius' response to Caecilius eliminates real cult altogether. What comes to take its place is a philosophical and ethical attitude, an interior disposition, a matter of the mind and heart. Rituals and ceremonies disappear altogether and are replaced by interior states and ethical acts. Since cult is the common setting within which superstitious people reveal their true colors, this spiritualized portrayal of Christian worship functions as a rebuttal to the numerous caricatures of Christians engaging in the grossest forms of cultic superstition, including ritual homicide, cannibalism, and incest. The Christians whom Octavius represents are men and women who worship God in mind and heart, persons characterized by nobility of spirit, refinement of intellect, purity of intention. If superstition is known by the company it keeps, this clearly is the wrong association—Octavius' Christians are at the farthest conceivable remove from superstition.

But the real thrust of the apologists' response to the charge of superstition consists not so much in their encomiastic self-portrayals as in their vituperative satires of their enemies and, in particular, of their antagonists at worship. In the apologists' counterattack, it is pagan cult that consti-

tutes the perfect paradigm of what superstition is all about. And art is at
the center of this degrading charade, functioning in the role of what Ter-
tullian[113] called the "material occasion" (or means) for the performance of
idol worship. Viewed semiotically, religious images in general and cult
statues in particular trigger the apologists' exposé of pagan popular religion
as gross and superstitious mummery. This is not to suggest that the apolo-
gists believed superstition could not exist without cult images—
Tertullian[114] for one made it clear that there was more to idolatrous forms
of superstition than just the worship of images. At the same time, one
must admit that without the example of cult statues the apologists' attack
on pagan superstition would have been far less juicy.

In unmasking the superstitious underbelly of pagan cult, the primary
connection the apologists pursued was between cult images and *daimones*.
Athenagoras (26.1–27.2) puts it thus:

> It is these δαίμονές who drag men to images [*eidola*]. They engross them-
> selves in the blood from the sacrifices and lick all around them. The gods
> that satisfy the crowd and give their names to the images, as you can learn
> from their history, were once men.

> The activity associated with each of them is your assurance that it is the
> *daimones* who usurp their names. . . .

> These movements of the soul [τῆς ψυχῆς κινήσεις: produced by contact
> with supposedly wonder-working *agálmata*], not directed by reason but by
> fantasy in the realm of conjectures, give birth to illusions which bring with
> them a mad passion for idols [εἰδωλομανεῖς]. When the soul is weak and
> docile, ignorant and unacquainted with sound teachings, unable to contem-
> plate the truth . . . the *daimones*, associated with matter [περὶ τὴν ὕλην],
> because they are greedy for the savor of fat and the blood of sacrifices, and
> because their business is to delude humans, take hold of these illusory
> movements in the soul of many, and by invading their thoughts flood them
> with fantasies produced in the mind, illusory images which seem to come
> from the idols and statues. . . .

At issue here is the existence of malevolent spiritual beings[115] that are
thought to be incomplete and hence imperfect, the so-called *daimones*.
They operate invisibly in the material world over which they exercise
direct control, indeed Athenagoras calls their chief "the king [*archon*] of
matter [*hyle*]."[116] Cult statues satisfy three of their needs, the first for a
personal identity and hence a personal name, the second for a body, and
the third for sustenance. Exploiting Euhemerism, Athenagoras imagines
that the *daimones* appropriate the names of divinized men and that these
names somehow become identical with cult images. Tertullian[117] carries
the theory farther by suggesting that at the moment of consecration a
bonding takes place between the name of the dead man, the image, and
the usurping *daimon*.

As to the need for a body, again it is Tertullian[118] who makes the
connection explicit: images function as the bodies of *daimones*, so that the

relationship between the body and the soul in a living person is paralleled in an ensouled image by the relationship between the material thing (stone, wood, metal, bone) and the *daimon*, which at the moment of consecration becomes its animating principle.

As for food,[119] on principle spiritual beings like *daimones* ought to need none, but in especially the Middle Platonic framework (Plutarch and Apuleius) theorists imagined that they had bodies, and this then prepared the way for the apologists' common conviction that *daimones* lusted after blood and gore. The latter, the remaining morsels of sacrifice, *daimones* found bespattered across the bodies of cult images, and, as Athenagoras reminds us, it is here that they were able to sate their ghoulish appetites.

The effect of image worship on devotees is disastrous. The *daimones* cause endless human suffering both in body and in mind. For Athenagoras it is primarily the latter. Plutarch's *pathos*[120] (emotional and mental instability feeding on *phobos*) is very much in evidence here. The *daimones* prey on weak, docile, irrational, licentious, and ignorant victims—as Justin[121] remarks, such persons are the primary prey of *daimones*—and the best defenses against *daimones* are a life led philosophically, purity of heart and mind, and freedom from passion and emotion. The *daimones* play on fantasy, and they stimulate illusions of the mind. They infect and possess their victims, bringing about their complete physical, mental, and psychological collapse.

The only element Athenagoras omits is the act of consecration, the ensoulment (*empsychosis*)[122] of the cult image, in this case the *daimon*'s penetration (*eiskrisis*) into the body of the image. Tertullian[123] and Minucius[124] amply compensate Athenagoras' omission. The two Latins satirize at length the concept as well as the act of consecrating pagan cult images, underscoring the absurdity of those who rely on a priestly action (*praxis*) to bring a god into being. At the moment of consecration, priests or magicians[125] invoked the *daimon* which they believed would bond with the body of the image, thereby bringing into being a divinity incarnated in a material form, a *daimon* inhabiting a cult image. Although the apologists ridiculed this act of priestly hocus-pocus, nonetheless like Athenagoras (*Leg.* 26.3–5) who discussed the possible efficacy of certain healing images, they did not deny altogether that some images might become ensouled and animated by evil *daimones*. Images in this category were judged to be especially dangerous,[126] hence to be avoided at all costs.

— Thus, in summary, responding to the charge that Christians were the dupes of a mindless and wicked superstition, the apologists produced two kinds of counterarguments. Both arguments emphasized cult as the most likely setting in which superstition would raise its ugly head. In the first half of their response the apologists invoked Stoic allegorization of cult, thereby portraying themselves and their coreligionists as persons who worshiped spiritually and rationally without the slightest taint of superstition. The absence of cult images from Christian worship was adduced as proof of their true and pure piety.

The second half of their response, which really occupied the bulk of their attention, concentrated on the use of cult images in pagan worship. The point was to equate the worship of statues with the worship of evil spirits. *Daimones* were said to promote their own worship by preying on the hearts and minds of their deluded devotees. This the apologists argued was δεισιδαιμονία/*superstitio* at its worst, the worship of gross, dirty, and disgusting matter, which was inhabited by inhuman, ungodly, malevolent spirits. Those foolish enough to participate in superstition of this sort became paralyzed and unhinged. Workmen fabricated images and priests consecrated them so that *daimones* could penetrate the images and bond with them, thereby achieving an individual identity and a real material body from which they could wreak havoc on their unsuspecting victims. In short, on the apologists' reading of this subject, pagan image worship provided the classic paradigm of superstition run riot, motivated by fear, sustained by excess and credulity, causing the complete spiritual, mental, and physical ruin of its victims.

Sexual Misconduct

The apologists also responded to this third accusation by invoking the attack on Greek art. Guilt by association was the essence of their counterattack. Greek art, they argued, immortalized gods and goddesses noteworthy for their flagrant disregard of accepted sexual mores, and therefore the people who worshiped images of these miscreant divinities revealed their true stripes as devotees of lechery. To the charge of Christian sexual immorality, the apologists responded in the predictable twofold manner: they portrayed themselves and their coreligionists on the side of the angels and their enemies in the gutter. Art, especially Greek religious sculpture, enters the argument only in the second half of their response, wherein they recite the *chronique scandaleuse* of mythopoetic religion.

In the ancient world (as in more recent times) art and sex were old friends. Evidences of their intimacy are abundantly attested in European and Near Eastern prehistory and as well in virtually all subsequent periods of Indo-European and Semitic history. Ancient divinities were gendered, and much of their story, transmitted to us in word and picture, recounts tales of sexual awakening, of potency and fecundity, and of amorous couplings between gods and goddesses as well as between divinities and humans. Visual symbols of sexually defined divinities are particularly conspicuous beginning in the Aegean and Near Eastern Bronze Age, and they or their derivatives persisted through the Iron Age into the later historical periods in virtually all the civilized environments of the ancient world, from the Ganges to the Aegean.

Along the Syro-Palestinian littoral, no doubt from the beginning of the monarchy, Israelites objected to indigenous Canaanite myth on the grounds of its sexual content. They also opposed the representation of sexually defined divinities, in particular Astarte[127] and her Baalim con-

sorts. In the eastern Aegean during the sixth century a similar ethical opposition to mythopoetic religion took root. Its earliest surviving expression is preserved in a fragment of Xenophanes' lost *Silloi:* "Both Homer and Hesiod have attributed to the gods all things that are shameful and a reproach among humankind: theft, adultery [μοιχεύειν], and mutual deception."[128]

Xenophanes identifies adultery by name as one of the ethical deficiencies that made the early Greek conception of divinity *aprepes:*[129] inappropriate, unseemly, and unfitting. Other Greek rationalists and moralists who followed in this tradition took a similar critical position, and many of them drew attention to the sexual irregularities attributed to the divinities recorded by the Hellenic mythographers. In the *Protreptikos*[130] Clement cites three Greek writers (Menander, Homer, and Euripides) who had already exposed the gods as frauds—in *Hercules Furens,*[131] for example, the tragedian unmasks Herakles as a moral midget, a drunkard, a glutton, and a madman. In his vision of the ideal state, Plato[132] had urged the guardians to bury Homeric and Hesiodic myth in a blanket of silence: it were better if innocent and impressionable children did not hear the stories of divine adultery, incest, pederasty, bestiality, and rape.

In short, both Israel's criticism of Canaanite myth and, more important, Greek rationalist criticism of Homeric and Hesioidic myth provided the earliest Christian apologists with a ready-made arsenal of antimythopoetic arguments based on sexual subjects. The apologists simply appropriated the Greek tradition of ethically inspired criticism and turned it against their enemies. Christians had been accused of sexual improprieties, but this, argued the apologists, was ludicrous coming from people whose religion and culture was permeated with paradigms of gods and goddesses behaving as guttersnipes. If the gods were real people, decency would require that one shun them and justice that they be exiled, imprisoned, or executed. Their behavior was an outrage. Greek art did nothing but glorify the insult, parading before the public in the name of religion a warren of salacious and debauched deviants.

The most important single contribution to this genre of apologetic *psogos* is Tatian's remarkable invention (*Or.* 33–34) of a sculpture gallery exhibiting twenty-nine immoral Greek females and seven immoral Greek males. This incredible rogues' gallery may be Tatian's response to a slur (*Or.* 33.1–5) on Christian women. It contains a little of something for every imagination, and it is unusual on several counts, perhaps most importantly for its broad cast of characters (divinities, historical personalities, politicians, poetesses, prostitutes, housewives, invented nonentities) and its equally indiscriminate mix of imputed crimes, pecadilloes, and indiscretions. Like much of his apology overall, Tatian's *Glyptothek* is a hodgepodge in which he condemns the entire dramatis personae for their sundry immoralities, with particular emphasis on the sexual realm. The Assyrian sophist's unholy *Glyptothek* deserves a fuller discussion, but not here.

Otherwise, the material that the apologists rehearsed to expose the sexual underbelly of mythopoetic religion and to indict image worshipers has a traditional ring. Clement has an interesting aside[133] (which may have some basis in fact) about boudoir gymnasts who painted dirty pictures (Philainian[134] σχήματα) on their bedroom walls. He (like Tatian) delighted in quirky Phlegonian[135] stories, for example the Kafkaesque tale of a lady (Eurymedusa)[136] who bedded Zeus in the form of an ant and who for her trouble became the proud mother of an antling humanoid (Myrmidon). Tatian's Glaucippe,[137] who took her pleasure in larger (elephantine) doses, is her antipode. These tales of *prodigiosi partuus* are traditional (Phlegonian) material. Equally traditional for the *chronique scandaleuse* of Greek myth are the catamites (Ganymedes, Antinous), the adulterers (Ares, Aphrodite), the pederasts (Zeus, Apollo), the rapists (Zeus, Herakles, Castor, Polydeuces), the mutilators, sexual and otherwise (Rhea, African Saturn, Gallic Mercury, Bellona, Kybele, Jupiter Latiaris, Artemis), the bestial players (Leda and her web-footed friend, Pasiphae and bullish Zeus), the perpetrators of incest (Zeus), and the harlots (Aphrodite, Helen). The moral is simple: what decency can one expect from people who worship statues glorifying monstrous gods and goddesses like these?[138] So much for the charges of sexual impropriety launched against Christians.

— Summary

This concludes our brief overview rehearsing the contents of the apologists' attack on Greek art. A great deal more could be said in detail, but the major contours are clear. The attack on Greek art is a purely apologetic device, which serves up an idealized portrayal of the new religionists. They are made to come across as philosophical theists, ethically impeccable, epistemologically correct, rationally committed to philosophical aniconism and, beyond it, to the highest philosophical and religious principles of life and worship—they eschew superstition and, in every conceivable degree, they exemplify true religion.

At the same time, the content of the apologists' attack on Greek art represents the enemies of Christianity as depraved and deranged fools who lack the most elementary ideas of what God is and of how God should be worshiped. These enemies are vicious savages, stupid, confused, immoral, and utterly immured in the muck of a degrading and evil superstition centering on the worship of images infected by *daimones*.

It goes without saying that both of these caricatures are apologetic conceits. Both build on real life but distort it to such a degree that actual conditions are barely recognizable, if at all. The major real-life issue that still confronts us here is to determine what Christians thought about art (and specifically art to be used in Christian contexts) during the second and third centuries of the present era. We now have a sense of what the

apologists said they thought. It remains only to determine if anything the apologists said can be believed.

Notes

1. P. C. Finney, "Antecedents of Byzantine Iconoclasm: Christian Evidence before Constantine," in *The Image and the Word*, ed. J. Gutmann (Missoula, Mont., 1977), 27ff. (and the literature cited there).

2. The earliest reliable (indirect) evidence of Christian forms of iconoclasm is found at Canon 60 of the synod held at Elvira (Illiberis in Baetica) in 309: "Si quis idola fregerit et ibidem fuerit occisus, quatenus in evangelio scriptum non est, neque invenitur sub apostolis umquam factum, placuit in numero eum non recipi martyrum" (*España Sagrada* 56, ed. A. C. Vega [Madrid, 1957]): since there is no biblical or other apostolic precedent, one should not seek out martyrdom based on a Christian form of iconoclasm. For the general principle (do not seek it out, instead let it come to you), cf. *Mart. Polyc.* 4.15–20. Canon 60 must have been formulated with a view to correcting an abuse. For the legendary Christian sisters, Justa and Rufina (remembered for having smashed the image of Carthaginian Salambo in the streets of Sevilla) and for Germanus and Servandus (likewise lionized as Christian iconoclasts), see B. Gans, *Die Kirchengeschichte von Spanien* (Regensburg, 1862), 372–75. Perhaps Hispanic Christians led the way in inaugurating Christian forms of iconoclasm. In my opinion, *Oct.* 8.4 ("templa et busta despiciunt, deos despuunt, rident sacra") and *Cels.* 8.38.3–5 (Christians strike *agalmata* of Zeus and Apollo: ἰδοὺ παραστὰς τῷ ἀγάλματι τοῦ Διὸς ἢ Ἀπόλλωνος ἢ ὅτου δὴ θεοῦ βλασφημῶ καὶ ῥαπίζω, . . .) do not consitute a reliable basis from which to infer the existence of Christian iconoclasm before 300—these are simply anti-Christian slurs with no basis in fact.

3. The title of a work attributed to Alexander of Kotiaeion (κοτιαέων = Phryg. Kutahia).

4. Practical atheists are known by their nonconformist or iconclastic behavior. The paradigms are Socrates, Alcibiades, and Kinesias; see Guthrie, *GkPhil*, 3:235ff.

5. Philosophical atheists can be defined on Plato's dictum (908b) as "complete disbeliever[s] in the existence of the gods"; in a similar manner: Aët. I.7.1, φασὶ μὴ εἶναι θεούς; Cic., *ND* I.42, 117, "ominino deos esse negabant." The canonical ancient list includes Diagoras of Melos, Prodicus of Keos (paraphrased at *ND* I.118), Kritias (ibid.), Euhemerus, and Theodorus of Cyrene; for discussion and literature, see Guthrie, *GkPhil*; also M. Winiarczyk, *Diagoras Melius, Theodorus Cyrenaeus* (Berlin, 1981); idem, "Wer galt im Altertum als Atheist?" *Philologus* 128 (1984), 157–83.

6. Min., *Oct.* 32.1–9; Sen., *Ep.* 41.1: "prope est a te Deus, tecum est, intus est"; also 120.14 and Epict., *Diss.*, 2.8.11ff.

7. On Epictetus, Marcus, and Seneca: H. Wenschkewitz, *Angelos* 4 (1932), 113–30. Stoic allegory of mythopoetic tradition: P. DeLacy, *AJP* 69 (1948), 241–71. On the ancient definition and uses of allegory: J. Tate, *CR* 41 (1927), 214–15; *CQ* 23 (1929), 142–52, 28 (1934), 105–15; also R. Lamberton, *Homer the Theologian* (Berkeley, 1986). On Plutarch's allegorization (at Eus., *PE* 3.1–2) of the cult of Daedalus at Platea, cf. J. Pépin, *Mythe et Allégorie* (Paris, 1976), 184ff.

8. For an elegant, brief description, cf. P. Courcelle, "Parietes faciunt chris-

tianos?" in *Mélanges d'archéologie, d'épigraphie et d'histoire offerts à Jérôme Carcopino* (Paris, 1966), 241–48; for a full bibliography, see my article in *Boreas* 7 (1984), 193–225.

9. Porphyry's *Peri Agalmaton* (frags. apud Eus., *PE* 3.7.1ff.) is the best example we have of a Stoic image allegory; unfortunately the only commentary on this treatise is still J. Bidez, *Vie de Porphyre* (Ghent, 1913), 143ff.

10. Sen., *Sup.* (apud Aug., *CD* 6.10): "Sacros," inquit, "inmortales, involabiles in materia vilissima atque inmobili dedicant . . ."; cf. *L. Annaei Senecae Opera Quae Supersunt Supplementum*, ed. Fr. Maase (Leipzig, 1902), frag. 31. Tertullian had a keen sense of the material nexus supporting pagan cult; cf. *Idol.* 4.1: Ex 20.4 was designed to root out "materiam idololatriae"; also *Cult. Fem.* I.5, 1; *Exhort. Cast.* 2.5.

11. The dependence on Seneca has been noted often; see P. Courcelle, "Virgil et l'immanence divine chez Minucius Felix," *JbAC* Ergbd. 1 (1964), 34–42 (with the literature cited there).

12. Koch, *Bilderfrage* 24, 49ff., 52, 84ff., 97 is representative: he interprets (incorrectly) Octavius' several responses to Caecilius on the subject of art as statements that describe accurately the real-life condition of new religionists rather than as apologetic replies to anti-Christian accusations.

13. I have already discussed this passage at *Boreas* 7 (1984), 214–17.

14. Although the specific form of access (by ownership, by lease, or by adverse possession) is unknown; see Finney, *Boreas* 7 (1984), 193ff. (with the literature cited there).

15. F. J. Dölger, "Die Heiligkeit des Altars und ihre Begründung im christlichen Altertum," *AC* 2 (1930), 161ff.

16. Just., I *Apol.* 20.10: μείζονα γὰρ τὸν δημιουργὸν τοῦ σκευαζομένου απεφήναντο.

17. *Oct.* 32.7: "Ubique non tantum nobis proximus, sed infusus est" (see n. 5); also Acts 17:28: Ἐν αὐτῷ γὰρ ζῶμεν καὶ κινούμεθα καὶ ἐσμέν, . . . ; 1 Cor 3:16, 6:19; 2 Cor 6:16; Lk 17:21; Ign., *Eph.* 15.3; Herm., *Mand.* 7.5.

18. Pers., *Sat.* 2.69–75: "dicite pontifices: in sancto quid facit aurum? . . . quin damus id superis . . . compositum ius fasque animo sanctosque recessus mentis et incoctum generoso pectus honesto. haec cedo et admoveam templis, et farre litabo"; for other parallels, cf. G. W. Clarke, *ACW* 39, ad loc.

19. *Rep.* 509D–511E, where the basic distinction is between *to noeton* (CB) and *to horaton* (AC). C is the point of division separating the less real, sensory world, AC, from the higher and more real world of cognition and mental perception, CB. The latter is subdivided into two unequal sections, a higher, smaller section (EB) called *noesis* or understanding free of links to the phenomenal world and a lower, larger section (CE) called *dianoia* or thought, a world of mathematical cognition based in some degree on the phenomenal world. The same subdivision applies for *to horaton*. Its higher, smaller section (DC) is called *physis* or nature (also *to skeuaston*), the physical world of plants and animals and things, and its lower, larger section (AD) is called eikasia or illusion (subsuming the realms of *skiai, phantasmata, eikones*), a world of shadows, reflections in water. AD has the least claim to reality in the line AB that Socrates instructs Glaukon to draw, and although in this immediate context Plato does not mention statues and pictures, it is clear (for example from 596B–597E) that they belong to *eikasia*.

20. Clement's τὰ αἰσθητὰ corresponds to Plato's *to horaton*, the latter di-

vided according to the instructions given to Glaukon, into higher (*physis, to skeuaston*) and lower parts (*eikasia, skiai, phantasmata, eikones*).

21. At *Rep.* 5.476D ff., Plato puts doxa between *episteme* and *agnosia;* at 6.509C ff., *doxa* is the cognitive apparatus that construes the world of appearance, that is, the physical world. The same is true at *Tht.* 187A–210B and *Ti.* 51D ff.: *doxa* apprehends the sense-world, *nous* the Ideas. On *logos doxastikos* in Antiochus of Ascalon and Albinus, see J. Dillon, *The Middle Platonists* (Ithaca, N.Y., 1977), 92, 281–82.

22. In Albinus *logos epistemikos* has as its object *ta noeta*, and its product is *episteme* or scientific knowledge; *doxastikos logos* has as its object *ta aistheta* and its product is *doxa*, or opinion; see Dillon, *Middle Platonists*, 273ff.

23. Origen quoting Celsus at *Cels.* 7.45 makes the distinction very clear: *ousia* is *noeton* and *genesis* is *horaton*. Truth is concerned with *ousia*, whereas error is concerned with becoming. *Episteme* is concerned with truth, but *doxa* focuses on error. Alb., *Didas.* 163, 28ff.: *episteme* and *doxa* are different and have different objects; also Cic., *Acad. Post.* 30ff. (reproducing the epistemology of Antiochus of Ascalon): *doxa* concerns mutable things in the phenomenal world; *episteme* concerns immutable ideas. On Xenokrates' tripartite reworking (into *episteme, aisthesis* and *doxa*) of *Rep.* 476D ff. and 509C ff., cf. Dillon, *Middle Platonists*, 36; also 6: Arist., *An.* I.2.404b, 16ff.: Plato's psychology, according to Aristotle, consisted of *nous, episteme, doxa* and *aisthesis.*

24. In one (Plin., *Nat.* 35.65) of the many anecdotes concerning this painter he is said to have painted grapes with such verisimilitude that birds flew up to them. At Cic., *Inv.* 2.1.2–3: Zeuxis prepares to transfer *veritas* from nature to the canvas. On Zeuxis, see J. J. Pollit, *The Ancient View of Greek Art* (New Haven, 1974), general index, s.v., and T. B. L. Webster, in *OCD²*, s.v.

25. Renown for painting "imagines adeo similitudinis indiscretae" (Plin., *Nat.* 35.88). Ael., *VH* 2.3: Apelles painted Alexander's horse so true to life that another horse neighed at the painting. For a comparison based on *similitudo* of Apelles' Aphrodite of Kos and Epicurus's gods, see Cic., *ND* I.75: what is at issue here is not so much the value of Apelles' painting but of Epicurus' theology, but it is also true, I think, that there is an implied devaluation of Apelles' work simply because Cicero brings it into conjunction with Epicurean error.

26. Diod. Sic., 4.77.4; for the literature on this famous (and much-debated) passage, see Pollitt, *Greek Art*, 109, n. 19.

27. *Prot.* 4.57.6: ἐπαινείσθω μὲν ἡ τέχνη . . .

28. *Prot.* 4.49.2: τότε προσκυνήθω τὸ κάλλος, ὅτε ἀληθινὸν ἀρχετυπόν ἐστι τῶν καλῶν.

29. *Prot.* 4.62.3: . . . ἢ τὰς Λυσίππου τέχνας ἢ τὰς χεῖρας τὰς Ἀπελλικάς, αἳ δὴ τῆς θεοδοξίας τὸ σχῆμα τῇ ὕλῃ περιτεθείκασιν.

30. *Cels.* 4.31: the intention of Deut 4:16–18 was that Jews should have *aletheia* and should not misrepresent *aletheia* with visual *mimesis;* 6.66: on looking up and ascending mentally from the visible and phenomenal world, the world of painters and sculptors and image makers who sit in darkness, to the higher world of the creator who is light (*phos*); 7:44: it is absurd to imagine that prayer offered to images, both visible and material, ascends to a God who is invisible and spiritual (its opposite is the argument used by Iconodules five centuries later).

31. Thus Clement συκοφαντοῦντες τὴν ἀλήθειαν at *Prot.* 4.47.1.

32. Guthrie, *GkPhil*, 1:44, 360–402 (Xenophanes); still a useful introduction: P. Decharme, *La critique des traditions religieuses chez les Grecs* (Paris, 1904).

33. Testimonia and attributions: *FrGrHist* 1.63; also Nilsson, *GGR* 2:283–89.

34. Diels and Kranz, *Vorsokr.* I. ΣΙΛΛΟΙ: frags. B10–B21; B14–B16 are preserved by Clement.

35. Ibid., frag. B15.

36. Ibid., frag. B16.

37. Anthisth., *Frag.*, 40B at *Prot.* 6.71.2 and 40A at *Strom.* 5.14.108,4; also at Eus., *PE* 13.13.35, 15–16, and Thdt., *Graec.* I.75. Cf. Xen., *Mem.* 4.3.13ff. (quoted by Clement at *Prot.* 6.71.3 and *Strom.* 5.14.108, 5): what God is in his form is unknown. Valuable for Antisthenes' epistemology: K. von Fritz, *Hermes* 62 (1927), 453–84. Xenophon's version of Antisthenes: idem, *RhM* (1935), 19–45.

38. Discussed under the section on aniconic societies.

39. *Prot.* 4.46.1–4. Generally *xoanon* carries the sense of an image carved (ξέω) in wood, sometimes nonanthropomorphic, in other cases human in form; cf. W. H. Gross, in *KlPauly*, s.v. "Xoanon" (with the literature cited there). On *xoanon* in Pausanias, see F. M. Bennett, *AJA* 21 (1917), 8ff. Paus. 9.3, 2: commenting on the festival of the Daedala at Plataea, "men of old used to refer to wooden images [*xoana*] as daidala."

40. *Prot.* 4.46.3 ἐπεὶ δὲ ἀνθρώποις ἀπεικονίζεσθαι τὰ ξόανα ἤρξατο, βρέτη τὴν ἐκ βροτῶν ἐπωνυμίαν ἐκαρπώσατο; borrowed from Aethlios, the historian of Samos, on whom see *FrGrHist* 3B.536. On a Pontic *bretas* of Serapis: *Prot.* 4.48.3.

41. *Prot.* 4.46.4: ἐπειδὴ δὲ ἤνθησεν ἡ τέχνη, ηὔξησεν ἡ πλάνη. Close parallel: Tert., *Idol.* 3.1, 2: long ago there was a time when idols did not exist, but then the devil created sculptors and painters, ". . . huius monstri [i.e., idolatry] artifices . . ."

42. *Prot.* 4.47.1: see n. 31.

43. *Cels.* 6.63.16,17: οὐδ' ἄνθρωπον ἐποίησεν εἰξόνα αὐτοῦ. οὐ γὰρ τοιόσδε ὁ θεὸς οὔτ' ἄλλῳ εἴδει οὐδενὶ ὅμοιος.

44. *Cels.* 6.64.15: οὐ γάρ φησι τὶς ἡμῶν ὅτι μετέχει σχήματος ὁ θεὸς ἢ χρώματος . . .

45. Thus Sen., *Sup.*, frag. 38 (apud Aug., *CD* 6.10): this despite the fact that in this early treatise Seneca was especially intolerant of superstition evidenced in cultic contexts.

46. *Cels.* 7.66.

47. A. O. Lovejoy and G. Boas, *Primitivism and Related Ideas in Antiquity* (New York, 1965), esp. 1–116 (chronological primitivism and primitivistic ideology based on nature as the norm).

48. At Aug., *CD* 4.31: "antiquos Romanos plus annos centum et septuaginta deos sine simulacro coluisse." At *HAW* 5.4 (1967), 150, K. Latte defended the historicity of Varro's aniconic construal of early Roman religion. This presumes that Italic, Iron Age conceptions of divinity in peninsular Italy were at once aniconic and nonfigural and that the impulse to figural representations of divinity came from the Etruscans (understood as outsiders [Asiatic Greeks?], non-Italic peoples). These are very hefty (also inaccurate) presumptions.

49. At *Prot.* 5.65.3 Clement makes Artaxerxes (son of Darius I) the culprit responsible for introducing cult images in Mesopotamia and Bactria, in Damascus and Sardis.

50. Philostr., *VS* 572, 575, 620; cf. Apsines at *Rhet. Gr.* I.2, 228, 247.

51. *Prot.* 4.46.1: . . . οἱ Ἄραβες τὸν λίθον . . .: presumably the black stone or *kaaba* at Mecca.

52. Clement does not use the term here, but that is clearly the intended meaning; on *baitylia*, see W. Fauth, in *KlPauly*, s.v.

53. *Prot.* 4.46.1: . . . οἱ Σκύθαι τὸν ἀκινάκην . . . On Scythians as noble savages: Lovejoy and Boas, *Primitivism*, 315–44. Tert., *Marc.* I.1.3 disagreed—in association with Marcion and in the interests of rhetorical *psogos*, he portrayed the Scythians as lustful, vicious, and violent.

54. *Prot.* 4.46.4: ἐν Ῥώμῃ δὲ τὸ παλαιὸν δόρυ φησὶ γεγονέναι τοῦ Ἄρεως τὸ ξόανον Οὐάρρων ὁ συγγραφεύς, οὐδέπω τῶν τεχνιτῶν ἐπι τὴν εὐπρόσωπον ταύτην κακοτεχνίαν ὡρμηκότων. Cf. Var., *Ant.* I = Cardauns frag. 18: "antiquos Romanos plus annos centum et septuaginta deos sine simulacro coluissse. Quod si adhuc . . . mansisset, castius dii observarentur . . . qui primi simulacra deorum populis posuerunt, eos civitatibus suis et metum dempsisse et errorem addidisse," with extensive commentary and bibliography.

55. *Prot.* 4.46.3.

56. *SVF* 1.264; at *Strom.* 5.76.1: λέγει δὲ καὶ Ζήνων ὁ τῆς Στωϊκῆς κτίστης αἱρέσεως ἐν τῷ τῆς πολιτείας βιβλίῳ μήτε ναοὺς δεῖν ποιεῖν μήτε ἀγάλματα; similar sentiments at *Strom.* 7.28.1–2; also Cels. 1.5 and at 4.31 the Hebrew commonwealth is a place where image makers are denied citizenship; also Plut., *Mor.* 1034B.

57. Word and concept are philosophical; *hyle* enters philosophy via the Milesians who are sometimes described as hylozoists; cf. Guthrie, *GkPhil*, esp. 1:62ff., and also C. Baeumker, *Das Problem der Materie in der griechischen Philosophie* (Münster, 1890).

58. Heber wrote the text at Wrexham in 1819, and the editio princeps appeared three years later in the *Christian Observer*. It was republished after his death in R. Heber, *Hymns* (London, 1827), no. 139.

59. The editio princips reads "strewn"; it was changed to its present form in the 1832 edition.

60. Heber's original manuscript (str. II.1.7) reads "savage" which he crossed out and made the less offensive substitution.

61. Guthrie, *GkPhil*, 3:238–42, 274ff.

62. Just., *Apol.* 9.4 (ἐξ ἀτίμων πολλάκις σκευῶν); Theoph., *Autol.* I.10 (Egyptians worship *podoniptra*); Athenag., *Leg.* 26.5; *Diogn. Epis.* 2; Tert., *Apol.* 12.2 ("uasculorum instrumentorumque . . ."); Min., *Oct.* 24.7 ("de immundo uasculo, ut saepius factum Aegyptio regi, . . .").

63. From the *De superstitione* at Aug., *CD* 6.10: "sacros immortales, involabiles in materia vilissima atque immobili dedicant."

64. *Autol.* II.2: "They [the pagans] regard them [gods that are sculpted, molded, painted, carved, cast, and constructed] as gods, but they do not know that they are just the same as they were when they were made by them—stone or bronze or wood or pigment or some other material [*hyle*]."

65. At *Apol.* 13.4 ("in caccabulum de Saturno . . . in trullam de Minerua . . ."). Tertullian creates the transformation from gods to a cooking pot and a ladle.

66. *Leg.* 17.5: pagan images are περίεργος τέχνη.

67. *Leg.* 4.1.

68. *Prot.* 2.24.2 (Diagoras mentioned by name); 2.24.4 (the story paraphrased).

69. Testimonia and attributed sayings: F. Jacoby, *AbhBerl* (1959), 1–48; also Guthrie, *GkPhil*, 3:236–37.

70. Fragments: *Poetae Melici Graecae*, ed. D. L. Page (Oxford, 1962); cf. *Suda*, s.v. "Diagoras": ἀσμάτων ποιητής . . . ὁ δὲ καὶ τῇ λυρικῇ ἐπέθετο, τόις χρόνοις ὦν μετὰ πίνδαρον καὶ Βακχυλίδην . . .

71. L. Woodbury, *Phoenix* 19 (1965), 178–211.

72. The canonical list included Diagoras, Prodicus of Keos, Critias, Euhemerus, and Theodorus of Cyrene; cf. Guthrie, *GkPhil*, 3:226ff.

73. Diels, *DoxGr.* 58ff.

74. Full documentation: B. Keil, *Hermes* 55 (1920), 63ff. Hellenistic Jewish parallels: *Wis* 13:11–12 and *Apocalypse of Abraham* 5.1–17.

75. Text at Jacoby, *AbhBerl* (1959), 5.

76. Thus Athenag., *Leg.* 4.9–10: (τὸ μὲν γὰρ θεῖον ἀγένητον εἶναι καὶ ἀΐδιον. . . . τὴν δὲ ὕλην γενητὴν καὶ φθαρτην) . . .

77. Testimonia and fragments: Diels and Kranz, *Vorsokr.* 2:308ff. Good discussion: Guthrie, *GkPhil*, 3: general index, s.v.

78. W. Schwartz, *Die poetischen Naturanschauungen der Griechen, Römer und Deutschen in ihren Beziehungen zur Mythologie der Urzeit* (Berlin, 1864–79); M. Müller, *An Introduction to the Science of Religion* (Oxford, 1873); also H. F. Willer, *Mythologie und Naturerscheinung* (Leipzig, 1863).

79. What Clement knew of Prodicus (and Euhemerus) was mediated in part by Alexandrian Jewish apology; cf. *Aristeas to Philokrates* 134–37.

80. *Prot.* 5.64.1–4: Clement does not mention Prodicus here by name (but he does elsewhere, e.g., *Paed.* II.110.1 and *Strom.* 5.31.2); however, the argument which is reductionistic and etymological in character bears considerable resemblance to the Kean sophist.

81. *Prot.* 4.50.4, καὶ τοῖς ἀγάλμασι τουτέοισιν εὔχονται, ὁκοῖον εἴ τις <τοῖς> δόμοις λεσχηνεύοιτο.

82. *Cels.* 7.62.

83. Diels and Kranz, *Vorsokr.*, 1:62, frag. B5.

84. On the meaning of the Greek (μαίνεσθαι δ'ἂν δοκοίη, εἴ τις αὐτὸν ἀνθρώπων ἐπιφράσαιτο οὕτω ποιέοντα): H. Fränkel, *Wege und Formen frühgriechischen Denkens* (Munich, 1968), 76ff.

85. *Prot.* 4.50.5: ἢ γὰρ οὐχὶ τερατώδεις οἱ λίθους προβτρεπομένοι . . .;

86. *Cels.* 7.66.

87. *Cels.* 7.64.5–7: οὐδεὶς ἐκείνων (i.e., barbarians, atheists) διὰ τὸ ἐκκλίνειν καὶ κατασπᾶν καὶ κατάγειν τὴν περὶ τὸ θεῖον θρησκείαν ἐπὶ τὴν τοιαύτηνὕλην . . .

88. *Prot.* 10.103.4.

89. *Iliad* 24.604; Ov., *Met.* 6.182–83.

90. Underlying the argument is a polemic that concerns gods, persons, and things that stand in opposition to YHWH—Israelite polemicists put all three under a blanket of unreality as if none of them had any real existence. The classic examples are found in Second Isaiah whose nomenclature includes three Hebrew words signifying the condition: the first is 'yn (אין) which denotes a state of nothingness; the second (m)' pṭ ((מ)אפס) conveys a similar meaning, nonexistence or something made ex nihilo, hence itself nothing. The third word, thw (תהו) is more problematic and seems to point toward what a Greek would call chaos or formlessness, confusion, emptiness, and unreality. On the pagan idol as κενὸν οὖδεν μάταιον and related concepts that unlie the notion that idolaters are transformed into the things that they worship, see H. C. Spykerboer, *The Structure*

and Composition of Deutero-Isaiah with Special Reference to the Polemics against Idolatry
(Groningen, 1976), with a review of the older literature). Later Hellenistic-Jewish
continuation of the teaching: Wis 15:7ff.: woes to the idolater.

91. *Autol.* II.35.

92. *Diogn.* 2.2ff.; Jewish parallel: *Epistle of Jeremiah* 59.

93. Also: Ps 115:4–8; Theoph., *Autol.* I.10.13: Γένοιντο δὲ τοιοῦτοι οἱ
ποιοῦντες αὐτὰ καὶ οἱ ἐλπίζοντες ἐπ᾽ αὐτοῖς.

94. *Prot.* 10.98.1.

95. *Prot.* 10.98.3. By contrast, at 10.98.2 the four famous Greek artists are
mikrotechnai.

96. W. Richter, in *KlPauly*, s.v. (with the literature cited there).

97. *Prot.* 4.51.2–6; *to ostreon* appears at 4.51.5.

98. Cic., *Div.* II.33: "ostreisque et conchyliis omnibus contingere ut cum
luna pariter crescant pariterque decrescant, . . ." (Pease: Cic., *ND*, gives the full
documentation).

99. The term is mine—more common is "cosmobiology," the idea that the
world is a large organism and that all living beings are sympathetically connected
with this macroorganism; for a brief account, see K. E. McVey, "The Use of Stoic
Cosmogony in Theophilus of Antioch's *Hexaemeron*," in *Biblical Hermeneutics in
Historical Perspective: Studies in Honor of Karlfried Froehlich*, ed. M. S. Burrows and
P. Rorem (Grand Rapids, Mich., 1991), 46–49 (with the literature cited there).

100. *Is. Osir.* (*Mor.* 381D–382C): on the principle that living beings (e.g.,
animals) are as good or better symbols of divinity than inanimate objects (such as
things worked in bronze or stone).

101. In both Luc., *J. Conf.*, and Luc., *J. Tr.*, esp. the latter (7–12) exhibiting
criticism of the gods based in the first instance on hylistic principles (they are worth
what they are made of) and in the second on banausic principles (their worth
depends on who made them).

102. Hor., *Sat.* I.8.1–50.

103. Just., I *Apol.* 9.9: on the absurdity of men guarding gods in temples; cf.
Wis 13:16: the cult image is powerless to help itself.

104. From his lost *Peri agalmaton* at Eus., *PE* 3.7, 1.

105. In explaining the typology of the cross at *Marc.* III.18.7, Tertullian is a
good example of symbolic thinking in early third-century Christianity. Writing on
the same subject, Justin at I *Apol.* 55.1–14 is an earlier example of the same
phenomenon. Min., *Oct.* 29.8 puts the matter succinctly: "signum sane crucis
naturaliter uisimus in naui." There is a great deal more that could (and should) be
said on this subject.

106. *Ep.* X.96.8: "superstitionem pravam et immodicum"; also X.96.9.

107. *Nero* 16.2: "superstitionis novae et maleficae."

108. *Ann.* 15.44: "exitabilis superstitio."

109. Variant senses of the term: Cic., *Div.*, at I.7, II.148; idem, *ND*, at I.45,
117 ("timor inanis deorum") II.72. Also J. P. Koets, *Deisdaimonia* (Purmerend,
1929), and M. Smith, "De Superstitione (Moralia 164E–171F)," in *SCHNT* 3, ed.
H. D. Betz (Leiden, 1975), 1–35.

110. On the classic opposition between *religio* and *superstitio* in Cicero, see
G. Lieberg, *RhM* 106 (1963), 62ff.

111. Smith, "De Superstitione," 2.

112. Especially in its feminine incarnation (anility); this latter was evidently a
common reproach directed against Christians, e.g. Min., *Oct.* 8.4: Christian

women as "credulis sexus"; also Tat., *Or.* 33 and Orig., *Cels* 6.24 Credulity in women was proverbial in Greek and Latin letters; see A. Otto, *Die Sprichwörter und sprichwörtlichen Redensarten der Römer* (Leipzig, 1890): under "anus."

113. *Idol.* 4.1: the Hebrew prohibition of images (Ex 20:4 and parallels) was conceived for this cause, namely "ad eradicandam scilicet materiam idololatriae, . . ."; on *materia* signifying "material occasion, the means," see Tert., *Cult. Fem.* 1.5.1: "aurum et argentum, principes materiae cultus saecularis"; also *Exhort. Cast.* 2.5: "neque enim diabolus voluntatem ei [Adam] imposuit delinquendi, sed materiam voluntati subministravit." Cf. Waszink and van Winden in Tert., *Idol.*, ad loc.

114. *Idol.* 3.1.

115. Thus Min., *Oct.* 26.8: "Spiritus sunt insinceri, uagi, a caelesti vigore terrenis labibus et cupiditatibus degrauati." But at 26.11 (on the authority of Hostanes) *daimones* become earthly beings ("terrenos": hence we may presume embodied beings?) who wander about "humanitatis inimicos."

116. *Leg.* 25.1; cf. Orig., *Cels.* 8.60: Celsus says that earthly daímones are preoccupied with created things and blood and sacrifices.

117. *Apol.* 10.2; *Spect.* 10.10, 12.4ff., 13.2ff.; *Idol.* 15.2.

118. *Idol.* 7.1, 11.2.

119. At *Apol* 22.6 Tertullian claims (the earliest attestation?) that *daimones* hid in images in order to eat sacrificial victims, their primary source of nourishment. Min., *Oct.* 27.2: *daimones* gorged with the reek of altars; also Orig., *Cels.* 3.29 (*daimones* are subject to *lichneia*); 3.37 (ibid.); 4.32 (*daimones* delight in blood and odors rising from burnt sacrifices); 7.5 (*daimones* have bodies nourished by sacrificial smoke, blood, and burnt offerings); 8.60 (ibid.).

120. *Deisd.* 164E: *amathia* and *agnoia* produce atheism and *deisdaimonia;* the presence of *pathos* makes both conditions immeasurably worse; 165B: *deisdaimonia* is a *doxa empathe* which crushes a person (*suntribontos* . . .); 165C: *pathe* in the soul are disgraceful but of all the many emotions that disrupt the soul (165D ff.) *phobos* is the worst, rendering its victims completely impotent—it inhibits action, prevents escapes, and affects all aspects of life. On *pathe* in Stoicism, see A. C. Lloyd, in *The Stoics,* ed. J. M. Rist (Berkeley, 1978) 233–46. Posidonius is representative for later (i.e., Plutarchean) Stoicism: frag. 157 (*pathe* emanate from the irrational part of the soul); they cannot be wholly eliminated, but (frags. 31; 165, 11.86ff.; 167) careful training can lead to their control. This is actually Platonic anthropology reshaping Stoicism, and Plutarch is but one of several examples illustrating the mix; see J. Dillon, *The Middle Platonists* (Ithaca, N.Y., 1977), index, s.v. "Passions." Clem., *Strom.* 2.8.40, 1ff.: fear is *pathos*, but not always; *deisdaimonia* is *pathos*, the fear of *daimones* that are at one and the same time *ekpathoi* and *empathoi.*

121. I *Apol.* 58.7–8; also 57.1–2; 14.1ff (. . . δαίμονες . . . ποτὲ δ'αὖ διὰ μαγικῶν στροφῶν χειροῦνται . . .); 7.1ff. (Christians practice the philosophical *bios*).

122. Information on consecration and ensoulment of images is considerable. Porphyry, Iamblichus, and Proclus provide the best literary evidence, the magical papyri (e.g., *PGM* 4.1830) the best documentary evidence. Still the place to begin: Th. Hopfner, *StudPalPap* 21 (1921) 802–21. On ἵδρυσις of *agalmata* (classical evidence): G. Hock, *Griechische Weihgebräuche* (Würzburg, 1905), 47ff. Sensible, brief, and informative: Bonner, *SMA* 14–17.

123. *Idol.* 15.5 (". . . per consecrationis obligamentum": *daimones* are bonded to objects at the moment of consecration); *Apol.* 12.2: at the moment of

consecration a metamorphosis occurs, brought on "licentia artis transfigurante"); Cor 10:2: crowning of the dead likened to consecration, thereby producing "idola"; *Spect.* 10.10, 12.4ff., 13.2: *daimones* reside in consecrated images. Very valuable on this subject: P. van der Nat, in *RAC* 9 (1976), 716–61, esp. 737–42.

124. Min., *Oct.* 24.8.

125. Thus Numenius (frag. 33, ed. E.-A. Leemans [*MémBrux*, 1937]) at Orig., *Cels.* 5.38: makers of *agalmata* and magicians (*magoi* and *pharmakoi*) call upon *daimones*, which are bound in this example to a Sarapis image.

126. In the Christian realm deliberations on this subject trace their origin to 1 Cor 8:1–13; 10.14–21.

127. Although the extent of her popular association with lovemaking and fertility is in fact problematic; see W. J. Fulco, in *ER* 1: s.v. "Astarte." The Phoenician-Canaanite prototype may have been transferred to Cyprus as Aphrodite, who was clearly a love goddess, but the historical link (argued mostly on etymological grounds) between Astarte and Aphrodite is still problematic; see W. Fauth, in *KlPauly*, s.v. "Aphrodite."

128. Diels and Kranz, *Vorsokr.*, 1. 1:frag. B11. *Silloi* = satires, mockeries, parodies, but probably Xenophanes himself did not designate his work by this term; cf. Guthrie, *GkPhil*, 1:365, 366.

129. W. Jaeger, *The Theology of the Early Greek Philosophers* (Oxford, 1947), index, s.v. A study of *theoprepes* and *hieroprepes* would be a useful addition to the literature on early Christianity.

130. *Prot.* 7.75.1–76.5.

131. At *Strom.* 5.75.2 Clement quotes *Hercules Furens* 1345–46: δεῖται γὰρ ὁ θεός, εἴπερ ἔστ' ὀρῶς θεός, <οὐδενός>. His purpose is to illustrate the principle that God needs nothing and that the gods of mythography amount to nothing more than *dystenoi logoi*.

132. *Rep.* 3.398A: the expulsion of the poets. On Plato's ideal polis and painters (also to be rejected, in part because they perpetuate *mythos*, but also because their form of *mimesis* is a lie), see E. Keuls, *Plato and Greek Painting* (Leiden, 1978), with the literature cited there.

133. *Prot.* 4.61.2: pagans dedicate *stelas anaischuntias* in their homes, meaning pictures of copulating couples.

134. On Philainis (according to Athenaeus from Leukas; according to Dioscurides from Samos); cf. *Suda* 4621 (Ἀστυαναββα) and P. Maas, in *RE* 19.2 (1938), s.v. Athen., *Deip.* 335b: Chrysippos compares Philainis with Archestratus of cookbook fame. Polybius 12.13.1: Timaios of Taormina puts Philainis and Botrys in the same smutty camp. Philainis' major claim to literary 'eminence' is his lost *Peri schematon sunousias* (On positions for intercourse): for Greeks, Philainis was proverbial for pornophilia.

135. Phlegon of Tralles, remembered primarily for his *Thaumasia;* see *FrGrHist* IIB.257.F36. Also Christ, Schmid, Stählin 2.2, 761ff., and O. Dreyer, in *KlPauly*, s.v. (with the literature cited there).

136. *Prot.* 2.39.6: according to Clement, ant worship was a Thessalian idiosyncracy (μύρμηκας ἱστοροῦνται σέβειν). After her unlikely encounter with Zeus as an ant, Kletor's daughter, Eurymedusa, begat Myrmidon, the eponym of an Homeric tribe; on Myrmidon, cf. Roscher, *Lex.*, s.v.

137. *Or.* 33.15–17: Nikeratos son of the Athenian Euktemon cast an *eikon* of Glaucippe who was impregnated by an elephant and who gave birth to a monster (παιδίον, ἥτις τεράστιον). On the presumed identity of Nikeratos, see A.

Kalkmann, *RhM*, n.s., 42 (1887), 502. At *Nat.* 7.34 among effigies of *mirabiles* which Pompey is said to have commissioned and set up in his theater, Pliny mentions Alcippe who bore an elephant—Tatian's Glaucippe and Pliny's Alcippe could be the same legendary figure; for another view, see Kalkmann, *RhM*, n.s., 42 (1887), 498. Apuleius (*Met.* I.9) also relates a story of a woman pregnant with an elephant.

138. This argument appears with considerable regularity in Clement's corpus, e.g., at *Prot.* 4.53.6 on Phryne the Thespian *hetaira* and on Alcibiades, the former a model for painters of Aphrodite, the latter a model for Athenian sculptors of Hermes: Clement asks: "do you really want to worship whores" (εἰ βούλει καὶ τὰς ἑταίρας προσκυνεῖν)?

4

The Emperor's Image

Once Pliny had ordered Trajan's bust to be brought into his courtroom, the imperial image continued to play a role in the persecution of early Christians right through to the Constantinian legitimation of Christianity in the early fourth century. But the kind of a role it played is still a matter for debate: did caesar's image have a bearing on evolving early Christian attitudes toward the visual arts or, more specifically, did it have a retarding effect on the development of a portraiture genre within the early church?

One cluster of literary traditions, namely apocalyptic writings, seems to suggest that the Roman government forced Christians to worship the image of the ruling princeps on pain of death. Two other literary settings, apologies and martyrologies, attest the government's use of that image in judicial and quasi-judicial settings to enforce loyalty to caesar from people who were suspected of being Christians. Under circumstances such as these it might be reasonable to suppose that the new religionists could easily have developed negative attitudes at the very least toward public images of politicians, and perhaps even toward the entire practice of portrait art.

Our present purpose is to test this theory. The chronological focus is the period before 251, the year that marks the outbreak of the Decian persecution, the first attested instance of an official government intervention that had the effect of suppressing Christianity.[1] Unfortunately, the evidence is thin, and without new evidence I doubt that there can ever be a definitive answer to this query. Nevertheless, certain commonsensical guidelines can be established.

As a matter of political principle, Rome sought to make the ruling princeps present to all his subjects. Because the ruler could not be present in his person,[2] not simultaneously to all his subjects, Rome devised an alternative, namely the manufacture and distribution[3] of caesar's image. Thanks to several informative publications[4] focusing on imperial images in the early and middle empire, we are unusually well informed about the manufacture and distribution of imperial portraits within the borders of the Empire and about the political ideology that inspired and sustained this propagandistic activity.

The portrait of the reigning princeps was presented under an exceedingly broad range of forms: stone and bronze freestanding statues; busts in stone, metal (base and precious),[5] and glass;[6] public and private reliefs; painted portraits in a wide range of contexts (public and private); numismatic; intaglio and cameo portraits; terra-cotta reliefs; and chased images on metal vessels. Thus, wherever they went, caesar's subjects were likely to be reminded of Rome's enduring presence under the image of her princeps. Given the times and circumstances, Christians who encountered this Orwellian presence might well have reacted negatively.

Mark 12:13–17

In this familiar gospel pericope,[7] an unfriendly group of Jews confronts Jesus. First they flatter[8] him, then ask a loaded question: is it right to pay taxes to Caesar? Jesus answers by calling for a coin. He looks at it, asks his interlocutors to do the same, and instructs them to identify the image on the coin and the superscription accompanying the image. At issue in this invented dialogue is the poll tax (*tributum capitis*),[9] which Jews had been paying to Rome since B.C. 27 for the privilege of survival. The coin in question is doubtless the Tiberian denarius,[10] which shows on its obverse the laureated head of the emperor facing right with the superscription: TI CAESAR DIVI AVG AVGVSTVS (Tiberius Caesar Augustus [son of] the divine Augustus). The reverse[11] of this coin shows a female (possibly Livia) facing right, seated on a throne, diademed and robed, holding a scepter in the right hand and palm or olive branch in the left, with the superscription: PONTIF MAXIM (High Priest).

Given the Jewish setting and the unhappy history of Jewish-Roman relations on Palestinian soil, it might be reasonable to expect from the Marcan redactor some mention of the anxieties and animosities that this coin would have evoked in the minds of pious Jews. Many Jews hated this coin and what it stood for, both its political associations and its evocation of idolatry. In the first instance the coin reminded Jews of their humiliating submission to Rome, their subordination to a gentile ruler. And in the second, observant Jews detested the coin because its subject embodied idolatry, the secular arrogation of absolute power which belonged exclusively to God. On the ruling of *Avodah Zarah*,[12] a Mishnaic tractate, faithful Jews were forbidden to look at figures of imperial authority including

those that held a staff, a bird, or an orb. And the *Tosefta*[13] forbade Jews to look at figures bearing a sword, a crown, a ring, or a snake. Obverse and reverse of the Tiberian denarius clearly fall within these rulings.

According to Hippolytus,[14] the Essenes, who were Jesus' contemporaries, upheld a strictly aniconic ethic within their community: on the principle that an observant Jew should not carry any idolatrous images on his person, Hippolytus alleges that the Essenes refused to carry the coin of the realm or even to touch it. The Jerusalem Talmud also contains the story of a third-century sage (Amora) named Nahum[15] who refused to handle or even look at a pagan coin in his lifetime and who for this act of piety was remembered as a "man of the holy of holies." Nahum and Hippolytus' Essenes evidently shared a strictly aniconic interpretation of their religion.

Archaeological evidence[16] of base-metal coins on the "farm" at Ain Feshkah and of silver coins (mostly Tyrian tetradrachms) discovered (Locus 120) in the wing of the settlement northwest of the Scrollery beneath the floor level of period II (first century B.C.) contradicts Hippolytus' depiction of Essene aniconism. Evidently, someone in the Essene community not only handled but hoarded pagans coins. Unbeknownst to his community brethren, the old mᶜbaqqēr could have buried the community treasure in this place or, perhaps even more likely, during the intermittent period of abandonment, a Jericho thief could have stashed his loot in this out-of-the-way place. If the former were the correct explanation, then clearly there is a contradiction between Hippolytus and the evidence of archaeology; according to the latter, it would appear that the people of the Scrolls did indeed handle coins.

Hippolytus adds that the Essenes refused to go "into the City" (Jerusalem) because they would have to pass through "the gate" (πύλη), which was adorned with idolatrous images (ἀνδϱιάντες):[17] Hippolytus does not specify the subject matter but, given his choice of nomenclature (ἀνδϱιάντες instead of ἀγάλματα), he probably means men (kings, benefactors, politicians), not gods. According to Hippolytus, the Essenes judged that it was against the law (ἀθέμιστον) to pass "beneath images" (ὑπὸ εἰκόνας). Which gate he meant we do not know, but we do know it was a common Roman custom to erect statues and reliefs at city gates.

This Hippolytan report of the Essenes is particularly interesting in view of the tradition[18] (transmitted by Josephus but unconfirmed by archaeology) that the Essenes maintained their own separate gate to enter and exit Jerusalem. Thus these reports of Essene aniconism tend to confirm the Tannaic and Amoraic portrayals of a rigorist strain within the world of Palestinian Jewry known to Jesus. Persons who interpreted the Law in this way—for example, Nahum—evidently went to considerable lengths to distance themselves from all contact with images of the gods and of the emperor.

In the form transmitted by the gospel narrative the confrontation between Jesus and his Jewish adversaries is a literary invention—it is

impossible to know if such a confrontation ever took place. The subject of the pericope unmistakably concerns taxes and Jewish loyalties to their overlords. While the saying about tribute has some claim to authenticity, the original context could have differed from what our Marcan redactor envisages. In its present narrative form the pericope also raises the question, albeit obliquely, about looking at the imperial image on a coin. Conceivably there could have been two original questions, one about paying taxes, the other about the lawfulness of Jews looking at the image of the emperor.

But regardless of the original context, which in any case is lost, the Marcan redactor makes Jesus' response hinge upon an act, looking at a coin laden with idolatrous subject matter, an act that many observant Jews would have found offensive in the extreme. Mark portrays a Jesus who is altogether indifferent to this issue, a Jew oblivious to the law forbidding Jews to look at idolatrous subjects, a Jew who invites his fellows to contemplate caesar's image, as if neither he nor they gave a moment's notice to the implications of their act.

In short, the one and only New Testament pericope that overtly mentions caesar's image (but only on a coin) treats the image in a purely matter-of-fact manner. It is implicitly dismissive of the larger issue concerning idolatry. All that we can conclude from this much-discussed pericope is that principled Jewish opposition to the idolatrous image of the emperor was not part of the gospel editor's theological or literary agenda. How and if Mark's focus reflects or deflects Jesus' view of this subject are matters for speculation.

Apocalyptic Literature

In chapter 12:1ff. the author of Revelation describes his vision of an unholy trinity, consisting of a huge red dragon whom John identifies as the devil or Satan (12.9), a beast that emerges from the sea (13:1ff.) to be identified with the Roman Empire symbolized by the principate, and a second beast that emerges from the earth (13:11ff.) and is the servant (13:12) of the first beast. This second beast should be identified as the provincial imperial priesthood, or Roman flaminate,[19] which we are told managed to win over the subjects of the first beast and persuaded them to erect a statue in honor of the first beast (13:14). On the common presumption that Revelation was composed at the end of the first century in western Turkey,[20] the second beast must represent an Asian imperial priesthood consisting mainly of pro-Roman provincial aristocrats who functioned as Rome's agents and representatives abroad. According to Rev 13:15, this second beast "was allowed to breathe life into this statue [of the first beast], so that the statue of the [first] beast was able to speak, and to have anyone who refused to worship the statue of the beast put to death."

The other references[21] to the image made by the second beast on behalf of the first add little or nothing to the essential disclosure at 13:15:

the priests gave life and speech to the imperial image, and anyone who refused to worship the image was killed. Persons who worshiped the image of the princeps were branded on the right hand or the forehead (Rev 13:16–18; cf.14:9–10, 16:2, 19:20, 20:4) either with the name of the beast or its numerical equivalent, 666. In other words, they became slaves of the first beast, the Roman emperor embodying the principate.

"Breathing life into the image" alludes to the ritual ensoulment (ἐμψύχωσις) of the image, a common late antique act of consecration (τελετή) by which a priest infused an object (often a statue, a bust, or an amulet) with an invisible *pneuma,* thereby endowing it with life and spiritual power—neo-Platonic, theurgic, and magical descriptions of this consecratory procedure are abundant, from Porphyry to Proclus.[22]

As for talking statues, ancient literary testimonies as well as archaeology confirm their existence, and Hippolytus[23] gives a well-known recipe for the construction of a talking skull made out of gypsum and beeswax and wrapped in an ox caul—a crane's windpipe or the trachea of some other long-necked fowl was to be inserted into the hollow cavity on the underside of the skull and fitted around the mouth opening. A magician or his slave could stand in the wings and make sounds pass through the windpipe and out the mouth of the talking head or, alternately, could force smoke and liquids through the windpipe.

If this is the kind of scenario that John envisages (apparently it is), we should certainly attribute it to his vivid imagination. That mummery of this sort was actually practiced by the imperial priesthood in Asia or anywhere else in the provinces is quite improbable. Furthermore, although we have several surviving Roman imperial statues carved out in back so that a person could stand disguised by the front of the statue and speak through a hole in the mouth, there is, to my knowledge, no evidence of statues representing the emperor and also fitted out for this kind of magic. Nor is it likely that new evidence will come to light. Magic of this sort belongs to another realm, namely to Nilsson's *niedere Glaube.* Men like Alexander of Abonuteichos[24] (who as a feature of his Asklepios-Glykan cult had a talking snake, fashioned of linen and horsehair) and other street-corner charlatans practiced deception on this level, but Imperial priests had neither the need nor the inclination.

As far as the imperial image is concerned, the major *crux* is Rev 13:15 in which priests demand on the pain of death that Rome's subjects worship the image of the princeps. The common external setting that exegetes envisage for this passage is an anti-Christian persecution supposedly instigated by Domitian (81–96). It is true that Domitian carried the imperial cult farther than any of his predecessors, excepting Gaius, and it is also clear that Domitian made considerable efforts to promote his own divinity (he may have introduced the practice of offering wine and incense before his statue and that of Jupiter), but these efforts met with a considerable lack of enthusiasm among his Italian subjects.[25] Excepting Jews, who enjoyed a statutory exemption from the requirement to participate in

pagan worship, Domitian punished those who refused to worship him under the law of treason (*maiestas*). Hegesippus, Melito, Tertullian, and Bruttius allege that he persecuted Christians, but the better evidence from Dio and Suetonius indicates that he punished people who were "Judaizers"—that is, people who were converts to Judaism or who lived in the Jewish manner without formal membership in a synagogue.[26] Perhaps there were Christians among these Judaizers. Perhaps not. There is no evidence, or even the likelihood, that Domitian ever issued a formal statute against Christians, nor is there the slightest historical basis for the claim that he persecuted Asiatic Christians.

John, the author of Revelation, perceived a crisis and wrote from a sense of urgency, but the real circumstances of that perceived crisis cannot be reconstructed.[27] The historical setting of Revelation is lost and, short of new discoveries, it will forever remain so. It is clear that John's purpose was to invoke a literary resolution of the perceived crisis, perhaps to provide what Collins calls a "catharsis": the diminishment of tension and feelings of aggression. The author saw his way clear to bring about this resolution through the use of symbolic language.

The literary inspiration for Rev 13:15 has long been recognized in Dan 3:1–23, the story of the three Israelite boys who refused to worship King Nebuchadnezzar's golden statue. That much is clear. But the real historical setting escapes us. And the suggestion that the writer took pen in hand because of a government-inspired persecution of Christians, including the forced worship of caesar's image, clarifies nothing. Probably the crisis John perceived had nothing to do with a Roman persecution of Asiatic Christians. He had a strong imagination, and this, more than anything else, prompted his literary pyrotechnics. He brought forth a powerful and compelling constellation of symbols, including the forced worship of the imperial image, but his evocative description of this subject corresponds to nothing either real or probable in the historical realm of Roman rule in western Asia Minor.

Two other Christian apocalypses need mentioning, one a Christian addition to a late Hellenistic(?), Jewish document, the second possibly a product of second-century Syrian (Jewish-Christian?) gnosticism. The first, sometimes called the *Testament of Hezekiah*, occupies verses 3.13b–4.18, the middle section of a composite document entitled the *Ascension of Isaiah*.[28] In its present form, the document is clearly the product of a Christian author or editor, but its date[29] and circumstances of composition are unclear. At 4.2, pseudo-Isaiah describes his vision of Beliar,[30] the great angel and the king of this world who will descend to this world in the form of a man, a king of iniquity and a matricide (probably Nero *redivivus*).[31] Beliar "will persecute the plant [the church] which the twelve apostles of the Beloved will have planted; one of the twelve [Peter or Paul] will be given into his hand." This Satanic angel will have cosmic power and will rule the world (4.4). As the "Antichrist" he will act and speak in the name of Christ, will call himself God and make claims to his absolute divinity,

and will perform miracles, and all people will believe in him, will worship and serve him, including those who formerly worshiped Christ (4.4–10). And finally, he will cause his image (Geʻez = gaṣṣu) to be set up in all the cities throughout his empire while he rules for the traditional apocalyptic period[32] of three years, seven months, and twenty-seven days (4.12).[33]

Charles wanted to connect this last verse with Caligula's infamous command[34] (probably in the spring of 40) to Publius Petronius, legate of Syria. At Jamnia gentiles had constructed a brick altar on which they intended to offer sacrifices to the Emperor. Jamnian Jews then smashed the altar, and when Caligula got word of this outrage, he directed Petronius to install a colossal gold statue of himself in the Jerusalem temple. However impossible to prove, the connection of *Testament* 4.12 with this incident in the Roman history of Palestine is plausible. Since we do not know as a matter of fact which emperor the apocalypticist intended in 4.12, and since the date of the *Testament* is a matter of conjecture, larger historical inferences based on this text and concerning the Christian reaction to the imposition of a putative imperial decree forcing the worship of caesar's image are only interesting speculations. All that is really certain is the literary role assigned to Beliar, the pseudo-Christ: he demands that his image be distributed far and wide and that it be worshiped.

It is equally difficult to connect with history the second of these two minor pieces of evidence. This latter concerns a certain Elchasai[35] ("hidden power" in Aramaic) who according to Epiphanius prophesied east of the Jordan. The date is unclear. In a fragment that Hippolytus attributes to this elusive character, the prophet says he preached in 101, the third year of Trajan's reign, but another Hippolytan fragment, also attributed to Elchasai, contradicts this chronology by more than a decade. In fact, the tradition concerning Elchasai, which we owe to the two heresiologists, Hippolytus and Epiphanius, is muddled. As preserved, the fragments attributed to Elchasai contain nothing explicitly Christian: they are Jewish, but perhaps tinged with an overlay of Christian gnosticism.

In one of the fragments[36] attributed to Elchasai he teaches "it is not a sin if a person who finds himself in a time of persecution happens to worship idols, provided that he does not worship in conscience and provided that whatever he confesses with his mouth he does not confess in his heart." If the time is Trajan's reign, if the setting is Transjordanian (Parthia?), and if Elchasai was a historical person and not just an eponym, then conceivably this saying is directed to Semitic Christians, advising them (under circumstances of extreme duress) to worship idols, understood as images of gods and perhaps in addition of Trajan. This very same attitude of outward conformity (but inward resistance) to an idolatrous secular authority Eusebius attributes to Basilides[37] and Agrippa Castor,[38] both second-century personalities, the former an Alexandrian philosopher of religion, the latter his opponent.

In fact within heresiological treatises, this allegation appears with some regularity—Tertullian, Irenaeus, Hippolytus, and Epiphanius all

repeat it—leading one to wonder if it is anything more than a *topos*, a commonplace literary reproach aimed at "heretics." In short, both the person of Elchasai and the saying attributed to him about worship of idols pose formidable critical problems. Given the nature of the evidence, it is wise to suppress inferences concerning the Syrian-Christian worship of the emperor's image in second-century Parthia during a period of persecution.

All that this leaves of apocalyptic sources that fall within our time period is Hippolytus' *On the Antichrist*, a document that Bardenhewer (and numerous others) wanted to connect with the Spartianus' report of an edict against Christianity, traditionally dated to 202. The Severan edict[39] is a fiction, as is Spartianus, although the persecution (possibly 204–206) of Alexandrian Christians is not. The only certitude concerning the date of *On the Antichrist* is that, by his own admission,[40] Hippolytus wrote it after his *Commentary on Daniel*, also an undated document. Furthermore, on the theory[41] (demonstrably false) that apocalyptic literature is invariably the product of real social and political crises, one might be tempted to conclude that both treatises were inspired by the Alexandrian persecution just mentioned, and thus that both belong to the early years of Hippolytus' literary career, which evidently began early in the Roman episcopacy of Zephyrinus (199–217) and extended close to Hippolytus' demise in 235 on the "island of death," Sardinia.

Hippolytus quotes Rev 13:11–18, John's vision of the beast from the land who served the beast from the sea with its seven heads and ten horns (Rev 13:1). In explaining to Theophilus,[42] his addressee, the meaning of this vision, Hippolytus reveals the identity of the two beasts. The second beast from the land he identifies with the kingdom of the Antichrist who rules "after the manner of the law of Augustus, by whom the Roman Empire was established." In chapter 50 of *On the Antichrist* Hippolytus deciphers the infamous cryptogram 666, which the second beast branded on the right hand or the forehead (Rev 13:16) of those who had worshiped the image of the first beast. At the prompting of Rev 13:18, where the apocalypticist reveals that the cryptogram is the number of an individual man, Hippolytus then fixes on this isopsephic equation:[43] 666 = LATE-INOS.

Thus, to paraphrase Hippolytus on this subject, the first beast from the sea is the Antichrist: his name is Latin, his number 666, and his epithet (although Hippolytus does not give it) must be *princeps*. The second beast is the Roman Empire whose ruler gives life to the image of the Antichrist and requires all subjects to worship the image. In short, according to Hippolytus' exegesis, the princeps (not the Imperial flaminate) gives life to the image of himself.

In assigning distinctive roles and identities to the two apocalyptic beasts, Hippolytus' explanation of Rev 13:11–18 lacks clarity. But in another respect, Hippolytus' intended meaning is patent: if the first beast is one man and if his name is Latin, this Antichrist can be none other than the Roman emperor. Which Roman emperor we do not know, nor does it

matter. Hippolytus commits himself here to a position of virulent hostility to the institution of the principate and its rule rooted in Augustan law. A rigorist, an uncompromisingly conservative churchman, and the first anti-pope, Hippolytus comes across here as an intrepid enemy of the Roman order. What prompted his injudicious choice of words we do not know. That it was worship of caesar's image forced upon some Alexandrian Christian (or Christians) is possible, but unprovable.

Apologies

The earliest Christian apologists devote only a few words to the imperial cult image. In commenting on the "tribute money" pericope at Mk 12:13–17, Justin[44] mentions the image once, but his subject is Caesar's portrait on a coin, not the imperial cult image per se. Tertullian[45] admits that Christians refuse to supplicate the imperial images or to swear by the emperors' tutelary spirits ("neque imagines eorum repropitiando neque genios deierando"), and Minucius[46] (closely following Tertullian) mentions the imperial cult image once in a passage where he is at pains to refute the pagan practice of worshiping the emperor's *genius*, which he identifies as an evil spirit or *daimon*:[47]

> The same applies to emperors and kings; they are not honored, as would be right, as great and extraordinary men, but they are flattered and fawned upon as gods, disgracefully and falsely. . . . This is how they [the king's subjects] come to invoke the godhead of such men, to make supplication before their images, to beseech their Genius, that is to say, their daimon [ad imagines supplicant, Genium, id est daemonum eius, implorant].[48]

In all the Christian apologetic literature predating the Decian persecution, only these three passages explicitly mention cult images of caesar, and since Justin's *locus* concerns the numismatic representation of caesar, its importance is secondary.

Only one further text requires brief mention here, a Syriac treatise[49] that purports to represent Melito's *Apology* to Marcus Aurelius. Thanks to Eusebius[50] we have three excerpts from the latter document in Greek, but beyond these testimonies the original text is lost. Based on the Eusebian excerpts it is clear that the Syriac text, which was composed in the fifth or sixth century, does not reproduce Melito's lost *Apology*. Instead, what the anonymous Syriac writer offers is a pseudoapology, an anti-idolatry tract masquerading as an apology.

The internal evidence of this Syriac text does not favor a Lydian (or for that matter, Anatolian) place of composition (Sardis, the capital, was Melito's residence). Instead the Syriac text, which exhibits affinities to the Syriac Aristides[51] and to Jacob of Serug's *Treatise on the Fall of Idols*,[52] points eastward, perhaps to Mabbug. What this Syriac writer has to say about the worship of images of kings is intriguing, including the claim that out of fear pagans pay greater honor to caesar than they do to their former

gods: "both tribute and produce are paid to caesar as to one who is greater than they [the gods]. And on this account those are slain who despise them [the images of caesar?] and thereby diminish the revenue of caesar.[53]

In this way the Syriac writer reverses the common hierarchy that subsumes the worship of caesar (including his *imago*, his *genius*, and his *tyche*) under the umbrella of traditional religion with its devotion to worship of the gods. Our anonymous author alleges that, at least in his world, the worship of the gods had come to be perceived as less efficacious than the worship of caesar. This is an interesting twist, one that is all the more thinkable in a late Roman or early Byzantine context, but it is anachronistic to adduce this anonymous Syriac treatise on idolatry as evidence of apologetic arguments composed by Christians in the pre-Constantinian period.[54]

In short, early apologetic evidence on the subject of the Roman imperial cult image is meager, bordering on nonexistent.[55] The problem for history is to determine why. Clearly, the apologists were aware of the conflicting demands imposed by adherence to the new religion and loyalty to the state evidenced by participation in the imperial cult. But they also managed to enshroud this subject in silence. Why is difficult to determine, since silence in history is like silence in real life, namely subject to multiple interpretations. But certain facts I think point to a probable explanation.

Their message consists in two parts. First, Christians refuse to worship caesar as a god and, second, excepting that qualification, Christians are caesar's most devoted subjects. On the latter point, virtually all of early apologists are at pains to underscore Christian support of the emperor: Christians pray for caesar, they honor him, their loyalty to him is unswerving, and they obey him and his law. One and all, the apologists endorse Paul's emphasis (Rom 13:1–7) on the duty of Christians to support secular authority, and with equal fervor they embrace 1 Tim 1:1–2, the latter recommending to Christians that they pray "especially for kings." In fact, the tone of Christian apology is unabashedly promonarchist, often bordering on sycophancy.[56]

Athenagoras[57] is the most egregious offender in this latter regard, but Tertullian is a close second. Demurrals of a principled nature questioning the appropriateness of monarchy as an institution have no resonance whatsoever in the pages of early Christian apology (or, for that matter, anywhere else in the Patristic *corpus*). One might have expected otherwise.

Since they opposed the Greco-Roman practice of according divine honors to kings, one can imagine that individual Christian writers would have felt the need to make a principled statement of opposition to kingship, and in following these promptings of conscience they could easily have invoked precedents within Israelite tradition, for example Jothams's Fable (Judg 9:7–15) or Samuel's *ex vaticinio* rebuke (1 Sam 8:10–22) of the Solomonic monarchy. As an alternative, the early Christian writers might have recited examples from the tradition of Greek Hellenistic rationalism

(for example, Euhemerism and its cognates), which questioned the appropriateness of venerating men as gods. But in their discussion of Christian attitudes toward the principate, the early apologists did not follow these putative promptings. Instead, like Melito,[58] they intoned paeans of praise to the splendor and glory of Augustus and, like Tertullian,[59] they expounded the Christians' unremitting loyalty to their princeps:

> Without ceasing we offer prayer for all emperors, for their prolonged life, for the security of the Empire, for the protection of the Imperial Household, for brave armies, a faithful senate, a virtuous people, the world at rest, for whatever as a man and caesar the emperor would wish. . . . You who think that we care nothing for caesar's welfare should look into God's words, as they are recorded in our Scriptures: . . . "Pray for kings and rulers and powers. . . ." (1 Tim 2.1–2)

At the same time the apologists admitted that neither they nor their coreligionists could participate in the worship of caesar as a god. They urged their addressees to understand why they could not worship caesar's *imago*, his *tyche*, or his *genius*. In short, they acknowledged and sought to explain why they refused to affirm caesar's divinity.[60] Caesar was not God but a mortal, admittedly an exceptional and distinguished human being, one worthy of great honor and obedience and unswerving loyalty from his subjects. But in the end, as they argued, caesar was beneath God, one of his mortal creatures, a lesser being.

And it is here, precisely in this literary context, namely in the admission of Christian refusal to worship caesar as a god, that we would expect some mention of the emperor's image. But excepting the one passage in Tertullian and Minucius' repeat of Tertullian, none of the apologists fulfills the expectation. Why? The answer, I think, is to be found in that very same constellation of circumstance that inspired the apocalyptic writers to capitalize on the symbolic potential of the imperial image, namely its dramatic, quasi-liturgical evocation of confrontation between good and evil. Of all the apologetic writers, Tertullian and Minucius are closest to the apocalyptic tradition in suggesting that the emperor's image is the locus of an evil *daimon*.

Refusal to worship caesar's image was a powerful outward act of hostility to Rome, a veritable proclamation of nonconformity, an overt act tantamount to *lèse majesté*, hence an act certain to ignite passions and incur extremes of anger. It was a public act, bound to provoke suspicion among Rome's subjects. The new religionists could expect strong countermeasures from the government. For the very same reason that the apocalypticists exploited this symbolic act to the full, because it was inflammatory, the apologists demurred and chose instead the more judicious, the more prudent, the quintessentially apologetic tactic: reticence. It was bad enough to have to admit that Christians would not worship caesar as a god. It was positively suicidal to draw attention to the fact, and refusal to worship the imperial image did just that. This was the kind of negative

public relations that the apologists thought Christians did not need. They were right to think so.

Judicial *Cognitio*

For the pre-Decian period what we know about the role that the imperial image played in the trial and execution of accused Christians comes from two sources of very unequal evidentiary value. The first is Pliny's *Letter* (X.96)[61] to Trajan written in the early second century either from Amasis or Amastris in northern Turkey. Pliny is an unimpeachable witness.

The same cannot be said for our second source of information, the *Acts of Apollonius*, a highly problematic document in all respects. Eusebius[62] knew a version of these *acta*, which survive complete in Greek[63] and Armenian[64] versions. All three witnesses agree that Apollonius was tried at Rome under the reign of Commodus, and Eusebius agrees with the Greek version in calling the presiding magistrate "Perenni[u]s." The Armenian incorrectly calls him "Terentius." Eusebius gives Perennis the title δικαστής, or judge; in the Greek version he is ἀνθύπατος, proconsul, and the Armenian Terentius occupies the office of "prefect." On the presumption that the reference here is to Tigidius Perennis,[65] who was praetorian prefect at Rome between the years 180 or 182 to 185, the Armenian text gives Perennis the wrong name but puts him in the right office.

Paragraph 7 of the Greek *acta* mentions the imperial image: "Perennis the proconsul said: 'Change your mind, Apollo,[66] and do what I tell you: offer sacrifice to the gods and to the image of the Emperor Commodus.' " It is conceivable that these words are roughly faithful to a real command issued by a real magistrate presiding at a real trial of a real Christian in late second-century Rome. It is also possible, some would argue probable, that the whole of the these *acta*, including paragraph 7, is a literary fabrication. In fact, there is no way to decide the issue, and hence the value for our subject of the *Acts of Apollonius* ranks far behind Pliny.

As for the latter's famous *Letter* the relevant details, most of them well known, are briefly as follows. Pliny had received delations (denunciations or complaints), accusing people within his jurisdiction (Bithynia-Pontus) of being Christian. He convened a judicial inquisition or investigation (*cognitio*)[67] to determine if the accusation was true, and while conducting the *cognitio* he succeeded in identifying three categories[68] of defendants: the yeah-sayers (X.96.3), the nay-sayers (X.96.5), and a third group (X.96.6) consisting of defendants who admitted to having been Christians either in the proximate or distant past but who denied (*negaverunt*)[69] they were Christians in the present.

The first category of defendants, the persons who persisted in confessing the name Christian, Pliny had executed on the ground (a judicial anomaly)[70] that they were stubborn ("neque enim dubitabam . . . pertinaciam certe et inflexibilem obstinationem debere puniri"). Since he

did not possess *ius gladii*,[71] the legal right to execute Roman citizens, Pliny sent citzens who belonged to this first category to Rome.

Remaining were the two other categories of defendants, those (X.96.5) who denied they were in the present or ever had been Christians and those (X.96.6) who admitted to having been Christians but claimed they had recanted. It is these two groups[72] that Pliny then submitted to a new(?) test of loyalty evidently devised on the spot and applied in three parts:

1. Following Pliny they had to recite a petitional prayer to the gods ("cum preeunte me deos appellarent").
2. With incense and wine they were required to pray to Trajan's image and to the images of the gods ("et imagini[73] tuae, . . . cum simulacris numinum . . . ture ac vino supplicarent").
3. They had to curse Christ ("maledicerent Christo").

Pliny evidently introduced a new judicial procedure for testing the loyalty of defendants accused of being Christians, and furthermore he had managed to insinuate the imperial image as an integral part of that procedure. He seems to have regarded Trajan's *imago* on an equal footing with traditional religious iconography (*simulacra numinum*)—at least that is the impression conveyed to Trajan.

In his *Letter* (X.97) of reply, an official rescript, Trajan approved the procedure in principle,[74] but he omitted all mention of images in the courtroom. Furthermore, without mentioning worship of his own image, he indicated (X.97.1) that defendants should be made to worship "our gods" ("id est supplicando dis nostris"). The fact that Trajan was silent on the subject of worshiping his own image might be construed as a criticism of Pliny's practice, which allowed the imperial cult to enter the courtroom, but I doubt that this was Trajan's intention nor is it at all likely that Pliny interpreted Trajan in this way. Instead the likely explanation is that Trajan was guided by political expediency: a living *princeps* should exercise conspicuous restraint[75] in promoting the cult of his person—those who had failed to do so, men like Gaius, Nero, and Domitian, were regarded *sub specie damnationis*. Trajan was silent on this subject because good form required it, not because he had any principled objection to the worship of his *tyche*, his *genius*, or his divine person represented in his image.

Thus, within the framework of the familiar *cognitio* procedure Pliny had created something new, and Trajan had approved it. Trajan's rescript ratifying the procedure established a judicial precedent, one in which the imperial image played a conspicuous role. That this judicial precedent became effective and was soon applied elsewhere is indicated by Apuleius who in 158 or 159 at Sabratha defended himself against the charge of magic at a court convened by Claudius Maximus (*PIR*[2] C933), proconsul under Antoninus Pius of the province of Africa. Apuleius delivered his *Apology*, which led to his acquittal, "in the presence of statues [no doubt busts] of Pius" ("ante has imperatoris Pii statuas").[76] The unfortunate and no

doubt unforeseen consequence of this new test was that before 251 in *cognitiones* of Christians Pliny's judicial intention, which was to ensure the loyalty of Rome's provincial subjects, might easily be misunderstood by people who were inattentive to legal detail, as were doubtless most of Rome's subjects worldwide. Christians were no exception.

The truth is that, in its practical application, Pliny's test of loyalty introduced more problems than it solved. The major problem centered on the judicial use of the imperial image to test and enforce the loyalty of Christians. Persons witnessing *cognitiones* of this kind (especially defendants) might easily conclude that Pliny was enlisting the Roman government in the business of actively persecuting Christians, perhaps on the presumption that Christians were engaged in some kind of covert political activity that was anti-Roman and treasonous. As a matter of fact neither the appearance nor the presumption was justified.

Rome was not an active persecutor in Pliny's lifetime, nor would the government adopt this unwise role for another 140 years—that is, not until 251.[77] Nor is there any evidence that the government suspected Christians (or had any reason to suspect them) of treasonable irregularities: Christians remained obedient and dutiful subjects of Rome throughout the pre-Constantinian period. Even so, the public display of the imperial image in a *cognitio* of Christian defendants and the negative Christian reaction to that image must have caused raised eyebrows. And more. The popular mind would leap to the inevitable conclusions: this new superstition must be politically suspect—the government must act to nip it in the bud before the "contagion" spread.[78] The suspicion was not true to fact, as we know, but it is not uncommon, as we also know, for popular perceptions to be carried on the wings of innuendo and untruth.

Under circumstances such as these it is entirely thinkable that individual Christians would have developed a strong dislike of the imperial image. Those Christians, for example, who had denied their faith and had submitted to the humiliation of publicly worshiping caesar's image rather than losing their lives might well have felt shame and repugnance when they happened on the imperial image in the marketplace, the bathhouse, or the amphitheater. In my view this could have been a factor (and probably was) in shaping early Christian attitudes toward art, especially portraiture, but unfortunately, for lack of pre-Decian evidence, we cannot be certain. Most of the answer to this question depends on the extent to which Christians were actually persecuted in the pre-Decian period[79] and on the extent to which the courts intervened and applied Pliny's test of loyalty—the latter became standard procedure after 251, but before that date, as we have just seen, the evidence is exceedingly thin.

Before summarizing, there is one further issue that needs clarification, namely the historical significance of an early Christian iconographic tradition that illustrates the story of the three Jewish boys who refused to worship the gold statue of King Nebuchadnezzar (Dan 3:12–18). In relief sculpture[80] the formal prototype of this tradition is located in a second-

century Roman *officina* (workshop) that produced mythological sarcophagi (in this instance versions of the Pelops-Oenomaus cycle), but in the early Christian context the image has a wider circulation[81] beyond relief sculpture on sarcophagi: it appears not only on sarcophagus fronts and lids but is also attested on wall frescoes in burial places, on gold glasses, ivories, lamp disci, and on North African terra-sigillata vessels.

Invariably, in early Christian renderings of this subject, the king's statue is reduced to the status of a bust (probably inspired by Roman imperial portraits), and the imperial bust is often shown surmounting a columnar pedestal (Figure 4.1). On one side of the pedestal the three youths are usually represented in a standing posture (that is, refusing *proskynesis*), facing front or in a three-quarter view, dressed in short tunics and often wearing Phrygian caps. And on the other side of the column one sees the seated image of the living King, usually pointing with his right hand to the bust of his lord, the latter occupying the visual focus of the scene overall.

Writing in 1913 to celebrate the sixteen hundreth jubilee of the "Edict of Milan," Erich Becker[82] argued that this iconography should be interpreted as a symbol of the struggle (*Kampfsymbol*) between pre-Constantinian Christianity and Rome: it signifies early Christian opposition to

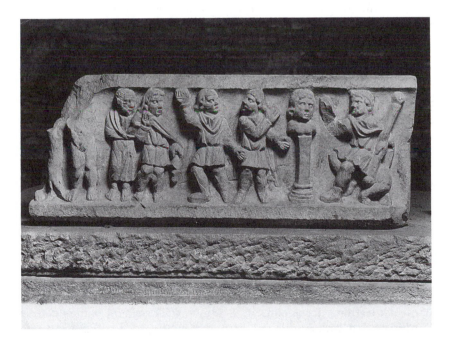

Figure 4.1. Sarcophagus lid: *Rep.* 338 (early fourth century). Three Hebrew youths refusing proskynesis before King Nebuchadnezzar's portrait. *Rome, San Sebastiano.*

the imperial cult. Two distinguished scholars[83] who ought to have known better followed Becker's interpretation. Political exegesis of this iconography is wrong on two counts. First, all the evidence is Constantinian or later (extending into the fifth century): as we have it, none of this iconography can be dated into the so-called Age of Persecution. Second, excepting lamps and terra-sigillata vessels whose archaeological provenience is unknown, iconographic renderings of this subject survive in contexts that are funerary—hence, one must look for interpretations that are first and foremost consistent with attested early Christian thoughts about death and the afterlife. Fourth-century patristic literature is the key: here the story is interpreted primarily as a symbol of resurrection.[84] Nothing forbids secondary levels of meaning. Iconographic renderings of this subject could conceivably have evoked residual political resonances[85] among the fourth- and fifth-century persons who commissioned the subject or who looked at the image, but clearly the primary meaning that attached to the image in a funerary context had to do with Christian beliefs about the afterlife, not politics.

This concludes our rapid review of pertinent evidence. Clearly a collection of sources such as the foregoing, heterogeneous and spotty in the extreme, raises a host of intriguing questions. First in order of importance come the inevitable queries about the founder of the new religion. It is clear that the factionalized Jewish world in which Jesus lived contained several nationalistic-religious groups that vigorously opposed the Roman rule of Palestine and the Roman symbols of oppression that polluted Palestinian soil. Perhaps the most open and visible—hence, the most hated—of those symbols was the imperial cult. Jewish apocalypticists and Jewish nationalists, including especially the Zealots, as well as rigoristically minded sages (Nahum), went to considerable lengths to distance themselves from any and all contact with this detested institution and its appurtenances, temples, priests, altars, statues. If we are to believe Hippolytus, the Essenes should also be counted in this camp.

What Jesus thought about the imperial cult and its image is beyond our knowledge, but that he had some rudimentary knowledge of the subject and an opinion to accompany his knowledge are virtual certainties. He would have passed through Sepphoris[86] often, Tiberias perhaps less frequently. Both were cities in which there was a substantial pagan presence, and in both places he would have been made aware of the fact that the Romans followed the custom of erecting and venerating statues of their gods, their kings, and other prominent people. Surely he knew that many of his Jewish kinsmen viewed imperial Roman iconography with particular loathing. Jesus himself, as the New Testament editors portray him, was a Jew with a profound distrust of gentiles.[87] In other words, on purely circumstantial grounds, it is almost certain that Jesus would have known the basic facts of Roman emperor worship and the Jewish hatred of

this form of idolatry. But none of the New Testament editors makes him out to be a Jew who takes issue with caesar's image or caesar's cult. Why? The most probable explanation, in my view, is that this concern did not fit the literary, theological, or confessional agendas of these several editors. Furthermore, while it is possible that Jesus spoke to this issue during his lifetime, it seems probable that on this subject there were no oral traditions that reached his editors, who, after all, were writing no earlier than 70.

In the end much of this question centers on one's view of Jesus and his teaching. Was he a Jewish nationalist or a Zealot, a sectarian apocalypticist or a rigoristic rabbi? If the answer to any of these is yes, then the imperial image might well have played a role, perhaps even a prominent role, in his beliefs and teachings. But the cluster of literary traditions that provide what we know about him omits all reference to this issue. One could argue that his editors simply whitewashed this aspect of his teaching, but that speculation takes us far afield into the quagmire of conspiracy theories propounded in varying degrees, for example, by Reimarus, Eisler, and Brandon.[88] In the end we can only conclude that the Jesus created by the New Testament editors is a Jew who remained silent on questions concerning Jewish reactions to the imperial cult image. Whether the historical Jesus did the same we cannot know.

As for discussion of the imperial image in apocalyptic and apologetic contexts, once again we are confronted with literary clusters that pose considerable problems of interpretation. The literary importance of the imperial image within the apocalyptic tradition can hardly be overestimated. But the jump from apocalyptic literature to real life is a long one, as those who have tried know: the idea that worship of the imperial image was forced upon persecuted Christians in western Turkey late in the first century (Rev 13:15) or in Trajanic Parthia (Elchasai) or in Severan Alexandria (Hippolytus) must be rejected. Forced worship of the imperial image in early Christian apocalyptic literature is best understood as a literary symbol, one that effectively presents a dramatic scenario of confrontation between a powerful, merciless government imaged as an all-devouring monster and its vulnerable but righteous victims.

The apologists, as we have seen, had relatively little to say about the imperial cult and even less about its image. One of their several literary purposes was to minimize whatever real or perceived conflict existed between Rome and Jerusalem. Refusal to worship caesar's image was an open act of provocation, an inflammatory action that was likely to elicit an unsympathetic response from various sectors of Greco-Roman society, not least from the stated addressees of Christian apology. In view of this fact it makes sense that the writers of the apologetic genre thought it best to let this important subject pass under the cloud of deafening silence with which they blanketed caesar's image.

The crux of the matter centers on Pliny's judicial use of the imperial

image and on the consequences that flowed from his action. While interrogating persons who had been delated for the Christian cause, Pliny introduced the imperial image into the courtroom. This act had real long-term consequences. Once it had been admitted to the courtroom, the image stayed in place and acquired the status of a permanent judicial icon. Nearly three centuries later Severian of Gabala witnesses and justifies its continuous presence:

> Consider how many magistrates [archons] there are over the whole earth. Now, since the emperor cannot be present to all of them, [instead] the emperor's image must be present in courtrooms, marketplaces, public halls, and theaters. The image must be present in every place where a magistrate exercises his power so that his actions are endowed with authority. For, since he is a man, the emperor cannot be present everywhere.[89]

At the very least, to the Christian mind Pliny's action was guaranteed to intensify perceptions of Rome as a persecutor. But it is not surprising that Christians writing before 251 wanted to draw public attention away from Christian refusal to worship the imperial image.

It is a reasonable speculation (I think a necessary one) that the prominence of the imperial image in *cognitiones* of Christians could have exercised a dampening effect on Christian attitudes toward public art in general, or at the very least toward portraits (political or otherwise) that were pressed into cultic usage. Clearly this putative dampening did not extend to all forms of visual art: from the early third century onward Christians were engaged in the production of noncultic images to adorn their underground burial spaces and, shortly thereafter, their holy places[90] above ground. But the absence of portraits, for example of Jesus[91] and Mary and the apostles, is indeed a striking feature of pre-Constantinian Christian art. The only possible exception consists in the painted portraits (originally twelve in number: apostles? Figures 4.2, 4.3) in the north lower chamber of a Severan-Roman hypogeum[92] in the Viale Manzoni, the so-called Tomb of the Aureli. But the Christian identification of these figures is problematic.

Roman Christian developments (and cognates elsewhere) in the creation of a symbolic pictorial language designated for the walls and ceilings of underground tombs proceeded apace over the entire course of the third century. A Christian tradition of relief sculpture took root in an unknown Roman pagan workshop (or workshops) at the middle of the century.[93] But still throughout this century the heroes of the Christian story, whether represented in two or three dimensions, continued to make their appearance under the guise of generic figures, namely shepherds, philosophers, magicians, and fishermen. Why do we have no third-century Christian portraits of Jesus and Mary, of Paul and Peter? Perhaps it is Pliny who drove the coffin nail into a pictorial tradition that could have blossomed but did not. It required the liberating influence of the Constantinian epoch to allow this dormant tradition to come alive.

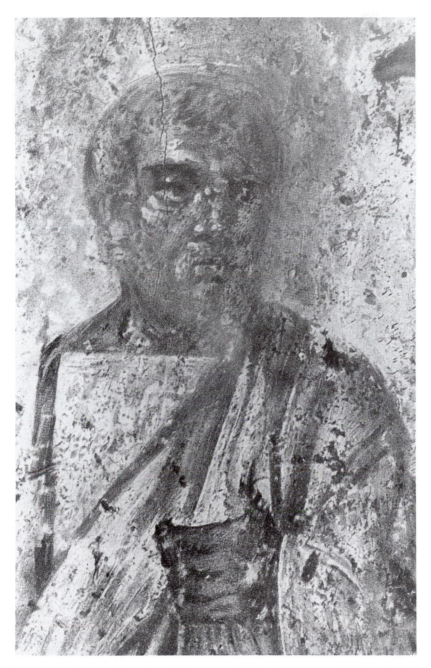

Figure 4.2. Tomb of the Aureli. Lower north chamber, west wall. Portrait detail. *Rome, Viale Manzoni.*

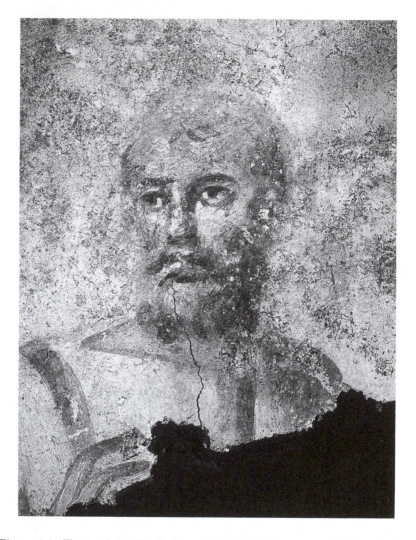

Figure 4.3. Tomb of the Aureli. Lower north chamber, west wall. Portrait detail.

Notes

1. J. R. Knipfing, "The Libelli of the Decian Persecution," *HTR* 16 (1923), 345–90.

2. As observed (see n. 88) by Severian of Gabala.

3. M. Stuart, "How were imperial portraits distributed throughout the Roman Empire?" *AJA* 43 (1939), 601–17; also S. R. F. Price, *Rituals and Power* (Cambridge, 1984), 173, n. 13.

4. The literature on this threefold subject is large. Manufacture and distribution: E. H. Swift, "Imagines in Imperial Portraiture," *AJA* 27 (1923), 286–301; M. Stuart, "How Were Imperial Portraits Distributed," 601–17; P. Zanker, *Prov-*

inzielle Kaiserporträts. Zur Rezeption der Selbstdarstellung des Princeps (Munich, 1983). Political ideology: H. Kruse, *Studien zur offiziellen Geltung des Kaiserbildes im römischen Reiche* (Paderborn, 1934); A. Alföldi, "Die Ausgestaltung des monarchischen Zeremoniells am römischen Kaiserhof," *RM* 49 (1934), 3ff.; Paul Zanker, "Prinzipat und Herrscherbild," *Gymnasium* 86 (1979), 353–68; "Zur Funktion und Bedeutung griechischer Skulptur in der Römerzeit," in *Fondation Hardt. Entretiens 25,* ed. H. Flashar (Geneva, 1979), 283ff.; *Augustus und die Macht der Bilder* (Munich, 1983) (*The Power of Images in the Age of Augustus,* trans. Alan Shapiro [Ann Arbor, Mich. 1988]; reviewed by A. Wallace-Hadrill, *JRS* 79 [1989], 157–64).

5. For example, the remarkable gold bust of Marcus Aurelius from Didymoteichon presently on exhibit in the Komotini municipal museum; see A. Vavritsas, *AAA* 1 (1968), 194–97; G. Lahusen, "Goldene und vergoldete römische Ehrenstatuen und Bildnisse," *RM* 85 (1978), 385–96 (and the older literature cited there).

'6. E.g., D. B. Harden, *Glass of the Caesars* (Milan, 1987), no. 1, green-glass portrait bust of Augustus; no. 2, blue-glass medallion with an imperial subject; nos. 3 and 4, blue-glass miniature portrait busts, imperial subjects.

7. Parallels: Mt. 22:15–22; Lk 20:20–26; Logion 100, *Gospel of Thomas* (fourth century, Sahidic Coptic); a Greek fragment, probably mid-second century of an *Unknown Gospel,* Egerton Papyrus 2 = van Haelst 586); cf. C. H. Roberts and T. C. Skeat, *The Birth of the Codex* (London, 1985), and J. van Haelst, *Catalogue des papyrus littéraires juifs et chrétiens* (Paris, 1976), no. 586, (with the literature cited there). Exegesis: H. L. Strack and P. Billerbeck, *Kommentar zum neuen Testament aus Talmud und Midrasch,* vol. 1 (Munich, 1926; rpt., 1956), 883ff.; G. Loewe, *Render unto Caesar; Religion and Political Loyalty in Palestine* (Cambridge, 1940); and D. Daube, "Four Types of Questions" *JThS,* n.s., 2 (1945), 45ff.; C. W. Hedrick, "Thomas and the Synoptics: Aiming at a Consensus," *SC* 7.1 (1989–90), 39–56 (with the literature cited there).

8. *Captatio benevolentiae:* Mk 12:14, "Teacher we know that you are true, and care for no man [i.e., we know you are an impartial judge] for you do not regard the position of men, but truly teach the way of God"; cf. Strack and Billerbeck, *Kommentar,* 883. οὐ γὰρ βλέπεις εἰς πρόσωπον ἀνθρώπων, . . . is unidiomatic in Greek and renders: ܪܠܝܪ ܠܒ ܪ ܪܐܐܝ ܚܦܐ ܒܘܪ ܝܪܘ ܝܠ ܪܠ *The New Testament in Syriac,* ed. R. Kilgour (London, 1919, rpt., 1966) ad loc. Loewe, *Render unto Caesar,* 103–06, thinks there were originally two sources, one concerning impartiality, the other concerning the admissibility of Jews looking at pagan coins, and he believes the conflation of these two led to the question put to Jesus in Mk 12:14. Loewe translates the Syriac as "gaze at the faces of people," but "give heed to the persons of men" is both idiomatic and makes better sense. Loewe's conjecture requiring the conflation of two originally independent sources is textually superfluous.

9. The Gospel pericope suggests the tax was called *census* (κῆνσος), which is inaccurate. A census was the basis from which the tax was levied, but the tax itself was universally known as *tributum capitis* (cf. W. Schwahn, *RE* 7.A1 [1939], s.v) not to be confused with Τὸ Ἰυδαϊκὸν Τέλεσμα which was gathered into the *fiscus judaïcus.* Judaean imposts and their Hebrew/Aramaic equivalents: (poll tax) M. Dessau, *ILS* nos. 1519; 2683: (*tributum capitis*); M. Rostovtzeff, in *RE* 6.2 (1909), 2403–4 (fiscus judaïcus); J. Juster, *Les juifs dans l'Empire Romain,* vol. 2 (Paris, 1914), 279ff., and M. Stern, "The Province of Judaea," in *CRINT* I.1 (Philadelphia, 1974), 330–35.

10. H. Mattingly, *Coins of the Roman Empire in the British Museum*, vol. 1 (London, 1923; rpt., 1965), 124ff., pl. 22/22, 23. Discussion by Mattingly: *Roman Coins* (London, 1960), 139ff. Denarii were not struck on Palestinian soil. As part of the policy of centralization inherited by Tiberius, gold and silver issues were concentrated at the Lyons mint. According to the Marcan narrative, neither Jesus nor his Jewish interlocutors had the coin on his person—it had to be fetched, meaning the coin, no doubt a Lyons denarius, was not so common as *aes* coinage, the regional bronzes and coppers used by provincials in daily transactions.

11. Excepting a Tiberian sequence of half-*aureii*, dated 15–37, the gold and silver Lyons issues all bore this same reverse type.

12. *Nezikim* (eighth subject, fourth order); cf. H. Blaufuss, *Götter, Bilder und Symbole nach den Traktaten über fremden Dienst* (Nuremberg, 1910); Strack and Billerbeck, *Kommentar*, 4.1, 385ff.; E. E. Urbach, *IEJ* 9 (1959), 149ff., 229ff.

13. Urbach, *IEJ* 9 (1959), 149ff., 229ff.

14. *Refutatio* 9.26.1, 2 (ed. P. Wendland, *GCS* 26 [Leipzig, 1916], 260); cf. M. Smith, "Essenes in Josephus and the Philosophumena," *HUCA* 29 (1958), 273ff.; G. J. Blidstein, "R. Yohanan, Idolatry and Public Privilege," *JSJ* 5 (1974), 161; also *Josephus* 9 (ed. L.H. Feldman, LCL 433, [Cambridge, Mass., 1965], appendix D, 561–63). My thanks to Gerald Blidstein for discussing this subject (per litteras) with me.

15. Nahum bar Simai: Urbach, *IEJ* 9 (1959), 152ff.

16. A total of 561 coins was discovered; cf. R de Vaux, *RB* 63 (1956), 567ff. A selection (153 of them, held in the Rockefeller Museum) was published by Marcia Sharabani in *RB* 87 (1980), 275ff. Publication of the complete corpus, begun by the late A. Spijkerman, is being prepared by Robert Donceel of Louvain.

17. In common usage, an ἀνδριάς is an honorific image set up in a public place to honor men and women; typically it is synonymous with εἰκών. In the literary and epigraphic evidence from the Athenian agora, for example, agalma is limited to divine figures, whereas fifty-five known honorary statues of men and women are denominated *eikones, chalkous/chalkai, andriantes*, but never *agalmata*; e.g. D. Chr., *Orat.* 31.9: ὅταν γὰρ ψηφίσησθε ἀνδριάντα τινί ("whenever you vote an honorary statue for someone"); also *Orat.* 31.47, 57, 83, 89, 95, 96, 98, 105, 147, 152, 153–54, 156; at 31.125 and 154 Dio uses *andriantes* and *eikones* interchangeably. But there is no consistency from one author to the next. Paus. 6.11.8, 9 uses *eikon, andrias*, and *agalma* interchangeably. In fact, *andriantes* of the Imperial period are attested: Price, *Rituals and Power*, 177, n. 31; also R. S. Stroud, *Hesperia* 48 (1979) 193: for Euagoras, king of Salamis 435–374/373 B.C., we should expect *andrias* or *eikon*, but not *agalma*. On the various compounds (e.g., *andriantopoios*): M. Fränkel, *De verbis potioribus quibus opera statuaria Graeci notabant* (Leipzig, 1873), s.v.; also E. Reisch, in *RE* 1 (1894), 2141. Christian use of *andriantopoietikos*: Athenag., *Leg.* 17.4; Eus., *PE* 1.9.13 *andriantoplasia*: Epiphan., *Haer.* 3, and 25.4

18. Essene gate: Jos., *JW* 5.145; cf. R. de Vaux, *Archaeology and the Dead Sea Scrolls*, 2d ed. [London, 1973], 18ff., and *The Temple Scroll*, vol. 1, ed. Y. Yadin (Jerusalem, 1983), 303–4: the Essene gate must have been located somewhere in the southwestern sector of the City.

19. Civic priests of individual emperors or of the Sebastoi: F. Geiger, "*De sacerdotibus Augustorum municipalibus*" (Diss., Phil. Halle 23.1, 1913); Magie, *RRAM* 2.1356ff.; on a ζάκορος τῶν θείων εἰκόνων, cf. L. Robert, *Opera Minora Selecta* 2 (Amsterdam, 1969), 832ff.

20. Rev 1:9: Patmos, a Roman penal colony in the southern Sporades is the traditional place of composition. Date: S. Giet, *L'apocalypse et l'histoire* (Paris, 1957), 50–69.

21. Rev 14:9, 11, 15:2, 16:2, 19:20, 20:4.

22. For a brief, intelligent description: Bonner, *SMA*, 15–17; also Th. Hopfner, *Griechisch-Ägyptischer Offenbarungszauber*, vol. 1 (Leipzig, 1921), 808–12: Porphyry, Iamblichus, Numenius, *Orphica*, magical papyri, *Hermetica*, Proclus.

23. Hipp., *Ref.* 4.41.1, 2; cf. P. Ganschinietz, *Hippolytus Capitel gegen die Magier. Refutatio Haeresium 4.28–42*, *TU* 39.2 (Leipzig, 1913). Eus., *HE* 9.3.1: on Theoteknos, an Antiochene minister of finance who may have used talking statues to eliminate Christians; Thdt., *HE* 5.22.1–6: Theophilus of Alexandria oversees the dismantling of hollowed-out wood and bronze reliefs. On a bust (Ny Carlsberg 416) of Epicurus, with holes drilled through the eyes and nostrils and possibly used for magical cures: F. Poulsen, "Talking, Weeping and Bleeding Sculpture," *AcA* 16 (1945), 178ff. (important but very speculative in parts).

24. Luc., *Philops.* 26.12 cf. Nilsson, *GGR* 2:472–75; also A. D. Nock, *CQ* 22 (1928), 160–62.

25. Magie, *RRAM* 1.576ff.; S. Gsell, *Essai sur le règne de l'Empereur Domitien* (Paris, 1894), 50ff., 75ff., 238ff.; M. Charlesworth, "Some Observations on Ruler-Cult Especially in Rome," *HTR* 28 (1935), 32ff.; J. Beaujeau, "Les apologistes et le culte des souverains," *Fondation Hardt. Entretiens 19*, ed. W. de Boer (Geneva, 1972), 107, 166: Beaujeau represents the older and no longer tenable view maximizing Domitian's abuse of power and failing to distinguish between his role in the provinces and his unsuccessful efforts at home, also representing Domitian as a persecutor of Christians, for which there is no reliable evidence; on the latter, cf. T. D. Barnes, *JRS* 58 (1968), 35, 36.

26. Barnes, *JRS* 58 (1968), 35, 36; also E. M. Smallwood, "Domitian's Attitude toward Jews and Judaism," *CP* 51 (1956), 1ff.

27. Thus A. Y. Collins, *Crisis and Catharsis: The Power of the Apocalypse* (Philadelphia 1984), 84–107: interesting (mainly sociological) speculations on the nature of the perceived crisis.

28. R. H. Charles, *The Ascension of Isaiah* (London, 1900); A. Dillmann, *Ascensio Isaiae* (Leipzig, 1877). Charles and Dillmann were at odds in the definition and interpretation of this document. For Charles it occupied 3:13b–4:18 of the *Testament* and was to be regarded as an independent whole added on by a Christian editor in the second or third century. Dillmann identified the *Ascension of Isaiah* under vss. 3:13-5:1 plus 1:3, 1:4a, 1:5, 1:15, 16, 11:2–22, 41 of the *Testament*, and he regarded all of the *Ascension* as a second-century Christian interpolation of the Jewish *Grundschrift*. Harnack, *Gesch.* 2.1:573ff., followed Dillmann's source analysis but thought the interpolations must be a product of the third century. To further confuse the issue von Harnack called the *Ascension* "Visio apocalyptica"; for a new translation, critical discussion and recent literature, cf. M. A. Knibb, "Martyrdom and Ascension of Isaiah," in *The Old Testament Pseudepigrapha*, vol. 2, ed. J. H. Charlesworth (Garden City, N.Y., 1985), 143–76.

29. *Terminus a quo*: 68 (Nero's death); *terminus ad quem:* the author of 4 Bar 9:18,20 (possibly early second century) appears to know chapters 1–5 of the *Ascension of Isaiah* in their Christian form. Thus the probable date: late first century; cf. Knibb, "Martyrdom," 149–50.

30. Variants in Greek: Belicheiar, Belcheira, Becheira, Becheiras, Melcheira; in Latin: Belchiar; (Geëz) Belkira, Abkira, Balkira, Belakira, Malkira, Melkira,

Milkiras, Ibkira. The literary context is clearly 1 Kings 22, concerning Zedekiah, son of Chenaan, one of the chief prophets of Baal. Etymologically, Belcheira/Belchiar/Belkira is probably derived from *baal keras* ("baal of the horns"), on which see V. Burch, *JThS* 21 (1920), 249. On horned baalim: K. Hadjioannou, in *Mission Archéologique d'Alasia*, vol. 4, ed. Cl. F.-A. Schaeffer (Paris, 1971), 33–42; also 505ff. on African horny baals: D. Harden, *The Phoenicians* (London, 1962), 82, 87, 94 (Baal Hammon on Djebel bou Karnein, Carthage).

31. 1 Jn 2:12, 22; 4:3; 2 Jn 7:2; 2 Thess 2:3–10. *Orac. Sib.* 3.63–76; 5.363 (μητροκτόνος ἀνήρ); 8.71, 145 (ὁ φυγὰς μητροκτόνος); also 4.119–24. Nero committed suicide in 68. Shortly thereafter it was rumored that he had not died but had fled to the east. Rev 13:3 refers to his violent death, and in Rev 17.10, 11 he is seen as the eighth king who will return and is depicted as the Antichrist, a dying and rising marauder, a literary antitype of the Lamb; cf. Collins, *Crisis and Catharsis*, 59.

32. In his *Historiarum Compendium*, George Cedrenus quotes this passage; see *CSHB:* Georgius Cedrenus I, ed. E. Bekker (1838), 120.

33. Nero ruled 54–68, and hence does not fit this description. Caligula (C. Iulius Caesar Germanicus) occupied the throne from 18 March 37 to 24 January 41. At *Testament* 4.12 the apocalypticist may have Caligula in mind.

34. Magie, *RRAM* 2.1367, n. 47; M. Stern, "The Herodian Dynasty and the Province of Judea at the End of the Period of the Second Temple," in *The World History of the Jewish People*, vol. 1.7, ed. M. Avi-Yonah (New Brunswick, N.J., 1975), 137, n. 32.

35. Sources: A. Hilgenfeld, *Novum Testamentum extra canonum receptum* 3.2.2 (Leipzig, 1881), 227–40; Harnack, *Gesch.* 1.1: 207–9; 2.2:167–68; E. Hennecke and W. Schneemelcher, *New Testament Apocrypha*, vol. 2 (Philadelphia, 1964), 745ff. For a reconstruction drawing on Manichaean sources: L. Cirillo, *Elchasai e gli Elchasaiti* (Calabria, 1984).

36. Epiphan., *Haer.* 19.1.7ff.

37. *HE* 4.7.7: "He [Basilides] taught that there was no harm in eating things offered to idols, or in lightheartedly denying the faith in times of persecution." The fragments of Basilides are collected and presented in English translation by B. Layton, *The Gnostic Scriptures* (Garden City, N.Y., 1987), 422–44. In his "The Significance of Basilides in Ancient Christian Thought," *Representations* 28 (1989), 140, Layton correctly observes that nothing in Basilides' writings supports the view that he encouraged Christians to apostatize instead of dying for their faith; e.g., frag. G (from Clem. *Strom.* 4.83.2): "Actually Basilides' presupposition is that the soul previously sinned in another life and undergoes its punishment in the present one. Excellent souls are punished honorably, by martyrdom; other kinds are purified by some other appropriate punishment."

38. Eus., *HE* 4.7.7–8; cf. Harnack, *Gesch.* 2.1:290, 701.

39. *HA:* Severus 17.1: "Iudaeos fieri sub gravi poena vetuit. idem etiam de Christianis sanxit"; also Eus., *HE* 6.1.1, 6.2.2; cf. K. Schwartz, *Historia* 12 (1963), 185ff., and T. D. Barnes, *JRS* 58 (1968), 40, 41 and *Historia* 16 (1967), 87ff.; W. H. C. Frend, *JThS*, n.s., 25 (1974), 333ff. (Frend thinks Spartianus' report is reliable).

40. Hipp., *Dan.* 4.7.1 and 4.13.1. Bardenhewer's judgment represents the consensus:"Die Abfassung [i.e., of the *Daniel Commentary*] ist sehr wahrscheinlich mit der hochgradigen Erregung in Verbindung zu bringen, welche sich unter Kaiser Septimius Severus mancher christlichen Kreise bemächtigte" in Bard., *Gesch.*, 2:574.

41. J. G. Gager, *Kingdom and Community: The Social World of Early Christianity* (Englewood Cliffs, N.J., 1975), 27.

42. Identity of Theophilus (perhaps an Alexandrian Christian?): K. J. Neumann, *Hippolytus von Rom in seiner Stellung zu Staat und Welt* (Leipzig, 1902), 11.

43. Isopsephy is common in several ancient literary/documentary contexts, especially in magical papyri and inscribed amulets. The most well known example is ABRASAX/ABRAXAS, which has the numerical equivalent of 365. The most striking instance of this phenomenon, common on Harpocrates amulets, is CHABRACH PHNESCHER PHICHRO PHNURO PHOCHO BOCH = 9999; see G. Zoega, *Catalogo del Museo Borgiano in Velletri* (Florence, 1878–80), 441 (appears as vol. 3 of *Documenti inediti per servire alla storia dei musei d'Italia, pubblicati per cura del Ministero della pubblica istruzione*). Greek APNOYME (from ἀρνέομαι, to deny) = 666; see n. 68 on Lyonnaise Christians who denied their faith.

44. I *Apol.* 17.2–3; cf. Tert., *Idol.* 15.3: ". . . reddite, ait, quae sunt Caesaris Caesari, et quae sunt dei deo, id est imaginem Caesaris Caesari, quae in nummo est, et imaginem dei deo, quae in homine est ("render to Caesar the things that are Caesar's and to God the things that are God's. He [Jesus] meant that the image of the emperor, which is on the coin, should be rendered to the emperor and the image of God, which is in man, to God").

45. *Nat.* I.17.2 *Apol.* 32.2: "Christians do not swear by the emperors' genii but by their safety [quae est augustior omnibus Geniis] . . . their genii are really *daimones"; Apol.* 33.13ff.: "I shall never call the emperor god"; *Apol.* 34.1ff.: "the founder of the empire Augustus refused even the name 'Lord' [*dominus*] . . . but I am willing to give him this name . . . but not when I am forced to call him 'Lord' in place of God"; 34.4: "it is the invocation of a curse to call caesar God before his death." 34.4 appears to imply that so denominating caesar after his apotheosis was acceptable (?) in Tertullian's view.

46. Min., *Oct.* 29.5.

47. Middle Platonism is the background for the second- and third-century apologists' understanding of *daimones*. Plutarch is the most important single source of information, followed in order of importance by Maximus of Tyre, Apuleius, and Celsus. Hopfner's commentary on chapters 25–31 of Plut., *Is. Osir. (Mor.* 351C–384C) is still a useful introductory compendium of testimonies: Th. Hopfner, *Plutarch über Isis und Osiris,* vol. 2 (Prague, 1941; rpt., 1974), 112–46. Essential: R. Andres, "Daimon," in *RE* Suppl. 3 (1918), 267–321, and the recent revisionist study by F. E. Brenk, *In Mist Apparelled: Religious Themes in Plutarch's Moralia and Lives* (Leiden, 1977), e.g. 112: "In short, Plutarch did not concern himself much with the intrusion of the daimonic into human life, and his humanitarian nature was offended by certain aspects of daimonological interpretation." For Christians all *daimones* are evil; they denominated good spirits as *angeloi*, on which see the excellent article, "Geister. C.III. Apologeten u. lateinische Väter" by P. van der Nat in *RAC* 9 (1976), 715–61.

48. Min., *Oct.* 29.5; Minucius is following Tertullian's response (*Apol.* 28–35) to the accusation that Christians commit treason by not worshiping Caesar. At *Apol.* 29.2 Tertullian repeats the standard rationalistic complaint normally made with reference to the images of the gods, but here he applies it to imperial statues: they are supposed to function as protective objects, places of refuge, but in reality the statues are nothing of the sort as revealed in the fact that they need to be protected by caesar's guards.

49. Syriac text: *Spicilegium Solesmense,* vol. 2, ed. J. B. Pitra (Rome, 1855),

lviii–liii; reprinted in Otto, *Corp. Apol.*, vol. 9, 497–512; see Th. Ulbrich, "Die pseudo-melitonische Apologie," in *Kirchengeschichtliche Abhandlungen*, vol. 4, ed. M. Skralek (Breslau, 1906), 67–148: Ulbrich thought (wrongly) that Bardaisan could have composed this treatise. Refutation of Ulbrich: F. Haase, *Zur bardesanischen Gnosis*, *TU* 34.4 (Leipzig, 1910), 67–72.

50. Eus., *HE* 4.26.5 (frag. 1); 4.25.6 (frag. 2); 4.25.7–11 (frag. 3); also Jerome's translation of Eusebius' *Chronicle* (Romanorum A.D. 170), ed. R. Helm, *GCS* 47 (Berlin, 1956): "Antonino imperatori Melito Asianus Sardensis episcopus Apologeticum pro XPianis tradidit."

51. Syriac Aristides (MS.Cod.Sinaïticus Syr.XVI, seventh century): C. Vona, *L'Apologia di Aristide, Lateranum* 16 (Rome, 1950) with Italian and German trans.: R. Raabe, *TU* 9.1 (Leipzig, 1893). English trans.: J. R. Harris, *TS* 1.1 (1891). According to Eusebius (*HE* 4.3.3), Aristides addressed his *Apology* to Hadrian, probably during the Emperor's first Athenian winter, ca. 125–26, but the Syriac Aristides addresses both Hadrian (near the bottom of folio 56r) and (ungrammatically: in forms that cannot be construed as either vocative or the dative) "Caesar Titus Hadrian Antoninus," i.e. Antoninus Pius early in his reign (138–161); the latter is surely an interpolation (erroneous) committed by a fourth-century scribe; cf. G. C. O'Ceallaigh, "'Marcianus' Aristides on the Worship of God," *HTR* 51 (1958) 227ff. Greek fragments: OxyPap 15.1778 and BM.Pap.Inv.No. 2486; on the latter: H. J. M. Milne, *JThS* 25 (1923–24), 73–77. The medieval Greek text (embedded in the *Life of Barlaam and Joasaph* [or *Josaphat*]): J. R. Harris and J. A. Robinson, 1.1, 2d ed. (1893). Armenian frag.: J. B. Pitra, *Spicilegium Solesmense*, vol. 4 (Paris, 1883), 6ff., 282ff.

52. Syriac text: M. l'Abbé Martin, "Discours de Jacques de Saroug sur la chute des idoles," *ZDMG* 29 (1875), 107–47; corrections and variants: B. Vandenhoff, "Die Götterliste des Mar Jakob von Sarug in seiner Homilie über den Fall der Götzenbilder," *OC*, n.s., 5 (1915), 234–62; German trans.: ed. P. S. Landesdorfer, *BKV* 6 (1913), 158–83.

53. Eng. trans.: Wm. Cureton, *Spicilegium Syriacum* (London, 1855), 43, line 10ff.

54. Thus J.-M. Vermander, "La parution de l'ouvrage de Celse et la datation de quelques apologies," *RÉAug* 18 (1972), 33–36: Vermander thinks (wrongly) that Celsus knew the Syriac Apology, presumably in its Greek form, and was engaged in refuting it. Bowersock correctly doubts the connection, but he does not reject it outright; G. Bowersock, "The Imperial Cult: Perceptions and Persistence," in *Jewish and Christian Self-Definition*, ed. B. F. Meyer and E. P. Sanders (Philadelphia, 1982), 175, n. 22. For Beaujeu the Syriac text is "selon toute probabilité, anterieur à la publication du Discours véritable de Celse en 178": Beaujeu, "Les apologètes et le culte des souverains," 113.

55. Bowersock, "Imperial Cult," 175: the apologists have "almost nothing" to say about the imperial cult.

56. In this regard, on the Athenian Athenagoras, representing the so-called Christian wing of the Second Sophistic and following the epideictic directives of *Logos Prosphonetikos* (as exemplified, e.g., by Menander the Rhetorician), see W. R. Schoedel, "In Praise of the King: A Rhetorical Pattern in Athenagoras," in *Disciplina Nostra: Essays in Memory of Robert F. Evans*, ed. D. F. Winslow (Philadelphia, 1979), 69–90. On the Imperial Oration (Basilikos Logos): Men. Rhet., *Diaer.*, Treatise II, 76ff. Many other examples from Isocrates (438–336 B.C.) onward: T. C. Burgess, "Epideictic Literature," *ChicSCP* 3 (1902), Index, s.v. On

appeals to the emperor (of which Christian apology is a prime example) from philosophers and other men of learning and importance: F. Millar, *The Emperor in the Roman World* (*31 BC–AD 337*) (Ithaca, N.Y., 1977), 465–549; also W. R. Schoedel, *HTR* 82 (1989), 55–78.

57. On his use of logos basilikos, see Chapter 2, n. 53.

58. Eus., *HE* 4.26.7–11 (frag. 3 of the lost *Apology* to Marcus).

59. Tert., *Apol.* 30.4; 31.1, 3.

60. Aristides repeats at length commonplaces about the folly of worshiping men as gods (Euhemerus) or gods who are nothing more than the personification of god's gifts to humankind in the form of nature's bounty, earth, water, fire, wind, and sun (Prodicus, Persaeus), but he does not mention either the worship of the emperor or his image. In the surviving fragments (see n. 49) of his *Apology*, Melito also omits the subject, as do Tatian, Athenagoras, and Clement, all of them impugning at length images of gods and divinized men, but not of the emperor. Otherwise the apologists who address the subject of honoring caesar but not worshiping him are as follows: Theophil.: *Autol.* I.11, III.14; Just.: I *Apol.* 17; Tert.: *Apol.* 10, 28–36, 39; *Nat.* I.17; *Scap.* 2; *Fug.* 2; *Idol.* 15; Min., *Oct.* 24.1, 29.5; Orig., *els.* 8.65, 67, 73.

61. Plin. *Ep.* commentary: A. N. Sherwin-White, *The Letters of Pliny* (Oxford, 1966).

62. Eus., *HE* 5.21.2–5. Eusebius' account: under Commodus, Apollonius, famous among Christians for his *paideia* and *philosophia*, was accused by one of his servants. At the start of the trial the servant's legs were broken, because of an Imperial decree requiring that delators be killed. Perennis, the presiding magistrate, entreated Apollonius to present his defense before the Senate, which he did. On the basis of an "ancient law" (ἀρχαίου παρ᾽ αὐτοῖς νόμον) stipulating that execution was the unavoidable punishment for defendants who could not change the mind of the Senate, Apollonius was decapitated; see T. D. Barnes, *JRS* 58 (1968), 40: the Imperial decree and the ancient law, respectively on delators and delated, are both fictions.

63. Greek text: *Ausgewählte Märtyrerakten*, ed. R. Knopf, G. Krüger, and G. Ruhbach, 4th ed. (Tübingen, 1965), 30–35.

64. Eng. trans.: F. C. Conybeare, *Monuments of Early Christianity* (London, 1894), 35–48; recent literature: E. Ferguson, in *EEC*, s.v.

65. *PIR* 3.146; cf. F. Grosso, *La lotta politica al tempo di Commodo* (Rome, 1964), 139ff., 190ff.

66. The Greek text consistently calls him "Apollos," no doubt at the prompting of Acts 18:24 and 19:1 (cf. 1 Cor 1:12, 3:4–11, 22; *Titus* 3.13). The preface of the Greek *acta* makes the biblical connection extremely probable, thus *Acta Apollonii*: Ἀπολλὼς δὲ ὁ ἀποστολος, ἀνὴρ ὢν εὐλαβής, Ἀλεξανδρεὺς τῳ γένει, φοβούμενος τὸν κύριον, . . . and *Acta Apostolorum* 18.24: Ἰουδαῖος δέ τις Ἀπολλὼς ὀνόματι, Ἀλεξαωδρεὺς τῳ γένει, ἀνὴρ λόγιος . . . δυνατὸς ὢν ἐν ταῖς γραφαῖς. Eusebius (*HE* 5.21.2) calls him "Apollonios," which is probably correct.

67. In his "Why Were the Early Christians Persecuted?" *PP* 26 (1963), 15, G. E. M. de Ste. Croix writes "that the standard procedure in punishing Christians was 'accusatory' and not 'inquisitorial.'" This is false. One would have thought the point well enough established to have required no further debate: Mommsen, *Straf.*, 148, 340–46. Technically *cognitio* was an administrative procedure although it subscribed judicial precedents. In a criminal *cognitio* the presiding magistrates'

adjudication had to be in line with criminal precedents in so far as they existed. In both civil and criminal jurisdictions, consistent with the *leges actiones* or formulary system, *quaestio* procedure was accusatory, meaning it was the accuser's responsibility to initiate (by summons, and enforcement of the summons, if necessary) the prosecution of the defendant and to conduct the prosecution in the presence of the presiding magistrate. On the evidence as we have it, *quaestio* procedure is clearly inapplicable to delated Christians (excepting perhaps the trial of Apollonius, where the procedures as described by Eusebius are unbelievable). In *cognitiones* of Christians, such as Pilate's of Jesus and Pliny's of unnamed defendants, which were inquisitorial proceedings conducted outside of the *ordo* (*extra ordinem*), the authorized magistrate alone inquired into the facts of the accusation and served up his adjudication, or as an alternative, due to overload of the court system and related exigencies, he might have delegated the case to another judicial authority (*iudex pedaneus*) who would then have conducted the trial in the very same manner; on *iudex pedaneus*: Mommsen, *Straf.*, 248. On *cognitiones extra ordinem* the jurists who use the term are late: Macer, *Dig.* 48.15.15, §1 "Qui hodie de judiciis publicis extra ordinem cognoscant"; Ulp., *Dig.* 48.19 ". . . praefecti [or] praesides, qui extra ordinem cognoscunt . . ."; idem, *Dig.* 47.19.2; cf. H. Jolowicz, *Historical Introduction to the Study of Roman Law* (Cambridge, 1967), 179, 406–8.

68. R. Freundenberger, *Das Verhalten der römischen Behörden gegen die Christen im 2. Jahrhundert*, Münchener Beiträge zur Papyrusforschung und antiken Rechtsgeschichte 52, (Munich, 1967).

69. On the phenomenon of Christians denying (ἄρνησις) their faith in a time of trouble, Eusebius provides several examples in his account of the massacre at Lyons, which is thought to have taken place late (177) in the reign of Marcus; *HE* 5.1, 33, 45, 46, 48, 50; e.g., 5.1.46: οἱ πλείους τῶν ἠρνημένων ("the majority of those who denied [their faith]").

70. In fact there were two judicial anomalies at work in Pliny's court: first, the absence of legislative instruments (e.g., constitutions, mandates, general laws, Imperial edicts or rescripts, *senatus consulta*) and, second, the inquiring magistrate's indifference to the question of intent to commit or actual commission of *scelera*, *delicta*, or *flagitia*. But under the principate, in criminal matters within provincial jurisdictions, the princeps' delegates possessed considerable judicial latitute, a fact noted and lamented by virtually all students of Roman criminal jurisprudence. Schulze's *dictum*, "nullum crimen sine lege, nulla poena sine lege" (F. Schulz, *Principles of Roman Law* [Oxford, 1936], 173), evidently had little or no relevance to the trial and execution of Christians. By his own admission (X.96.3) Pliny executed professed Christians because they exhibited "pertinaciam" and "inflexibilem obstinationem." On the theory that Pliny executed the loyal Christian defendants because they had committed *contumacia* (a behavior that had real legislative status and was thus judicially actionable), cf. A. N. Sherwin-White, *JThS*, n.s., 3 (1952), 210. There can be no doubt that Pliny was empowered to act in this arbitrary manner: after all, Trajan's rescript, a document with legislative status, confirms his action.

71. X.96.4: "fuerent alii similis amentiae, quos, quia cives Romani erant, adnotavi in urbem remittendos." Ius gladii: Ulp., *Dig.* 1.18.6, 8: ". . . qui universas provincias regunt ius gladii habent . . ." (excluding provincial legates); Mommsen, *Straf.*, 243–45, esp. 244, n. 2.

72. At X.96.8 as a way of getting at the truth, he indicates he also tortured certain members (deaconesses) of the third category of defendants; cf. Sherwin-White, *Letters*, 708.

73. In denominating the Emperor's image, Pliny's terminology is technically correct: *imago* renders the Greek *eikon*, and both words were commonly (but not invariably) used to denote honorific images, statues or busts, set up in public places, excluding temples. The Latin term suggests a secular, not a sacred, image, but in practical application there is considerable variance of usage; cf. n. 17; also Price, *Rituals and Power*, 176–77.

74. This represents Trajan's reply to X.96.1: ". . . quid et quatenus aut puniri soleat aut quaeri. . . ." He specifices no universal punishment and leaves the matter to the *arbitrium iudicantis:* Sherwin-White, *Letters*, 710–13.

75. M. Charlesworth, "The Refusal of Divine Honours, an Augustan Formula," *PBSR* 15 (1939), 1–15; Price, *Rituals and Power*, 17, 72–74, 226; also A. Momigliano, *American Scholar* (Spring 1986), 187.

76. *Apol.* 85.1; cf. R. Helm, *Apuleius Verteidigungsrede Blütenlese*, Schriften und Quellen der alten Welt 36 (Berlin, 1977).

77. T. D. Barnes, *Tertullian: A Historical and Literary Study* (Oxford, 1971; rpt., 1985), 143–63: a compelling portrayal of the sporadic and disorganized nature of the early persecution of Christians; also Barnes, *JRS* 58 (1968), 32–50.

78. The characterization of Christianity as a *contagio* is Pliny's (X.96.10). Vogt presents a revisionist reading of this subject, arguing that the conflict between Rome and Christianity was essentially religious in nature, rather than political: "Wir sehen ihren Ursprung [i.e., of the Christian persecutions] im Glauben an die römischen Götter, der bis zuletzt ein Stück echter *religio* bewahrt hat." J. Vogt, "Zur Religiösität der Christenverfolger im Römischen Reich," *HeidAkad phil.-hist. Kl.*, Sb. 1 (1962), 7–30. Vogt is not to be believed.

79. Barnes, *Tertullian*, 143ff.; also Barnes, *JThS*, n.s., 19 (1968), 509–31.

80. Surveyed in C. Carletti, *I tre giovani Ebrei di Babilonia nell'arte christiana antica* (Brescia, 1975), 64–95.

81. M. Wegner, "Das Nabuchodonosor-Bild. Das Bild im Bild," *JbAC*, Ergbd. 8 (1980), 528–38.

82. E. Becker, "Protest gegen den Kaiserkult und Verherrlichung des Sieges am Pons Milvius in der christlichen Kunst der konstantinischen Zeit," in *Konstantin der Grosse und seine Zeit*, ed. F. J. Dölger (Freiburg im Breisgau, 1913), 155–90.

83. H. Kruse, *Studien zur offizellen Geltung des Kaiserbildes im römischen Reiche* (Paderborn, 1934), 86–89; Kruse promised (p. 89, n. 1) an essay soon to appear and entitled "Die Nabuchaodonosor-Szene in der altchristlichen Literatur und Kunst." It evidently never appeared. H. von Schoenebeck, *Beiträge zur Religionspolitik des Maxentius und Constantin*, *Klio* Beiheft 43 (Leipzig, 1939), 19ff.; Alföldi, *RM* 49 (1934), 75.

84. Carletti, *I tre giovani*, 96–106.

85. The seeds of political exegesis had been planted in the pre-Constantinian period. Thus at *Idol.* 15.3, 8–10, based on the testimonies of the "Tribute Money" pericope and Daniel and the three Hebrew youths, Tertullian discusses honors paid to kings or emperors (15.8.38: "quod attineat ad honores regum vel imperatorum"). The exegetical tradition that Tertullian puts into play here is disciplinary, concerning the Christian reaction to pagan idolatry, analogous to (but independent of) the Mishnaic tractate *'Avodah Zarah*. Clearly this exegetical tradition

was bound to have political consequences for Christians, as did the Talmudic rulings for Jews, but in neither case was the exegetical tradition itself primarily defined by political goals. Parallels between *Idol.* and *'Avodah Zarah:* W. A. L. Elmslie, *TS* 8 (1911). A recent, unreliable monograph in French argues incorrectly that Tertullian knew the *'Avodah Zara:* C. Aziza, *Tertullien et le Judaïsme* (Nice, 1977), 189.

86. On the association of Jesus with Sepphoris, Antipas' (*PIR²* A746) first toparchich capital, which between 2 B.C. and A.D. 8 he endowed richly with Hellenistic amenities: S. J. Case, *JBL* 45 (1926) 14–22; H. Hoehner, *Herod Antipas* (Cambridge, 1972); R. A. Batey, *NTS* 30 (1984), 249–58; S. Freyne, *Galilee from Alexander the Great to Hadrian 323 B.C.E. to 135 C.E.* (Wilmington, Del., 1980), index, s.v. Recent excavations: E. M. Meyers, E. Netzer, and C. L. Meyers, *BA* 49 (1986), 4–19, *BA* 50 (1987), 223–31.

87. Convincingly argued in G. Vermes, *Jesus the Jew* (London, 1973), 49; 50; 237, n. 41; thus 49: "It may have been Galilean chauvinism that was responsible for Jesus' apparent antipathy towards Gentiles. For not only did he feel himself sent to the Jews alone (*Mt.* 15:24); he qualified non-Jews, though no doubt with oratorical exaggeration, as 'dogs' and 'swine' (*Mt.* 7.6; *Mk.* 7:27; *Mt.* 15.26). When the man from Gerasa (one of the ten Transjordanian pagan cities) whom he freed from demonic possession begged to be allowed into his fellowship, Jesus replied with a categorical refusal: 'Go home to your own folk'(*Mk.* 5.18–19; *Lk.* 8.38–39)."

88. H. H. Reimarus, *Von dem Zwecke Jesu und seiner Jünger*, publ. G. E. Lessing (Braunschweig, 1778), II, par. 2: "Demnach hat Jesus wohl wissen können, dass er die Juden durch solche rohe Verkündigung des nahen Himmelreichs, nur zur Hoffnung eines weltlichen Messias erwecken würde; und folglich hat er auch die Absicht gehabt sie dazu zu erwecken." For the more explicit association of Jesus' goals with the religious nationalism of Zealot Jewry: R. Eisler, *Iesous basileus ou basileusas; Die messianische Unabhängigkeitsbewegung . . .* (Heidelberg, 1929–30), and S. G. F. Brandon, *Jesus and the Zealots* (Manchester, 1967), e.g., 355: "the profession of Zealot principles and aims was not incompatible with intimate participation in the mission of Jesus."

89. *De mundi creatione Oratio VI* 489e, *PG* 56 (1862).

90. P. C. Finney, *Boreas* 7 (1984), 193–225.

91. J. Kollwitz, *Das Christusbild des dritten Jahrhunderts* (Münster, 1953); also P. C. Finney, *RivAC* 57, (1981), 35–41.

92. G. Bendinelli, "Il monumento sepolcrale degli Aureli al viale Manzoni in Roma," *MonAnt* 28.2a (1922–1923), 289–520; Gnostic interpretation: G. Wilpert, *PARA.Atti/Serie III/Memorie I.II* (Rome, 1924), 1–43; skeptical: P. C. Finney, *Numen* Suppl. 41.1 (1980), 442–50. For an ingenious (but very speculative) neo-Pythagorean interpretation: J. Carcopino, *De Pythagore aux Apôtres* (Paris, 1956); sober and intelligent skepticism: J. M. C. Toynbee, *Gnomon* 29 (1957), 261–70. Minimalist interpretation (the paintings in the hypogaeum cannot be called pagan, or Christian or crypto-Christian): N. Himmelmann, "Das Hypogäum der Aurelier am Viale Manzoni," *AbhMainz Geistes-sozialwiss. Kl.*, Nr.7 (1975).

93. G. Koch, "Stilistische Untersuchungen zu spätantiken und frühchristlichen Sarkophagen" (Habilitationsschrift Göttingen, 1977 [unpubl.]). My sincere thanks to Guntram Koch for sending me a copy of this valuable work.

5

Christianity Before 200: Invisibility and Adaptation

We now turn to the material side of the discussion. In the present chapter the major fact that needs explaining is the absence of Christian art before the year 200. Previous efforts to explain this fact have varied in details, but one of the abiding temptations is to view absence of art as a sign of principled early Christian opposition to pictorial representation. In light of the discussion set forth in the previous four chapters, this explanation is no longer convincing; hence, we must seek a new interpretative paradigm that will make better sense of the material record as we have it.

No distinctively Christian art predates the year 200. This is a simple statement of fact. It can mean one of two things: Christians created no art before that date, or what they created has perished. The first explanation is probably the correct one, but unfortunately the case is far from clear-cut. The relatively late (after 200) appearance of a distinctively Christian form of art has been interpreted in the light of these three interrelated generalizations:

1. The earliest Christians (like their Jewish forebears) opposed on principle all arts of visual representation.
2. They were spiritual, (lege: antimaterialistic) people, and this explains their opposition to art.
3. The earliest Christians were otherworldly, their sights set on the eschaton or the parousia (or both), and for this reason they produced nothing distinctive in the material realm, art included.

99

Taken together these three represent the nineteenth century's ideal-ization of *Urchristentum*. All three are arguments from silence. The first misreads the earliest apologists. The second and third perpetuate several misleading assumptions, including that early Christian spirituality and eschatology were antithetical to the creation of distinctively Christian forms of art.

The approach that follows in this chapter challenges these three por-trayals of early Christianity, but my goal is the same, namely to explain the nonappearance of Christian art before 200. Although overall the character of this study is intentionally historical, much of the following discussion has a theoretical edge. This I think is unavoidable. Any attempt to explain why Christians produced no art before 200 is bound to rest on hypothetical foundations, because hard evidence survives only in fragments, of which there are not many. The hypothesis presented here makes better histori-cal sense of the bits and pieces that do survive, but only time and further study will prove if this approach is on target.

To repeat, the point of departure is the fundamental claim (no Chris-tian art before 200),[1] and we can extend the scope of this generalization indefinitely to include the entire universe of material culture in the first and second centuries: nothing in any material category (papyri[2] excepted) that is distinctively Christian and predates the third century. The infer-ence that flows from this absence of evidence is compelling: before 200 Christians produced nothing that was materially distinct, no art and no separate material culture in any form.

But this too is an archaeological argument from silence, and argu-ments in this genre are notoriously slippery. This one is no exception. The major pitfall is the tendency to confuse absence of evidence with negative evidence: as any undergraduate history major can tell you, they are not the same. Not knowing if a thing exists is different from knowing it does not. Before 1932, for example, the complete absence of figural art from pre-Byzantine Judaism was taken as a sign that the so-called normative form of (à la George Foote Moore) this ancient religion was strictly aniconic. Then came Dura. The discovery of the synagogue with its rich complement of biblically inspired wall paintings forced a reevaluation—indeed, a dra-matic and rather far-reaching one. Sixty years later, the historical assess-ment of Judaism in later antiquity is still in progress, including an ongoing evaluation of the putative role that aniconism[3] played in the life of this community. A similar discovery in the Christian realm could have equally dramatic consequences. All it would take is one monument (large or small), positively identified as Christian and predating the year 200. Noth-ing forbids such a discovery, although in my view the likelihood is exceed-ingly slim.

Still, any intelligent evaluation of this subject must admit at the outset that the basic point of departure possesses a tentative character: it is valid only so long as a new discovery does not force us to declare it null and void. The need for qualifications has to be acknowledged. The best way to put

the matter is this: *evidently* the new religionists created nothing that was materially their own, art included, until the early third century. This leaves open the possibility that what appears to be the case is not: some-day, somewhere, the claim that Christians produced no art before 200 may be proved false.

Meanwhile, in defense of the generalization it is worth noting that the study of early Christian archaeology is one of the oldest academic disciplines in European scholarship. Its roots are in the Counter-Refor-mation.[4] The publication (1632) of Bosio's famous study[5] marks the traditional beginning of the modern discipline; thus early Christian archaeology is at least two centuries older than most of the other historical disciplines we today dignify as *Wissenschaften*. In all that time, however, no one has succeeded in identifying even the smallest scrap of Christian art or other material evidence that is distinctively Christian and that predates the third century.

Papyri are the only real exception: several Christian fragments can be reliably assigned to the second century. Furthermore, both the codex[6] and the *nomina sacra* contractions[7] (the former a distinctive material form for the binding of leaves, the latter an orthographic convention) constitute second-century material innovations, both of which seem to have been prompted directly by Christian intentions. But in the end, what really differentiates Christian from non-Christian papyri is their literary content, not their material form.

One could also argue that the absence of Christian art before 200 is due to the accidents of preservation—before 200 Christians produced their own art and other distinctive material forms, but the evidence has per-ished. This is a tradition of interpretation which students of so-called New Testament archaeology (an oxymoron) occasionally have found congenial.

But this explanation raises more problems than it solves. Why should art or other forms of material culture supposedly produced by Christians before 200 have perished (in entirety), whereas what they created after 200 has survived? There is nothing in the circumstantial realm, no late second- or early third-century natural disaster, no historical institution, event, or person, and no historical anomaly that would help explain this hypothesis. In short, given the length of time that the disicipline has been in existence, given the intensity of exploratory work within the field of early Christian archaeology and given the absence of plausible connectors in the circumstantial realm (during the Severan[8] period: 193–235), if the new religionists had produced their own distinctive art or material culture before 200, it seems reasonable to expect that by this late date we would have at least some scraps. Since we have none, to repeat, the basic point of departure is compelling.

Other groups who were contemporary with first- and second-century Christians provide parallels. For example, Roman neo-Pythagoreans who were in first-century Rome at the same time as Peter and Paul (if either was ever in Rome) also produced nothing distinctive in the material realm,

Cumont[9] and Carcopino[10] to the contrary notwithstanding. And second-century gnostics[11] who together with Christians were in Rome, Alexandria, and the Rhône valley likewise created no art and no distinctive material culture. Although their belief systems are extensively documented in literature, they evidently left no imprint on their material environs, at least none that we can detect. Thus the phenomenon that we encounter here has its direct parallels in other groups who lived in the relevant time period. In the earliest Christians we confront a group of people who for roughly the first two centuries of their history created an impressive written record attesting their ideological convictions, yet at the same time these people left no mark on their material environment. In the study of all histories (but especially prehistory and ancient history), this evidentiary conjunction (all of one thing and nothing of another) is not so unusual.

The analogy with prehistory[12] is striking. Prehistorians routinely confront evidence that is skewed: all material culture and no literary-documentary sources. Ours is exactly the opposite pattern. We have a rich literary corpus from the first two Christian centuries but no material culture in any form. In prehistory the most reliable inferences are those concerning diet, shelter, technology, defense, and economy—in other words, the inferences that flow directly from the material character of the evidence. The principle is the same for the study of early Christianity: the most reliable inferences are those that concern belief systems and ethical paradigms, in the broad sense, religious ideologies. After all, this overwhelmingly is what the earliest Christian literature is about.

Lest we forget, the absence of literary-documentary evidence in prehistory does not prevent prehistorians from discussing the beliefs and ideas of their subjects, even though *sensu stricto* knowledge of these things (when the subject is dead) requires the survival of written evidence or its oral equivalent. By analogy with prehistory, the absence before 200 of art and other material evidence that is distinctive should not prevent us from discussing the probable material conditions that shaped early Christianity.

In both scenarios (prehistorians reconstructing lost ideas and belief systems, historians reconstructing lost material settings), what is required is the creation of hypotheses. First and foremost, these must be consistent with the evidence that we do have, and they must be continuously tested against the surviving store of information. Hypotheses constructed to satisfy privately held psychological, political, or religious shibboleths are by definition invalid—this is just as true in prehistory as it is in history. In both disciplines hypotheses are purely secular, heuristic tools, and like all such tools, their value is only predictive. If and when they no longer square with the evidence, hypotheses must be discarded.

Why is all of this important to our main subject, attitudes toward art? The answer is simple: the same hypotheses that purport to explain the absence of Christian art before 200 also affect the interpretation of its presence after that date. If it were true, for example, that Christianity was

at its beginning a form of religiosity opposed on principle to visual representation, then the appearance of Christian catacomb paintings in the early third century would have to be interpreted as a violation of the principle. Or consider the proposition that the earliest Christians were spiritual and otherworldly, antimaterialistic men and women who had no time for the things of this world, their energies entirely given over to preparations for a joyful reunion with their returning Messiah. If this were an accurate portrayal, then by contrast the third-century Christians who turned their attention to the acquisition of land and the gradual creation of distinctively Christian forms of material culture would necessarily come across as turncoats and materialistic backsliders. Klauser[13] turns them into illiterate lay people who suffered from a superficial grasp of Christian teaching and ideological recidivists with a burning desire to turn back the clock and reduce[14] Christianity to pagan idol worship.

The underlying hypothesis in all of the traditional discussions of this subject is that the three religions of the Book represent essentially aniconic forms of religiosity—all three are based on the spoken and written word, and all three oppose the variant competing forms of paganism, which express themselves typically in visual images along with cognates in word and action. It follows *ex hypothesi* that the aniconic, spiritual, and otherworldly children of Jewish parents would conform to the patterns set by their elders: they would not produce a visual culture. Those who did— for example, the people of the earliest Roman catacombs—simply rejected their parents. In other words, the birth of Christian art marks the rejection of both aniconic Judaism and aniconic *Urchristentum*.

But all of this is an idealization. It portrays the earliest Christians in the spirit of Stoic-Cynic primitivism (discussed in Chapter 3). The new religionists come across as bodiless sprites, detached from the material side of life. The connection between art and materialism is an essential credo in this primitivist idealization: absence of art (and hence of involvement in the material side of life) supposedly equates with a higher form of spirituality. As for the latter, we have already seen that early Christian literature is saturated with spiritualizing commonplaces. So is Hellenistic Jewish literature, for example the Philonic[15] corpus and the Qumran[16] library. But it would occur to no responsible historian either of Alexandrian Jewry or of the Essenes to portray their subjects as disembodied beings, detached from the world and disinterested in the material side of life. Nor should it occur to historians of Christian origins. To do so is to impose a literary caricature on real life, and this is just as inappropriate for the earliest Christians as it is for Palestinian and diaspora Jews. Life and literature are not the same thing.

I have already rejected the notion that Christianity (supposedly like its parent religion, Judaism) was a form of religiosity opposed on principle to the use of art: this mistaken idea rests on several shaky foundations, including a misreading of the eariest apologists. I also reject the caricature of the earliest Christians as purely spiritual, antimaterialistic, and other-

worldly beings: if this were true, they would never have made it out of Palestine, much less out of the first century. In sum, none of the hypotheses hitherto set forth to explain the nonappearance of Christian art before 200 makes much historical sense. These theories rest on a foundation made up of wrongheaded preconceptions mixed with idealization and caricature, the misreading of literary sources and the confusion of literature and life.

But it is one thing to criticize and reject what previous scholarship has had to say on this subject—it is quite another to find a better explanation. The latter is what I propose here. In the present case the real challenge is to identify hypotheses that will make historical sense of the two patterns of evidence that we actually have: before 200 the nonappearance of Christian art, after 200 the emergence of a distinctively Christian form of art. In the two sections that follow, I can offer only the merest sketch of an interpretative model. Much more could (and should) be said in detail, but for the present all that is possible is to block out the contours. My goal is to present a plausible historical explanation of why Christians produced no art and nothing else that was materially distinctive before the early third century. Historical plausibility is the objective: only time and further study will tell if I have achieved it.

Christians: An Invisible Group in Greco-Roman Society

By the year 100 many (or most?) Christians had some sense of their separateness. As for specific signs of social differentiation, the new religionists belonged to separate groups, which they called ἐκκλησίαι,[17] assemblies or (the more familiar usage) churches. On the evidence of the canonical Book of Acts, the Pastoral Epistles, the *Didache*, Ignatius's *Letters*, the *Letter* of pseudo-Barnabas, the *Shepherd of Hermas*, and Clement's *Letter to the Corinthians* there can be little doubt that by the early second century many Christians judged their religious identity by membership in a local church. One can trace this sense of identity to an earlier point[18] in time, but this is not my subject here. Instead, my primary consideration at present is to assert as a matter of fact that by the early second century many of the new religionists sensed of their separateness, and this sense was nurtured within the social context of their assemblies, their congregations, or churches.

Christian *ekklesiai* had boundaries.[19] First, there were conditions for joining the group. Once one had become a member, rules of conduct—ethical standards of behavior for persons who desired to remain in good standing—obtained. Ritual actions were also performed within *ekklesiai*, and it was incumbent on members to participate. The earliest churches were also communities of power in several forms, spiritual, moral, intellectual, economic, and, to a degree, even political. Power was divided up and distributed hierarchically and patriarchically within each church. Christian *ekklesiai* were small, voluntary communities of shared beliefs and ideol-

ogies and hopes; shared behaviors; and, perhaps to a degree, even shared resources (for example, Acts 2.44-45).[20] Those who belonged knew they were on the inside, and knew what they must do in order to maintain their membership. But what about outsiders? What did they know about Christians, either as individuals or as members of a group?

So far as I am aware, only two outward marks identified the earliest Christians, two external signs by which insiders might be said to differentiate themselves from the common lot of humanity. One was the name.[21] Christians were not just an anonymous collectivity. They had a name, and evidently at least some of the less discrete paraded it openly. As we have already seen (Chapter 4), accused Christians who acknowledged the *nomen* in a judicial setting put their lives at risk. Second, some Christians refused to worship the gods and caesar—this too was a public and outward sign, in this case of nonconformity and nonparticipation in Greco-Roman society. Refusal to worship set a clear boundary between the new religionists and their neighbors.

But what Christians lacked in the way of external markers far exceeded what they possessed. For example, they had no territory that they could call their own, no land that they either owned or controlled. As a consequence they had neither a separate secular government nor a separate economy. They did not have distinct blood lines and hence could not claim to constitute a separate race (genus), nor so far as we can tell did they regard rules of kinship as determinative either for membership or for the holding of offices.[22] As for language, although there may be evidence to suggest that from an early point in their history some Christians (the Johannine[23] circle, for example) developed distinctive modes of expression (a *Sondersprache*?),[24] nevertheless so far as we can tell, in their daily comings and goings the new religionists spoke the regional vernaculars. They did not have a special diet (although some evidently refused to eat meats[25] that had been sacrificed by pagan priests). They did not dress[26] in distinctive ways. In short, viewed from the outside, the new religionists seemed rather unexceptional—they looked and behaved pretty much like everyone else.

Around the year 200 an anonymous Christian wrote to the imperial procurator of Egypt, a certain Ti. Claudius Diognetus (*PIR* 2²; *CIL* 3.6087), and in doing so he put down some intriguing thoughts on the worldly condition of his coreligionists:

> Christians distinguish themselves from other people not by nationality [οὔτε γῇ] or by language [οὔτε φωνῇ] or by dress [οὔτε ἔσθεσι]. They do not inhabit their own cities or use a special language or practice a life that makes them distinctive or conspicuous [βίον παράσημον].[27] . . . They live in Greek and barbarian cities, following the lot that each has chosen, and they conform to indigenous customs in matters of clothing and food and the rest of life. (5.1, 2, 4)

The *Epistle to Diognetus* is a bald apology, and hence as evidence it is subject to all the qualifications that I mentioned in chapters 2 and 3. The

writer is not bashful in making clear his deliberative purposes: he wants his highly placed addressee to change his assessment of Christians and, even more important, he wants him to change his course of action toward the new religionists. The writer exaggerates pagan vices and exalts Christian virtues. Futhermore, the passage just cited is part of a larger section (5.1–6.10) in which the author makes Christianity the centerpiece of several literary commonplaces. One (6.1) is Stoic: Christianity is to the world as the soul is to the body. The others, on the virtues of poverty, chastity, charity, and the simple life are a mix of Stoic and Cynic *topoi* pointing in the direction of a primitivist idealization. What this means is that the evidentiary value of the passage just quoted must be carefully weighed and modified in the light of the author's apologetic intentions and his use of literary commonplaces.

Having said this, I am also convinced that the passage in question gives a plausible description of the real-life conditions that obtained for many first- and second-century Christians living within Greco-Roman society. *Bios parasemos* is the key concept: a life that is indistinct and inconspicuous. What the author of the *Epistle to Diognetus* seeks to convey is the idea that Christians are discreet, modest, unobtrusive. The new religionists do nothing to draw attention to themselves. People can recognize Christians in the world by the same criteria they would use to recognize all other people, but Christian piety (or religiosity: ἀόρατος . . . θεοσέβεια, 6.4), the thing that gives the new religionists their special identity, remains invisible to outsiders.

One can put this same phenomenon in a slighty different perspective by introducing the concept of a "culture." Its ancient correlate is *ethnos*.[28] On one definition (many[29] exist) cultures and *ethne* are defined by a congeries of attributes: land, government, economy, blood (kinship), language, religion, and art. Hecataeus' Egyptians and Herodotus' Persians, Aristotle's Lycians and Thracians, Posidonius' Scythians, Celts, Arabs, Galatians and Iberians, Strabo's Jews, Varro's Romans, Plutarch's Etruscans, and Tacitus' Germans count as *ethne*. These are groups of people who meet the criteria of a culture, people who controlled and governed territory, who conducted their own economies, people defined by distinctive bloodlines, language, religion, and art. By itself religion alone does not and cannot constitute a culture. Religions in antiquity existed in relation to cultures. Ancient *ethne* subsumed ancient religions, not vice versa. Cultures in antiquity supplied the context, the soil in which religion could germinate and flower.

At the beginning of their history all that Christians possessed by way of a distinctive group identity were certain inchoate beliefs joined to very simple cult acts, including prayers at meals and initiatory rites of water immersion. In addition there were the boundaries just mentioned, the preconditions for joining the group, the rules of conduct and internal hierarchies of power within the group, the *nomen* and the refusal to worship. But taken together, these do not add up to cultural or ethnic distinc-

tion. Christians were small religious groups within the warp and woof of Greco-Roman society. Culturally they were heterogeneous. Christians did not represent themselves as constituting a separate and distinct *ethnos*, nor did outsiders consider them in this light.

Jews, by contrast, were an *ethnos* and Rome acknowledged their right to exist and to practice their religion under the umbrella of their ethnicity. Some communities of diaspora Jews also constituted their own *politeuma*[30] (a separate administrative jurisdiction within a city), notably those who lived within the polis of Alexandria. Again Rome acknowledged and affirmed the Jewish right of self-determination within the *politeuma*. But Christians were neither, not an *ethnos* and most emphatically not a *politeuma*. In point of fact, viewed from the outside and from the perspective of Greeks and Romans trying to understand what Christianity was about, the new religion had a fuzzy, even an obscure identity. Among other things, this fact made it possible for the enemies of Christianity to launch a wide range of anti-Christian slanders, which under other circumstances (that is of ethnic identity) outsiders might have taken less seriously.

At the beginning of their history, Christians had little to stand on. Compared with other religious cultures, and especially to Judaism (in several places the main competitor), the earliest Christians lacked the independent cultural foundations that gave other religions their identity and that brought them respect within the Greco-Roman social nexus. Christians had the words of Jesus, the memory of his life and death, a skeleton of beliefs and hopes, and they had one another.[31] They were a bit like the European socialists who in 1914 had the words of Marx and Engels along with the memory of their example but who lacked everything else that would give separate and distinct cultural identity to their ideology. Christianity like European socialism was constructed on a thin foundation. It was a vulnerable group at the outset, and much of its exposure was the direct consequence of a community that had come into the world without the benefits of distinctive ethnic identity, land, capital, and the rest.

Cultures typically produce things (material artifacts), and cultures are known by the things they produce. For the latter anthropologists have coined the term *material culture* (technically a misnomer).[32] Material culture includes anything and everything that is palpable and the product of a distinctive culture, including cities and their buildings, manufactured goods, tools and machinery, weapons, public furnishings, domestic utensils, and, in monetized cultures, economic units of value called money. And last but not least: art. Absence of these things commonly denotes the absence of a materially defined and thus distinct material culture. Finally, to complete the tautology, absence of material culture implies the absence of culture.

To return to Judaism, during the first and second centuries A.D. we can locate Jews at least in part because they left behind traces of their material culture. These traces are admittedly fragmentary. Out of context they are often difficult to identify. One must admit that by comparison

with contemporaneous Greco-Roman material culture, there are not many of these traces. For the period under consideration Jewish material culture is comparatively impoverished and inconspicuous. But even so, there are building fragments, floor pavements, burial artifacts, and other small finds.[33] All of these artifacts attest unmistakably the ethnic distinction and separateness of Jews living in the period stretching from Augustus to Septimius Severus.

In the same time period, Christians produced nothing distinctive in the material realm. Hence, in the archaeological record (as in real life), Christians remain (and remained) invisible. We cannot see them: we know they are there, but since they have no material distinction, they might as well not be. So also their contemporaries in real life: Christians were present in Greco-Roman society for most of the first century and for all of the second, but to many outsiders they might just as well have been absent. It was hard to detect them. The external marks of their separate existence, including material signs, were either subtle or nonexistent. Christians had their religious beliefs, they had one another, and not much else.

Jews by contrast could and did exhibit *bios parasemos*. Indeed, among outsiders, Greeks and Romans, they were proverbial for their ἀμιξία[34] (their inhospitable and separate ways). Jews constituted a separate and distinct *ethnos*, a religious culture which at the same time possessed all the marks of secular ethnicity. Although, as just indicated, the evidence for the first and second centuries is not extensive, Jews even possessed a degree of materially defined ethnic distinction. Jews would have had a much higher degree of material distinction in the period under consideration if they had managed to maintain control of Palestine, but Rome had annexed this territory in 63 B.C., and after A.D. 6 it was completely controlled and administered by Romans.

Still, by comparison with Christians in the first and second centuries, Jews had considerable material distinction. Christians produced nothing, including art in all the traditional categories: architecture, painting, sculpture, and the several minor arts. The reasons for the nonappearance of Christian art before 200 have nothing to do with principled aversion to art, with otherworldliness or with antimaterialism. The truth is simple and mundane: Christians lacked land and capital. Art required both. As soon as they acquired land and capital, Christians began to experiment with their own distinctive forms of art. But for the earliest segment of their history they remained materially indistinct, an invisible group within the warp and woof of Greco-Roman religions, all of them defined and identified along ethnic lines.

Christianity and Greco-Roman Art: Selective Adaptation

A candid but rational inquiry into the progress and establishment of Christianity may be considered as a very essential part of the history of the Roman

empire. . . . Our curiosity is naturally prompted to inquire by what means the Christian faith obtained so remarkable a victory over the established religions of the earth.[35]

Thus Gibbon: introducing his famous chapter 15 explaining the causes for the growth and success of Christianity in the Imperial period. He listed what he considered to be the five "secondary causes"[36] that made the difference: inflexibility and intolerance (learned from Jews), doctrine of the future life, miracles, morality, and polity. In failing to underscore the adaptative qualities of early Christianity, Gibbon missed an opportunity, but he should be excused: Gibbon lived before Darwin. That Gibbon's more recent commentators[37] missed the point is inexcusable.

Adaptation is a key concept in evolutionary theory, and the earliest Christians showed a remarkable capacity for adapting to a highly evolved and complex environment, namely the milieu of Greco-Roman society from the time of Augustus to the Tetrarchy. This is clearly one of the major reasons for the stunning secular success of Christianity in later antiquity. It is I think easily as important as the five so-called secondary causes that Gibbon listed.

Every organism must adapt to its natural habitat. The alternative is extinction. Humans must adapt not only to their natural but also to their social environment, the earlier the better. Children who do not learn social adaptation early in life are likely to find themselves at a considerable disadvantage later in life when they are forced to navigate the inevitable twists and turns that come with adulthood. "Cultural ecology"[38] (adaptation to a social environment) is a fact of human life. And successful adaptation to culture is a benchmark of survival and sanity—it is important in evaluating the health both of individuals and groups, in the past as well as in the present. At the beginning of its history and judged on the criterion of its adaptative capacities, Christianity appears to have been an unusually healthy social organism.

As for the issue at hand, namely the absence before 200 of distinctively Christian art forms, invisibility and adaptation are correlates—they are obverse and reverse of the same coin. As noted previously, for the first and second centuries, viewed from the outside, Christians looked like their neighbors and behaved like them. In a real sense there was no difference: they and their neighbors were culturally identical. They spoke the same languages, ate the same foods, used the same money, patronized the same markets, wore the same clothes, exploited the same natural resources, labored in the same workplaces, lived in the same neighborhoods, buried their dead in the same plots,[39] and acknowledged the same political authorities. The result: their high degree of adaptation to the prevailing Greco-Roman environment provided the new religionists with a social mechanism that guaranteed a low profile, in material culture a profile best described as invisible.

A few of the new religionists refused to adapt. The earlist Christian

martyrs provide a dramatic paradigm of social maladaptation. The endur-
ing irony of their refusal to cooperate with Roman authorities is that they
may have contributed more to the secular growth and success of the new
religion than to its opposite. But most of the new religionists were not
martyrs. The majority chose another route, clinging to life in this world
and adapting as best they could to the prevailing political, economic, and
social environments. The second- and third-century apologists were
spokespersons for this silent majority.

The third century was a period of dramatic change for Christians.
Over the course of this century the new religionists were able to assert
their own separate and distinct cultural identity. A scenario of widespread
political, economic, and social instability[40] provided the secular setting,
and disequilibrium in these realms may have helped the Christians as
much or more than it hindered them. By increments, from the period of
the Severi to the Tetrarchy, Christians were able to express their separate-
ness as a religiously motivated *ethnos*. What had previously been a group of
persons possessing only a few outward markers and an identity based
largely on intangibles was transformed into something new, namely a
religious culture, materially defined, and with a sufficiently broad and
stable base to serve as the foundation of Constantine's so-called revolution
(surely a misnomer).

As for early Christian material culture (including art), the *sine qua non*
was control of real property.[41] Group acquisition of land was itself an
expression of cultural independence, and it provided both the context and
the occasion for other material expressions, including around the year 200
the creation of a new Christian picture language, wall and ceiling paintings
in Roman-Christian hypogea.[42] Rome is unquestionably the best (but by
no means the only) setting that attests the dramatic changes that were
taking place in the material realm of Christianity over the course of the
third century. The Roman churches must have grown[43] significantly in
numbers during the second century, perhaps especially in the Antonine-
Severan period, and in the early third century some of these churches
evidently found themselves in a position to assert their public identities
openly and materially. By the year 200, at least some Roman Christian
communities had matured to the point that they were ready to go public in
asserting their distinct identity as part of an emerging religious culture.

With the community control of real property came the creation of
pictorial art, formulated awkwardly at the initial experimental stage
(190/200–210/220),[44] first in a rudimentary painted form, subsequently
(after 260)[45] in the form of relief sculpture. The introduction of art (which
was a public event, not private or clandestine or *crypto-Christian*)[46] was a
sign that Christianity was coming of age. We are in the fortunate position
of being able to witness this fascinating process, the birth of Christian art,
based not only on direct (albeit fragmentary) material evidence but also
based indirectly on a written testimony that sets forth the rationale by
which the new religionists may have first formulated their ideas on the

Christian uses of pictorial art. Both types of evidence, direct and indirect, point unmistakably to adaptation as a key element in the development of an art that over time became distinctively Christian.

In the treatise entitled *The Teacher* (*Logos Paidagogos*), written around 200 and addressed to baptized Christians, Clement of Alexandria instructed his addressees on the kinds of pictorial devices they should choose for the finger ring that they wore as a signet (σφραγίς, or seal):

> Our seals should be a dove or a fish or a ship running in a fair wind or a musical lyre such as the one Polycrates used or a ship's anchor such as the one Seleucus had engraved on his sealstone. And if someone is fishing[47] he will call to mind the apostle [Peter] and the children [baptizands] drawn up out of the water. We who are forbidden to attach ourselves to idols must not engrave the face of idols [on our rings], or the sword or the bow, since we follow the path of peace, or drinking cups, since we are sober. Many licentious people carry images of their lovers and favorite prostitutes on their rings . . . (*Paed.* III.59.2–III.60.1)[48]

Clement's advice to his Christian addressees is remarkably simple. It can be reduced to two principles: first, they should patronize already-existing markets and, second, their patronage should be selective.

On the first point, he instructs his addressees to purchase stones exhibiting generic devices (dove, fish, ship, lyre, anchor). Antonine-Severan[49] intaglios illustrating these subjects survive in large numbers. They represent the second-century stonecutter's[50] stock-in-trade. There is nothing new or innovative or unusual about second-century intaglios exhibiting these garden-variety devices. Buyers could have found ready-made stones of this sort on display in the *officinae* of numerous gemstone cutters. And in addition, buyers would have found these stones in the vendor's market.

Clement does not advise his addressees to go fishing for rare seals. Nor does he encourage them to commission novelties—for example, stones illustrating a human victim hanging on a cross[51] (Figures 5.1, 5.2) or a man about to be swallowed by a big fish[52] (Figure 5.3). Instead, Christians should operate within the already-existing repertory of intaglio devices. They should buy within the established market. Clement does not encourage his coreligionists to create alternative or competing markets; no, they should function within the status quo. In short, Clement does not advocate *bios parasemos:* his addressees he urges to adapt.

The second Clementine principle is equally clear. It is especially conspicuous in verses 11–16 of *Paed.* III.59.2 where Clement lists five devices (idols, swords, bows, cups, lovers [in both genders]) that offend Christian standards and, as a result, his addressees must avoid. He does not comment on the first of these five, perhaps because it was so obvious (at least to Clement) that Christians must have nothing to do with idols.[53] But he does draw attention to the other four. Swords and bows violate the Christian commitment to peace. Christians practice self-control and tem-

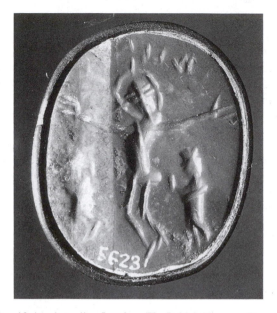

Figure 5.1. Crucifixion intaglio. *London, The British Museum.* Reg. no. G231.

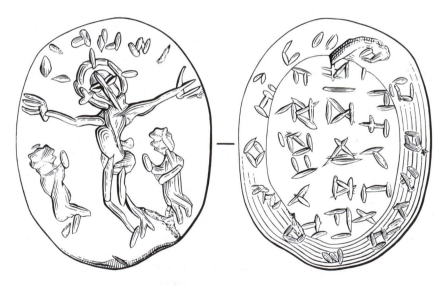

Figure 5.2. Crucifixion intaglio. Ibid. Obv. and rev. Scale: 4/1.

perance (*sophronousin*), hence drinking cups (which promote drunken-ness) must be considered off-limits.

And last but not least, Clement writes[54] than many people have im-ages of their male lovers (ἐρωμένους) and of their favorite prostitutes (ἑταίραι) emblazoned on their rings; they do this so they may be contin-

uously reminded of their erotic passions and their delight in debauchery (ἀκολασία). Sex with *hetairai* was ipso facto off-limits for Christian men. As for homosexual lovers, Clement is probably alluding to pederasty, although he could also have in mind other illicit liaisons. Whatever may be the specific nature of the couplings envisaged here, one point is clear: because they are strictly forbidden, Christian men and women must avoid intaglio devices illustrating these subjects.

It is obvious that Clement is thinking symbolically with respect to the five forbidden images: they represent behaviors which Christians cannot indulge. I think it very likely that he is also thinking symbolically about the five images he recommends, although it is true[55] he does not spell out the specific symbolic equivalents for any of these five. He leaves this issue open-ended here, although in other places he submits at least the dove, the fish, and the ship to *interpretatio christiana*. Why he does not do so here is unclear. We must presume I think that the five recommended images are of a sort (at least in Clement's mind) that they could be harmonized with Christian intentions. In other words, the Christian intaglio buyer could find meaning in the image of the dove, of the fish, and so on.

Mention of intentionality in this context needs a word of clarification: it is the intention of the buyer that is at issue, not of the maker. This is different, for example, from Tertullian's similar but different advice

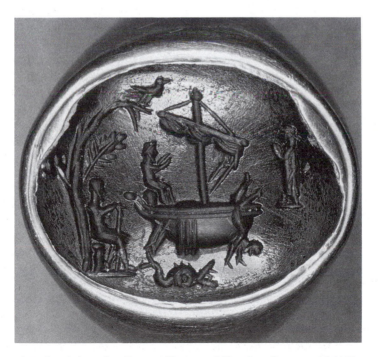

Figure 5.3. Jonah intaglio. *Boston, Museum of Fine Arts*. Inv. no. 03.1008.

(*Idol.*3.1–8.5), which is directed to Christian workers (*artifices*)[56] employed in the art-related manufacturing sector of the Carthaginian economy—Tertullian's words are to makers, not to buyers. It is also different from what one normally presumes in both art[57] and literary criticism where discussions that turn on intention are commonly understood in relation to the artist, not the patron.

In the present case what the *scalptor* intends by way of symbolic associations when he carves the image of a fish in stone is immaterial to Clement's argument. It is what the buyer sees that determines the symbolic content of intaglio devices. In short, the nature of the symbolic content contemplated (but never voiced in so many words, at least not for the five recommended images) is private and subjective. Two buyers can look at the exact same fish intaglio and see quite different things—perhaps the one calls to mind Peter,[58] the fisher of souls, or baptizands[59] washed clean of their sins or Jesus the big ICTHYS,[60] whereas the other is reminded of his love of sport fishing and broiled tuna. The image does not change: a tuna is a tuna. But the subjective intentions read into the image can be quite different.

What Clement recommends in this intriguing passage is a classic example of Christian adaptation to an already-existing category of material culture, namely the repertory of devices on stones manufactured and distributed for the purposes of sealing personal property and attesting documents. But it is also very clearly a selective form of adaptation. He calls upon his addressees to buy in one category of intaglios and to boycott in another. This is different from Paul at Ephesus (Acts 19:23–41):[61] he calls for a blanket boycott, thereby utterly rejecting adaptation or accommodation to an already-existing market. Clement's advice, as I have just mentioned, envisages a form of adaptation that remains essentially private and subjective. By exercising their right of selection in this manner, the Christian buyers would cause the creation of no new intaglio devices, nor does Clement encourage them to do so: they should keep buying the *scalptor's* stock-in-trade, provided of course that they choose non-offending devices that could be harmonized with Christian intentions. Consequences were bound to follow.

The Christian population of Rome was on the rise in the second century. The same was true elsewhere in in other urban centers such as Alexandria, Antioch, Caesarea, Carthage, Edessa, and Lyons/Vienne. Based on the Roman epigraphic evidence, many of the members of the Roman churches in the Severan period were freedmen,[62] either themselves former slaves or the children of manumitted slaves. Their financial circumstances are difficult to reconstruct, but no doubt as a group they controlled some capital or its equivalent, real property. Christians elsewhere clearly did: Clement's addressees, for example, evidently enjoyed considerable prosperity and needed seals to secure their personal property and to perform their duties as public[63] stewards. In the home those Chris-

tian women who oversaw substantial personal property (their own, their husband's, or both) had to protect their valuables against peculating slaves.[64]

If we imagine that all (or even some) of Clement's addressees actually followed his advice when they went to buy their seals, then the end result would be pressure on the supply side of the intaglio market. Demand would necessarily shape supply. Gemstone cutters would need to readjust their inventories to meet the demand for more fishes and fewer *hetairai*. If further we presume that the numbers of Christian property owners continued to grow in Antonine-Severan cities, then in the short run (two or three generations) the available range of ready-made intaglio devices might shift (by diminishment) in order to meet the new market demands. This would be nothing more than the obvious consequence of Christian pressures exerted on the demand side of the intaglio market.

Presuming the continued third-century growth of Christianity, over the long run (a century or more) intaglio inventories would have to be brought into conformity with the demands of the buying public. Fish and dove intaglios would become common and relatively cheap, whereas lovers (including the ubiquitous Philainian σχήματα)[65] on seals would become increasingly scarce and expensive. In short, selective adaptation (if one presumes such factors as the size and the wealth of the Christian property owning classes) might cause the exertion of significant pressures on intaglio markets. The same is true (*mutatis mutandis*) for all other art-related markets: painting, sculpture, mosaic, terra cotta, glass, metal, bone, wood and ivory, and textile.

In the end, due to the absence of hard evidence, the problem posed here is relatively intractable. But I think Clement provides at least a plausible basis which supports both of the previously mentioned hypotheses, invisibility and adaptation. Admittedly, the intaglio market represents a very narrow niche within Greco-Roman manufacture, and it is dangerous to draw grandiose conclusions from such a specialized sector of the economy. But what is at issue here is not so much the size of the market but the rationale of customer choice and selection. It seems to me that same rationale can be applied to other markets in which all Christians (not just property owners) had a stake.

Terra-cotta lamps provide an excellent example: all Christians needed them. Household and funerary lamps (the latter for use in hypogea, columbaria, and mausolea) were manufactured in large numbers over the full span of the second century, and in central Italy where we know Christianity was taking root, we have a well-developed lamp typology, which allows for inferences that are more than just speculations. In view of Clement's advice that Christians should adapt (selectively) to already-existing iconographic repertories, the most interesting category of late second-century lamps are those which have discus scenes showing a shepherd carrying a sheep.

Shepherd Lamps

All the lamps in question were formed in plaster die molds (matrices), and all were manufactured in central Italy. Most of the lamps that concern us here were distributed no doubt locally within Romano-Campanian territory. On the basis of their several attributes these lamps belong to the late end of Loeschcke's type-eight series.[66] It is well known that none of the lamps in Loeschcke's study of the Vindonissa (Windisch in the Swiss Aargau) corpus postdates the early Trajanic period, roughly 101, but based on the British Museum collection of late Roman lamps, Bailey has written the post-Trajanic family history of Loeschcke's type-eight series, extending its later life from the early second century to approximately 400.

Bailey has succeeded in identifying four subtypes (O, P, Q, R) within the type-eight family, and most of the lamps relevant to our subject belong to subtype Q, further subdivided into ten groups.[67] The chronological setting for shepherd lamps that fall within Q is the late Antonine to late Severan period, approximately 175–225. As noted, for Q the place of manufacture and the distribution pattern (based on archaeological provenience where it is known) converge: central Italy, probably somewhere along the Rome-Ostia axis.

While shepherd lamps throw some light on our subject, one must be careful not to overstate the case. Both of the previously mentioned hypotheses (invisibility and adaptation) acquire added probability when tested against this ceramic corpus, but definitive material proof eludes us. It is probable, in my view, that some second-century Roman Christians purchased shepherd lamps. We have positive proof, however, in only one surviving example, namely Wulff 1224[68] (Figures 5.4–5.6), which is the same as Bellori/Bartoli 3.29 (Appendix 5.1). This lamp was transferred from Rome to Berlin (evidently in 1698)[69] and is presently housed in the Museum für Spätantike und Byzantinische Kunst (formerly the Frühchristlich-Byzantinische Sammlung) of the Bode Museum, Berlin. But before we turn to that remarkable piece, a brief review of essentials is needed.

On shepherd lamps in general most of the facts are well known.[70] Terra-cotta, moldmade lamp disks illustrating bucolic subjects, including shepherds and sheep, survive from many periods of the Roman pottery industry. Between roughly 175 and 225, six or seven[71] central Italian potters produced late Loeschcke type-eight lamps with discus scenes illustrating the shepherd-*kriophoros*. To my knowledge, all of the lamps with disks illustrating the latter subject fall under the *Firmalampen*[72] rubric, meaning that each lamp base was stamped with the maker's name in abbreviation. Of the six or seven central Italian potters (*figuli*)[73] who manufactured shepherd lamps in the late second century, three are important for the present discussion, namely Annius[74] Serapidorus, Florentius,[75] and Saeculus.[76] The original quantity of lamps manufactured in this category is not known, nor is the exact size of the surviving corpus (many

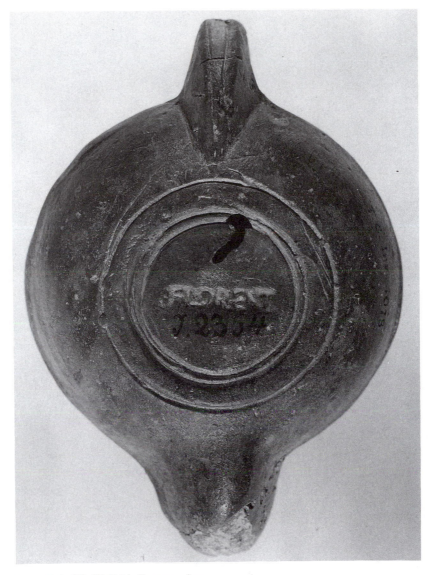

Figure 5.5. Wulff 1224. Bottom view.

Other than names, we have no literary-documentary information about the potters who manufactured shepherd lamps in central Italy from the late second to the early third centuries. A bald onomasticon is all that survives, nothing more. Thus a basis for providing biographical reconstructions is wanting. The older lucubrations, promoted by de Rossi[77] and Leclercq,[78] on Annius' religion (if he had one) are futile: the evidence simply does not permit this. At the same time there is no doubt that de Rossi and Leclercq (following Bosio[79] who in 1632 had published an AN-NISER lamp: Figure 5.7) were on target in focusing on Annius: he was the

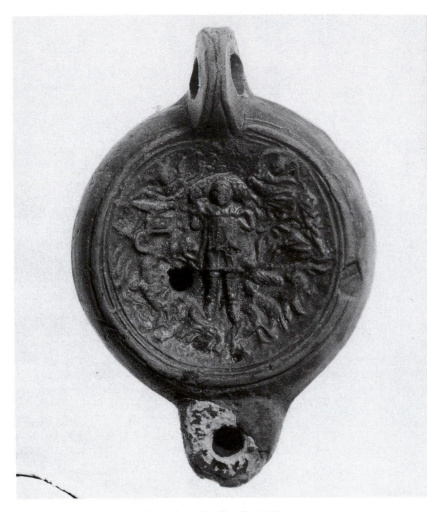

Figure 5.4. Wulff 1224. Top view. *Berlin, Bode Museum.*

pieces are still unpublished). By my reckoning, there are certainly more than one hundred surviving examples, but whether the extant corpus exceeds two hundred is unclear. Obviously the original output was larger, but by what factor we should multiply the extant corpus in order to arrive at the original number of shepherd lamps manufactured in the Antonine-Severan period is a matter for speculation. The dating of individual pieces within the late Loeschcke type-eight series is only relative: fixed points of chronology are either rare or nonexistent. But overall, based on cumulative evidence which subsumes hundreds of typological parallels, the corpus of shepherd lamps that concerns us here must be assigned a *terminus a quo* in the late Antonine, a *terminus ad quem* in the late Severan periods: to repeat 175–225.

primary central Italian manufacturer of shepherd lamps in the Severan period. His shepherd lamps were smaller[80] and inferior in quality to those of Florentius and Saeculus, but the quantity of his output was substantially larger than any of his central Italian competitors.

Unfortunately there are many unknowns in the study of shepherd lamps. We cannot identify places of manufacture or the size and internal workings of the respective potteries that were involved, nor do we know in precise terms their methods and markets for distribution, whether inside or outside of central Italy. Judged by the size, the quality of both the fabric

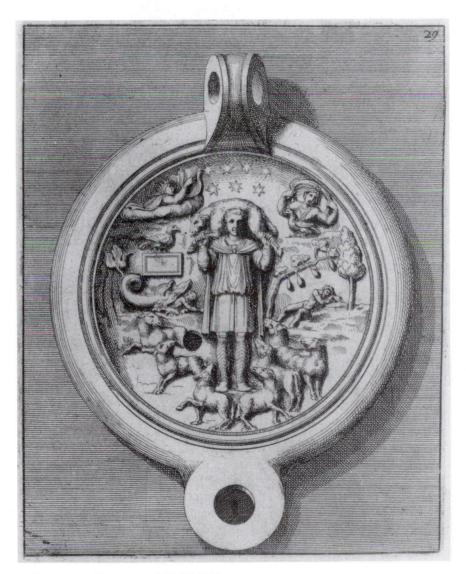

Figure 5.6. Engraving of Wulff 1224.

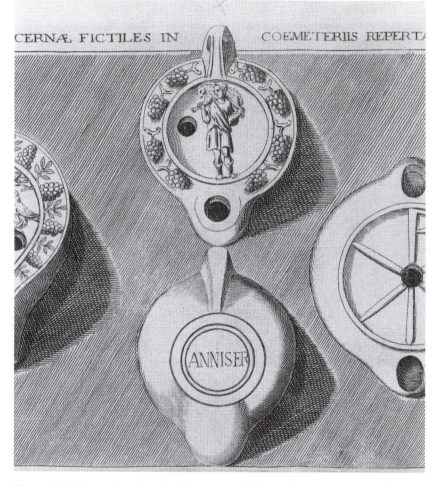

Figure 5.7. Engraving of an Annius shepherd lamp. Present whereabouts un-known.

and the execution, and the relative simplicity of both the lamp bodies and their disks, Annius' shepherd lamps, were evidently manufactured in relatively large numbers and distributed at a low retail cost per unit. Hence Annius' profit margin per unit would have been narrow. It is extremely unlikely that Annius' lamps would have been carried any significant distances by river or sea transport, and it is out of the question (given the cost of land transport) that they would have been carried overland more than a few kilometers for distribution. Thus, Annius' enterprise, understood as both a place of manufacture and of distribution, must have been local in character, situated in or around Ostia and Rome. In other words, if part of

Annius' customer base was Christian, then we must envisage market demand at the local level, in and around the capital City and its port.

Some of Annius' lamps did find their way outside of central Italy, for example to Roman Gaul[81] and Britain[82] (Figures 5.8, 5.9), and it is possible (although in my view unlikely) that Annius maintained a branch *officina* on foreign soil, either as an independent franchise or as a workshop in which he retained direct ownership and delegated management responsibilities to an *institor*,[83] a freedman, or slave branch-manager. But the size of the surviving lamp corpus that we can attribute to Annius, the evident pattern of distribution, which is preponderantly local, and his narrow profit margin do not favor this scenario. It is more likely that all of Annius' lamps were manufactured in his Ostian *officina* and distributed either at the workshop itself or, perhaps more likely, by a vendor who maintained a market (or markets) close to the workshop, no doubt in one or more of the commercial *fora* at Ostia or Rome, or both. Those lamps discovered far afield were probably carried to their final destination by their owners rather than manufactured abroad or distributed from branch workshops.

In size, Annius' lamp production represents a medium range, its quality is mediocre, and its choice of discus subjects is conservative. Annius' output was significantly smaller than that of Florentius, his contemporary and competitor, or of his predecessors in the central Italian pottery market, Fortis[84] and C. Oppius Restitutus.[85] Saeculus,[86] another of Annius'

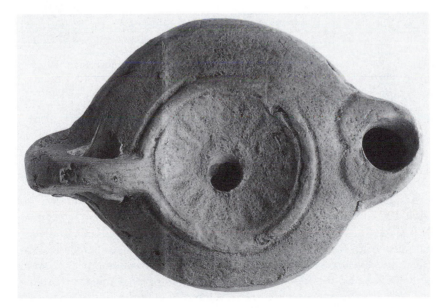

Figure 5.8. Annius lamp. *London, The British Museum.* Reg. no. PRB 1924,11–5, 1 = Bailey, *Cat.* 2: Q1375 PRB. Top view.

Figure 5.9. Annius lamp. Bottom view: detail of base ring and incuse AN-
NISER.

contemporaries and a competitor, was considerably more innovative, as his
shepherd lamp (Figures 5.10, 5.11) in the British Museum clearly suggests.
Both Florentius and Saeculus manufactured lamps that must have cost
more than Annius': this is an inference based on the considerations of
discus complexity and innovation, body size, and overall quality of the
fabric and its execution. The *poinçons* or stamps that were used to form the
disk archetypes for Florentius' and especially Saeculus' upper body die
matrices were significantly more complex and innovative than those An-
nius had at his disposal, and this fact alone would have added to the cost of
manufacture. Distribution costs, including loading and unloading, trans-
portation, and breakage have to be factored in as well: all of these costs
were passed on to the consumer, and in the case of the larger, finer, and
more complex lamps such as those produced in Florentius' and Saeculus'
officinae, the final retail price per unit could easily have been two or three

times what Annius' typical lamp cost. In short, judged by comparison with competitors in central Italian, Antonine-Severan ceramic markets, Annius' lamps were probably a bargain.

By and large Annius repeated tried-and-true discus[87] formulas: fauna (horses, hares, sheep, conches) and flora (roses, rosettes, grape clusters, palm fronds). Under mythological animals, chimaerae and griffins are attested, and under the category of figural disks, he manufactured several mythological types: winged cupids, Apollo, Bacchus, Diana, Leda, Hercules, Helios, and Aphrodite. Under scenes illustrating daily life, he produced disks exhibiting gladiators, soldiers, and men at the gaming table. So far as we can tell from the surviving examples, Annius did not manufacture lamp disks illustrating maritime subjects (hence the iconographic matrix for Jonah scenes is wanting); he did not produce portrait busts of historical personages, cultic and military objects, Thespian and comic scenes or theatrical masks, grylloi, dwarves and grotesques, nor (excepting Leda and her web-footed friend) did he manufacture disks illustrating sexual couplings (hetero- or homosexual), no *soixante-neuf*, no copulating

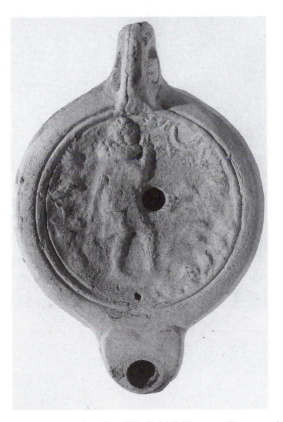

Figure 5.10. Saeculus lamp. *London, The British Museum.* Reg. no. MLA 1756,1–1, 1093 = Bailey, *Cat.* 2: Q1370. Top view.

Figure 5.11. Saeculus lamp. Bottom view: detail of the base ring with internal molding and an incuse SAECVL.

animals, no *hetairai* fellating their patrons, and no monkeys or bears mounting women from the rear.

Based on the surviving corpus of his lamps (which may or may not represent accurately the iconographic breadth of his original output), Annius put considerable time and money into the manufacture of lamps with discus scenes exhibiting the shepherd carrying a sheep. His workshop owned several upper-body matrices with more than one discus die illustrating the same subject.

In summary, Annius' discus repertory represents the conservative middle range of the lamp market. Provocative subjects, especially those that were sexual in nature, are conspicuous by their absence. His large output of shepherd lamps was no doubt prompted by a growing market demand[88] for bucolic subject matter in the Antonine-Severan period. The quality of his lamps was mediocre and the cost probably on the modest side. He did not aim to provide his customers with an innovative and unusual product. As for distribution, it seems likely that Annius was serving an exclusively local market.

This brings us to the last question: would Christians have bought Annius' lamps? A definitive answer is impossible. The best one can hope to achieve is probability based on circumstance. Under the latter category, several facts are well known and can be rehearsed in rapid succession. First, Christians were living in second-century Rome and Ostia—indeed, at least in the Capital toward the end of the century, their numbers were significantly on the rise. Second, we also know that some Severan-Roman Christians were beginning to commission paintings in their underground funerary chambers, and it is clear that one of the most conspicuous iconographic features of these burial paintings was the image of the shepherd-*kriophoros*. Writing in 210/211, Tertullian[89] says that his Carthaginian Christian contemporaries were choosing the same subject as a painted device to decorate their eucharistic cups. Thirty years later, on the example of the painted shepherd carrying the oversize sheep in the lunette decoration over the Dura baptismal font, the practice had spread from Rome to the Syrian *limes*. In Rome, shepherds carrying sheep began to appear around 260 in relief sculpture (sarcophagus fronts) commissioned by the new religionists. Last but not least, within the literary culture of the new religionists (including literature for worship), there existed a long-standing exegetical tradition that associated the founder of the movement with shepherding metaphors. Under circumstances such as these, it is reasonable to suppose that at least an occasional Christian customer will have been prompted to purchase one of Annius' shepherd lamps on the basis of its discus subject.

Admittedly, we have no direct evidence to prove this conjecture. None of Annius' shepherd lamps is marked with Christian inscriptions or monograms or explicitly biblical subjects. The image of the shepherd carrying the sheep, Hermes-*kriophoros* for example, was a well-known and popular fixture within Greco-Roman pictorial tradition, and hence even

within the circumstantial realm there is no necessity that any of Annius'
customers was Christian.

But on the twin presumptions of invisibility and adaptation, the shep-
herd-*kriophoros* figure was an ideal device. It was an image Christians
could easily adopt and adapt to their own universe of private meanings.
Christians who bought Annius' lamps (and surely some did) would have
simply been continuing their own material anonymity—nothing objec-
tively new in the iconographic realm would have come into existence by
their act of purchasing Annius' product. They would have been exercising
their right of selection, as Clement said conscientious Christians should
do. For their own private reasons, they would have been adopting a ready-
made Greco-Roman pictorial cliché and thereby adapting to the already-
existing pictorial tradition. But if there were enough of these clients, and if
nine times out of ten they chose shepherds over *hetairai*, Annius and his
fellow potters might have begun to rethink their strategy for selling lamps.
In short, with numbers on their side, the new religionists might have
begun to exercise an influence on the supply side of the Roman ceramic
industry. This would explain the dramatic growth in the manufacture and
distribution of shepherd lamps in the early third century.

Finally, there is Wulff 1224 (Figures 5.4–5.6). The discus iconography
of this lamp is a hapax, which makes the evaluation of this lamp doubly
difficult. But two preliminary objections must be clarified and dismissed.
First, the lamp survives: Schumacher's presumption[90] (followed by Him-
melmann)[91] to the contrary is false—Wulff 1224 was not on exhibit in 1989
at the time of my last visit to Berlin, but it is certainly in the collection of
the Bode Museum. Second, I can see no reason to condemn the lamp as a
modern forgery.[92] A thermoluminescence[93] test[94] performed recently
(1990) suggests that the fabric must have been fired approximately seven-
teen hundred years ago (plus or minus 25 percent). The lamp body has
dozens of close parallels, and in one example (Bailey Q1340: Figures 5.12,
5.13) there is a near-perfect correspondence. The fact that the discus
scene of Wulff 1224 is unparalleled does not constitute a legitimate basis
for condemning the lamp, especially in view of the fact that the lamp was
fired in antiquity and that the rest of the lamp's attributes are perfectly
consistent with Florentius' corpus attested elsewhere.

Wulff 1224 is a large[95] late Loeschcke type-eight lamp, moldmade
with a circular body and a short, rounded nozzle which has been restored.
The original nozzle was very likely Loeschcke's Schnauze H (Figure 5.14)
with a heart-shaped groove on the upper surface where the nozzle joins the
shoulder, but unfortunately the restorer did not understand the signifi-
cance of this detail and obscured it. At the rear of the vessel is a pierced
ring-handle with double grooves etched along its upper surface. Pierced
near the edge of the discus opposite the nozzle is an air hole. The rounded
shoulder, narrow and plain, slopes inward to a double molded rim enclos-
ing the disk.

The lamp stands on a raised annular profile or base ring (Figure 5.5),

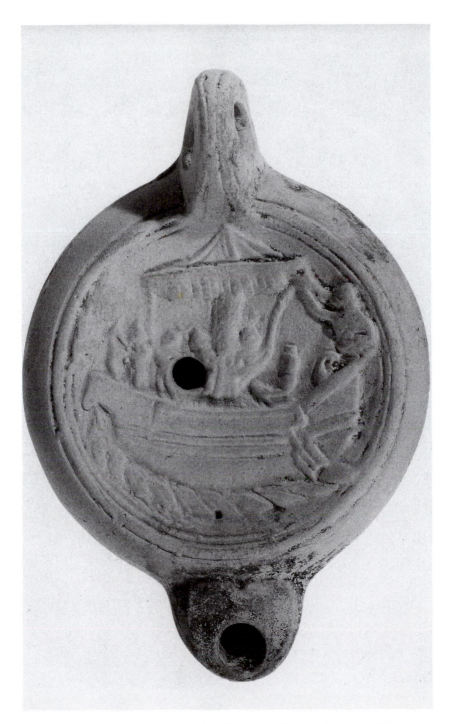

Figure 5.12. Florentius lamp. *London, The British Museum*. Reg. no. GR 1814,7–4,143 = Bailey, *Cat.* 2: Q1340. Top view.

Figure 5.13. Florentius lamp. Bottom view: detail of the base ring with an internal molding and an incuse FLORENT.

which has both internal and external concentric moldings. An incuse FLORENT is impressed within the innermost base molding: the name was stamped onto the base of the archetype from which the lower-body matrix was formed. As noted[96] earlier, the correct reading of this abbreviation is Florentius, not Florentinus. The lamp fabric is orange, micaceous clay covered with a worn slip, which varies in color from orange to dark brown.

There are numerous parallels, but Bailey Q1340 (Figures 5.12, 5.13) is very close. Wulff 1224 is two millimeters longer and one millimeter wider than Bailey Q1340, and the external molding surrounding the base ring is missing in the London lamp. Otherwise, excepting their respective discus scenes, the two lamps are identical. The disk of Bailey Q1340 shows a commercial ship leaving a harbor headed left—beyond the bow is a three-tiered lighthouse with a fire burning on its uppermost platform, and behind the stern to the right there is a harbor statue, probably of a Triton blowing a trumpet held in the right hand and holding a fish in the left.

The discus of Wulff 1224 shows a central shepherd-*kriophoros* facing front. Left of this central image Jonah is shown cast up (Jon 2:11) from the mouth of the big fish (LXX Jon 2:1: κῆτος μέγας) and right of center, Jonah rests under the colocynth bush (LXX Jon 4:6: κολοκύνθη) that God caused to sprout over the prophet's pergola[97] (LXX Jon 4:5: σκηνή). Left of the shepherd's right shoulder, a bird faces right and is perched on a

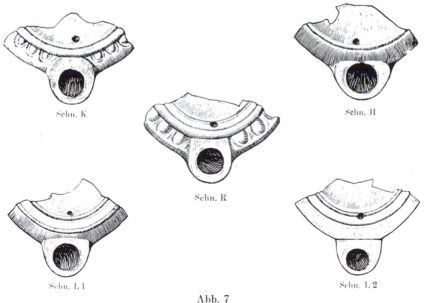

Schn. K Schn. H Schn. R Schn. L 1 Schn. L 2

Abb. 7

Hauptvarianten der Schnauzen bei Typus VIII.

Figure 5.14. Loeschcke type-eight nozzles: major variants.

rectangular box (LXX Gen. 8:8–9: κιβωτός, or ark]). Bird and box represent Noah's dove standing on the ark. The bird does not have a twig in its beak or claws, hence the image captures a moment either before or after the bird's first exploratory flight. The ark as a box is an iconographic commonplace.[98] In the field above, left and right, there are personifications of Helios and Selene, and between them, seven stars, the conventional reference to the Pleiades. A second bird, below and in front of Selene, faces left: following a Callimachean convention (frag. 693) widespread in later antiquity, this bird must represent one of the Pleiadic doves. Sheep flank the shepherd below left and right, four to his left, three to his right.

The shepherd obviously constitutes the primary symbolic focus of the discus field. The flanking sheep and the animal straddling his shoulders are to be read as attributes. Helios, Selene, and Jonah mark secondary levels of meaning. In the case of the first two, cosmogonic myth is clearly the subject. The Jonah scenes fill approximately 30 percent of the discus field overall: the iconographic models for the representation of the prophet are Greco-Roman, but the ultimate inspiration for the choice of this figure is the Hebrew Bible.

Bailey[99] has described the probable scenario for the construction of discus archetypes. In the case of Wulff 1224 we have no way of knowing if the *poinçon* maker was an itinerant stamp cutter or someone in Florentius' workshop. But whoever cut the discus archetype must have taken his cue either directly from the client or indirectly from the workshop foreman (*officinator*). Three iconographic details (the bird on the box, the man emerging from the mouth of the big fish, and the same man lying naked under the gourd tree) were inspired by the Hebrew Bible and can only be explained as the products of Christian intentions. It is unlikely that a Roman Jew would have commissioned this lamp.[100] Helios, Selene, the Pleiadic stars, and the shepherd are traditional to the Greco-Roman iconographic stock-in-trade, although the fact that the client was a Christian clearly raises the question about the intended symbolic identity of the shepherd, whether Jesus or some other generic shepherd-*kriophoros*.

The *kriophoros* is the central symbolic image in both Annius' shepherd lamps and Wulff 1224. Whereas both Christians and pagans could have purchased Annius' shepherd lamps, only a Christian (or Jewish) client would have been able to make sense of the disk on Wulff 1224. In purchasing Annius' shepherd lamps, the buyer would have revealed nothing explicit about his or her religious identity, whereas whoever bought Wulff 1224 did just that. The Berlin lamp represents a second (overtly Christian) stage of adaptation to Greco-Roman tradition. In Annius' lamps (presuming Christians bought them) the level of adaptation was essentially private and subjective. In Wulff 1224 the formal contents of the discus field are determined at least in part by stories inspired directly by the Hebrew Bible. Wulff 1224 signals the move from invisibility to public identity as a Christian. It attests the beginning of a distinctively Christian

iconographic tradition—the forms continue to be those of the Greco-Roman stock-in-trade, but the symbolic content and hence the identity of the discus field changes in favor of a new set of suppositions.

Conclusions

For roughly 170 years (30 to 200) we have no art and no other material evidence marked with distinctively Christian subjects. This probably means that what appears to have been the case actually was: Christians produced nothing materially distinct before the early third century. The explanation of this phenomenon should be sought in the nexus of political, legal, economic, social, and cultural conditions that defined the status of the new religionists. In most places before 200 Christians were a small and relatively insignificant minority. Outsiders could recognize them only if they publicly acknowledged their identity (by confessing the *nomen*) or if and when they refused to worship the gods and caesar. Otherwise the new religionists exhibited no distinctive culture traits, nothing in the public and open realm that would give outsiders a clue about their religious identity. Unlike Jews, Christians did not constitute a distinctive and separate ethnos.

In the material realm Christians remained invisible until the early third century. This is exactly what one should expect from a group lacking separate and distinct ethnic identity.[101] The earliest Christians were fully adapted to Greco-Roman material culture, indeed to such a high degree that if their literature did not survive, we would have no way of knowing they ever existed. During the first several generations of their history, the only distinction that Christians possessed was their belief system, but this left no marks in the material realm.

This is not to suggest that the new religionists were in perfect harmony with their environment, as if fully and uncritically assimilated to all of its standards and practices. We know this is not the case. From its very earliest history, Christianity set up boundaries both in relationship to Judaism and to Greco-Roman culture in general, notably to the religious traditions of Greece and Rome. As for material culture, Clement provides the earliest insight into the boundaries that might exist between a conscientious Christian and his or her material environment. On the one hand he encourages his addressees to adapt to the prevailing material environment, but on the other he urges them to do so in a selective manner.

The Clementine model of adaptation is correctly described as conscientiously eclectic, not indiscriminately syncretistic. Christians should discriminate. They should pick and choose carefully, accepting some parts of Greco-Roman iconographic tradition, rejecting others. At issue is the question of adaptation by harmonization, the intentional reconciliation of already-existing devices with Christian meanings. Fishes could be harmonized but *hetairai* could not—hence, Clement urges his addressees seeking signets to choose the former over the latter. Clement's principle of

selective eclecticism points in the opposite direction from magical ico-
nography,[102] which appears to have been indiscriminately eclectic. Se-
lective adaptation is the correct interpretative model in evaluating the
emergence of distinctively Christian art forms around the year 200. Indis-
criminate eclecticism and syncretism misrepresent this phenomenon.

It is clear that by the year 200 a few central Italian Christians were
beginning to acquire the rudiments of cultural and ethnic distinction. As
far as art is concerned, land and capital were twin preconditions. Whoever
commissioned Wulff 1224 was a member of this group. So were the people
of the oldest nuclei within the Callixtus catacomb, members of an *ekklesia*,
people in control of real property and people with a sense of their separate-
ness and their distinctiveness as a religious culture. On the example of
Wulff 1224, the earliest experiments in the creation of a distinctive Chris-
tian picture language took place within an iconographic framework that
was entirely bound by Greco-Roman tradition. Innovation was kept to a
minimum. The only hapax in Wulff 1224 is the compositional arrangement
showing a man emerging from the mouth of a big fish. Otherwise the
discus field presents nothing new. Wulff 1224 represents a small step away
from the initially invisible stage of Christian adaptation to Greco-Roman
culture. The owner of this lamp made a gesture in the direction of assert-
ing a new public identity, a gesture that was visible for all who had eyes to
see.

APPENDIX 5.1

Are Bellori 3.29 and Wulff 1224 the Same Lamp?

On plate 29 (Figure 5.6), in part three of his lamp catalogue (G. P. Bellori
and P. S. Bartoli, *Le antiche lucerne sepolcrali figurate raccolte dalle caue sot-
teranee e grotte di Roma* [Rome, 1691]: Parte Terza, Nelle quale si con-
tengono uari simboli et Emblemi con le lucerne sacre de Christiani),
illustrated throughout with Bartoli's splendid engravings, Bellori pub-
lished a lamp whose upper half (viewed from the top—no side profile is
given) appears to reproduce the same iconography as that found on Wulff
1224 (Figures 5.4–5.6). Consistent with seventeenth-century antiquarian
practice, Bellori did not comment on the lower half of the lamp body nor
did he include an illustration of the lamp base. In other words we have no
way of knowing if the base of Bellori 3.29 was stamped FLORENT. But the
iconography of the two disks is the same.

At the beginning of the eighteenth century Lorenz Beger (from 1693
to his death in 1705 chief curator of the Prussian Kurfürstliches Anti-
kenkabinett) translated Bellori's vernacular catalogue into Latin and pub-

lished in Berlin his *Lucernae veterum sepulchrales iconicae . . . = LVS* (Coloniae Marchicae, 1702). At the end of entry 3.29 he included a parenthetical, explanatory note indicating that the lamp had been transferred to the cabinet of the Elector, Frederick III of Brandenburg: "Lucerna fuit J. Petri Bellorii, nunc in Thesauro Regio-Elect. Brandenburgico servatur." Beger also made no mention of the lamp base or its stamp, presuming it had both. Beger's illustration of Bellori 3.29 gives the exact same iconographic details as Bartoli's 1691 engraving, in other words there can be little doubt that the lamp Beger was illustrating, and which he said had been transferred to Berlin, was Bellori 3.29 (or its duplicate?).

Bellori died on 19 February 1696, and soon thereafter his heirs (*ignoti*) decided that his collection of antiquities should be dispersed. In a letter dated 27 May 1696 Beger secured a commitment from the Elector (who would become the first King of Prussia five years later) to purchase Bellori's antiquities for the sum of one thousand ducats. Among the objects listed as belonging to the collection were "10 metallinen und 30 irdenen Lampen, so alle mit figuren und theils auch inscriptionen gezieret" (G. Heres, *ÉtTrav* 10 (1978) 12 and n. 22). As already mentioned, Bellori's antiquities were crated into wooden boxes and delivered at the Elector's Palace in Berlin on 4 May 1698. Presumably, Bellori 3.29/Wulff 1224 was one of the "irdenen Lampen" inventoried in the letter of 27 May 1696.

The archives of the Prussian State Museums show that in 1897 Bellori 3.29 was transferred from the Antiquarium to the jurisdiction of the Staatliche Museen. In short, the lamp became public property in that year. The archival notes were handwritten by Oskar Wulff in the year of the transfer, and twelve years later Bellori 3.29 became entry no. 1224 in Wulff's catalogue (*Königliche Museen zu Berlin. Beschreibung der Bildwerke der christlichen Epochen 3: Altchristliche und Mittelalterliche Byzantinische und Italienische Bildwerke. Teil I: Altchristliche Bildwerke*, 2d ed. [Berlin, 1909]). It is clear from entry 1224 that Wulff thought the Berlin lamp was the same lamp that had once been in Bellori's collection. The lamp was preserved during the second World War, and it was not transferred west to Dahlem in 1945, or thereafter. As I have already noted, it is still in Berlin in the Early Christian Collection of the Bode Museum. In other words the ownership stemma seems relatively clear: Bellori owned the lamp in 1691 (and earlier, although for what period we do not know); it passed to his heirs in 1696; they sold it to Beger as agent for Frederick; it was transferred to Berlin in 1698 and remained in the Royal Cabinet until 1897 at which time it became the property of the Prussian State; today it is the property of the Federal Republic's State Museums.

Two factors cloud the stemma, but in my view, neither is decisive. First, there is the Latin edition of *LVS* published by Alexander Duker at Leiden in 1728: Duker claims that the lamp was still in Bellori's collection. This is no doubt a simple factual error due to Duker's lack of up-to-date information.

The other factor is slightly more complicated. First, Giovanni Battista

de Rossi composed an article ("Lucernae cristiane trovate fra molti e preziosi arnese d'arte profana in una case antica di Ostia," *BullAC* [1870] 77–85) in which he compared an Ostian upper-body lamp fragment with Bellori 3.29. According to de Rossi's own account of this matter, he had the Ostian fragment transported to Rome where he was able to compare it with Bartoli's original drawing of 3.29, which de Rossi said was easily accessible in the Vatican Codex Ottobonianus 3105, p. 151 (but inaccessible to me). If Bellori 3.29 had been in Rome (or if a duplicate were available), presumably de Rossi would have compared the Ostian fragment with the real thing rather than, as he did, with Bartoli's drawing of the Bellori original. In other words, de Rossi's information in this note is consistent with the presumption that the lamp was no longer in Rome in 1870 when he published his first note on Bellori 3.29.

But the comparison between the Ostian fragment and Bartoli's drawing evidently inspired de Rossi to devote a second study exclusively to Bellori 3.29 ("Della singolare lucerna nella quale è effigiato il pastore con i busti del sole della luna e sette stelle sul capo," ibid., 85–88). He observed correctly that Bartoli's settecento style and that of the lamp disks which he was drawing were very different ("i disegni del Bartoli, . . . sono tanto liberi ed abbelliti o per meglio dire diversi dallo stile antico ed originale," p. 85), but (again correctly) this did not lead him to doubt the authenticity of the lamps in Bellori's collection. He says nothing about having seen the Bellori collection (in Berlin), and thus his comparisons between Bartoli's drawings and the originals must have been based on lamp disks similar to those in the Bellori collection.

In one place de Rossi compares Bellori 3.29 with a lamp described by the epigrapher Gaetano Marini. He gives Marini's description of the lamp, evidently from the handwritten manuscript of Marini's well-known *Iscrizioni antiche dolari* . . . [Rome, 1884]:

> . . . lucerna fictilis in qua opere satis elegante conspicitur bonus pastor, qui manibus tenet oviculam collo impositam et incedit ea parte qua visitur luna crescens et stellae septem; in area multae oves, pone collum pastoris caput radiatum solis et infra arbor: in aversa facie litteris bonis et incusis
>
> SAECVL

De Rossi thought this must be a description either of Bellori 3.29 drawn by Bartoli "od uno simile." He speculated that there might have been two lamps, the one Bellori 3.29, the other a simplified version of same, but without Jonah and Noah's ark. He also acknowledged that he did not know the whereabouts of either lamp, Bellori 3.29 or the lamp Marini had seen.

Since Marini was first and foremost an epigrapher, it seems reasonable to suppose that he read the inscription on the base of the lamp correctly, and if that presumption is correct, then the lamp he saw must have been Bailey Q1370 (Figure 5.10, 5.11), "od uno simile." The problem with this theory is that the British Museum accessioned Bailey Q1370 in 1756, and

Marini was born in 1740; thus he would have had to see (and remember) the lamp while he was still a boy, long before his career went in the direction of collecting and publishing inscriptions. This is scarcely possible.

Though not much in the way of positive consolation, I think we can draw one minor negative conclusion from this antiquarian material: the SAECVL on the lamp described by Marini and the FLORENT on Wulff 1224 do not constitute a contradiction in the ownership stemma of Bellori 3.29. De Rossi's report of the lamp that Marini had seen does not undermine the identification of Bellori 3.29 with Wulff 1224. These are almost certainly the same lamp. De Rossi was not sure if the lamp Marini had seen was or was not identical with Bellori 3.29, but the base inscription (no doubt accurately transcribed by Marini) makes this conjecture impossible.

Notes

1. For the western half of the Empire the best survey of this subject is still A.-M. Schneider, "Die ältesten Denkmäler der Römischen Kirche," *Festschrift Akad. Gött. II, Phil.-hist. Kl.* (Göttingen, 1951), 166–97; Schneider's conclusion: "Weder Archäologie noch Epigraphik haben bis heute—trotz ausgedehnter Forschungsarbeit—auch nur ein christliches Denkmal zutage gefördert, das mit Sicherheit vor 200 angesetzt werden könnte." For the eastern half of the Empire, see E. Dinkler, "Älteste christliche Denkmäler—Bestand und Chronologie," in *Signum Crucis. Aufsätze zum Neuen Testament und zur christlichen Archäologie* (Tübingen, 1967), 134–78: same conclusion. I reject the claims of New Testament archaeology to the degree that this discipline imagines the survival of material forms that were directly produced by first- or second-century Christians. For example, under the inspiration of Bellarmino Bagatti, the Italian School (Studium Biblicum Francescanum) in east Jerusalem has long maintained the position that it is possible to demonstrate the independent material existence of a first-century, Aramaic-speaking form of Palestinian Christianity. Uncritical surveys: J. Finegan, *New Testament Archaeology* (Princeton, N.J., 1969), and I. Mancini, *Scoperte archeologici sui giudeo-cristiani* (Jerusalem, 1970). Wild speculations: E. Testa, *Il simbolismo dei giudeo-cristiani* (Jerusalem, 1962). Sober and critical, but limited in scope: R. H. Smith, *PEQ* 106 (1974), 53–66. On the Italian excavations at Capernaum: J. F. Strange, *BASOR* 226 (1977), 65ff., and 233 (1979) 63ff. Bagatti's bibliography: *Studii Biblici Francescani. Collectio maior* 22.1 (1976), 17–27. A sweeping rejection of Bagatti's work and of the work of the Studium Biblicum Francescanum in general: J. E. Taylor, *Christians and the Holy Places* (Oxford, 1992).

2. C. H. Roberts and T. C. Skeat, *The Birth of the Codex* (London, 1985), 40–41: fifteen second-century Christian papyrus frags., eleven biblical, four nonbiblical; also J. van Haelst, *Catalogue des papyrus littéraires juifs et chrétiens* (Paris, 1976); also C. Roberts, *Manuscript, Society and Belief in Early Christian Egypt* (London, 1979), 13–14.

3. J. Gutmann, "Jewish Art and Jewish Studies," in *The State of Jewish Studies*, ed. S. J. D. Cohen and E. L. Greenstein (Detroit, 1990), 193ff. (with the earlier literature cited there). For a recent restatement of an older interpretative theory arguing the priority of Jewish over Christian visual imagery: K. Weitzmann and H.

L. Kessler, *The Frescoes of the Dura Synagogue and Christian Art* (Washington, D.C., 1990); also J. Gutmann, *ANRW* II.21.2. (1984), 1313–42.

4. Hence its original purposes (contrary to popular misperceptions) are polemical and apologetic, concerned primarily with the exposition and defense of Roman Catholic teaching; see P. Fremiotti, *La riforma cattolica del secolo decimo sesto e gli studi di archeologia cristiana* (Rome, 1926); also H. R. Seeliger, *RivAC* 61 (1985), 167–87; P. C. Finney, *SC* 6.4 (1987–1988), 203ff.

5. Bosio, *RS*; on Bosio (ca. 1576–1629): *DACL* 2.2 (1910), 1084–93.

6. Roberts and Skeat, *Codex;* also Roberts, *Manuscript,* e.g. 47: ". . . the all but universal adoption of the papyrus codex as the vehicle for the sacred books of Christianity."

7. Roberts and Skeat, *Codex;* also Roberts, *Manuscript,* 26ff., e.g. 47: "In form the nomina sacra cannot be explained as imitative of or even adapted from either Greek or Jewish scribal practice; . . . Like to so much in early Christianity, they are sui generis." Dinkler, "Älteste christliche Denkmäler," 176–78: sigma-tau ligatures (or contractions) on second-century Christian papyri; Dinkler calls the device "Staurogramm"; also idem, *JbAC* 5 (1962), 93–112; cf. W. Wischmeyer, "Christogramm und Staurogramm in den lateinischen Inschriften altkirchlicher Zeit," in *Theologia Crucis—Signum Crucis. Festschrift für Erich Dinkler,* ed. C. Andresen and G. Klein (Tübingen, 1979), 539–50. Contractions on magical papyri in two forms, ideograms and nomina sacra ligatures: *PGM* 2:269–70; also Roberts, *Manuscript,* 82–83.

8. There is abundant evidence (literature, epigraphy, archaeology) demonstrating that in the period of the Severi momentous changes were taking place within Christian *ekklesiai,* especially in North Africa and Italy; thus G. la Piana, *HTR* 18 (1925), 201–77; W. H. C. Frend, *JThS,* n.s., 25 (1974), 333–51; T. D. Barnes, *Historia* 16 (1967), 87ff. But to my knowledge there is nothing to explain the conundrum raised by the theory that Christian art made before 200 has perished in its entirety.

9. Putative Pythagorean influences in Roman art: F. Cumont, *Recherches sur le symbolisme funéraire des romains* (Paris, 1942), index général, s.v.; criticism (in my view convincing): A. D. Nock, *AJA* 50 (1946), 140–70, esp. 151–55. Nilsson, *GGR* 2:396ff.: does not mention putative neo-Pythagorean influences on Roman art. The inspiration for a Roman rebirth of Pythagorean thought is commonly credited (Suetonius following Cicero) to Nigidius Figulus (ca. 100–45 B.C.). For a useful and mostly sober treatment of this intriguing character (who has unfortunately inspired much scholarly *Schwärmerei*): A. della Casa, *Nigidio Figulo* (Rome, 1962). On the other neo-Pythagoreans, reported by Alexander Polyhistor and Sextus (Apollonios, Kronios, Moderatos, Nikomachos, Numenios, Okellos Lucanus): J. Dillon, *The Middle Platonists* (Ithaca, N.Y., 1977), general index, s.v.; also H. Thesleff, *The Pythagorean Writings of the Hellenistic Period* (Åbo, 1965).

10. More speculations (ingenious and erudite) on Pythagorean influences in Roman art (including a version of gnosticism tinged with Pythagoreanism, expressed visually in the Tomb of Aureli): J. Carcopino, *De Pythagore aux Apôtres* (Paris, 1956); criticism (again convincing): J. M. C. Toynbee, *Gnomon* 29 (1957), 261–70.

11. P. C. Finney, *CIAC.Atti* 9.1 (1978), 391–405; idem, *Numen* Suppl. 41.1 (1980), 434–54.

12. Evidence in prehistory: G. E. Daniel and C. Renfrew, *The Idea of Prehistory,* 2d ed (Edinburgh, 1988); B. Trigger, *Beyond History: The Methods of Prehistory*

(New York, 1968); idem, *Anthropos* 18 (1976), 33ff.; C. Renfrew, M. J. Rowlands, B. A. Segraves, eds., *Theories and Explanation in Archaeology* (New York, 1982).

13. Th. Klauser, *CIAC.Atti* 6 (1965), 232–35; e.g. 232 on the female influence: "Immer mehr Gläubige, vor allem Frauen, werden damals gleich Constantia das Bedürfnis empfunden haben, ihre Frömmigkeit an religiösen Bildern zu nähren." Cf. idem, *ZKG* 76 (1965), 7: the impulse for the birth of Christian art must have come either from the laity or from heretical groups in opposition to the official (*lege:* episcopal) aniconic will of the church. Among early, image-loving heretics Klauser cites the examples of the Carpocratians, the Simonians (supposedly founded by Simon Magus, Acts 8:9ff.; Iren., *Haer* 1.23.4, 1.29.1), and the Manichaeans; on the Carpocratians as second-century, Christian-gnostic idolaters who supposedly worshiped *eikones/imagines* of Jesus, see P. C. Finney, *CIAC.Atti* 9.1 (1978), 391ff., and idem, *RivAC* 57 (1981), 35ff.

14. The same thesis (Christian recidivism: the new religionists sliding back into paganism) is argued on architectural evidence by F. W Deichmann, "Vom Tempel zur Kirche," in *Mullus. Festschrift Th. Klauser, JbAC* Ergbd. 1 (1964), 52ff.; for another view: P. C. Finney, *HTR* 81.3 (1988), 319ff.

15. Thus, with respect to Philo's spiritualization of Jewish cult: H. Wenschkewitz, *Angelos* 4 (1932), 131–51; also H. Lewy, *Sobria Ebrietatis* (Giessen, 1929).

16. Again, with respect to Jewish cult: G. Klinzing, *Die Umdeutung des Kultus in der Qumrangemeinde und im Neuen Testament* (Göttingen, 1971); also S. E. Johnson, *ZAW* 66 (1954), 106–20, and P. C. Finney, *Boreas* 7 (1984), 193ff.

17. *Ekklesia* is a secular Greek term, meaning assembly, for example the assembly of the Athenian demes; see K. L. Schmidt, in *TDNT* 3:487ff. (καλέω). On the transition from *ekklesia* as a religious community of believers and worshipers to *ekklesia* as a place of worship (and finally a building): Finney, *Boreas* 7 (1984), 193ff.

18. For example, the sense of belonging to an *ekklesia* located (for purposes of worship) in the house of a community member is certainly attested at the middle of the first century in the Pauline corpus: Philem 2 (the church in the house of Philemon); 1 Cor. 16:19 (the church in the house of Aquila and Prisca; also at Rom 16:5); Rom 16:1 (the church at Cenchreae possibly [?] gathered in the house of Phoebe the deaconess); Col 4:15 (possibly deutero-Pauline): the church in the house of Nympha. Attestations of the same phenomenon in Acts are more numerous (cf. *Boreas* 7 [1984], 208–9) but their value as evidence is beset with numerous critical problems.

19. F. Barth, "Introduction," in *Ethnic Groups and Boundaries*, ed. F. Barth (Boston, 1969), 9–38.

20. Also Clem., *Paed.* 2.119.1–121.1 (e.g. 2.120.3: κοινὰ οὖν τὰ πάντα καὶ μὴ πλεονεκτούντων οἱ πλούσιοι, and Tert., *Apol.* 39.11: "Omnia indiscreta sunt apud nos praeter uxores" ("All things are held in common among us, except our wives"), and H. Chadwick, *The Sentences of Sextus: A Contribution to the History of Early Christian Ethics* (Cambridge, 1959), 228: "For those who have God in common—and as father at that—it is impious for their property not to be common." On the socialistic principle of sharing resources in early Christianity: A. Bigelmair, *Die Beteilung der Christen am öffentlichen Leben in vorconstantinischer Zeit* (Munich, 1902), 73–76; also L. Wm. Countryman, *The Rich Christian in the Church of the Early Empire: Contradictions and Accommodations* (New York, 1980), esp. 54ff., 76ff.

21. According to Acts 11:26 it was in Antioch where "the disciples were first called 'Christians,'" presumably by outsiders. Discussion of the *nomen:* see Chapter 4 (under judicial cognitio).

22. An early Jerusalem tradition, transmitted in various sources but especially prominent in the pseudo-Clementines, may constitute an exception to this generalization. James, one of Jesus' four brothers, is the key figure (Mk 6:3par. and Gal 1:19). In a fragment that Eusebius preserves (*HE* 2.1, 3) from Clement's lost *Hypotyposes,* Clement claims that Peter and John elected James as bishop of Jerusalem, and in another place (*HE* 7.19) Eusebius writes that Jesus appointed his brother the first bishop of the Jerusalem church. At *HE* 3.11.1 after James' death, the Jerusalem community elects Simeon as James' successor, and on the authority of Hegesippus Eusebius writes that Simeon was the son of Klopas, a brother of Joseph, thereby establishing Simeon and Jesus as first cousins. Thus there appears to have been an early Jerusalem tradition asserting consanguinity as a criterion for office holding; cf. G. A. Koch, in *EEC,* s.v. "James."

23. Thus J. L. Martyn, *The Gospel of John in Christian History* (New York, 1978), 91: "the Gospel is written in the language of a community of initiates"; also W. A. Meeks, "The Man from Heaven in Johannine Sectarianism," *JBL* 91 (1972), 44–72, e.g. 62: "The language patterns . . . [of the Johannine group or community] have the effect, for the insider who accepts them, of demolishing the logic of the world, particularly the world of Judaism, and progressively emphasizing the sectarian consciousness." The working hypothesis here is that early Christianity (or at least its Johannine incarnation) was a sectarian movement (on which, see R. Scroggs, "The Earliest Christian Communities as Sectarian Movements," in *Christianity, Judaism and Other Greco-Roman Cults—Studies for Morton Smith at Sixty,* vol. 2, ed. J. Neusner [Leiden, 1975], 1–23). For another view: R. E. Brown, *The Community of the Beloved Disciple* (New York, 1979), 13ff.

24. On the separate existence of an early, Latin-Christian *Sondersprache:* H. H. Janssen, *Kulture und Sprache, LCP* 8 (Nijmegen, 1938); Chr. Mohrmann, *De struktuur van het Oudchristelijk Latijn* (Utrecht, 1938); idem, *Études sur le latin des chrétiens* (Rome, 1958).

25. Eidolothuta: (instead of the Jewish *hierothuta*): C. K. Barrett, *NTS* 11 (1965), 138–53; J. Murphy-O'Connor, *CBQ* 41.2 (1979), 292–98. The earliest Jewish attestation: 4 Macc 5:2; also ps.-Phokylides 31 (probably a Christian interpolation, based on Acts 15:29); see F. Büchsel, in *TDNT,* s.v.

26. In *De pallio* (written after 205) Tertullian portrays the pallium (hymation) as the Christian garment of choice; this rhetorical conceit may correspond to real life but probably does not; see J. Geffcken, *Kynika und Verwandtes* (Heidelberg, 1909), 58–138. Clement's ideas on Christian attire, which he sets forth with excruciating detail in books II and III of *Paed.,* amount to the exhortation that Christian ladies and gentlemen should bedeck themselves modestly and inconspicuously.

27. *Diogn.* 5.2 (οὔτε βίον παράσημον ἀσκοῦσιν) [Marrou]: "leur genre de vie n'a rien de singulier." Parasemos: exhibiting a false *sema* (sign, characteristic, mark, token), hence falsely marked, a counterfeit. The common usage is pejorative and with reference to persons normally denotes a fraud, a notorious person. Parasemos (variously nuanced) plays a very important role in Plutarch's vocabulary; see D. Wyttenbach, *Lexicon Plutarcheum,* vol. 2 (Leipzig, 1843), s.v. At Acts 28:11 Luke uses the word in a neutral sense to describe a thing: a boat marked with the sign of the Dioscuri (ἐν πλοίῳ . . . παρασήμῳ). The author of *Diogn.* uses the epithet as the functional equivalent of *asemos:* without a *sema* (hence incon-

spicuous, lacking distinction, insignificant). LXX provides three good parallel uses of *asemos:* Gen 30:42 τὰ πρόβατα . . . τὰ ἄσημα; Job 42:11: τετράδραχμον χρυσοῦν ἄσημον (an unmarked, gold tetradrachm); 3 Macc 1:3: ἄσημόν τινα (an insignificant person).

28. For an intelligent, brief introduction: C. W. Fornara, *The Nature of History in Ancient Greece and Rome* (Berkeley, 1983) 12–16; also F. Jacoby, *Klio* 9 (1909), 22–23, 34ff.; K. Trüdinger, *Studien zur Geschichte der griechischen-römischen Ethnographie* (Basel, 1918), is still useful. K. E. Müller, *Geschichte der antiken Ethnographie und ethnologischen Theoriebildung*, vols. 1 and 2, Studien zur Kulturkunde 29, 52 (Wiesbaden, 1972, 1980), contains a great mass of material, much of it undigested and presented uncritically.

29. Definitions of culture: R. M. Keesing, *Annual Review of Anthropology* 3 (1974), 73ff.; also R. H. Winthrop, in *Culture and the Anthropological Tradition. Essays* . . . , ed. R. H. Winthrop (Lanham, Md., 1990), 1–13, and L. A. White with B. Dillingham, *The Concept of Culture* (Minneapolis, 1973). On religion as a "cultural system," meaning in this case symbol systems within cultures: C. Geertz, *Anthropological Approaches to the Study of Religion* (New York, 1966), 1–66.

30. The term arose in the Hellenistic period to denote ethnic communities (e.g. Macedonians, Greeks, Persians, Jews) in the midst of foreign populations, usually in Egypt or in the cities of the Seleucid territories. *Politeumata* were administratively autonomous; cf. V. Ehrenberg, *The Greek State* (New York, 1964), index, s.v. *"politeumata."* Alexandrian Jewry as a *politeuma: Letter of Aristeas* 310; Jewish *politeumata* in Cyrenaica: *CIG* 5361, 5362. More examples: V. Tcherikover, *Hellenistic Civilization and the Jews* (Philadelphia, 1966), 296ff. *CIJ* 694 (Stobi): Tiberius Polycharmos: πολειτευσάμενος πᾶσαν πολειτείαν κατὰ τὸν ἰουδαϊσμὸν.

31. A fact whose importance should not be underestimated: *ekklesiai* were eleemosynary communities of mutual care and concern, and in assessing the growth of Christianity, this fact counts for a great deal; correctly observed by E. R. Dodds, *Pagan and Christian in an Age of Anxiety* (Cambridge, 1965), 136ff.

32. Cultures, which consist in relationships between people, are by definition immaterial. People in relationship produce things, the material products of their culture. *Material culture* is a short-hand paraphrase of the latter.

33. A convenient inventory of Palestinian monuments: R. Hachlili, *Ancient Jewish Art and Archaelogy in the Land of Israel, HbO* Abt. 7 Bd. 1.2 (Leiden, 1988). There is no up-to-date equivalent for diaspora Jewry—one must still rely on Goodenough, *Symbols*.

34. Hecataeus of Abdera (*FGrHist* 3A.264; frag.6): Moses established a form of life contrary to humanity and hospitality. Thence a *topos* carried by Diodorus Siculus, Apollonius Molon, Lysimachus (Philo, *Ap.* 1.34), Apion, Juvenal, and Tacitus; the latter (writing of Jews at *Hist.* 5.1: "adversus omnes alios hostile odium: separati epulis, discreti cubilibus . . . alienarum concubitu abstinent"); cf. Stern, *GLAJJ* 2, no. 281.

35. Gibbon *Decline*, quoted from 2:1, 2 of chap. 15 entitled "The Progress of the Christian Religion, and the Sentiments, Manners, Numbers and Condition of the Primitive Christians."

36. The primary cause according to Gibbon being Christian doctrine and "the ruling providence of its great Author": Gibbon, *Decline*, 2:2.

37. E.g., J. Pelikan, *The Excellent Empire: The Fall of Rome and the Triumph of the Church* (San Francisco, 1987). This was a lecture honoring the memory of Walter Rauschenbusch, the champion of the social gospel. This would have been an ideal

forum for Pelikan to discuss social adaptation as a key element in the rise of Christianity. He chose not to do so.

38. J. W. Bennett, *The Ecological Transition: Cultural Anthropology and Human Adaptation* (New York, 1976); R. Rappaport, *Ecology, Meaning and Religion* (Richmond, Calif., 1979); A. W. Johnson and T. Earle, *Evolution of Human Societies* (Stanford, Calif., 1987).

39. Hence the absence of identifiable Christian interments before the third century. Roman Christians, for example, probably buried their dead alongside pagans, very likely in subdial plots which have long since been overbuilt. Ferrua's excavations of several open-air plots at Domitilla may provide an example of the kinds of mixed interments that Christians were able to afford in the second century; see A. Ferrua, "Il cimitero sopra la catacomba di Domitilla," *RivAC* 36 (1960), 173–210.

40. G. Walzer and T. Pekary, *Die Krise des römischen Reiches* (Berlin, 1962); G. Alföldy, *Die Krise des Römischen Reiches . . . Ausgewählte Beiträge* (Stuttgart, 1989), includes twenty essays, richly documented. Economy, politics, and historiography in the third century: D. S. Potter, *Prophecy and History in the Crisis of the Roman Empire* (Oxford, 1990), 3–94.

41. The earliest evidence for Christians controlling real property is provided by the plot (approximately thirty by seventy meters) overlying Area I on Level 2 of the Callixtus catacomb (see Chapter 6); the date at which Christians gained control of this plot is disputed, but it must fall in the period ca. 160–180. The conditions of their tenancy are obscure (and much debated). We have no direct documentary evidence. The possibilities are three: ownership (by bequest, by outright purchase, and conceivably [?] by adverse possession), valid control (by lease or by free grant of use), invalid control. Given the delicate (and also unfortunately obscure) legal status of Christians in the second century and given the price of suburban land south of Rome, invalid or illegal control (squatting) is not very likely. The best general presentation of this subject is still G. Bovini, *La proprietà ecclesiastica e la condizione giuridica della chiesa in età precostantiniano* (Milan, 1948); also still informative: Th. Mommsen, *ZSav* (Romanistische Abt.) 16 (1895), 203–20. A new study is needed.

42. On the distinction between hypogeum and catacomb: P. C. Finney, in *EEC*, s.v. "Catacombs."

43. A. von Harnack, *Die Mission und Ausbreitung des Christentums in den ersten drei Jahrhunderten*, 4th ed. (Leipzig, 1924), 445ff. The most reliable and revealing evidence is epigraphic, however Christian inscriptions predating ca. 180 are to my knowledge either very rare or nonexistent. Early Christian epigraphy in Rome really commences with the earliest hypogeal interments under the bishopric of Zephyrinus; cf. U. M. Fasola and P. Testini, *CIAC.Atti* 9.1 (1978), 105ff., and A. Ferrua, ibid., 583ff.; also H. Zilliacus et al., *AIRF* I.1, 2.

44. On problems of dating: L. Reekmans, *RivAC* 49 (1973), 271–91.

45. The best general introduction to this subject: G. Koch, "Stilistische Untersuchungen zu spätantiken und frühchristlichen Sarkophagen" (Habilitationschrift, Göttingen, 1977); the standard older work (F. Gerke, *Die christlichen Sarkophage der vorkonstantinischen Zeit* [Berlin, 1940; rpt., 1978]): needs to be completely rewritten.

46. Unfortunately, this term enjoys considerable popularity in archaeological and art-historical circles. In some contexts it is justified, e.g. Jn 12:42–43: Christians who refuse to reveal their religious identity openly for fear they would be

ejected from the synagogue; see R. E. Brown, *The Community of the Beloved Disciple* (New York 1979), 71–73. But applications of this term to material culture are mostly misleading in my opinion (discussed in Chapter 7).

47. Alternative: "If someone is a fisher: κἂν ἁλιεύωντις ἦ.

48. On this passage: P. C. Finney, *DOP* 41 (1987), 181–86 (with the literature cited there).

49. The examples are too numerous to list here; the most accessible iconographic inventory can be found in the four volumes of *AGDS*. For a useful and informative discussion of devices on Roman intaglios (many of them second century): M. Henig, *A Corpus of Roman Engraved Gemstones from British Sites, Bar* 8 (Oxford, 1974).

50. H. von Petrikovits, "Die Spezializierung des römischen Handwerks," in *Das Handwerk in vor- und frühgeschichtlicher Zeit*, vol. 1, ed. H. Jankuhn et al. (Göttingen, 1981), 63ff., s.v. "Scalptores gemmarum"; continued (Teil II) for the period of late antiquity in *ZPE* 43 (1981), 285ff.

51. Of which the six earliest examples, in my view, date to the fourth century; see P. C. Finney, in *EEC*, s.v. "Cross." Morton Smith has expressed the opinion that the Pereire crucifixion (formerly in Paris, now in the BM.MLA) dates "about A.D. 200" (*Jesus the Magician* [San Francisco, 1978], 61). I doubt this claim and shall discuss this subject at greater length in my forthcoming *Catalogue of Late Antique and Early Byzantine Intaglios in the British Museum*. On the Pereire stone: Ph. Derchain, "Die älteste Darstellung des Gekreuzigten auf einer magischen Gemme des 3. (?) Jhdts.," in *Christentum am Nil*, ed. K. Wessel (Recklinghausen, 1963), 109ff.

52. Jonah on intaglios: Dalton (1901) nos. 25, 26. Boston, MFA inv. no. 03.1008 = Bonner, *SMA* 347; also *Hesperia* 20 (1951), 338, no. 58 (here Figure 5.3). Bonner, *SMA* 346 (formerly in the Newell Collection, but transferred to ANS at Mr. Newell's death) was not an intaglio, but a magical amulet in argillaceous schist; it was destroyed at ANS. General introduction: *DACL* 6.1, (1924), 794ff.; 7.2, 2572ff. Jonah in other material settings: A. Ferrua, *RivAC* 38 (1962), 7–69; also E. Ferguson, in *EEC*, s.v. "Jonah."

53. The long passage (*Prot.* 4.46.1–63.5; discussed in Chapter 3) on idols and idol worship is Clement's major (but certainly not his only) statement on this subject.

54. *Paed.* III.60.1: πολλοὶ δὲ τῶν ἀκολάστων ἐγγεγλυμμένους ἔχουσι τοὺς ἐρωμένους ἢ τὰς ἑταίρας, ὡς μηδὲ ἐθελήσασιν αὐτοῖς λήθην ποτὲ ἐγγενέσθαι δυνηθῆναι τῶν ἐρωτικῶν παθημάτων διὰ τὴν ἐνδελεχῆ τῆς ἀκολασίας ὑπόμνησιν.

55. As emphasized by H.-D. Altendorf, *ZNW* 58 (1967), 134–38: there is no explicit symbolic referent here, no positive relationship established between any of the five recommneded images and Christian meanings. Clement recommended these five, in Altendorf's reading of the passage, because they were "religiös neutral" (132), "unschuldige Bilder" (135), "religiös indifferente Bilder" (138).

56. In addition to this generic term (signifying in English workman, craftsman, or artisan) he mentions *plastes* (3.2), *caelator* (3.2), *albarius tector* (8.2), *pictor* (8.2), *marmorarius caelator* (8.2), *aerarius caelator* (8.2), *Qui de tilia Martem exsculpit* (wood sculptor, 8.3). At 8.4 he alludes to gilders without mentioning *aurator*, as he does in the same passage to the artifices of large dishes (*lances*) and large, two-handled drinking vessels (*scyphi*). In 8.5 he alludes to the makers of *coronae*. On this nomenclature (with literary and epigraphic attestations): von Petrikovits,

"Spezializierung." Tertullian's very sensible advice to these craftspeople (all of them employed in the production of idols) is that they should transfer their skills to the manufacture of other things. Good commentary: Waszink, van Winden, in Tert., *Idol.* ad loc. G. Schöllgen, *JbAC* Ergbd. 12 (1984), 225–30: otiose. Intriguing rabbinic parallels: W. A. L. Elmslie, *TS* 8.2 (1911).

57. In the visual arts, criticism based on the artist's intention is as old as Vasari. For a brief discussion of the role that intention plays in philosophical aesthetics: M. C. Beardsley, *Aesthetics* (New York, 1958), index, s.v. In modern criticism, the parallel to Clement's concern is the so-called reception theorists (the Konstanz School), who focus not on the artist and his or her intentions but instead on the artist's audience responding to the work of art; see H. J. Jauss, *Die Theorie der Rezeption* (Konstanz, 1987).

58. Clement does not mention Peter by name in this context, but at *Paed.* III.52.2 he is explicit: "the Lord taught Peter to catch men as one would fishes from water."

59. Tert., *Bap.* I.3: "Sed nos pisciculi secundum ΙΧΘΥΝ nostrum Iesum Christum in aqua nascimur"; see Dölger, *ΙΧΘΥΣ* 1:42ff.

60. E. Ferguson, in *EEC*, s.v. "Fish" *ΙΧΘΥΣ* as an inscription on late-antique intaglios: Dölger, *ΙΧΘΥΣ* 1:262–336.

61. The mood and *mise-en-scène* are suspiciously reminiscent of Jewish anti-idolatry attacks (prophets vs. *baalim*)—the passage is probably a literary fiction; see E. Haenchen, *Die Apostelgeschichte*, 5th ed. (Göttingen, 1965), ad loc.

62. Liberti: F. Grossi-Gondi, *Trattato di epigrafia cristiana latina e greca* (Rome, 1920), 101ff. O. Pergreffi, *Epigraphica* 2 (1940), 314–36; 3(1941), 110–31; J. Suolahti, *AIRF* I.2 (1963), 167–184.

63. Implied at *Paed.* III.58.2,22: ἐμπολιτευμένους.

64. *Paed.* III.57.1: signets and seals would not be necessary if slaves were as honest as their mistresses. On slaves (proverbially liars, cheats, and crooks): A. Otto, *Die Sprichwörter ind die sprichwörtlichen Redensarten der Römer* (Leipzig, 1890): "servus"; also *Philogelos* 263 (ed. A. Eberhard [Berlin, 1869]): the stupid master corks and seals his wine jug, but the clever and conniving slave bores a hole in its bottom.

65. Philainis (at *Suda* 4621: Αστυανασσα) was said to have composed a *Peri schematon sunousias* (On positions for intercourse).Tat., *Or.* 34.3 lumps him together with Elephantis, another famous ancient pornophile. Clement (*Prot.* 4.61.2) says that Greeks put Philainian σχήματα on their bedroom walls, and the evidence of Romano-Campanian wall painting tends to confirm his reproach.

66. S. Loeschcke, *Lampen aus Vindonissa* (Zurich, 1919), 49–55: Gruppe I (Bildlampen) Typus VIII: Lampen mit einfacher Rundschnauzen.

67. Bailey, Cat. 2: nos. Q1327–Q1422. The type is very familiar: circular body, concave discus surrounded by rounded shoulder, short rounded nozzle, pierced handle at the rear.

68. O. Wulff, *Altchristliche und Mittelalterliche Byzantinische und Italienische Bildwerke*, vol. 1 (Berlin, 1909), Keramik: 1224.

69. Bellori's antiquities were packed in wooden crates and shipped to Berlin in that year; they arrived at the Berliner Schloss on 4 May 1698—presumably Wulff 1224/Bellori 3.29 was in that shipment; see G. Heres, "Die Sammlung Bellori: Antikenbesitz eines Archäologen im 17. Jahrhundert" *ÉtTrav* 10 (1978).

70. The most accessible and comprehensive inventory: A. Provoost, "Iconologisch onderzoek van de laat-antieke herdervoorstellingen," 3 vols. (Pro-

efschrift, Catholic University of Leuven, 1976), nos. 920–71 (with extensive bibliography). I am very grateful to Arnold Provoost for providing me with a copy of his valuable thesis.

71. They are known by their names commonly abbreviated and stamped on the bases of their lamps: ANNISER/Annius Serapidorus; BESTALIS/Bestalis; FIDEL/ Fidelis; FLORENT/Florentius; LCAESAE/L. Caecilius Saecularis; SAECVLI/Saeculus; MARI FRVC/?

72. Loeschcke, *Lampen*, register, s.v. The original stamps were probably metal (bronze?), and the letters were raised (cameo). The clay archetype was stamped creating an incuse (or intaglio) abbreviation. Thus the lower-body matrix formed from the archetype would have a cameo version of the stamp, and the final product, an incuse version.

73. Nomenclature for persons (free and slave) employed in the manufacture of Roman ceramics (*cretaria ars*): Petrikovits, "Die Spezializierung." "Lucenarius" at *CIL* 15.6263 may refer to a potter who makes lamps or a vendor (thus *OLD*) who sells them. The Roman pottery industry: H. Gummerus, in *RE* 9.2 (1916), 1439ff.; also A. H. M. Jones, *The Later Roman Empire 284–602* (Norman, Okla., 1964), index, s.v.

74. Annius' incuse stamp (ANNISER): *CIL* 2.6256, 7; 3.1634, 1; 5.8114, 5–6; 8.22644, 32; 10.8053, 20; 12.5682, 4; 15.6295–96. Also Bailey, *Cat. 2:* index of inscriptions, s.v. Annius' floruit: late Severan, early third century.

75. Florentius incuse stamp (FLORENT): *CIL* 3.6008,23; 5.8114,52; 7.1330,14; 10.8053,81; 11.6699,85; 12.5682,48; 13.10001,135; 15.6445. Also Bailey, *Cat. 2:* index of inscriptions, s.v. Wulff, transcribed FLORENT "Florentinus." Provoost, "Iconologisch onderzoek," repeated the error. Evidently W. N. Schumacher, *Hirt und Guter Hirt*, *RQ* 34 Suppl. (Rome and Freiburg, 1977), 95, accepted Wulff's faulty reading.

76. Saeculus incuse and cursive stamp (SAECVLI, SAECVL): *CIL* 2.4969, 49; 10.8053, 178; 11.6699, 3; 12.5682, 104; 13.10001, 10; 15.6221. Also Bailey, Cat. 2: index of inscriptions, s.v. Provoost wanted to read SAECVL as Saecularis and surmised that these lamps were produced as souvenirs for the Saecular Games—this seems unlikely; see Provoost, "Iconologisch onderzoek," 1: no. 931.

77. *BullAC* (1867), 9–16; (1870), 77–85; (1879), 27–29; (1881), 114–15.

78. *DACL* 2.1 (1907) 2225: speculating on the religion of the "patron" of the *officina* that produced lamps stamped ANNISER. It is not clear what Leclercq meant under the French term *patron*, whether *dominus* (proprietor and principal), *institor* (agent for the principal), or *officinator* (workshop foreman)—it is possible that Leclercq did not know the distinctions between these three.

79. Bosio, *RS*, 211.

80. Bailey, Cat. 2: Q1375 (L: 93 mm. W: 64 mm.) is representative.

81. La Gratiène (Provence) south of Aix: *Gallia* 16 (1958), 419, fig. 11.

82. Bailey, *Cat. 2:* Q1375, Type Q/Group 6 (L: 93 mm. W: 64 mm). Discus: rosette with petals. "Said to have been found in 1875, about six feet from the surface, on the site of the donor's house: The Friary, Ponteys Lane, Middleton St. George., Co. Durham, Eng."

83. *OLD:* "A small retailer, a shopkeeper, a pedlar, or sim." This is misleading. *Institor* was an office of agency, typically a manager working for a principal; thus Ulp., *Dig.* 14.3.5; Paul., *Dig.* 14.3.18; Gaius, *Inst.* 4.71; see W. V. Harris, *JRS* 70 (1980), 140–41; also Petrikovits, *Das Handwerk in vor- und frühgeschichtlicher Zeit*, 1:100.

84. Fortis' stamp in relief (FORTIS); Bailey, *Cat.* 2: index of inscriptions, s.v. The original Fortis was perhaps L. Aemilius Fortis, one of the earliest makers of *Firmalampen*. He may have begun production under Vespasian in a workshop located near Modena. The *officina* may have been relocated in Romano-Campanian territory after his death—in any event there was a central Italian Fortis workshop still producing lamps in the Severan period.

85. C. Oppius Restitutus incuse stamp (C.OPPI.RES): Bailey, *Cat.* 2: index of inscriptions, s.v. "The most prolific central Italian lampmaker of his period." Floruit: late Flavian-Antonine.

86. See n. 77.

87. The fullest iconographic inventory is still the one provided by Dressel in *CIL* 15.2, 6296. It needs to be completely rewritten.

88. Thus Provoost, "Iconologisch onderzoek," 2: "Interpretatie."

89. *Pud.* 7.1 "A parabolis licebit incipias, ubi est ouis perdita a Domino requista et humeris eius reuecta. Procedant ipsae picturae calicum uestrorum; 10.12 ". . . pastor, quem in calice depingis, prostitutorem et ipsum Christiani sacramenti, merito et ebrietatis idolum et moechiae asylum post calicem subsecuturae." Tertullian is addressing his Catholic Christian enemies; parenthetically, he mentions that they paint the picture of their shepherd on their eucharistic cups. At 10.13 he writes "At ego eius Pastoris scripturam haurio, qui non potest frangi." This seems to me a legitimate basis for concluding the painted cups were in a breakable form, either terra cotta or, to my mind more likely, glass; see P. C. Finney, in *EEC*, s.v. "Shepherd."

90. *Hirt und Guter Hirt*, 95: "Heute ist die Lampe vernichtet."

91. N. Himmelmann, *Über Hirtengenre in der antiken Kunst, AbhRh-Westf.Akad* 65 (Opladen, 1980), 140ff.

92. Schumacher, *Hirt und Guter Hirt*, 95: "Wir glauben . . . in der Berliner Lampe eine Fälschung aus 18. Jh. . . . sehen zu müssen."

93. On procedures, degrees of accuracy, problem areas and general background: M. J. Aitken, *Thermoluminescence Dating* (London, 1985).

94. I have not been able to obtain a written copy of the test and hence must rely on the informal report sent to me by Dr. Arne Effenberger, director of the Frühchristlich-Byzantinische Abteilung in the Bode Museum: "Inzwischen konnten wir im Rathgen-Forschungslabor mit Erfolg die Thermoluminiszenz-Untersuchungen durchführen lassen. Es ist nunmehr erwiesen, dass Oberseite und Unterseite aus demselben Ton gefertigt sind und die Lampe ein Alter von 1700 Jahren ± 25% aufweist, somit antik ist" (addressed to me, signed by AE 10 January 1991).

95. L: 152 mm.; W: 103.0 mm.; H (from the bottom of the base ring to the shoulder): 36.4 mm. and to the top of the ring handle: 54.0 mm. Discus diam.: 88.0 mm.

96. See n. 47.

97. The lamp does not show the σκηνή, which comes to be interpreted in early Christian art as a lattice-work arbor or trellis; the best Latin equivalent is "umbraculum" (*OLD*, s.v.); for literature, see Chapter 6, n. 125.

98. The best-known examples are the famous bronze reverses, which span the years 193–253 and were struck at Phrygian Celenus/Apameia/Kibotos, 145 kilometers east of Ephesus; see *Age of Spirituality*, ed. K. Weitzmann (New York, 1979), no. 350. Celenus is the Phrygian and Apameia the Macedonian toponym—Kibotos must have been added because of a local tradition that Noah's ark landed

in this place after the flood waters subsided. Noah iconography: J. Fink, *Noe der Gerechte in der frühchristlichen Kunst* (Münster, 1955).

99. Bailey, *Cat.* 2:7.

100. Cosmogonic and cosmological symbolism was fairly common in second-century material culture shaped by Jews. They exploited Helios symbolism extensively; cf. Goodenough, *Symbols* 8:167ff.; 13: index of subjects, s.v. Selene was less common, and the Pleiades are mostly absent in their traditional Greco-Roman form (seven stars), but Jewish astral symbolism was widespread and common. Menoroth may represent the *interpretatio judaica* of the Pleiades. Doves were also common; see P. C. Finney, in *EEC*, s.v. What was not at all common, however (indeed it is altogether unattested), was the representation of the biblical figures that appear in early Christian art: Adam and Eve, Noah, Moses, Jonah, and Daniel. From the Hebrew Bible the only subject that is attested both in pre-Byzantine Jewish iconography and in early Christian iconography is the *akedah*. It is the presence of Jonah on this lamp which points I think unmistakably to a Christian owner. On the evidence of the Randanini and Torlonia catacombs, some Jews in the Severan Rome buried their dead in places marked with wall and ceiling fresco paintings, but the extant paintings exhibit nothing inspired by the Hebrew Bible (with the possible exception of the Randanini Orpheus/David, on which see P. C. Finney, *JJA* 5 [1978], 6ff.).; also Chapter 6, Appendix 2.

101. Thus M. C. S. Kelly and R. E. Kelly, "Approaches to Ethnic Identification in Historical Archaeology," in *Archaeological Perspectives on Ethnicity in America*, ed. R. L. Schuyler (Farmingdale, N.Y., 1980), 133–43.

102. The evidence survives in small quantities on papyri and in large quantities on gems, some used for sealing, most worn purely for their amuletic properties. The best introduction is still Bonner, *SMA;* also P. Zazoff, *Die antiken Gemmen* (Munich, 1983), 349–62: brief overview with literature, but unfortunately Zazoff wants to retain the rubric *gnostic* in describing these stones; see P. C. Finney, *Numen* Suppl. 41.1 (1980), 434ff.

6

The Earliest Christian Art

Crede mihi, plus est quam videatur, imago
Ovid, *Heroides* 13.154
(Laodamia to Protesilaus)

At the beginning of the third century (circa 190/200–210/220) a small group of Roman Christians commissioned and oversaw the execution of fresco paintings for the walls and ceilings of ten underground burial chambers[1] within a catacomb complex situated on the Appia Antica (Figure 6.1 no. 44) southeast of Rome and named after Callistus,[2] an ex-slave who also was bishop of Rome in the years approximately 217 to 222. Most of the paintings in these rooms have perished. Of those that survive, a few illustrate biblical subjects inspired either by the Hebrew Bible or the Gospels.

The Callistus paintings are products of roughly the same geographical and chronological environments that produced Wulff 1224—thus, based on this conjunction of evidence together with other bits and pieces, the year 200[3] (plus or minus ten or fifteen years) should be identified as the likely *terminus a quo* for the creation of distinctively Christian forms of art. Along with the Berlin lamp, the paintings surviving within the oldest nuclei of the Callistus catacomb mark the birth of Christian art.

For several reasons, this earliest generation of Callistus Christians constitutes an excellent test case for attitudes toward art. First, so far as we are aware, they represent the first Christians committed to the use of pictures in religious places. Second, they constitute a community of persons, possibly a funerary college[4] or an *ekklesia*, but in any event a collectivity, families of men, women, and children, not just an isolated person or two. Wulff 1224 represents the latter, as do the fragments (possibly a few of them Christian) in the Piazzuola beneath San Sebastiano (Appendix

Key to Catacomb Map on Overleaf
(Figure 6.1)

VIA FLAMINIA
1. S. Valentinus

VIA SALARIA VETUS
2. Pamphilus
3. via Paisiello
4. Basilla-S. Hermes
5. Ad clivum Cucumeris-
 Ad caput S. Johannis

VIA SALARIA NOVA
6. Maximus-S. Felicitas
7. Thrason
8. Jordani-S. Alexander
9. via Anapo
10. Priscilla

VIA NOMENTANA
11. Nicomedes
12. Villa Torlonia (ebraico)
13. S. Agnes
14. Majus
15. Vigna Rosselli

VIA TIBURTINA
16. Cyriaca-S. Laurentius
17. Novatianus
18. S. Hippolytus

VIA PRAENESTINA
19. Gordiani

VIA LABICANA
20. Aurelii (intra muros)
21. S. Castulus
22. Vigna Apolloni (ebraico)
23. Ad duas lauros-Ss. Petrus
 et Marcellinus
24. Centocelle
25. del Grande

VIA LATINA
26. Ss. Gordianus et Epimachius
27. Villa Del Vecchio
28. Trebius Justus
29. Tertullinus-S. Eugenia
30. via Dino Compagni
31. Apronianus
32. Cava della Rossa
33. S. Stephanus

VIA APPIA
34. Campana, ad Scipiones
 (intra muros)

35. Cacciatori
36. Vibia
37. Santa Croce
38. Casale dei Pupazzi (Casa
 Schneider)
39. Praetextatus
40. Vigna Randanini (ebraico)
41. Circus Maxenti
42. S. Soteris
43. Lucinakrypten
44. S. Callixtus
45. Casale della Torretta
46. Vigna Chiaravoglio
47. S. Sebastianus in
 Catacumbas
48. Polimanti

VIA ARDEATINA
49. Balbina-S. Marcus
50. Catacomba Martiri non identificati
51. Basileus-Ss. Marcus et Marcellianus
52. Domitilla-Ss. Nereus et Achilleus
53. Nunziatella

VIA OSTIENSIS
54. Commodilla-Ss. Felix et Adauctus
55. S. Paulus
56. Timotheus

VIA LAURENTINA
57. S. Thecla

VIA PORTUENSIS
58. Pontianus-Ss. Abdon et Sennen
59. Monteverdi (ebraico)
60. Ad insal(s)atos-S. Felix
61. Basilica Julii
62. Generosa

VIA AURELIA
63. S. Pancratius
64. Doria Pamphilj
65. SS. Processus et Martinianus
66. Duo Felices
67. Calepodius

VIA CORNELIA
68. Gianicolo (Salita di S. Onofrio)
69. S. Petrus

VIA TRIUMPHALIS
70. Catacomba anonima al IV miglio
 della via Trionfale

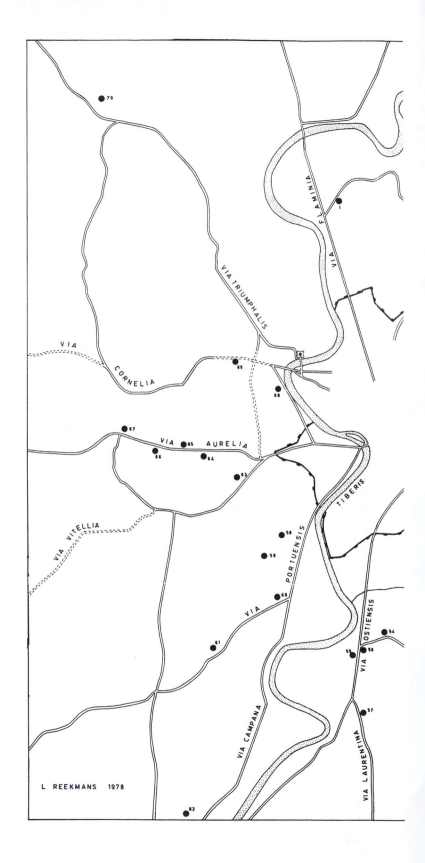

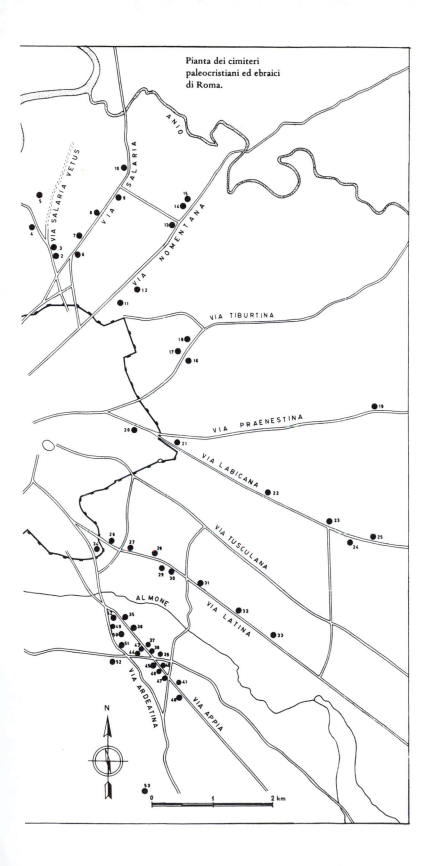

Pianta dei cimiteri
paleocristiani ed ebraici
di Roma.

6.1). Wulff 1224 and Piazzuola fragments are intriguing bits of evidence, but they are also *disiecta membra*, hence their value as evidence is limited—to be sure, they reflect the decisions of isolated individuals, but without a larger context it is difficult to make them the basis of meaningful inferences that have a broader, representational character. At Callistus, by contrast, we are in the presence of a group that acted in consort. They may have pooled[5] their resources in order to pay for the construction and decoration of their underground funerary chambers: material culture in this place probably represents a communitarian and collective decision.

Third, qua evidence, the Callistus paintings possess a real-life quality, a pragmatic reality that contemporaneous literature lacks. Despite the prolixity of men like Clement and Tertullian, in the end their writings give us no real sense of the spaces in which they buried their dead or in which they gathered with their coreligionists to celebrate their common meal. In their literary personae, both men exhibit a strong puritanical streak, but the presumption that this carried over into real life—for example, that they insisted on frequenting places of worship which looked like Quaker meetinghouses—cannot be justified. There are simply too many literary variables and too many historical unknowns to allow this inference. In these two writers, as in all of the second- and third-century apologists, language is always a problematic indicator of material reality.[6] This is in contrast to the Callistus evidence, which is materially unmistakable and irrevocable: here is a place where Christians gathered to bury their dead, a place that attests their decision to use pictures in a religious setting, a place where this decision has left behind an indelible mark in the material world.

Fourth and last, both in matters of iconography and style the Callistus chambers are representative (for Rome and elsewhere) of developments that occurred throughout the third century, at the very least to the end (305) of the Tetrarchy. The history of Christian painting after 220[7] is not my subject here, but it must be noted that the decisions made by the people of the Callistus catacomb are broadly representative for all Christians who lived in the later third century, not just for those who happened to live in Severan Rome.

The latter is my present focus. It is there that we encounter the pictorial record of the first generation of Christian picture makers who made their presence known at Callistus. The pictures they left behind constitute the primary evidence. This was a birth moment, the initial impulse, the innovative beginning that marks the first appearance of Christian art on a sufficiently broad basis to justify the inference that a cultural event of some importance was taking place. The story after 220 is fascinating in its own right, and it deserves to be told in detail, but not here: instead I am limiting the scope of this presentation to the first twenty years of the third century. This may seem unnecessarily restrictive, but under the circumstances it is the only sensible approach.

The people of the Callistus catacomb stood at a threshold in Roman

Imperial social history. They represent the transition from models of accommodation and adaptation that were materially invisible to a new level of Christian identity that was palpable and visible. They signal the movement from implicit to explicit attributions in iconography. They constitue the earliest attested material expression of Christianity as a culturally distinct religious minority. Later generations followed in their footsteps, but the Severan Romans were the pioneers. In a word, the first generation of Callistus Christians is important, indeed it stands I believe as a test case for the entire pre-Constantinian period, and what is lost (namely later third-century developments) by the narrow focus is also compensated several times over by a full-length portrait of the pioneers who represent the terms of Christian attitudes toward art for the rest of the pre-Constantinian period.

This focus on the first generation of Callistus Christians should not be construed as an effort to revive a Rome-centered version of diffusionism. I have no interest in calling up the ghost of Josef Wilpert.[8] The earlier debate[9] about the putative geographical points of origin for Christian art was fueled by ethnocentric (and, in Wilpert's case, dogmatic) concerns, but this debate has run its course and is now little more than a historiographic fossil. In my view this was never a very productive line of inquiry, and it would be pointless to revive it here.

We do not have enough evidence to support any version of diffusionism, whether it be Roman, Alexandrian, Aegean, Scythian, or central Asiatic. The evidence I think points in quite another direction: Christian art came into the world according to a pattern that is best described as random. At the beginning of the third century, Christians inhabiting widely disparate parts of the Empire gradually (and it seems simultaneously) began to experiment with distinctive expressions that gave material identity to their religious beliefs and aspirations. It is not as if this phenomenon began at one fixed point and then spread to others. In fact we have early iconographic fragments in a variety of places, including Rome (Callistus, San Sebastiano, and possibly two anonymous hypogea, one[10] near the Circus of Maxentius, the other[11] in the Via Paisiello off the Salaria Vetus), peninsular Italy (Cimitile[12] [beneath the Church of the Holy Martyrs], Naples[13] [St. Januarius catacomb]), and Egypt (Alexandria [in a hypogeum[14] within the Wardian/Minet el Bassal necropolis]). It is also possible (though unproved) that there are equally early fragments in other locales, including Asia Minor, North Africa, Sicily, Sardinia, and Malta.

Uniformitarianism (a uniform iconographic stemma that traces every early expression of Christian pictorial subject matter to a single model or family of models) simply constricts the evidence. The same may be said for Weitzmann's stemma that derives all of the earliest Christian types from a family of hypothetical Alexandrian-Jewish[15] archetypes. To repeat, the creation of early Christian art seems to have taken place simultaneously and in various places. In every attested example, the scenario

involved Christians turning to pagan workshops and exploiting their al-
ready existing iconographic repertories. The search for a single point of
origin for early Christian art is an exercise in futility. The Callistus evi-
dence is useful not because it supports or contradicts a Rome-centered
version of diffusionism, but because what happened at Callistus repre-
sents an unusually broad-based social event that was repeated elsewhere
in the early third century, but in other places on a smaller scale.

Although my purpose here is to discuss people, not things, much of
the following analysis concerns mute artifacts. This follows as a matter
of necessity based on the nature of the evidence. For better or for worse,
the people of the Callistus catacomb left behind no written record explain-
ing their attitudes toward art, whether it be their own art or someone
else's. Furthermore, they left no written clues concerning the meanings
that they attached to the paintings in their funerary chambers. In fact, the
sum total of what the earliest generation of Callistus Christians be-
queathed to posterity consists in the few rooms and adjoining corridors
that happen to survive in their underground burial places along with the
wall and ceiling paintings that adorn those spaces. Thus, we have no other
choice than to infer attitudes and meanings directly from things left be-
hind.

One conclusion is obvious: the people of the Callistus catacomb were
amenable to the use of pictorial imagery as a vehicle for conveying reli-
gious meanings. They were not iconophobes. Nor did they conceive of
Christianity as a form of religiosity bound by aniconic rules of communica-
tion. But this simply states the obvious. My present ambition is to pursue
the discussion several steps beyond the obvious. In fact, the Callistus
evidence is suggestive on several levels, or to paraphrase the Ovidian
quote given at the outset of this chapter, the Callistus paintings contain
more than meets the naked eye ("plus est quam videatur"), indeed con-
siderably more. The goal here is to draw out to the fullest extent possible
the historical and religious implications of the frescoes in the oldest of the
catacomb's nuclei—attitudes toward art are the heart of this exercise. The
question of attributed or implicit meanings also bears on attitudes, and I
shall have something to say about this subject both here and in the con-
cluding chapter.

The Callistus Christians and Their *Officina*

The relationship between the people of the Callistus catacomb and the
officina or workshop that decorated their funerary chambers can be de-
scribed in economic terms. The former were buyers, the latter the seller.
There was probably a representative (*procurator* [Gaius, *Inst.* 2.39, 4.84];
interpres, or *manditarius*)[16] for the buyers and likewise an agent, probably
the workshop foreman (*officinator*[17] acting as *institor*[18] [Paul., *Dig.* 14.3.18;
Gaius, *Inst.* 4.71]) representing the seller. The representative for the
buyers would have been a respected community member entrusted with

the responsibility of negotiating the most advantageous possible agreement or contract[19] (*stipulatio*). In view of his financial[20] experience and savvy, Callistus might have made a good choice as agent for the buyers (presuming Hippolytus' character assassination[21] of Callistus has little or no basis in fact).

In the strict sense, also by statute, the seller of paintings would have been the owner (*dominus*) or workshop principal, but depending on the *officina's* size and internal organization (both unknown), precontract negotiations could have been conducted between the buyer and principal or buyer and the principal's agent, in this case the workshop foreman (*officinator*). In the present scenario it seems reasonable to suppose that the *officinator* represented the workshop in contract negotiations, since the foreman would have possessed the fullest overall grasp of what his workshop was capable of producing. Of course, there is always the possibility that *dominus* and *officinator* were the same person. But we should probably envisage agents for both buyers and seller, although I hasten to add that there is considerable uncertainty with respect to the seller, depending on the unknowns just mentioned.

We must presume that it was the agent for the buyers who initiated negotiations. He would have presented his constitutents' demands. Specification of certain pictorial subjects and respect for the limitations of the community purse would have figured prominently in this agent's list of desiderata. In response, the workshop foreman would have produced models or sketchbooks[22] which would have allowed both parties to refine the terms of the agreement, especially with regard to the execution of figural subjects. It would have been the foreman's responsibility to explain in what degree and at what price his workshop could meet the buyers' demands.

The Callistus *officina* obviously employed journeymen wall painters (*pictor parietarius*).[23] We have no way of knowing if figure painters (*pictor imaginarius*) were also in the employ of this workshop, but in my view it is clear that no figure painter laid brush to plaster anywhere within the oldest surviving chambers at Callistus. Obviously this does not mean that the workshop lacked employees in this category, only that this specific set of buyers could not afford them. Perhaps others could. The workshop may also have employed plasterers (*tectores*)[24] and diggers (*fossores*).[25] As for the latter group, the men who dug the stairways and prepared the underground corridors and adjoining chambers, it is also possible that the Callistus *officina* subcontracted this work to a separate workshop: we have no way of knowing. As for plasterers and painters, they are attested epigraphically working both apart and together. For labor underground, in cramped conditions such as obtained at Callistus, certainly the most practical solution to the logistical challenge of coordinating labor resources would have been for the same *officina* to employ both *tectores* and *pictores*. Again, however, in reconstructing this detail of the work scenario at Callistus, we are at a loss.

On analogy with Hadrianic-Antonine material evidence[26] from Ostia (apartment interiors, mausoleum walls and ceilings at Isola Sacra), from the Vatican necropolis, and from other second-century Roman sites, it seems reasonable to infer that the agent for the buyers would have sought out a Roman painting *officina* at the middle to lower end of the market. The Callistus workshop was probably accustomed to serving private persons of limited means, no doubt in the decoration of their apartment interiors and funerary spaces, possibly also (though less likely) the interiors of modest houses and adjoining garden walkways (*tecta ambulatiuncula*).[27] But clearly the Callistus *officina* did not service rich equestrians, senatorial families, or the Imperial household.

These considerations bear on the question of attitudes toward art in the following degree. What is at issue here is the buyers' attitudes toward an already-existing Romano-Campanian workshop tradition of painted walls and ceilings. The buyers were faced with three possible choices. They could accept the tradition, reject it, or accept it with modifications. In the analytical sections that follow, our purpose is to decide which of these three is correct. In what degree did the Callistus Christians accept the already-existing iconographic repertory and style tradition propounded (perfunctorily it seems) by the Callistus workshop? And in what degree did they reject or modify it? In assessing this matter, the first, last, and only court-of-appeal is the corpus of Callistus paintings itself—there simply is no other evidence.

The Oldest Burial Nuclei at Callistus

Under circumstances we cannot reconstruct,[28] the Callistus Christians succeeded in asserting control of a small burial plot (approximately thirty by seventy meters, labeled Area I: Figures 6.2, and 6.3) on the Appia Antica (southeast of Rome) in the late Antonine period, circa 160 to 180. How they managed this is less important than the simple fact that they did it. Once they had acquired control of this property, the occupants of the small subdial (*sub divo*)[29] plot must have inhumed their dead in trenches or cists until they exhausted the available land surface. This may have occurred sometime toward the end of the century's last decade, perhaps 195–200. All subdial and distinctively Christian evidence (if any ever existed) of late Antonine interments[30] at Callistus has disappeared. Thus we have no way of knowing, for example, if before 200 graves (and their accompanying *tituli*, if any existed) were marked with Christian devices[31] or if grave goods similarly marked were deposited with the deceased.

Once the available surface terrain within the plot perimeter had been used up, the occupants hired fossors who commenced the laborious task of cutting the subterranean staircases (*scalae*), the adjoining burial galleries (*cuniculi, dromoi,*[32] *porticus ambulatoria*), and chambers (*cubicula*) within Area I. In constructing the latter, fossors first cut two staircases (A and B: Figure 6.3), and at the foot of each they extended galleries (A and B) oriented on a northeast-southwest axis. From these two main galleries,

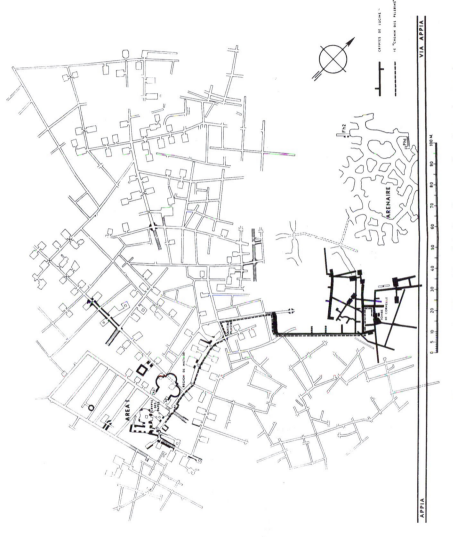

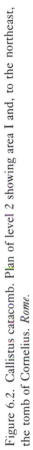

Figure 6.2. Callistus catacomb. Plan of level 2 showing area I and, to the northeast, the tomb of Cornelius. *Rome.*

155

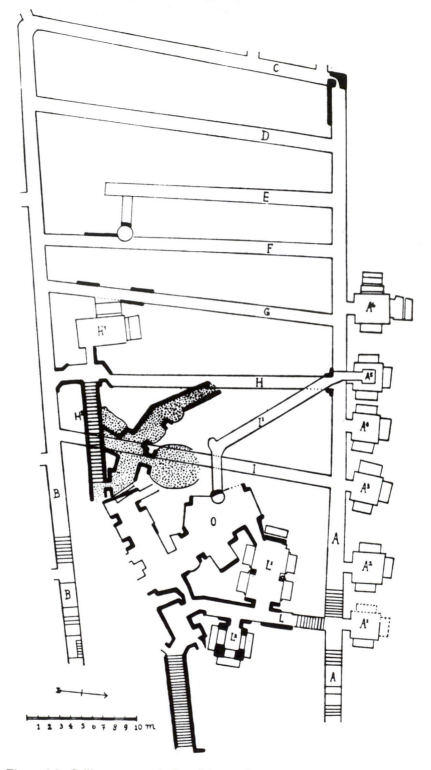

Figure 6.3. Callistus catacomb. Level 2, area I.

working from A to B, they cut transverse galleries,[33] thereby creating a subterranean grid pattern. East of transverse dromos L, they cut a duplex or double chamber (L1: later the so-called Crypt of the Popes),[34] and east of the same gallery they cut a single chamber (L2: the so-called Orpheus cubiculum). Into the north wall of the main gallery A, they cut six single chambers A1–6. Overall, this subterranean grid, bound north and south by the main galleries A and B, east and west by transverse galleries L and C, composes Area I: it appears as noted at level 2 of the Callistus catacomb, measures roughly thirty by seventy meters, and probably corresponds both in orientation and size to the original subdial plot, but there is no proof of this hypothesis. Area I constitutes one of the two oldest subterranean burial nuclei within Callistus.

The second ancient nucleus, also on level 2, lies approximately 150 meters northeast of Area I (Figure 6.2). Originally there were also two separate staircases in this second region (Figure 6.4), but in contrast to

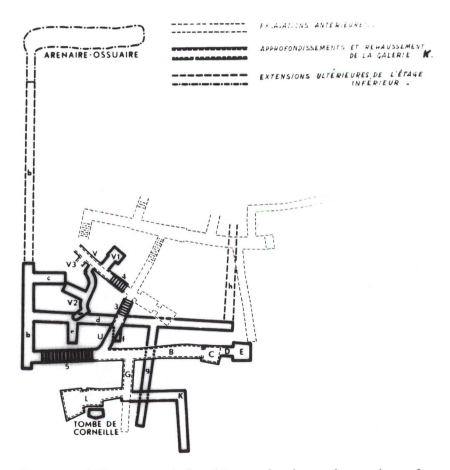

Figure 6.4. Callistus catacomb. Level 2, second ancient nucleus northeast of area I.

Area I, in this second place they led down to two separate and distinct *hypogea*, Reekmans'[35] alpha and beta (Figure 6.5). Alpha consisted of a main gallery (A) cut on a northwesterly course, a transverse gallery (U) oriented northeast-southwest, and a duplex[36] (X/Y) cut into the west wall of U—X/Y in alpha and L1 in Area I are architectonic cognates.

Approximately fifteen meters to the north, hypogeum beta consisted of a staircase leading down to a main gallery (B), roughly parallel in alpha to a transverse gallery (G) running northeast and a large single chamber (L) cut into the east wall of G. The two main corridors in alpha and beta, as noted running on a parallel course, are fifteen to eighteen meters apart and could possibly represent perimeters of a subdial plot. Hypogea alpha and beta were joined (probably very soon after the original staircases and their respective galleries were cut) by extending and lowering transverse gallery U in a northeasterly direction from the main gallery A in alpha to connect with the main gallery B in beta. In popular parlance, hypogeum alpha is denominated by reference to the so-called Crypt of Lucina in duplex X/Y, and hypogeum beta by reference to the grave of Pope Cornelius[37] (d. 253), whose body was transferred from Civitavecchia (Centumcellae) to hypogeum beta, possibly before 257.

The sequences just described—staircases, galleries, and adjoining chambers—were cut in several phases over a period of twenty to thirty years, circa 190/200–210/220. Unfortunately we cannot be more precise about either end, *a quo* or *ad quem*. Horizontal niches (loculi:[38] typically [for one cadaver] 2 meters long by half a meter high by one meter deep) were cut into the cubicula walls, and the bodies wrapped[39] in linens were deposited in these niches. The loculi were then sealed, typically with brick and tufa aggregate, which was buttered smooth on the exterior using a trowel against a mortar-plaster facing. Once the staircases, galleries, chambers, and loculi had been cut and cleared of debris, the fossors' work was done. *Tectores* and *pictores* were then called to the jobsite to complete the work.

The people of the Callistus catacomb left their funerary floors (which over time became well-trodden, hard, metalled tufa surfaces) unfinished, probably for financial reasons. They evidently could not afford tessellated[40] or other forms of worked floor surfaces (for example *opus spicatum* [Vitr. 7.1.4; Plin. *Nat.* 36.187: brick or terra-cotta fragments laid in a herringbone pattern).

The plasterers and the painters may have worked in the same room either simultaneously or seriatim. If the latter, then the painters must have followed the plasterers in very close sequence. The funerary chambers are not large enough nor would there have been sufficient light (emitted from *faces* or *lampades/lucernae*, or both?) and oxygen to allow several workmen to labor simultaneously in the same cubiculum. It is reasonable to suppose that the plasterers and painters who worked at Callistus were employees of the same *officina*, but in the absence of epigraphic proof this is only a guess.

HYPOGEE α

HYPOGEE ß

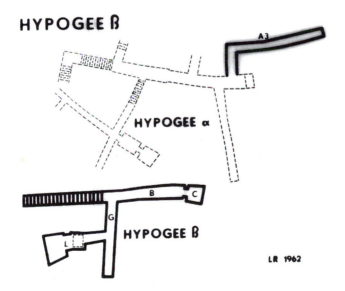

Figure 6.5. Callistus catacomb. Level 2, second ancient nucleus northeast of area I. Hypogea alpha and beta.

For the purpose of technical analysis (but only for that purpose), it is useful to separate walls from ceilings. Both are integral parts of the overall decorative ensemble,[41] and to get a sense of the whole visual effect it is essential to assess the interrelationship between ceilings and walls. Consistent with much of Roman practice elsewhere, the floors evidently were not considered part of this decorative ensemble. There is clearly sufficient decorative distinction between the ceiling and wall zones to justify their separation for analytical purposes. In both zones, three issues are at stake: the application of compositional principles (judged by the emplacement of linear, painted frames), the iconographic repertory, and the painterly style (judged especially by the rendering of figural subjects).

Ceilings

Seven painted ceilings survive from the earliest period of occupation in these two burial nuclei, four in Area I (L2: Figures 6.6, 6.7; A2: Figures 6.8, 6.9; A3: Figures 6.10, 6.11; A4: Figures 6.12, 6.13), two in hypogeum alpha (X: Figures 6.14, 6.15; Y: Figures 6.16, 6.17) and one (C: Figures 6.18, 6.19) in hypogeum beta. Excepting ceiling X (75 percent destroyed) in alpha, the state of preservation is relatively good. The line drawing of X (Figure 6.15) that I give here reconstructs the linear compositional frame of the painted ceiling only to the extent permitted by the surviving fragment.

The dating of cubiculum C (Figure 6.5), at the northern end of beta's main dromos B, is controversial. Reekmans thought this chamber was cut later than the duplex X/Y in alpha, but in my view the evidence is inconclusive. On analogy with the original staircases leading down to the two main galleries in Area I, if the staircases leading down to alpha and beta were begun simultaneously, and if their respective main galleries were extended northward at an equal excavation pace, then there is no reason to suppose that C was materially later than duplex X/Y, which was itself the product of construction phase 2 in alpha, as Reekmans readily admitted. I can find no material discontinuities in the horizontal stratigraphy[42] of gallery B in beta, nothing marking a break between C and the rest of the gallery. This leads me to conclude that chamber C marks the end of the first construction phase in beta.

The fact that the painted compositional frames in ceiling C (Figure 6.19) differ from those in Y proves nothing about their respective dates. The painted frames of ceiling C are paralleled several times over in other second-century chambers, for example in a room[43] beneath St. John Lateran and in another[44] within the so-called House of the Painted Vaults at Ostia. The ceiling painters of C could have simply chosen a compositional frame different from the one they executed in Y, and as the comparative evidence makes clear, ceiling C exhibits nothing that is either anomalous or anachronistic.

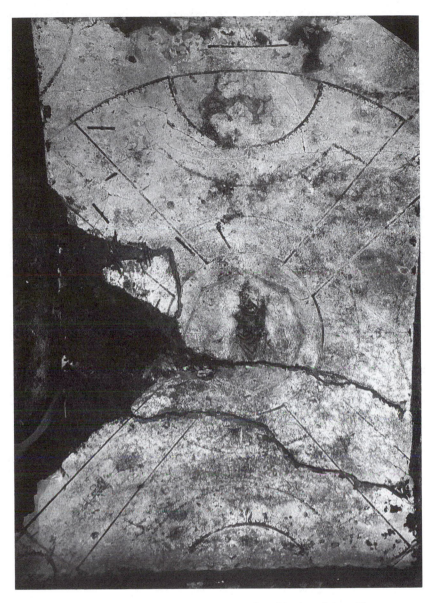

Figure 6.6. Callistus catacomb. Level 2, area I, cubiculum L2, ceiling.

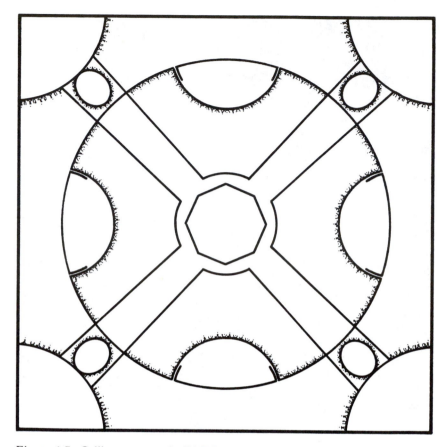

Figure 6.7. Callistus catacomb. Ibid. Reconstruction of the linear frame.

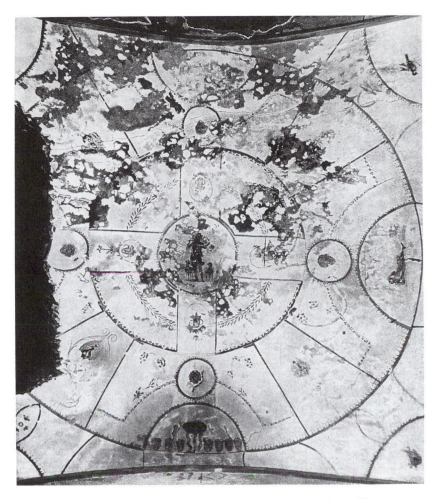

Figure 6.8. Callistus catacomb. Level 2, area I, cubiculum A2, ceiling.

163

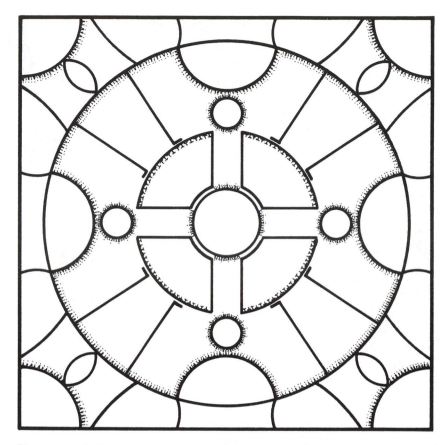

Figure 6.9. Callistus catacomb. Ibid. Reconstruction of the linear frame.

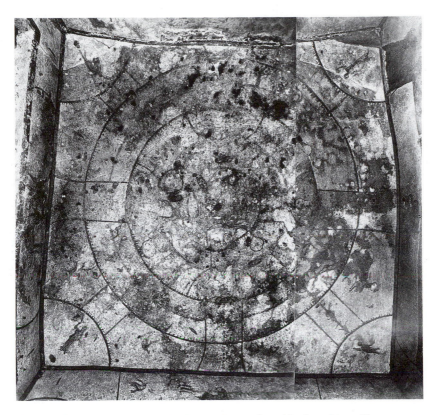

Figure 6.10. Callistus catacomb. Level 2, area I, cubiculum A3, ceiling.

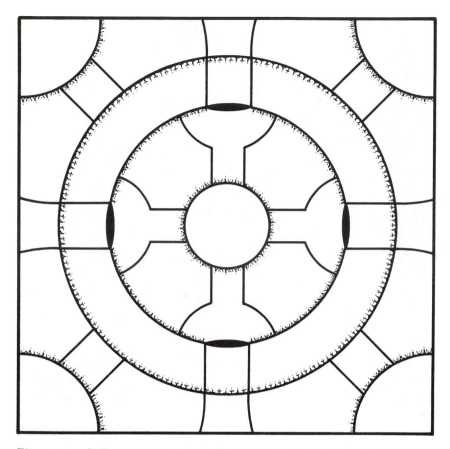

Figure 6.11. Callistus catacomb. Ibid. Reconstruction of the linear frame.

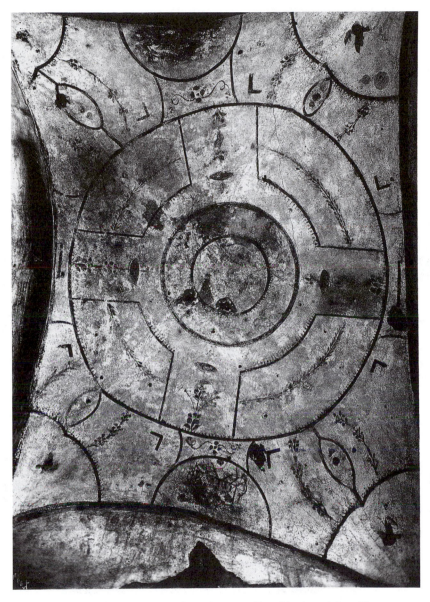

Figure 6.12. Callistus catacomb. Level 2, area I, cubiculum A4, ceiling.

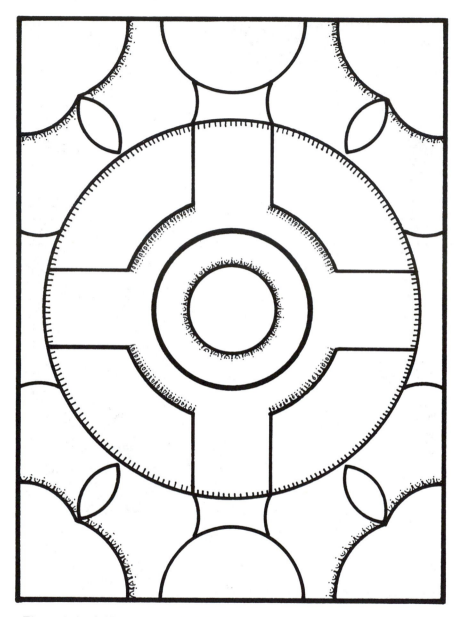

Figure 6.13. Callistus catacomb. Ibid. Reconstruction of the linear frame.

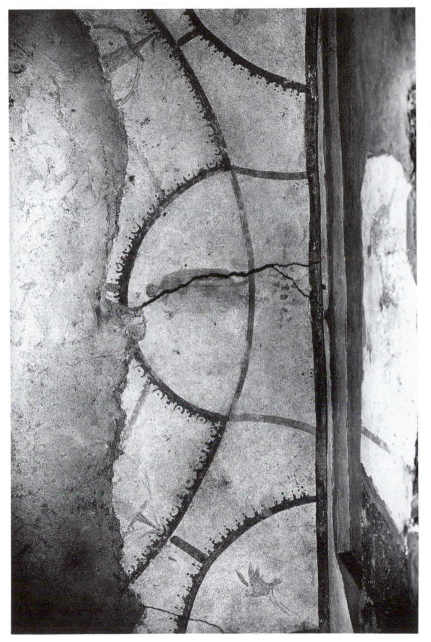

Figure 6.14. Callistus catacomb. Level 2, Reekmans' hypogeum alpha, cubiculum X, ceiling.

169

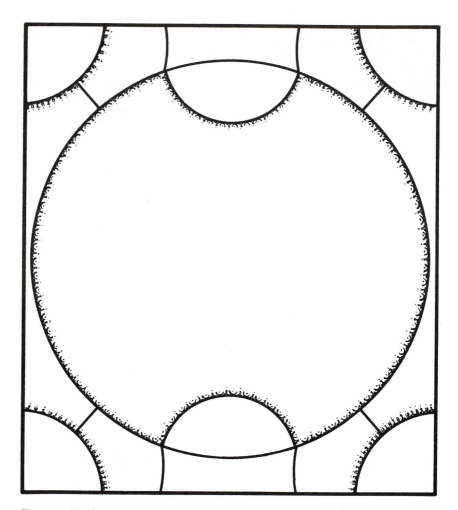

Figure 6.15. Callistus catacomb. Ibid. Reconstruction of the linear frame.

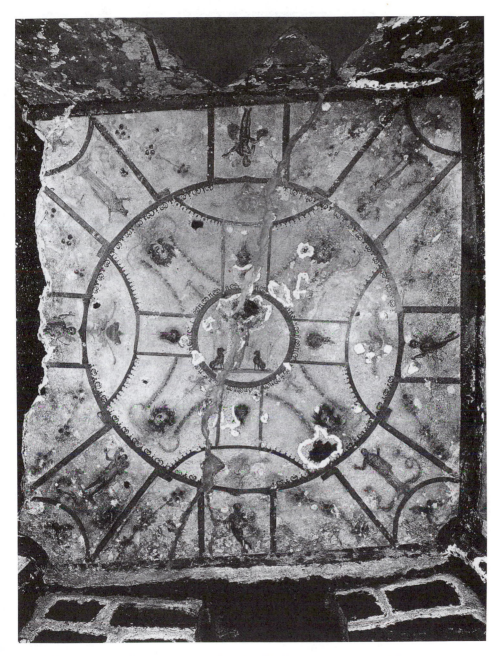

Figure 6.16. Callistus catacomb. Level 2, Reekmans' hypogeum alpha, cubiculum Y, ceiling.

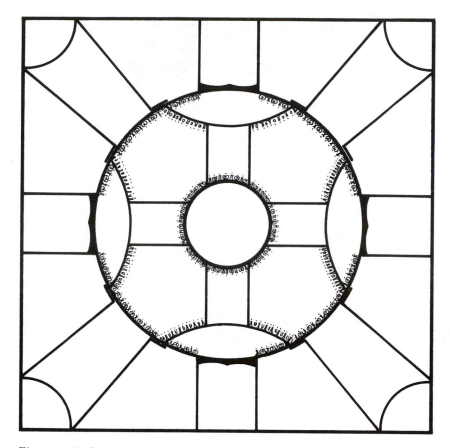

Figure 6.17. Callistus catacomb. Ibid. Reconstruction of the linear frame.

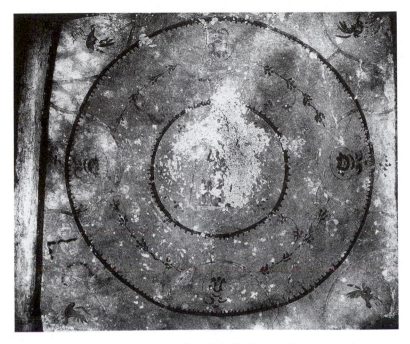

Figure 6.18. Callistus catacomb. Level 2, Reekmans' hypogeum beta, cubiculum C, ceiling.

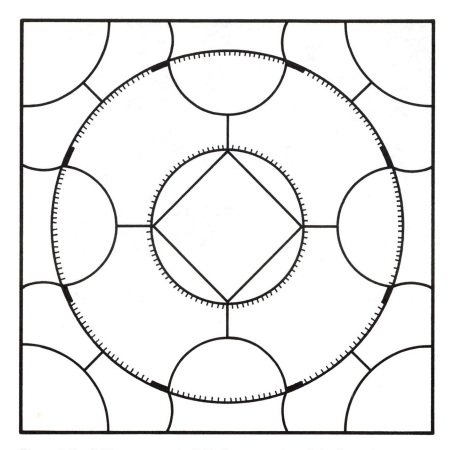

Figure 6.19. Callistus catacomb. Ibid. Reconstruction of the linear frame.

Square perimeters were cut for all seven chambers, excepting A4, which has a rectangular outer limit. All of the ceilings are slightly domed with an apex located approximately at the center of the square ceiling field: this is the place of honor, the most important symbolic focus not just of each ceiling field but of each room overall. Each of the domed ceilings was covered with a single coat of unwashed white plaster. The several laminations we find elsewhere in the finer examples of Romano-Campanian painting—for example (at Pompeii, Herculaneum, Boscoreale, and especially Boscotrecase)[45] a rough initial coat, a middle and slightly finer lamination, and a thin, burnished finish-coat made up of plaster mixed with marble dust—are absent here. The Callistus workmen painted directly onto the initial, unwashed plaster coat: clearly, cost was a major constraint. Each ceiling presents a white canopy, a slightly concave field, billowing upward as if a square, windblown linen sheet were tied at its corners. The intention was to create the illusion of an albumen-like upper world, an ethereal and pristine canopy.

— *Composition*

All of the white-ground ceilings were overpainted with a network of red and green linear frames, which typify two familiar systems of composition. The first[46] is centralized and annular; the second,[47] converging and transverse. The centralized system consists typically of a painted medallion situated at the center of the ceiling field and framed by one or more concentric rings enclosing annular registers wound about the central medallion. Obviously this solution adapts well to fields that have a square format. All of the ceilings under consideration here exhibit this compositional system, including A4 (Figures 6.13, 6.14) despite its rectangular format. It is probable (but unprovable) that the ceiling of chamber X (Figures 6.14, 6.15) conformed as well to this type. In Romano-Campanian tradition this system reaches back to the first century (Domus Aurea), and it was repeated many times over in Trajanic, Hadrianic, and Antonine contexts.[48] It became the compositional system of choice in the third century and was applied extensively in central and southern Italian catacombs, including those in Sicily.

The second compositional system consists of transverse frame lines that converge at the center and radiate outward from the center of the field, either on perpendicular or diagonal axes in relation to the outer perimeter of the central medallion. In ceiling A2 (Figures 6.8, 6.9), for example, eight transversals radiate outward from the central roundel and frame four roughly trapezoidal or pie-shaped segments that fill most of the first annular register. Farther out from the center there is a second annular register, and it too is divided by eight gammalike transversals, arranged like the jambs of a pylon temple (⟩ ⟨)—these divide the second annular field into eight sectors. But among the examples that concern us here, clearly the most dramatic use of transverse linear frames that emanate outward from the center of ceiling field is the ceiling in the so-called

Orpheus cubiculum, L2 (Figures 6.6, 6.7): eight diagonals extend from the outer perimeter of the pierced concentric circle that frames the central octagon; they continue across the broad annular register, pierce its perimeter, and connect finally with the outer perimeter of annular quarter-circle sectors situated at the four corners. These eight transversals create a cruciform pattern—the overall effect is of a *crux decussata*[49] (Greek *chi;* Latin *X*), a cross within a circle, the latter in turn enclosed within a square.

This compositional system also has its roots in the first century, at Pompeii and in the Domus Aurea, but the better-known examples are located in second-century contexts, for example, the Antonine ceiling of the Roman Tomb of the Nasonii,[50] the late Antonine ceiling[51] of the Ostian House (Ambiente IV) of the Painted Ceilings, and the Severan vault[52] of Tomb 57 at Isola Sacra. And like the centralized-annular system, this second became very popular among workshops hired out to paint catacomb ceilings from the late second century onward: a well-known example survive on the carpetlike ceiling (Figures 6.20–6.22) of dromos L (Figure 6.23), the main gallery in the so-called Hypogeum of the Flavians within the Domitilla catacomb—I refer to Sector II (Figure 6.24) at the northeast end of the gallery ceiling. There are numerous other parallels, in the Domitilla catacomb, in the Hypogeum of the Aureli, in the catacombs of Peter and Marcellinus, Nunziatella, Hermes, and the Coemeterium Maius.

Both compositional systems are designed to highlight the central medallion (or octagon as in L2 [Figures 6.6, 6.7], or circumscribed square as in chamber C [Figures 6.18, 6.19] in hypogeum beta). The complex maze of attendant linear frames surrounding the centerpiece can work against this effect, causing a viewer's eye to wander from the intended message of the field overall. This is notably the case in the ceiling of chamber Y (Figures 6.16, 6.17) in hypogeum alpha. But even despite these distractions, the fundamental intention cannot be gainsaid: the center of the ceiling field is its symbolic focus, and all of the annular segments and registers that surround it are to be read as subordinate to this central feature. The viewer is directed to find the primary symbolic meaning of the ceiling, indeed of the entire room, at the apex of the dome soffit. By contrast, in many of the catacomb gallery ceilings one encounters nondirectional compositional systems,[53] such as the painted coffers (Figure 6.25) on the ceiling between A2 and A3 in dromos A of Area I.

These linear ceiling systems should be viewed primarily as a function of the workshop, or the seller's know-how. We have no way of knowing how much input (if any) the buyers had in the initial choice of compositional systems, but beyond the desire to underscore a message, the buyer probably played a passive role. These compositional systems exhibit a high degree of correlation with Romano-Campanian tradition: they are standardized, even formulaic in character. Ceiling painters repeated standard compositional formulas all over central Italy in the first three Imperial centuries, and the workshop painters at Callistus simply reiterated the

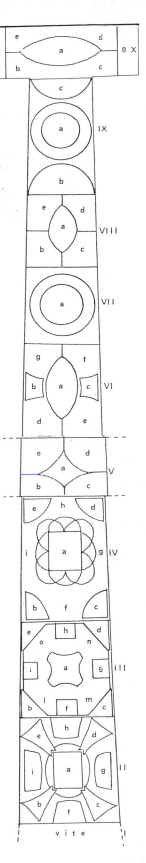

Figure 6.20. Domitilla catacomb. Hypogeum of the Flavians, Dromos L ceiling. Reconstruction of the linear frame. *Rome.*

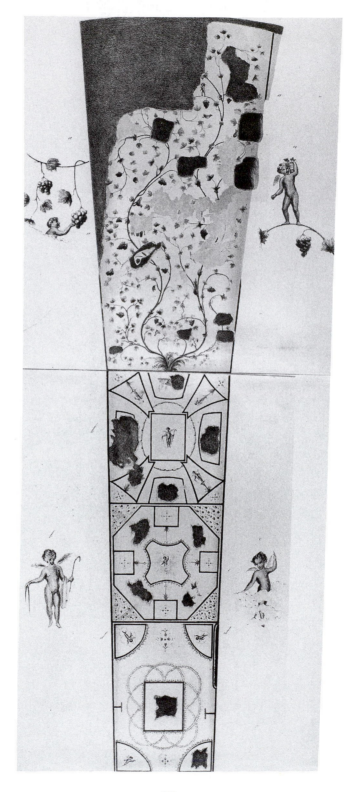

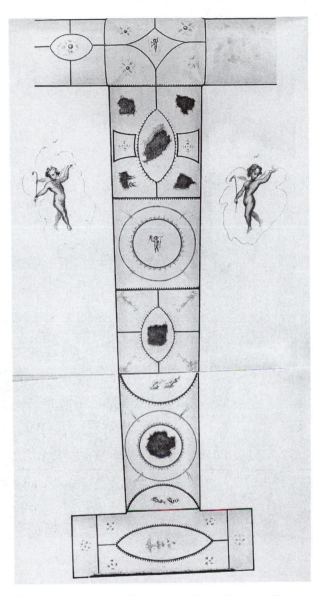

Figure 6.21. Domitilla catacomb. Hypogeum of the Flavians, Dromos L ceiling.

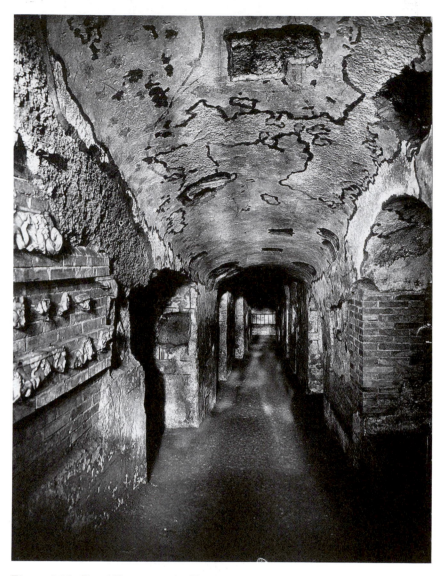

Figure 6.22. Domitilla catacomb. Hypogeum of the Flavians, view of Dromos L from the northwest end.

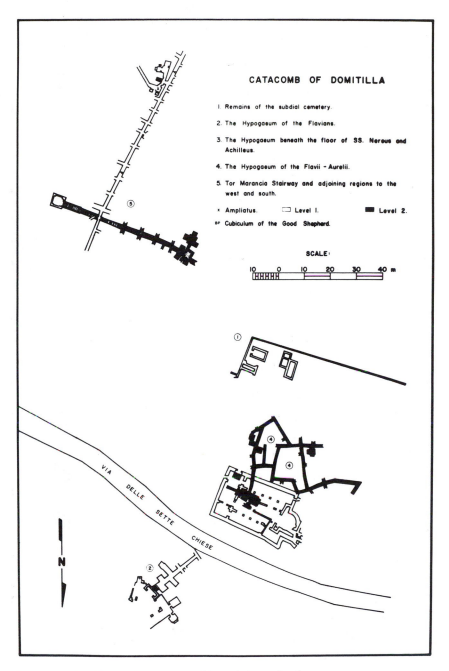

CATACOMB OF DOMITILLA

1. Remains of the subdial cemetery.

2. The Hypogaeum of the Flavians.

3. The Hypogaeum beneath the floor of SS. Nereus and Achilleus.

4. The Hypogaeum of the Flavii - Aurelii.

5. Tor Marancia Stairway and adjoining regions to the west and south.

x Ampliatus. ▭ Level I. ■ Level 2.

ᵇᴾ Cubiculum of the Good Shepherd.

SCALE:

10 0 10 20 30 40 m

VIA DELLE SETTE CHIESE

N

Figure 6.23a. Domitilla catacomb. Plan of the major features.

181

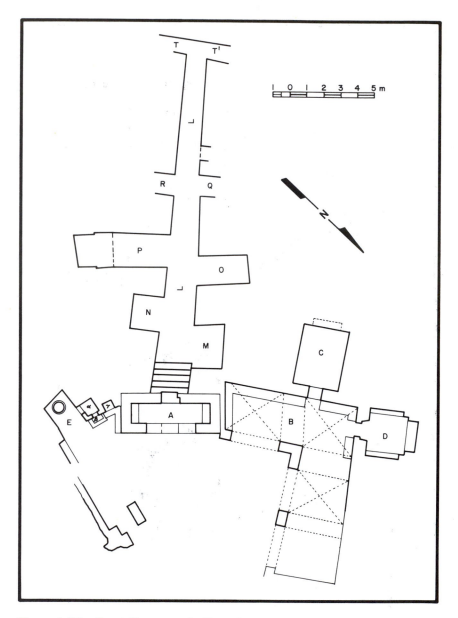

Figure 6.23b. Domitilla catacomb. Plan of the entire Hypogeum of the Flavians: Dromos L and its vestibule (A); well and the space for the preparation of food (E, alpha, beta, gamma); adjacent cubicula C and D; large room B for gatherings of family and friends.

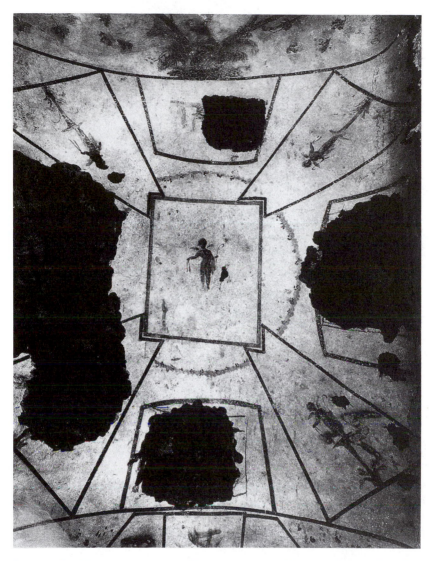

Figure 6.24. Domitilla catacomb. Hypogeum of the Flavians, Dromos L ceiling, sector II: detail.

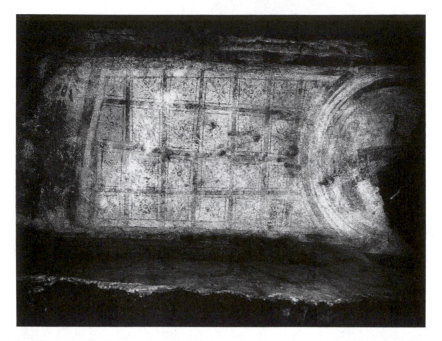

Figure 6.25. Callistus catacomb. Level 2, area I, Dromos A, painted ceiling in the gallery between A2 and A3.

types they had learned in the years of their apprenticeship—they knew these types by heart. There is nothing innovative or anomalous in any of these ceiling compositions: they represent the journeyman wall painter's rote learning, the kind of exercise he could have done in his sleep.

Perhaps in one small respect, however, the compositional frames do suggest a degree of input from the buyer. As noted, the ceiling frames highlight the importance of a central image,[54] and they do so in a manner that is uniform and predictable. There is no room for doubt about the hierarchy of visual values in these ceilings. The center of the domed soffit is unquestionably the place of honor—secondary and tertiary themes are found farther out from the center in concentric annular registers. This compositional hierarchy might be interpreted as a function of the buyer's insistence on clarity in highlighting the central message in each and every one of the Callistus chambers.

— *Iconography*

It is difficult to achieve a balanced assessment of the Callistus iconography. Many have tried, few have succeeded. Four issues are critical:

1. To which images did the people of the Callistus catacomb attribute symbol-specific meanings?

2. On the presumption that at least some attributions in the latter category existed, what was the imputed content: Jewish, Christian, pagan, or an amalgam of all three?
3. To which images did the buyers attribute purely neutral, generic, or decorative meanings?
4. What were the iconographic models?

The first three speak to the question of meaning, specifically the implicit or attributed meanings[55] that the buyer associated with the images in question. The fourth concerns material precedents, to wit the already-existing iconographic repertory that the Callistus painters appropriated in order to satisfy the buyers' demands for funerary decoration. So far as I am aware, a definitive answer to any of the first three queries is impossible. Within limits, the fourth can be answered with certainty.

For the first three there are three possible interpretative contexts: belief systems, cult practices, and the immediate material environment. But one must discriminate. Not all belief systems and cult practices are of equal value in assessing this matter, nor is it at all clear precisely how much weight one should attribute to the material haunts in which these paintings make their appearance. In every case one must guard against arguments that are anachronistic or otherwise historically irrelevant. In the ongoing interpretation of catacomb paintings, especially those that are pre-Constantinian, retrojections and interpolations are a constant danger. On beliefs and cult practices, thanks to Dölger[56] and his followers, we now know that a major interpretative component in the study of the catacomb paintings is the role that paganism played in shaping early third-century Christian iconography. This is an indispensable component in the iconographic study of early Christian art overall, but at the same time one needs to strike a balance.

At Callistus as is true elsewhere in the catacombs, the primary faith context was Christianity, and Christian beliefs as well as Christian practices concerning death and the afterlife must be granted some distinction. But one must discriminate according to the demands of history: many parts of the early Christian belief system along with liturgical practices developed in the post-Constantinian period have a secondary importance for a setting such as Callistus. Traditional dogmatic subjects (Trinity, Christology, pneumatology/ecclesiology, Mariology) are also secondary, as are baptism and the eucharist (since this place was a setting for neither of these sacraments). At the same time none of these subjects is entirely irrelevant.

As for the immediate material setting (prompting the Dölgerites' so-called *realistische Deutung*), this I think is a subject that is relatively intractable. Stuiber's well-known monograph,[57] for example, written from this "realistic" point of view, presses materialistic interpretation beyond the point of historical credibility.

A balanced presentation of the Callistus iconography is really some-

thing of a juggling act. Based on the several criteria just mentioned, one must attempt to distinguish and classify categories of subject matter. An image may be called symbol-specific if it can be demonstrated that the people of the Callistus catacomb attributed to it explicitly Christian meanings. If the attributed meanings were explicitly pagan or Jewish, images of this sort might also also fall under the symbol-specific rubric. All other iconography must be classified under the neutral, generic, or decorative categories. As for precedents, this is a constant and essential component in the study of early Christian art, the Callistus frescoes included.

Finally, in the midst of this evaluation process and in the effort to strike an intelligent balance between all of these competing demands, one is continuously brought up short by the combined ambiguity and scarcity of evidence. The major problem is the lack of literary or documentary sources that can be shown to have a direct bearing on the objects in question. Of course there is no lack of Christian literature that is contemporaneous with the paintings in the oldest chambers at Callistus—the critical problem, however, is to establish what necessary relationship (if any) exists between literature and images.

At root this subject concerns a family of open-ended, even elusive images, a subject that requires a delicate touch. As Brandenburg[58] observed some time ago, the images in question possess an associative character. In fact, qua signs and symbols these images bear an uncanny resemblance to cognates in the literary realm. The same sort of multilayered, associative symbolism is conspicuous in the synoptic Gospels and the Gospel of John, in the literature of the second and third centuries (Clement and Origen in particular) and in the post-Nicean corpus (especially the Cappadocians, Ephrem, and Augustine).

My purpose in drawing this last analogy is neither to excuse imprecision nor encourage fuzzy thinking. But one must respect the fact that the images in question are both ambiguous and fluid. It is difficult to pin down exact meanings. In general, iconography is not an exact science. Consistent with the nuanced character of this particular subject matter, one needs to tread lightly, guided by the associative character of the images themselves. Heavy-handed treatments are bound to quash what they seek to explain. Tunnel vision will only produce its own kind, and dogmatic rules[59] of interpretation are especially inappropriate to this subject. "C'est le ton qui fait la musique": the visual score at Callistus is rich but nuanced and ambiguous; hence, there is considerable room for different modulations and tonalities, different emphases of interpretation. Lockians, Humeans, and other like-minded empiricists would be best advised to seek another subject—they will not find much satisfaction in this one.

As for ceiling images that are likely to have been read in a symbol-specific sense, those at the apices of the Callistus cubicula take pride of place. This includes the four ceiling shepherds in Area I, cubicula A2–4: (Figures 6.8, 6.10, 6.12), and in cubiculum C in Reekmans' hypogeum alpha: (Figure 6.18). Also included are the Orpheus in cubiculum L2

(Figure 6.6) and the Daniel on the ceiling of chamber Y in hypogeum alpha (Figure 6.16). Jonah represented four times[60] in subordinate emplacements on ceilings A2 and A4 also belongs under this rubric. All of the foregoing are images to which the people of the Callistus catacomb probably attributed specific meanings, which they derived from a common core of belief. Further discussion of the latter must be held temporarily in abeyance.

Many scholars would place the rest of the Callistus ceiling iconography under some other rubric. The most common designations (neutral, generic, decorative, pagan) imply that the images in question were not perceived either implicitly or explicitly as vehicles of Christian meaning.[61] This includes the three-legged table (*tripous*)[62] flanked by seven baskets of bread (Area I, ceiling A2 [Figure 6.8]: north lunette of the second annular field; detail of the lunette: Figure 6.26), the birds, the sea-bull (*taurocampus*) in ceiling L2 (east lunette: Figure 6.6), the flowers[63] and flower sprays, the rosettes, the fruits, the vases nested on floreated brackets (or candelabras) and the garlands,[64] along with the subjects that are Dionysiac by derivation: maenads,[65] masks[66] (*oscilla*), cupids[67] and shells[68] (*konchai/conchae:* associated originally with Thetis and the Nereids, but in Roman art transferred to Dionysus and the nymphs). In addition, the outermost zone of ceiling Y (Figure 6.16) in hypogeum alpha shows two shepherds standing on floreated brackets and two female orants perched on the same kind of pedestals: these too have also been classified under the neutral or generic rubric.

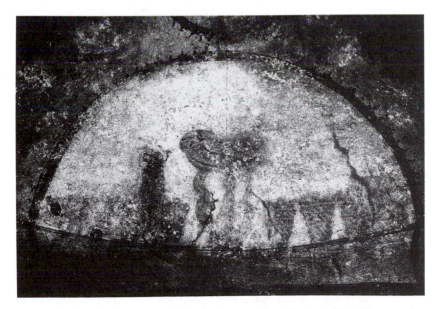

Figure 6.26. Callistus catacomb. Level 2, area I, cubiculum A2 ceiling: north lunette.

The rationale for this classification is simple: we can only be sure that symbol-specific meanings were attributed to biblically derived images. This represents the wisdom of the minimizers,[69] and in the study of early Christian iconography minimalism has been elevated to a principle of hermeneutical correctness. Thus on the strict application of this rule, in the Callistus ceilings as elsewhere, the only symbol-specific images intended as vehicles of Christian meaning are the Jonah and Daniel figures. Orpheus, though symbol-specific, is not derived from the Hebrew Bible and hence is not a vehicle of Judeo-Christian meaning.

As for subjects derived from Christian scriptures, again arguing from a minimalist perspective, the only figure that might warrant inclusion under the symbol-specific rubric is the shepherd[70] carrying the sheep (κριοφόρος), an image traditionally associated (via Lk 15:5: . . . ἐπιτίθησιν [τὸ πρόβατον] ἐπὶ τοὺς ὤμους . . .) with Jesus the good shepherd (Jn 10:11, 14). But *kriophoroi* are relatively common in Greco-Roman iconography. Furthermore, in numerous Christian contexts (for example, at Callistus on ceiling Y [Figures 6.16, 6.17]) the figure is represented in multiple renderings in the same place and also in subordinate emplacements, suggesting not one but several shepherds, not one specific shepherd who can be identified by name but numerous generic shepherds, all of them *ignoti* and of lesser symbolic importance. Hence the minimalist conclusion: this figure cannot have been intended to signified Jesus as ὁ ποιμὴν ὁ καλὸς . . . (Jn 10:11a)—it must have referred to other shepherds as symbols of non-Christian meaning. Klauser has concocted a similar argument ruling out the possibility that the Callistus Christians attributed Christian symbol-specific meaning to the orant[71] figures.

Since Dölger's premature death in 1940, this minimalist approach has played an increasingly important role in the study of early Christian iconography. There have been benefits, not the least of them being the fact that early Christian iconography has been put back in its proper place alongside the Greco-Roman vernacular. In reaction to Wilpert and echoing in part the insights of Mamachi,[72] Marangoni,[73] and especially von Sybel,[74] the minimalist school has insisted correctly that early Christian art represents the formal continuation (not the termination or interruption) of pagan painting and sculpture. The opposite proposition, that Christians severed all ties with the Greco-Roman past, a theory promoted with missionary fervor by Wilpert, has little to recommend itself. Minimalist arguments are broadly convincing, especially for the Christian art of the pre-Constantinian period, but it is also true that such arguments speak primarily to questions of iconographic models and precedents. Only in a secondary (and less convincing) sense do they address the matter of attributed meanings.

Yes, the sheep carrier has a long pre-Christian history, not just in Greece and Rome but also in the Near East. It represents a classic late antique example of a migrating iconographic type (Löwy's *Typenwan-*

derung.)[75] As it roamed about, the type acquired new (and often conflict-
ing) levels of meaning. This is true not only for the shepherd figure but for
numerous other iconographic types within the early Christian repertory.
But from the beginning of its history Christianity (following Hebrew pre-
cedents) associated its hero with shepherding[76] metaphors. Klauser for-
bade even the possibility that an occasional early Christian could have
espied Jesus in the figure of the sheep carrier. This is heavy-handed and
dogmatic. It represents a useful observation (on the pre-Christian history
of the *kriophoros*) misapplied and gone sour. With reference, for example,
to the lunette (Figure 6.27) over the baptismal font at Dura, it is both
absurd and perverse (given the demonstrated context: forgiveness of sin)
to forbid a Christian interpretation of the well-known shepherd carrying an
oversized sheep.[77]

A similar criticism of minimalist orthodoxy might be made with re-
spect to the other so-called neutral, generic, or pagan images that appear
on the Callistus ceilings: the doves and peacocks, the flowers, vases and
garlands, the shells, the three-footed table, and baskets of bread. The
figural subjects that can be added to this list include the seated Orpheus
on ceiling L2 (Figures 6.6, 6.7) and the orants on ceiling Y. The nonfigural
groups represent the journeyman wall painter's stock-in-trade, garden-
variety Romano-Campanian funerary decoration. Nothing demands that
the people of the Callistus catacomb saw religious meanings in any of
these subjects. Nor does anything forbid this possibility. Each of these
subjects could have been harmonized (and elsewhere was harmonized)
with Christian intentions. We have no way of proving that this happened
at Callistus, but conversely and in the same degree we have no way of
proving the opposite. A *non liquet* seems to me the most intelligent solu-
tion.

The case is similar for Orpheus,[78] who was a popular figure in the
pictorial arts of the early, middle, and late empire. Images[79] of the Thra-
cian citharode survive in a wide variety of geographical settings and mate-
rial contexts, including mosaics, sculpture (relief and freestanding), fres-
coes, and numerous minor arts. Based on literary evidence, it is also clear
that the early Christians were drawn to Orpheus. No doubt the earliest
literary inspiration (mediated to Christian writers in the second century)
came via an *interpretatio judaica* promulgated in Ptolemaic Alexandria by
apologists for the Jewish cause. Frescoes of Orpheus appear in the Roman
Christian catacombs, but what we do not know, whether at Callistus or
elswhere, is their attributed meaning. It seems reasonable in my view to
infer from the presence of this image that at least some of the new reli-
gionists in Callistus might have seen Christian meaning in the familiar
musician image, but that they would have gone so far as to equate Christ
with Orpheus is impossible to prove. It is equally impossible to disprove
this theory.

As to iconographic models, it follows *a fortiori* that all the so-called
neutral, generic, or pagan subjects were precedented. Even within the

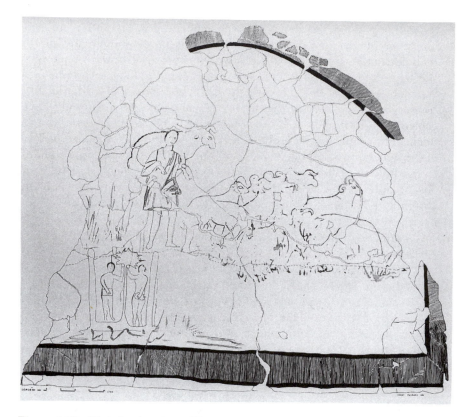

Figure 6.27. Christian baptistry. West wall, lunette over baptismal font. Dura Europos.

much smaller corpus of symbol-specific images inspired by biblical precedents I can find very little that is iconographically new.[80] The shepherd-*kriophoros*, as noted, has a long pre-Christian history. The seated Orpheus, facing front, plucking a lyre and flanked by animals, was a Greco-Roman iconographic commonplace. Daniel rendered at Callistus as a heroic nude, standing and facing front, is equally banal—the prophet's gesture (arms raised left and right, suggesting the orant posture) is a bit unusual for heroic nudes, but it is certainly not a hapax. The sea matrix for Jonah cast overboard subscribes familiar maritime precedents,[81] and the composite *ketos*[82] (part fish, part land animal) has a long, pre-Callistian history. Jonah reclining on land is modeled on Selene's eternally somnolent heartthrob, Endymion.[83] The vine trellis or pergola[84] (pergula: Plin., *Nat.* 14.11, 19.69; Col., *Re Rustica* 3.9.2), which protects the prophet against the noonday sun, is a common feature of Romano-Campanian garden iconography. In short, excepting a poorly preserved and hence somewhat conjectural image (Area I, ceiling A2: second annular field, south lunette; see Figure 6.8) of Jonah emerging from the mouth of the *ketos*, the Callistus ceilings repeat familiar iconographic clichés, all of them widely attested in earlier Romano-Campanian fresco painting and elsewhere.

Style

Essentially the same is true for the style of white-ground[85] painting on the Callistus ceilings. A network of circular, elliptical, and rectilinear frames was painted over the white concave surface. White-ground fresco painting is really a species of monochromatic[86] fresco painting—in Roman-Campanian tradition this was a common form of interior decoration for both ceilings and walls from the first century onward. For reasons of economy, white-ground walls and ceilings were popular especially in rooms that served utilitarian functions, for example kitchens, storage areas, and slave quarters. But on the example of the Domus Aurea, Nero elevated white-ground painting to a more dignified status. Columbaria, mausolea, and hypogea in second-century Rome, at Isola Sacra, and elsewhere in provincial Italy came increasingly to exhibit monochromatic interior surfaces, including numerous apartment interiors at Ostia. This can be explained with equal justice as the function of taste or of a declining economy: no doubt both were contributing factors.

The frontal rendering of ceiling figures was also a Romano-Campanian convention. The only exceptions on the Callistus ceilings are Orpheus and the Jonah scenes where the prophet is rendered either in profile or three-quarter view. All the ceiling subjects, both figural and nonfigural, are arranged symmetrically within compositional frames, and all the subjects float free without environmental connectors: no land-, city-, or seascapes, no *skenographia*. The only environmental hints consist in an occasional groundline or a tree. The rule is to represent one isolated subject per

register. Figures are rendered facing front, motionless, symmetrically spaced, in isolation and (with the exceptions just mentioned) in standing postures.

Traditional painterly refinements in the rendering of the Callistus figures are largely conspicuous by their absence. Shading is minimal to nonexistent: the modulation of flesh-colored tonalities across planar surfaces to suggest light bathing a body volume plays little or no role in the definition of these figures. Anatomical passages are stiff and flat, abstract, sketchy, and two-dimensional, more graphic than painterly. Hills and valleys in the rendering of garment folds are schematic and linear. Excepting the flying cupids (for example, Figures 6.10, 6.16) with their legs drawn to the side in scissorslike fashion and their garments billowing about their torsos, ceiling depictions of figures in motion are unconvincing. Overall the figural passages are flat and unarticulated, two-dimensional and static, linear and graphic rather than painterly.

An important but largely neglected detail is the Callistus *officina*'s use of painted embroidery borders (remotely reminiscent of classical architectural ornament, *kymatia* and dentilations;[87] see Figure 6.28) as part of the ceiling ornament. These embroidery borders appear typically on the inner side of the frame that faces toward the center of the field. Also typical is an embroidery border on the painted frame enclosing the central ceiling medallion, but here the dentilations appear on the outer side of the frame and are thus oriented away from the central domed apex. All of the surviving ceiling frames in the oldest Callistus chambers follow this formula. Dentilated borders compound the visual complexity of the Callistus ceilings—they imbue the ceilings with a sense of ornamental refinement. They also add to the cost. Compared with the walls, the Callistus ceilings appear dense, cluttered, and complex. This is a consequence of several factors, but there is no doubt that the border ornament on the painted frames is a contributing factor.

Qua painting, the Callistus ceilings are best described as signaling the late antique movement away from Greco-Roman naturalism, the movement in painting toward two-dimensionality and abstraction from nature. Judged on the criterion of Greco-Roman naturalism, the best-quality painting in the Callistus ceilings is to be found in the flowers, garlands, and birds, in other words, the subjects best understood and most often repeated by the journeymen *parietarii* hired out to decorate this place. All of these stylistic features are accentuated in the accompanying wall paintings.

Walls

Although wall and ceiling paintings in Callistus bear certain common resemblances, the differences between frescoes in these two zones are certainly as great as their similarities. On analogy with language, painted frames are to syntax as individual images (and clusters of images) are to

Figure 6.28. Callistus catacomb. Level 2, cubiculum ceilings: composite line drawing of dentilation types.

words (and phrases). At Callistus the ceilings and walls share a common pictorial syntax: both have white grounds overpainted with red and green lines, but there are significant differences in the principles of organization. As for individual visual units, the pictorial equivalent of words and phrases, there is some continuity from ceilings to walls, but not much.

Composition

As indicated previously, the ceiling frames reproduce common systems widely attested in Romano-Campanian fresco decoration. This is not true for the walls. Preconceived systems of painted frames seem to have played little or no role in the division of the wall surfaces into banded registers. For example, the division by tripartition of each wall into three horizontal and three vertical registers is largely absent from the Callistus walls. Tripartition played a defining role both at Pompeii and in post-Pompeian fresco tradition, but at Callistus, excepting the south wall of chamber Y in hypogeum alpha (Figure 6.29), it seems to have disappeared.

In dividing the walls into painted registers, the workmen seem have been guided by a different principle of spatial organization, the configuration of the underlying tufa interments being the determining factor. Normally the north, west, and east walls of each chamber contain loculus interments, and in those few examples where there is enough evidence to make an assessment, it is clear that painted frames were executed to highlight loculi. What this means in practical terms is that the wall frames must have varied considerably in size, orientation, and number depending on the underlying loculi per wall. The north wall of A3 (Figure 6.30) in Area I, for example, exhibits five vertical and five horizontal registers, all of them delineating loculi.

Tripartition could be employed on the south wall of Y, as just observed, because the wall functioned only as a pierced partition guaranteeing privacy within the room and affording a means of access in and out. Admittedly, it is difficult to draw hard-and-fast conclusions on this subject, because the wall painting in Callistus has been so extensively destroyed, but the divergence between ceiling and wall compositions is no doubt correctly described as a function of the different purposes that these two zones served. The ceilings did not contain interments. The walls (but not the partitions) did. And herein lies the difference in the organization of painted wall registers.

By comparison with the ceilings the Callistus walls are clear and uncluttered. They are easier to read than the ceilings, and in part this is a direct consequence of the relatively greater syntactical simplicity that characterizes the arrangement of wall registers. As we have noted, the ceilings consist in a complex nexus of painted frames enclosing densely packed images. The ceiling syntax also subsumes a wide range of geometrical types: squares, rectangles, rhombs, trapezoids, and trapezoidal brackets (�), pentagons, tetracuspids (closed: ◇ and open: ⌗), cir-

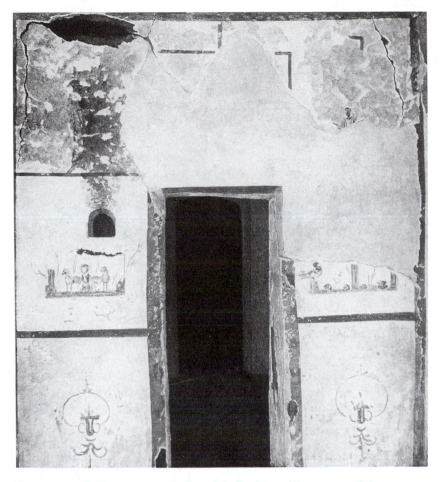

Figure 6.29. Callistus catacomb. Level 2, Reekmans' hypogeum alpha, cubiculum Y, south wall showing tripartition.

cles, half-circles and quarter-circles, spherical or almond-shaped lozenges (mandorlas), and an octagonal frame on ceiling L2 in Area I. The wall frames, by contrast, consist mostly of simple rectilinear lines. Elliptical segments do appear as lateral frames on the ends of horizontal wall registers[88] (and occasionally elsewhere),[89] but they are highly abbreviated and do not contribute to the kind of visual complexity that characterizes ceiling ellipses. Futhermore, the wall frames lack embroidery borders, an omission that adds to the visual simplicity of the wall sequences at Callistus.

A brief comparison of the Callistus walls with those in the so-called villa piccola[90] beneath San Sebastiano is revealing. The painted frames of the room shown here (Figure 6.31) resemble a cobweb[91] stretched out against white-ground walls. The panels seem to have a random configura-

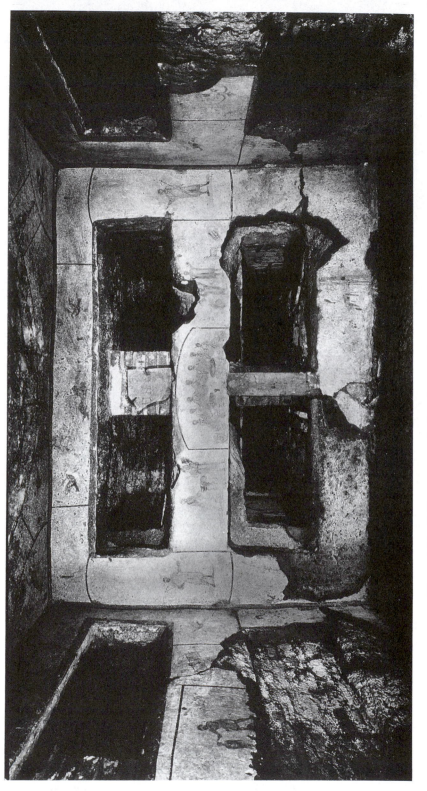

Figure 6.30. Callistus catacomb. Level 2, area I, cubiculum A3, north wall.

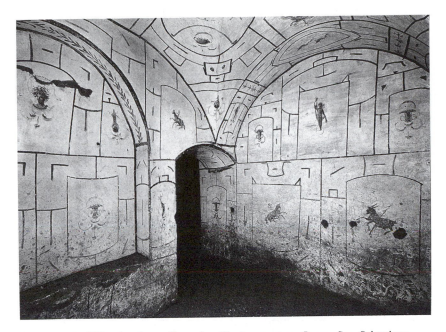

Figure 6.31. Villa piccola, wall, and ceiling sequence. *Rome, San Sebastiano.*

tion. There is scarcely any difference between ceiling and wall frames. The entire decoration of this room consists in linear frames run riot over all the ceiling and wall surfaces. There is no visual hierarchy in this room, no sense that some panels contain messages that are relatively important, whereas other panels are subordinate and secondary by virtue of their emplacement or by virtue of the iconography that they carry. The entire room exhibits a kind of uniform meaninglessness—this is pure linear decoration devoid of symbolic content.

By contrast, the Callistus walls are at the opposite end of the decorative spectrum. Painted frames are relatively few in number, they set off registers that are laden with highly evocative, symbol-specific images, and the visual hierarchy is clear and legible. In short, the Callistus frames are purposeful. The visual clutter that characterizes the Callistus ceilings or the random, linear meandering that typifies the villa piccola walls and ceilings contrast dramatically with the linear frame organization of the Callistus walls.

Iconography

An iconographic program, defined as a narrative pictorial sequence, a story in pictures exhibiting a beginning, middle, and end, is lacking in the oldest surviving chambers at Callistus. At the same time, there is I think a certain thematic unity in these rooms, and it is best defined on the exam-

ple of the several abbreviated pictorial paradigms illustrating people being saved (*Rettungsparadeigmata*), delivered from affliction, redeemed. In some instances, the figural clusters contemplated here envisage violent and dramatic forms of death: Abraham's near-sacrifice of his son, Jonah swallowed by a large sea monster, Daniel cast into a den of lions. The Israelites dying of thirst in the desert is a slightly less dramatic but equally threatening scenario. The frescoes illustrating New Testament subjects also relate to deliverance, salvation, and redemption. This includes Lazarus raised from his tomb, the shepherd carrying the sheep, baptism, the fisherman, the paralytic, possibly also the orant.

Like the ceilings, the walls also suggest a visual hierarchy of images: emplacement is the key. The wall opposite the doorway (at Callistus typically on the north) carries the most important messages, whereas the oppposite wall is iconographically the least significant. As for the importance of the two lateral walls east and west, I can detect no relative hierarchy of iconographic values. To repeat, within the overall family of wall and ceiling subjects, there is a thematic unity, but serious problems arise when one attempts to extend this principle of unity to the ceilings. Clearly one can establish a connection between the images at the dome apices and the salvation images on the walls, but the ceiling images in the subordinate annular registers (Jonah excepted) are best described as loosely connected. Minimizers would argue there is no connection whatsoever.

Despite the high degree of wall-plaster degradation, it is clear that a large percentage of the Callistus wall iconography is biblically derived, hence symbol-specific. Most of the wall figures are rendered frontally: they address the viewer directly. Again, as in the ceilings, the main exception is the profiled Jonah who appears, for example in Area I, chamber A6 (west wall, middle register: Figure 6.32), in the familiar tripartite horizontal sequence (from right to left): thrown overboard, cast up, and resting under the pergola. The only other exception to the rule of frontality is the powerful evocation of a baptismal (more correctly, postbaptismal) scene (in three-quarter view) in the fragment on the upper half of the north wall (Figure 6.33) in chamber X, hypogeum alpha.

The Jonah sequence in A6 (Figure 6.32) deserves a further word. In my view, this compositional arrangement provides a legitimate basis for speculation on the possible existence of an antecedent narrative tradition, presumably a text illustration that the buyer might have seen and described (?) to the seller. Furthermore, the A6 *parietarius* makes the story unfold from right to left. This could be explained (and dismissed) as merely the material consequence of the sequence in which the room was painted: first the north wall, then the adjacent lateral walls proceeding from north to south. But on the presumption of an illustrated book, it also suggests a text written in a Semitic rather than an Indo-European tongue. It is difficult to imagine that Christians created a tradition of Old Testament illustrations before 200, and hence the right-left sequence (paral-

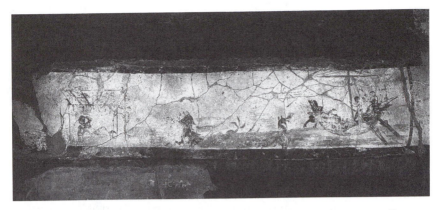

Figure 6.32. Callistus catacomb. Level 2, area I, cubiculum A6, west wall, middle register. Right to left: Jonah thrown overboard, Jonah cast up, Jonah resting under the pergola.

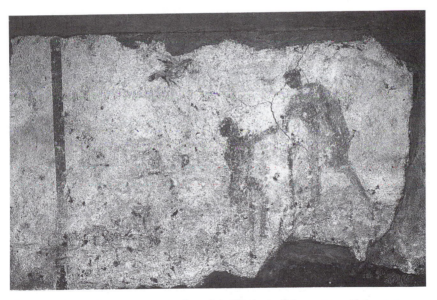

Figure 6.33. Callistus catacomb. Level 2, Reekmans' hypogeum alpha, cubiculum X, north wall, upper register: probably the visual equivalent of Mk 1:9–11 (the baptism of Jesus in the Jordan). Jesus left; John (in a sleeved[?], loose [*discincta*] tunic [?]) right; upper left of register: bird in flight.

leled elsewhere) might be interpreted as lending support to Weitz-mann's[92] theory that Jews (in Ptolemaic Alexandria?) illustrated the Bible (LXX) long before Christians came on the scene.

Almost without exception, Callistus wall subjects that fall under the neutral, generic, or pagan rubric appear as lateral framing pendants on the ends of horizontal registers. Their subordinate emplacement declares their attributed importance. Although not so often recognized, the arrangement of ceiling subjects exhibits a parallel hierarchy of pictorial values: neutral, generic, or pagan subjects are placed in annular registers, which are intended to be read as subordinate to (and in a sense framing) the central domed apex of the ceiling field.

The Callistus walls exhibit fewer neutral, generic, or pagan subjects than the adjoining ceilings, and I think it is arguable that the *parietarii* diluted the character of the nonfigural wall pendants in favor of greater symbolic neutrality. For example, except for one surviving mask (*os-cillum*[93] in Area I, chamber A5, north wall: on the horizontal strip between the second and third loculi; [Figure 6.34]—its pendant [Figure 6.35] is half destroyed), there are no Dionysiac derivatives on the Callistus walls, no maenads, no cupids, no shells, and no hanging Dionysiac masks. Admittedly, the Callistus walls exhibit numerous surviving examples of flowers, flower sprays (no garlands, however), and occasional vases nested on floreated brackets, but it is stretching the case to insist that in early third-century Romano-Campanian funerary painting these subjects were intended (except perhaps very remotely) as vehicles of Dionysiac meaning.

In short, the nonfigural wall subjects that are made to appear in subordinate emplacements as pendants are probably best described as intentionally neutral in their attribution. This includes the various species of wall flora and, under the faunal category, birds either perched or aflight. In decorating these cubicula walls with nonfigural, framing pendants, it appears that the Callistus painters made a concerted effort to deflect the viewer's focus to the figural subjects at the center of each register. It is possible (but unprovable) that the buyer prompted this effort.

The most important possible exception to this rule of thumb (if that is what it was) is the fragmentary scene on the north wall (middle/lower register) of cubiculum Y in hypogeum alpha. Here we have the famous opposing fishes (Figure 6.36), the left one facing right, its pendant facing left: both were clearly intended as pendants set left and right of red elliptical frames (to which the painters have added horizontal, perpendicular brackets) enclosing a scene that does not survive. Wilpert[94] convinced himself that the lost central scene within the elliptical frames must have been a sigma meal (recumbent symposiasts or diners on a C-shaped [Greek sigma] platform lined with cushions). I have no quarrel with this supposition, provided it is recognized for what it is: a guess. On their backsides the two pendant fishes bear baskets piled high with round bread loaves: six cover the mouth of the basket left, five the basket right.

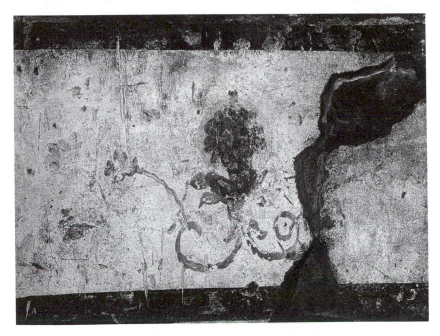

Figure 6.34. Callistus catacomb. Level 2, area I, cubiculum A5, north wall: nimbled *oscillum*.

Figure 6.35. Callistus catacomb. Pendant to Figure 6.34.

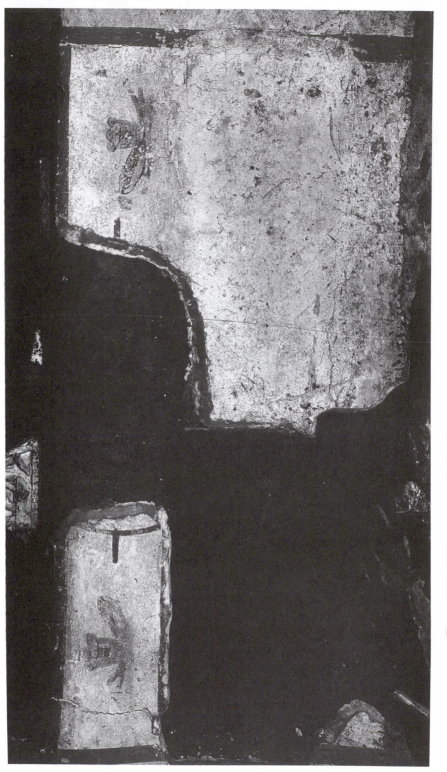

Figure 6.36. Callistus catacomb. Level 2, Reekmans' hypogeum alpha, cubiculum Y, north wall, middle/lower register: opposing fishes.

If Wilpert's presumption were correct, then it would also be possible that the relationship between the hypothetical meal scene and the two breadbasket-carrying fishes was more than just coincidental: the fishes and breads might have been linked thematically to the content of the meal. But even if there was a meal depicted within the elliptical frames, we do not (and cannot) know the symbolic content of the meal. Given the setting (an interment) and the occasion (commemoration of the dead), a funerary interpretation makes sense, for example, a *refrigerium*[95] meal, not as Wilpert believed, a eucharistic[96] meal.

It was common Roman practice[97] for the family and friends of the deceased to gather periodically at the gravesite where they would eat a meal and make offerings to the disembodied spirits (*manes*) of the dead. Bread was an invariable part of Roman funerary meals, fish a variable element. Thus the pendant fishes in cubiculum Y could point to the enactment of a funerary meal. Unfortunately, we have no contemporaneous written evidence that discloses the specifically Christian content (if there was any) of the funerary meals that the new religionists celebrated at gravesites in the early third century. Thus, the opposing fishes in Y may or may not constitute an exception to the generalization on the largely neutral or generic character of pendant wall images in the earliest Callistus chambers.

I can find no necessity for attributing symbol-specific meaning to the fish (Figure 6.37: dolphin?)[98] wound about a trident on the east wall (middle register, far right) of A2 in Area I. Its pendant on the far left is lost. Very likely both fishes were intended as decorative fillers which bear no necessary thematic relationship to the scene (Figure 6.39) at the center of the horizontal register that shows a naked Lazarus facing front, standing in front and to the right of the *Vetus Latina/Vulgate* "monumentum" (Jn 11:7, 31, 38a)

But just to complicate what seems to be a very simple matter, it is worth noting that the "friendly" sea mammals were proverbially saving fishes: Athenaeus (*Deip.* 13.606e) calls the dolphin ζῷον φιλανθρω-πότατον and invokes Phylarchus' familiar story concerning Koiranos of Miletus who was saved (ἐσώθη) by dolphins in a shipwreck off Mykonos. Clement[99] could (and did) paraphrase Athenaeus at length, but there is no good reason to suppose the same of the Callistus Christians (who on the evidence of their third-century *tituli* were only marginally literate). On the other hand, is it too much to ask of third-century Roman freedmen that they could have known the proverbial association between dolphins and salvation? After all, these *ignoti* did not need to possess reading skills in order to know the commonplace: the idea of dolphins and other sea animals[100] conveying the souls of the departed across the ocean of death to the Blessed Isles, Elysium (or Christian Paradise?), was widespread in the funerary iconography of Imperial Rome.

The same may be said, *mutatis mutandis*, for the rest of the nonfigural framing pendants (birds, sheep,[101] and flowers). For example, on the

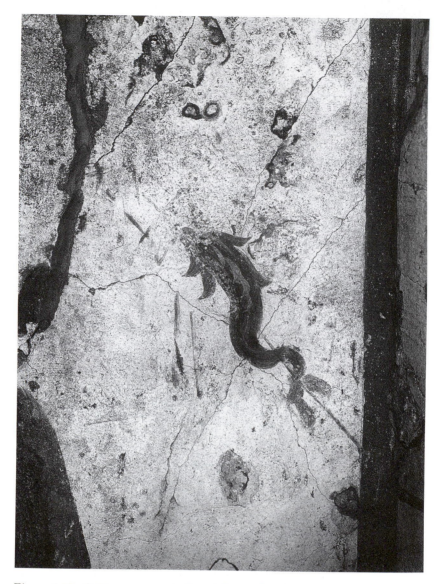

Figure 6.37. Callistus catacomb. Level 2, area I, cubiculum A2, east wall, middle register: fish wound around a trident.

same panel just described, at the middle register on the east wall of A2 (Figure 6.38) on its right end we see a well-executed bird facing left, perched on a branch; its pendant on the left end of the register has been destroyed. Minimalist wisdom argues that birds bear no thematic relationship to Lazarus (Figure 6.39: at the center of the register) or to any other symbol-specific images (baptism excepted), either in Callistus or in any other third-century Christian iconographic contexts (frescoes, sarcophagi,

Figure 6.38. Callistus catacomb. A2 East wall, middle register: bird.

Figure 6.39. Callistus catacomb. A2 East wall, center of the register: classical facade (Vulgate "monumentum": Jn 11:17, 31, 38a). At the right end of the facade a standing naked figure, and farther to the right, the head, right shoulder, and arm of a figure otherwise destroyed.

and small finds). This could be true, but just as likely it is false. Is it really just an accident of workshop tradition that birds appear in such great numbers at Callistus? Soul birds,[102] it will be recalled, were a staple of Greco-Roman funerary iconography, and it seems to me reasonable to suppose that at least some early Christian viewers might have interpreted the birds flanking Lazarus in the light of funerary intentions.

The classification of figural subjects (philosophers, orants, fossors) that appear as pendants in subordinate emplacements is also a subject of controversy. The philosopher[103] is identified by the scroll (*uolumen*) he carries in one hand. On the north wall (vertical register, far right of the middle register) of A2 in Area I, the seated figure (Figure 6.40), dressed in a pallium (the philosopher's costume) and gesturing with his raised right arm toward the center of the wall, may be intended as a philosopher but the telltale attribute (the scroll) is missing. By contrast, at the east side of the south wall in the same chamber, the standing figure (Figure 6.41: facing front, head obscure, right arm extended, left arm extended right beneath the folds of the pallium, holding a *uolumen*) is a dead giveaway: the generic philosopher. Also intended as figural pendants are the upper torsos of two orants appearing on the north wall of A4 (Figure 6.42: above the elliptical frame of the lunette, which sets off a loculus)—so are the diggers (their attribute: the fossors' pickax [long- and short-handled *dolabra*[104] *fossaria:* ⊤ ⊤ represented left and right of the middle registers on the north wall of A3 (Figures 6.43, 6.44) and the south wall of A4 (Figures 6.45, 6.46) in Area I.

Of the three pendant figural types just mentioned (philosophers, orants, fossors), clearly the second is the most controversial. This is a figure (male or female, but more commonly the latter) that stands facing front, typically with both arms extended and the palms of the hands open. Bosio[105] thought the figure signified the deceased waiting for her resurrection, and Rossi[106] saw the type as a symbol either of the departed soul in paradise or of the triumphant *ekklesia*. More recently, Klauser[107] has pointed to the appearance of orantlike female figures on second- and third-century Imperial Roman coin reverses where the image is accompanied by the legend, "PIETAS." The two female figures perched on floreated brackets in opposite corners of ceiling Y in hypogeum alpha (Figure 6.16) correspond to the numismatic type.

But it may be recalled that the figure within the central medallion of that same ceiling, namely Daniel facing front and flanked by diminutive lions, also exhibits the same orantlike formula: arms raised and extended, palms open. The Daniel figure is clearly a salvation paradigm, hence a symbol-specific image carrying an explicitly Christian message (mediated via an *interpretatio christiana* of the Hebrew Bible). The critical issue is to determine if pendant, third-century orant figures (typically females) in subordinate emplacements were also perceived as *Rettungsparadeigmata*, but to my knowledge there is no compelling evidence in the circumstantial realm (literature, epigraphy) that would help to solve this problem.

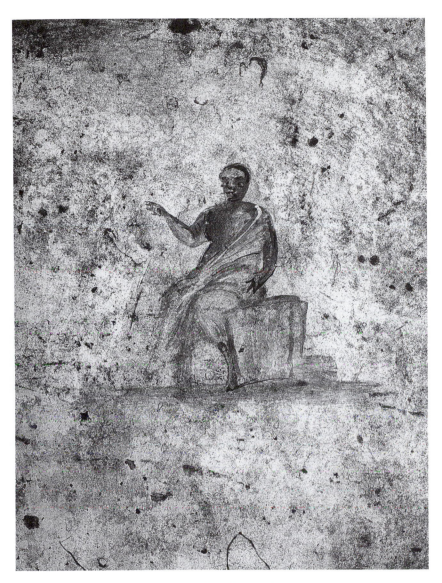

Figure 6.40. Callistus catacomb. A2 North wall, far right vertical panel: seated *palliatus* gesturing with right arm toward the center of the wall.

Figure 6.41. Callistus catacomb. A2 South wall, east side: standing *palliatus*.

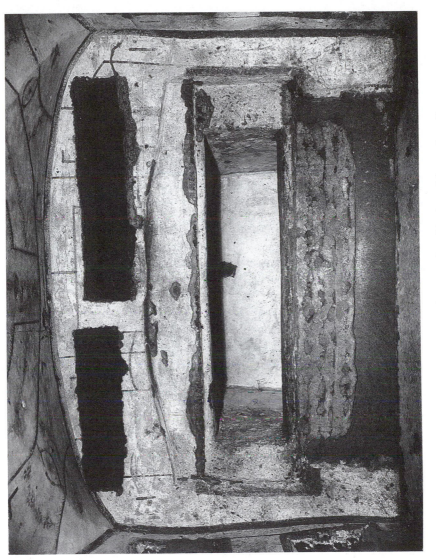

Figure 6.42. Callistus catacomb. Level 2, area I, cubiculum A4, north wall: or- ants at the upper left and right edges of the broad elliptical lunette that en- closes the center loculus.

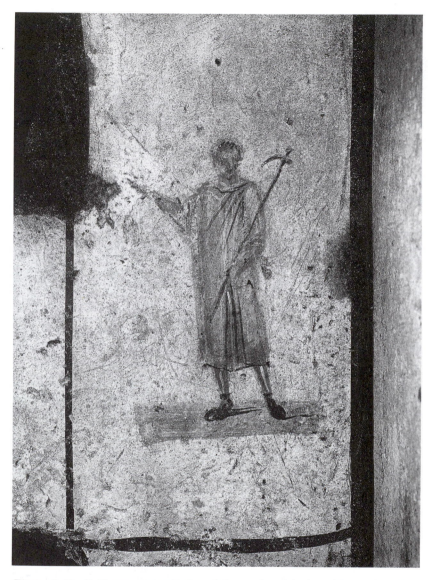

Figure 6.43. Callistus catacomb. Level 2, area I, cubiculum A3, north wall middle register, lateral register on west end: standing *fossor* holding a *dolabra fossaria* mounted on a long *pedum* and nestled in the crook of the right arm, facing front, gesticulating with the left arm to the center of the register, dressed in a long, free-flowing, sleeved tunic (*tunica discincta manicataque*).

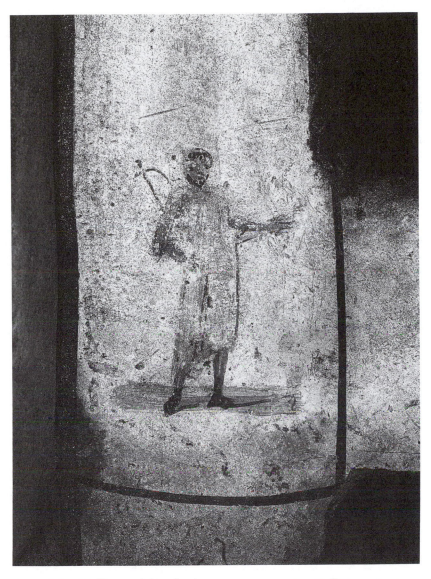

Figure 6.44. A3 East end (pendant): same posture, same attribute, same gesticulation (reversed), same dress.

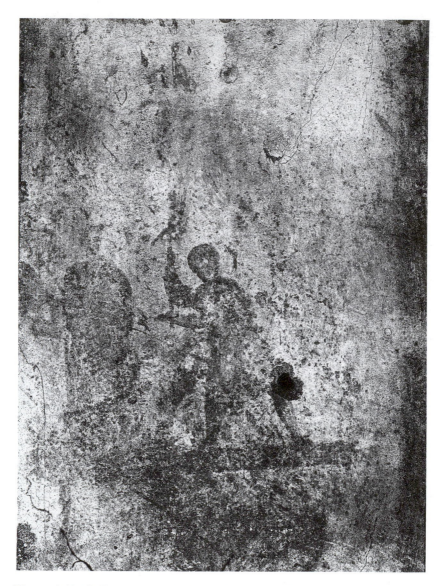

Figure 6.45. Callistus catacomb. Level 2, area I, cubiculum A4, south wall, west side of door: standing *fossor* in three-quarter view, facing left, dressed in short tunic (?), *dolabra* mounted on long *pedum* raised in right arm and poised to strike.

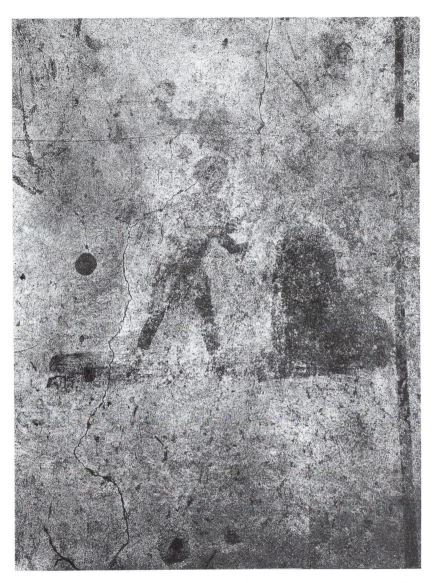

Figure 6.46. Callistus catacomb. A4 Pendant: same emplacement on east side of door, same details (reversed).

The attributed meanings for figures carrying scrolls and fossors carrying pickaxes are also unclear. The former clearly point to the value of *la vie intellectuelle*,[108] and at least on third-century, Christian sarcophagus fronts the philosopher type may have been intended to apply in some form to the deceased, but under precisely which temporal application (past, present, or future) is unclear, as is the content of philosophy attributed to the man represented. Diggers, on the other hand, point in quite a different direction. These men were clearly members of the despised[109] banausic class, manual laborers, slaves, occasionally freedmen,[110] but in any event men who could make little pretense to *la vie intellectuelle*. The labors they performed were as essential as they were impressive, and in the post-Constantinian period fossors were admitted to the minor ranks of the clergy, but the religious meaning (if any) attributed to them as painted pendants in the early third-century context of Callistus is obscure, or so it appears to me.

In Area I on the north wall of cubiculum A3 (Figure 6.30) the scene (Figure 6.47) on the horizontal middle register left of the central sigma meal presents special problems. There are three components: a large three-footed table, which overlaps the register's lower frame line (suggesting Wölfflin's *übergrosser Vordergrund*),[111] and two standing figures left and right of the *tripous*. The male figure left wears the pallium and stands to the rear left side of the table (spatial recession is suggested by the painted shadows that flow from both of his feet). With his long naked right arm drawn dramatically across his upper torso, he gesticulates toward the central table surface, which carries a large round breadloaf and a fish. The lower end of his left arm reiterates the gesture. The figure right is a female, facing front, dressed in armless tunic (chiton), head veiled, her stubby arms raised and extended with open palms (per hand four fingers stretched and separated wide: a mourning gesture?).[112] Her right foot touches and slightly overlaps the register's lower frame line—in other words, she stands forward of her male counterpart but is still positioned to the rear (and right) of the prominent central table. Dark striations follow in oblique lines (right) on her heels, thus a second time suggesting shadows from an imaginary light source that is front and slightly left of the panel.

Right of the central sigma, the pendant (Figure 6.48) to this intriguing and problematic scene gives an important clue. Here we encounter a familiar *Rettungsparadeigma*: Abraham (dressed in *tunica discincta*) and Isaac (dressed the same but with *clavi*) as orants giving thanks for God's intervention and deliverance of the boy from his father's knife. The female left of the central sigma, the Patriarch, and his son all exhibit the same gesture.

Wilpert interpreted the scene left of the central sigma meal in three[113] different ways, first as a priest reciting the words of eucharistic consecration, second as the moment of communion when the bread and wine were offered to the congregation, third as the visual equivalent of the multiplication of the loaves and fishes, with the female orant symbolizing the

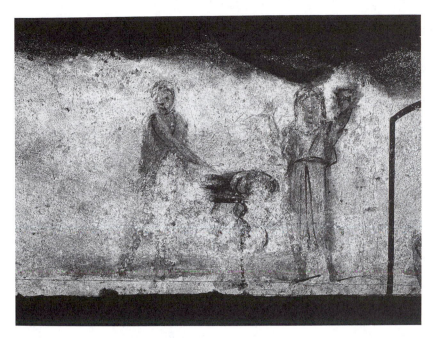

Figure 6.47. Callistus catacomb. Level 2, area I, cubiculum A3, north wall, middle register, left of center: two standing figures flanking a three-footed table.

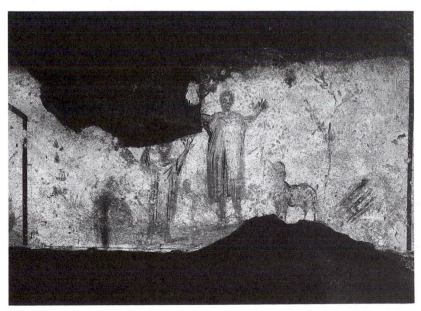

Figure 6.48. A3 Pendant (right of center): Abraham and Isaac, substitute victim, spindly tree (not a thicket) and faggots.

soul of the dead. Klauser[114] thought the scene represented a call (or summons) to a cult event (*Zitationsvorgang*), and Stuiber[115] (forcing his materialistic interpretation) believed the scene represented a "realistic" version of a real-life person offering real food to the *Verstorbene*.

The simple but lamentable truth is this: no one (myself included) has the foggiest idea what the scene left of the central sigma is supposed to represent. The table is clearly the visual and hence symbolic center of the scene. What is being prominently displayed here is a large *tripous* bearing a breadloaf and a fish. For Dölger[116] the table was a secular object, a piece of household furniture (*Hausmöbel*). This is possible but given the funerary setting, improbable. If (as is more likely) the table had been intended as a piece of cult furniture, then the *Vorgang* involves the cultic display of bread and fish. To claim anything more than this seems to me unwise. What the people of the Callistus catacomb saw in this scene we do not know. But, given the surviving pendant (Figure 6.48) with its clear evocation of salvation, it seems reasonable to suppose the scene of the two standing figures and the table between them is thematically tied in some form to *interuentus diui*: deliverance, redemption, salvation.

Overwhelmingly and persistently, the Callistus wall iconography reiterates familiar salvation paradigms: Moses[117] (Figure 6.49) at Massah and Meribah (Ex 17:7) striking the rock with his wand (*uirgula/kerykeion*), God's deliverance of Isaac just mentioned, the ubiquitous Jonah in the familiar threefold sequence already mentioned, the washing and deliverance of a baptizand (Figure 6.33 [on the north wall of cubiculum X, hypogeum alpha]: probably Jesus at Mk 1:9par.), the paralytic (Figure 6.50) carrying his miserable *krabbatos*,[118] thus saved from his debilitating illness, and the much-lamented Lazarus, whom Jesus loved, freed from his shadowy entombment Figure 6.39; also Figure 6.51: the moment depicted here is Jn 11:44, ἐξῆλθεν ὁ τεθνηκὼς . . .—the sense of motion is conveyed pictorially.

In Area I, A3, on the eastern half of the south wall (Figure 6.52), a figure dressed in a sleeved tunic (*tunica manicata*, or, if this is a female, a chiton with sleeves at a half-arm's length) bends over a cistern or well, drawing water with a bucket dipped from the right hand. This is likely a visual recension of Jn 4:7: the Samaritan woman at Jacob's well in Sychar. In the upper left-hand corner of the register, the seated *palliatus* holding an opened scroll is probably to be interpreted as Jesus reading aloud (and at the same time imposing his own midrash on Isa 12:3, 44:3, 55:1, 58:11, or Sir 21:24). What is being promised here is . . . τὸ ὕδωρ . . . εἰς ζωὴν αἰώιον (Jn 4:14): a spring of water that guarantees eternal life (that is, salvation). The standing figure at the well is paralleled on the wall immediately south of the font in the Dura[119] baptistery, and the seated lector echoes an equally familiar parallel[120] (Figure 6.53) on the west wall of the lower north chamber in the splendid Roman-Severan hypogeum of the Aureli.

The seated fisherman who appears twice on the Callistus walls, once

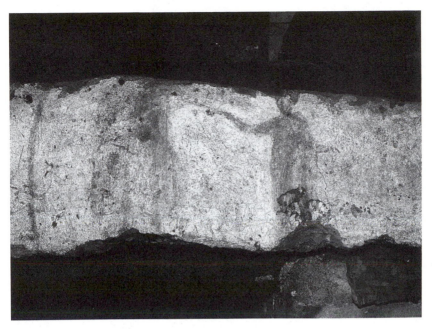

Figure 6.49. Callistus catacomb. Level 2, area I, cubiculum A2, west wall, middle register. Moses striking the rock.

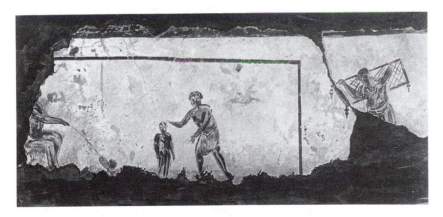

Figure 6.50. Callistus catacomb. Level 2, area I, cubiculum A3, west wall, middle register. Left to right: seated fisherman, baptizand, baptizer and bird in flight, standing figure (paralytic) facing front carrying pallet.

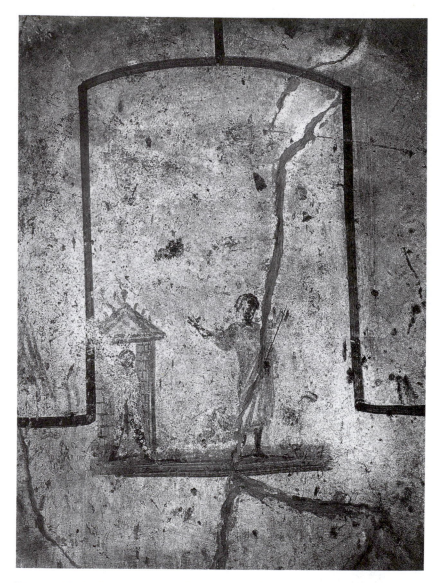

Figure 6.51. Callistus catacomb. Level 2, area I, cubiculum A6, south wall, west side: left, a classical facade, acroteria projecting from the raking sima, in front of the facade a standing naked figure, legs splayed to suggest movement; to the right, a larger standing figure facing front, dressed in sleeved tunic, staff held in the left hand (=Jesus the magician).

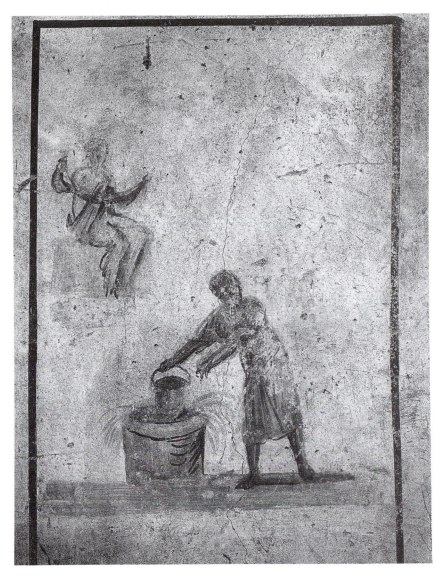

Figure 6.52. Callistus catacomb. Level 2, area I, cubiculum A3, south wall, east end. Upper left: seated figure reading from open scroll. Lower center: standing figure obtaining water from a well.

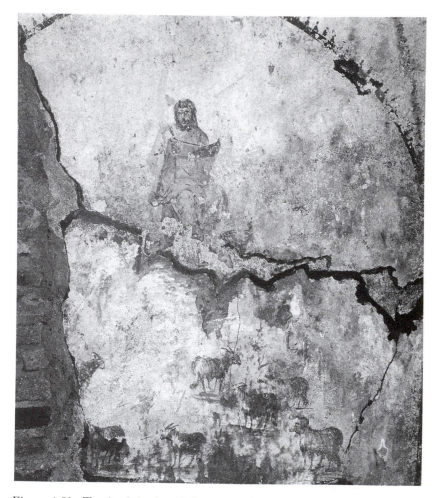

Figure 6.53. Tomb of the Aureli. Lower north room, west wall. Upper center: seated figure reading from open scroll. Lower half of register: sheep grazing. *Rome, Viale Manzoni.*

(Area I, A2, west wall, middle register center, between Moses striking the rock and symposiasts at a sigma meal: (Figure 6.54; also Area I, A3, west wall, middle register left, together with a baptismal scene: Figure 6.55) could have been intended in either neutral-generic or symbol-specific. Probability and context favor the latter, in my opinion. In the first example, there is an associative link, a semiotic[121] or signitive connector: both Moses' wand (*uirgula/kerykeion*) and Peter's fishing rod ([h]*arundo*) function visually as *instrumenta salvationis*. And in chamber A3 the common semiotic matrix is water.

As to the question of iconographic models on the Callistus walls, I can

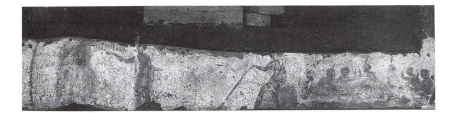

Figure 6.54. Callistus catacomb. Level 2, area I, cubiculum A2, middle register, slightly left of center: standing figure facing front, dressed in a long, free-flowing tunic, right arm extended, staff in hand, large mass (the rock at Horeb) to the left; seated fisherman slightly right of center; farther right: seven reclining symposiasts at a *sigma*.

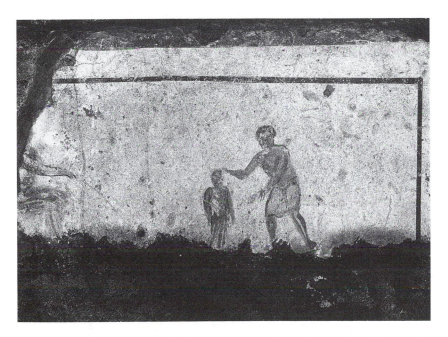

Figure 6.55 (detail of 6.50). Callistus catacomb. Level 2, area I, cubiculum A3, west wall, middle register, left end: seated figure facing right, right arm extended holding a line (head, shoulder, back, and feet destroyed); to the right: baptism as *impositio manus*.

find little or nothing that is unprecedented. Baptism (excepting the remarkable version hypogeum alpha, cubiculum X: Figure 6.33) is Roman *impositio manus*.[122] The paralytic is a Roman stevedore; Lazarus, a Christianized Osiris[123] either naked or wrapped in linens; Jesus with his wand (*uirga/kerykeion*), a generic Greco-Roman *magus*/γόης.[124] Jonah is Endymion asleep; the pergola or trellis[125] that shades him, a piece of Romano-

Campanian vernacular within the iconographic family of garden architec-
tural furnishings; and the composite *ketos*,[126] a familiar Greco-Roman
motus inanis (Cic., *ND* 1.105, 106; also 1.78),[127] a figment of the imagina-
tion, and, like hippocentaurs, Chimaerae, and hippocampi, a member of
the familiar menagerie of hybrids widely attested in Greco-Roman ico-
nography. Insofar as one can speak of iconographic matrices on the Cal-
listus walls, the familiar Greco-Roman and Romano-Campanian maritime
and bucolic settings are clearly the primary archetypes. On both the walls
and ceilings, all of the other figures (orants, philosophers, fossors, sympo-
siasts, fishermen, shepherds) simply repeat tried-and-true Greco-Roman
clichés. The same is obviously true, *mutatis mutandis*, for the nonfigural
subjects.

Style

With allowance for some significant differences, the two fresco zones
(walls and ceilings) in Callistus reflect the same style of painting. The
most important single inference that we can draw from this fact is that the
same workmen painted both zones: Diocletian's price edict[128] (301) distin-
guishes wages for two kinds of painters, wall painter (*pictor parietarius*) and
figural painter (*pictor imaginarius*), with a daily wage for the latter at twice
that of the former. In view of this distinction and given the quality of the
Callistus painting, it seems likely that the persons involved in preparing
the cubicula plaster and decorating it with paintings were *tectores* (*alba-
rii*)[129] *et pictores* (*parietarii*)[130] but not *pictores* (*imaginarii*). This inference
would square with what must have been the rather limited economic
conditions of the Callistus Christians, and it would also explain why in
both the ceiling and wall zones the Callistus painters were at their best in
executing frames, flowers, and birds and why they were at their worst
in executing figures.

Judged on the criterion of Greco-Roman naturalism in painting, the
most successful wall and ceiling renderings are clearly the flowers (individ-
ually and in sprays), the vases and floreated brackets, the garlands and the
birds. The latter in particular are lively and true to life: the brush was
adeptly applied in broad striations across the body of the bird (Figure 6.56,
6.57), then quickly lifted from the plaster surface to render the tail cov-
erts. The Callistus painters executed both aviary and floral subjects swiftly
and with secure strokes: thanks to their early training as workshop appren-
tices, they understood these subjects well, and the images flowed with
ease from their brushes. It must have been a kind of second nature for the
Callistus journeymen wall painters to execute birds and flowers. In short,
the ceiling frames, the floral and aviary subjects, represent the true force
of workshop tradition at Callistus.

Judged on the same criterion, the artists who painted the figural sub-
jects at Callistus (especially wall figures) were no artists. Where they were
required to paint naked figures (Daniel, Jonah recumbent, Lazarus, bap-

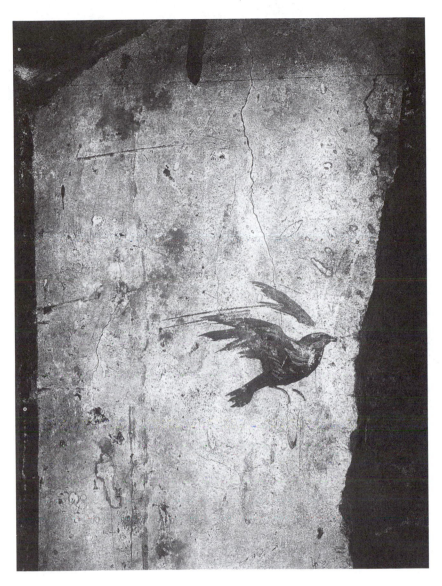

Figure 6.56. Callistus catacomb. Level 2, area I, cubiculum A6, middle register, lateral right end: bird in flight facing right.

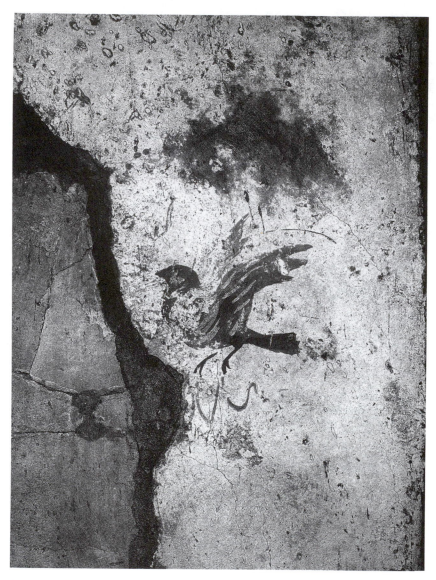

Figure 6.57. Callistus catacomb. Level 2, area I, cubiculum A6, middle register, lateral left end: pendant to 6.56.

tizands), their grasp of anatomy is revealed as elementary, bordering on nonexistent. For example, the baptizand in Area I, A2 (north wall, middle register: Figure 6.58), is flat, stiff, and lifeless—he lacks hands and a neck, the body parts are unarticulated, and physiognomic details consist in sloppy daubs at the eyes, nose, and mouth. The same is true for the baptizand in Area I, A3 (west wall, middle register: Figure 6.55). In both figures a pale wash has been applied over the darker primary coat so as to suggest a light source in front of the panels and to evoke a sense of light bathing across body volumes, but convincing illusions of plasticity are wanting in both figures. As already noted, the most convincing rendering of baptism is found in hypogeum alpha, cubiculum X (Figure 6.33); however, this is due not to interpretations of anatomy (which we cannot judge due to deterioration of the wall), but to the overall sense of composition, which evokes a keen sense of tension in motion. The baptizand's left leg and head slightly cocked back are particularly impressive.

Both compositionally and anatomically, the reclining Jonah was the most challenging of the naked figures. The best-preserved example is in Area I, A5 (east wall, middle register: Figure 6.59): the torso and legs are rubbery, like stretched taffy, the prophet's body parts are unarticulated, the left arm rises in an unnatural arc, and the scissors pattern imposed on the legs is awkward (though not so awkward as the rendering in A6, west wall, middle register: Figure 6.60). Due to the deterioration of the fresco surface, it is difficult to judge the same subject in Area I, A3 (north wall, upper register: Figure 6.61). Of these three examples, the latter may well have been the most true-to-life rendering of a reclining, naked, male figure, but even this is a long way from Greco-Roman renderings of the sleeping Endymion.

The rendering of garments is also revealing. These journeymen wall painters articulated hills and valleys in the traditional manner, namely by the application of variegated pigment tonalities (Figures 6.40, 6.41, 6.43, 6.44, 6.47–6.49, 6.51, 6.52, 6.58). Light passages marked with dark striations highlight the interplay of garment surfaces. Part of the traditional purpose is to convey an illusion of depth, foreground and background, undulating cloth wrapped around a body volume and modulated to an imaginary light source in a rhythmic play of ins and outs. But the net effect here is abstract, flat and two-dimensional, more linear and graphic than painterly.

Illusions of spatial recession are also minimal. As I already mentioned, the central leg of the three-footed table in A2 (Figure 6.47) overlaps the lower frame line. In A3 the composite scene (Figure 6.52: seated reader and standing figure) provides an example of what these painters could do with vertical perspective. The seated figure in the upper left of the register is to be read in the background, the standing figure at the lower center of the register in the foreground. But the painter did not understand the common Euclidian principle of size-distance relationships (the size of a volume in space is inversely related to its distance from a viewer); hence,

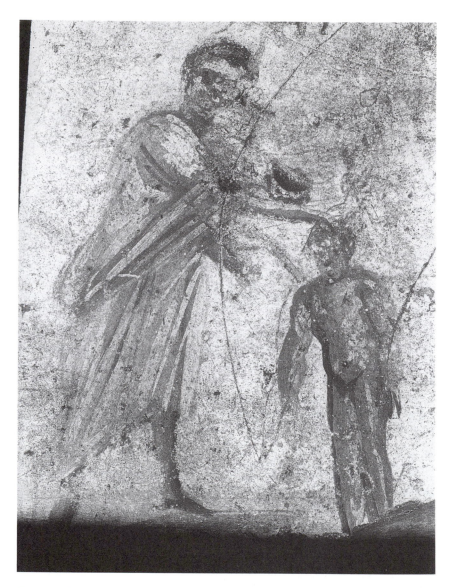

Figure 6.58. Callistus catacomb. Level 2, area I, cubiculum A2, north wall, middle register, roughly the center of the panel: adult male in three-quarter view, dressed in pallium, bending forward and to the right, right arm extended to the head of the small, naked baptizand, facing front, turned slightly left.

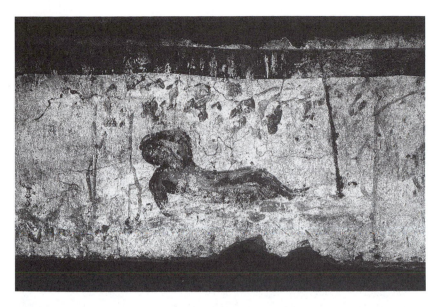

Figure 6.59. Callistus catacomb. Level 2, area I, cubiculum A5, middle register within a broad red-banded frame: reclining figure, head left, *kolokynths/cucurbits* hanging from the *skene/pergola*.

Figure 6.60. Callistus catacomb. Level 2, area I, cubiculum A6, west wall, middle register, left end of the panel: reclining, naked figure, head left, foreshortened pergola and hanging gourds.

Figure 6.61. Callistus catacomb. Level 2, area I, cubiculum A3, north wall, upper register: recumbent Jonah, head right; opposing pendant birds in flight.

the seated figure is shown in the same dimension as the figure at the well. The only other surviving concessions to perspective in Callistus both involve overlap: the paralytic in A3 (Figure 6.50) and the hindquarters of the left sheep overlapped by a cylindrical volume in cubiculum Y on the south wall, middle register, east side of the doorway (Figure 6.62; cf. Figure 6.29).

In summary, judged on the criterion of style, the Callistus ceilings are more tradition-bound, the walls more innovative. The ceilings repeat formulas that are derived from the third and fourth Pompeian styles and that are widely attested in post-Pompeian contexts. Thus, the ceilings represent the force of Romano-Campanian workshop tradition—they reflect the seller's know-how and have less to say about the buyers' input. Even though they could fall back on a full iconographic repertory of ready-made archetypes, the Callistus painters encountered considerable difficulty in the rendering of wall subjects. They were unsure of their subjects here and were forced to improvise on the spot. The most important barrier that the Callistus *parietarii* had somehow to overcome is that they were wall painters, not figure painters. Even their extensive reliance on ready-made clichés cannot disguise the difficulties they encountered: they were forced to adapt pagan models to new settings, and they were ill-equipped for the job. Judged comparatively, the Callistus wall frescoes represent failed Greco-Roman naturalism.

Attitudes toward Art

Von Sybel[131] was right: early Christian art represents the last gasp within the overall history of ancient art. The earliest Christians did not set about to uproot the noble trunk of the Greco-Roman artistic past; instead, they grafted their own nascent needs onto this venerable trunk. The Callistus frescoes represent one of the earliest (if not the earliest) manifestations of distinctively Christian art within the overall history of art, but at Callistus there is no radical break with the past. Indeed, the older view of this subject (vigorously promoted by Wilpert), which presumed the formal and iconographic discontinuity between pagan and early Christian art, is misleading and inaccurate. The two shared more similarities than differences, and the Callistus frescoes constitute an eloquent witness to the persistence of Greco-Roman tradition under the aegis of a new community within the religions of later antiquity.

The buyers at Callistus reflect a clear attitude of affirmation and openness toward an already-existing pictorial tradition of funerary decoration. Along with their non-Christian, Roman-Severan contemporaries, the Callistus Christians represent the seventh generation of Romans responsible for continuing Romano-Campanian fresco tradition in its post-Pompeian context. In particular what was carried forward here was the workshop

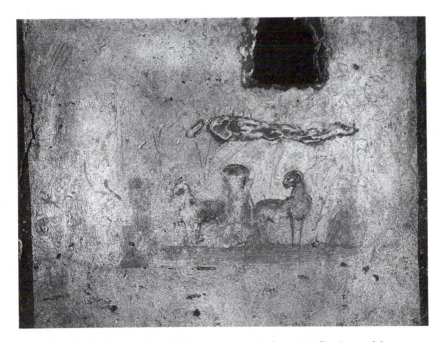

Figure 6.62 (detail of 6.29). Callistus catacomb. Level 2, Reekmans' hypogeum alpha, cubiculum Y, south partition, east side of doorway: two sheep flanking a *mulctrum* set on a pedestal.

tradition of white-ground, funerary painting, which derived ultimately from Beyen's[132] third and fourth Pompeian styles.

The Callistus Christians showed a much greater willingness to adopt and adapt all aspects of this tradition (iconography included) than did, for example, their Roman Jewish contemporaries (or near contemporaries) who decorated catacombs (Appendix 6.2) beneath the Torlonia estate and the Randanini vineyard. Jews also hired pagan *officinae* to decorate both places, but they did not allow the appropriation of Greco-Roman iconographic clichés to convey meanings that were symbol-specific to Judaism, and more particularly they did not allow Romano-Campanian figural archetypes (in painting) to be put to work in the service of an *interpretatio judaïca*. By contrast, the Callistus Christians reflect considerably more liberal attitudes toward the Christian uses of pagan tradition in explicitly Christian contexts. Thus, to resume the discussion set forth in Chapter 5, the Callistus Christians reflect a high degree of adaptation both to immediate prototypes in Romano-Campanian painterly tradition and to the remoter (but ever-present) influence of Greco-Roman iconographies pressed into the service of religious monuments.

But one must be careful to strike the right balance: the adaptation of Callistus Christians to already-existing pictorial traditions was selective and discriminating. That fact is patent everywhere in the Callistus chambers, but particularly in the wall zones. The Callistus frescoes do not represent indiscriminate adaptation and are misnamed if classified under the rubric "late antique syncretism." Callistus is not analogous to the indiscriminate farrago that one encounters in magical iconography,[133] or (if it existed) that one might encounter in gnostic[134] iconography. There is deliberative and distinctive purpose at Callistus, and for all the borrowing and adaptation and grafting onto a Greco-Roman trunk, this purpose clearly and unmistakably discloses a core of meaning that is Christian. In short, von Sybel was also wrong: there is more at stake here (and elsewhere in third-century Christian art) than just the continuation of the Greco-Roman past.

The Callistus paintings mark a new beginning. They signal a new direction in the painting of later antiquity, a direction that is innovative and fresh, an orientation in art impregnated with the promise of new meanings. The Callistus paintings resume the past and the present in Greco-Roman tradition, but in doing so they redirect that past to an anticipated future filled with hope for a new kind of deliverance from the dreaded and abysmal fate that confronted Greeks and Romans on the far side of the grave. What the Callistus paintings promised was a new core of attributed meanings, a new hope *coram morte*. On all counts, the identification of this new core of meaning is the most controversial part of the entire Callistus corpus of paintings.

We shall return briefly to this theme in the concluding chapter.

APPENDIX 6.1

Christians in the Piazzuola beneath San Sebastiano

Mancini's way of characterizing the epigraphy in the Piazzuola (Figure 6.63), namely that it reflects "un sapore christianeggiante," is appropriate not just for selected inscriptions but also for parts of the iconography in this inscrutable place; see G. Mancini, *NSc* 320 (1923), 3ff. The Piazzuola is a sunken, oval courtyard (Figure 6.64). It is sandwiched archaeologically between the Arenarium (pozzolana quarry) below and the Memoria Apostolorum, the famous shrine of Peter and Paul above. Thus, the Piazzuola constitutes level 2 of subterranean San Sebastiano (beneath the Basilica's south-central nave). Interments may have begun in the Piazzuola early in the second century, and it is possible that some of them, even at this early date, could have been Christian, but the evidence is far from clear. Interpretation of material culture in the Piazzuola is not an easy matter, and even at this late date in the study of subterranean San Sebastiano there is still no consensus.

The problem is the evidence itself. True, there is a lot of it, but it is fragmentary and riddled with discontinuities in both kinds: synchronic and diachronic. From roughly 100 to 250 the Piazzuola was a sunken, open-air courtyard on the Appia Antica—it was always a funerary place and evidently always open to the public. The Piazzuola was also quite clearly subject to dramatic material changes over the short span of its life. The material evidence in the Piazzuola is of four kinds: architectonic (construction history of the site), architectural (Mausolea a, i, and h on the northwest perimeter of the Piazzuola), epigraphic, and iconographic. The latter two are especially important for the evaluation of a putative Christian presence in the Piazzuola. Based on character of both the Piazzuola epigraphy and iconography, most investigators have drawn two conclusions:

1. There were Christians in the Piazzuola.
2. They were not orthodox.

The first conclusion is justified, but the second, in my view, is not; cf. P. C. Finney, *Numen* Suppl. 41.1 (1980), 447–50.

A word about archaeological context. The lower and upper dates of the Piazzuola can be fixed approximately. The *terminus a quo*, based on *ICVR* 5.12905 (*titulus* of Marcus Ulpius Calocerus, *libertus* or son of a *liberatus* under Trajan) is late first or early second century and the *terminus ad quem* (based on dipinti in Tomb i dating to the years 238–244) is mid to late third century; for the Piazzuola inscriptional evidence, see Mancini, *NSc* 320 (1923), 3f. The floor of the oval courtyard (Co) was laid up in the late first or early second centuries (after the quarrying of the Arenarium ceased), and the three mausolea on its north-northwest perimeter were

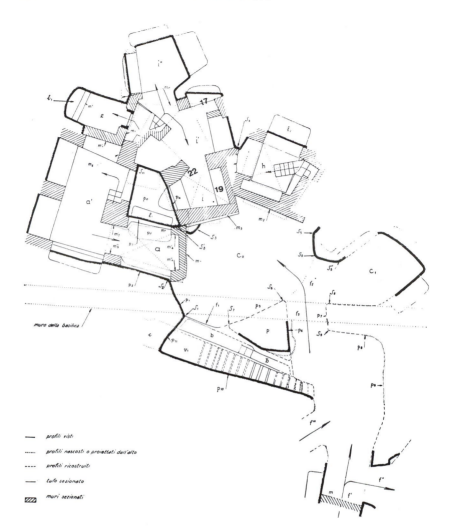

Figure 6.63. Piazzuola. Plan. *Rome, San Sebastiano.*

constructed during the first half of the century. The long stairway (P[10]) on the south side of the courtyard belongs to level 1 (the pre-Trajanic Arenarium), when the site was still being quarried for pozzolana—the Arenarium was probably opened up in the Augustan period. Like the long stairway, the large dromos (f') to the southeast is also a feature of this first occupational phase. The interments cut into the east and southeast wall of the Piazzuola courtyard are very likely transitional (this includes the loculus marked by the Atimetus *titulus* [Figure 6.65] and the loculus sealed by the Ankotia Irene *titulus* [Figure 6.66]—burials in this part of the

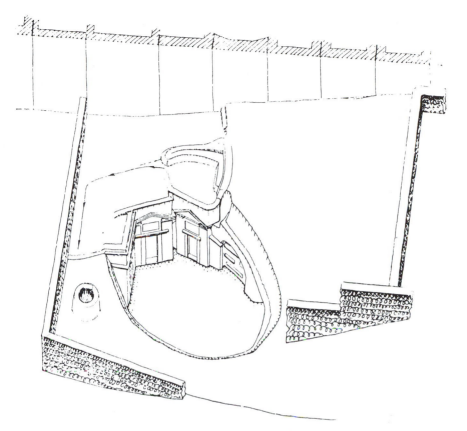

Figure 6.64. Piazzuola. Axionometric reconstruction.

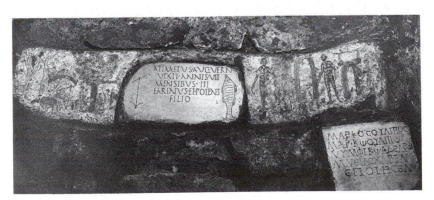

Figure 6.65. Piazzuola. Marble *titulus*. *ICVR* V.12892. Evidently introduced as a secondary feature into the center of a loculus, whose plaster sealant is painted with scenes that have not been identified.

233

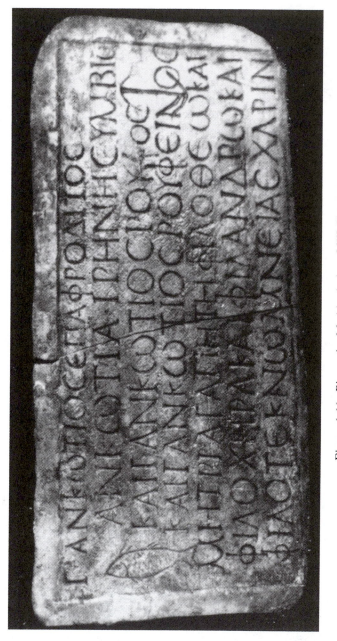

Figure 6.66. Piazzuola. Marble titulus. *ICVR* V.12900.

courtyard may have begun during the first phase of occupancy and continued into the second.

Overall within level 2, only one bit of evidence proves a Christian presence in the Piazzuola, namely in the upper chamber of Tomb i, *ICVR* 5.12889: ΙΤΧΘΥΣ (Figure 6.67). This is no hapax—ΙΧΤΘΥΣ at Kánatha (el Qanawat; coordinates 302.242: see *Qedem* 5 [1976] s.v) is well known and much discussed (Dölger, ΙΧΘΥΣ 1:12* = no. 89; 5:702, n. 23). Admittedly, the tau (Τ) inserted between the first and third letters is anomalous, but this is hardly a basis for interpreting the familiar acronym-acrostic as anything other than Christian. Paul Styger's denial of its Christian character (*Die römischen Katakomben* [Berlin, 1933], 339; *Römische Märtyrergrüfte* 1 [Berlin, 1935], 41) is perverse and desperate.

On tau symbolism: E. Dinkler, *JbAC* 5 (1962), 93–112; *ZTK* 48 (1951), 148–72, and 62 (1965), 1–20—in fact, the cruciform tau prompts what I regard as legitimate speculation that the letter may have been inserted into the acronym-acrostic not by accident, but instead by design, as an intended allusion to Christian crucifixion soteriology. The graffito was found scratched into the mortar (whether wet or dry has never been determined) in the upper level of Mausoleum i; see Mancini, *NSc* 320 (1923), Tav. III.2.22 (here: Figure 6.63, no. 22). When it was executed is a matter of conjecture, but obviously it must date sometime after the mausoleum was built (circa 125–150) and before the Piazzuola was filled in (circa 250–275) to make room for the construction of the Christian shrine that was situated above Mausolea a, i, and h.

Three of the inscriptions found on Level 2 are accompanied by incised images of a fish and an anchor:

ANCOTIAE·AUXESI
ANCOTIVS·EPAPHROD (ITVS)
ET·ANCOTIA·IRENE
PARENTES
B·M·F
ICVR 5.12891 (Figure 6.68)

Figure 6.67. Piazzuola. Findspot: Tomb i; cf. plan in Figure 6.63, no. 22. Graffito. *ICVR* V.12889. Fish acronym/acrostic.

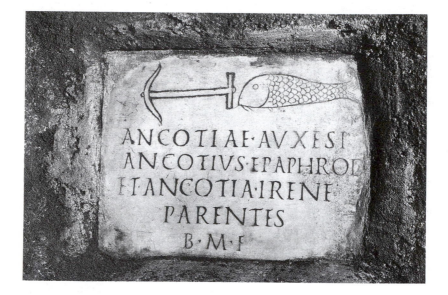

Figure 6.68. Piazzuola. Marble *titulus*. *ICVR* V.12891.

ATIMETVS·AVG·VERN (A)
VIXIT·ANNIS·VIII
MENSIBVS·III
EARINVS·ET·POTENS
FILIO

ICVR 5.12892 (Figure 6.65)

Γ·ΑΝΚωΤΙΟΣΕΠΑΦΡΟΔΙΤΟΣ
ΑΝΚωΤΙΑ·ΙΡΗΝΗ·ΣΥΜΒΙ
ΚΑΙΓ·ΑΝΚωΤΙΟΣΡΟΥΦΟΣ
ΚΑΙΓ·ΑΝΚωΤΙΟΣΡΟΥΦΕΙΝΟΣ
ΜΗΤΡΙΑΓΑΠΗΤΗΦΙΛΟΘΕωΚΑΙ
ΦΙΛΟΧΗΡΑΚΑΙΦΙΛΑΝΔΡω·ΚΑΙ
ΦΙΛΟΤΕΚΝωΜΝΕΙΑΣΧΑΡΙΝ

Transcription:

Γ. Ἀνκώτιος Ἐπαφρόδιτος
Ἀνκωτία Ἰρήνη συμβίῳ
χαὶ Γ. Ἀνκώτιος Ροῦφος
χαὶ Γ. Ἀνκώτιος Ρουφεῖνος
μητρὶ ἀγαπητῇ φιλοθέῳ καὶ
φιλοχήρᾳ χαὶ φιλάνδρῳ καὶ
φιλοτέχνῳ μνείας χ[[ά]]ριν
 ICVR 5.12900 (Figure 6.66)

For the combination of fish and anchor, there are many epigraphic parallels, for example, *ICVR* 2, Tab. XXXII; 3, Tab. VIII, X; 4, Tab. X, XIII, XVI, XXVII; 5, Tab. XI, XVI, XXIV, XXVII, XXXII. Anchors and fishes are also extremely common in other early Christian contexts, for example on intaglios (Figure 6.69; for discussion and literature, see my *Catalogue of Late Antique and Early Byzantine Intaglios in the British Museum*, forthcoming). On strictly linguistic grounds, neither *ICVR* 5.12891 or 12892 requires a Christian interpretation, nor *sensu stricto* does *ICVR* 5.12900; however, the four epithets (φιλόθεος, φιλοχήρα, φίλανδρος, φιλότεκνος [on the latter see *CIJ* 321, 363, 541]) attributed to Ankotia Irene are certainly suggestive, perhaps especially φιλοχήρα, which may be a Christian neologism; see F. Grossi Gondi, *Trattato di Epigrafia Cristiana . . .* (Rome, 1920), 175; also *Supplementum Epigraphicum Graecum* 2.521.6; *Apostolic Constitutions* 2.4.1, 2.50.1. The other three epithets are widely attested in pre-Christian and non-Christian contexts. As for fishes and anchors, which often accompany Christian epigraphic usages, alone they cannot be construed as constituting irrefutable proof; thus: P. Bruun, *AIRF* I.2 (1963), s.v. "Ancora" and "Piscis."

In the Piazzuola there is a good deal more inscriptional evidence which might be drawn in to support the theory of a Christian presence.

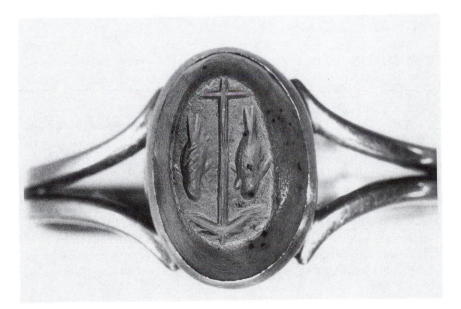

Figure 6.69. Oval cornelian mounted in a bezel. *London. The British Museum.* MLA Reg. no. 86, 8–30, 4.

One would certainly want to include the charming dedication to little Theonoe:

ΕΝΘΑΔΑΠΟ
ΚΕΙΤΑΙ ΘΕΟ
ΝΟΗ ΠΑΙΣ ΕΥΣ
ΕΒΗΣ ΠΡΑΕΙΑ
ΣΕΜΝΗ ΚΑΙ ΚΑ
ΛΗ ΣΟΦΗΤΕ ΑΜΑ
ICVR 5.12902

And the *titulus* found in Tomb i and offered by her parents to "the most god-loving" (θεοφιλεστάτη) Julia Krispa (A. Ferrua, *RivAC* 21 [1944–1945], 204; no. 7 can also be drawn into this discussion:

’Ι (ούλιος) Ἄλκιμος καὶ τορευμάτι (α?),
’Ι (ουλία) κρίσπη, θυγατρὶ θεοφιλεστάτη,
μνήμνης χάριν, θ (εοῖς?) δ (αιμοσιν?)

So can the fragmentary dedication ([?] ΚΕΙΤΑΙ ΠΑΡΘΕΗΟΣ) to an unnamed *Parthenos*, *ICVR* 5.12903.

In his erudite and ingenious (though broadly unconvincing) *De Pythagore aux Apôtres* (Paris, 1956), 356–57, Jérôme Carcopino convinced himself that Theonoe's parents professed a kind of philosophical Christianity ("ses parents professaient une manière de christianisme philosophique . . . l'épitaphe de la petite morte a été rédigée par un chrétien"). Here Carcopino was echoing Cecchelli, who viewed the epitaph as "un documento de paganesimo mistico . . . siamo dunque in un clima di alta spiritualità"; see C. Cecchelli, *Manumenti cristiano eretici di Roma* (Rome, 1944), 191, 192. But for a more sensible approach, see A. Ferrua, "Questioni di epigrafia eretica romana," *RivAC* 21 (1944–1945), 205. In point of fact, the choice of the girl's name proves nothing about the parents' religious or philosophical inclinations.

As for Ankotia Irene, whose epitaph was deposited at a rock-cut subdial loculus on the problematic southeast wall of the Piazzuola just sightly north of Theonoe's *titulus*, Carcopino convinced himself that the honoranda had been a schismatic Jewish-Christian sectarian, either an Ebionite or a Nazarean—for Carcopino her care of infants and of the elderly in conjunction with her commitment to a life of poverty earmarked the lady among the "Franciscains avant la lettre" (Carcopino, *De Pythagore*, 358, 359).

Carcopino invoked a similar freewheeling, associative method for interpreting the intriguing red dipinto found in Tomb i (see plan Figure 6.63, Tomb i, no. 19):

μανης παυλα ετ Ξανθιας
τουε παρ κυει (ε)δ Αδουδας ματρει συε φηκηρουν
νως

ICVR 5.12896 (Figure 6.70)

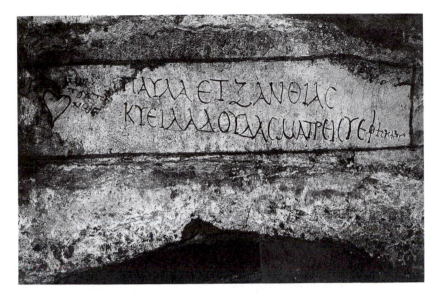

Figure 6.70. Piazzuola. Tomb i. Dipinto. *ICVR* V.12896. *Rome, San Sebastiano.*

The dedicants, Paula and Xanthias, he argued, were "probably" Levantine Jews, but it is "certain" (*sûr*) that they had "secoué le joug de la synagogue pour entrer dans un cercle des païens où brillaient des doux rayons d'espérance et de charité chrétiennes" (Carcopino, *De Pythagore*, 344, 345). Cecchelli, *Monumenti*, 187, convinced himself that this inscription was "tipicamente orientale" and that the world it evokes consisted in "un gruppo d'indovine orientali . . . in questa zona c'erano veramente dei gruppi mistici che non ritenevano repellente la vicinanza di elementi cristiani." Carcopino also commented in an erudite manner on the relationship between (e)d Adoudas and Hadad, the west Semitic storm god known from Ras Shamra. In reality, however, *ICVR* 5.12896 can be best explained as the recording of a rather banal event, one that has nothing to do with fortune-tellers, oriental mysticism, or Ras Shamra. The inscription (Greek orthography rendering Vulgar Latin) attests the making (and presumed deposit) of a pot/jug/urn/jar (dûḏâ/'âḏûḏâ (ܐܕܘܕܐ/ܐܕܘܕ / דוד)) for the mother of the two dedicants, thus: "Paulus et Xanthias qui(dam) doudas (uidelicet ollam) matri su(a)e fecerunt."

In sum, Carcopino's and Cecchelli's reconstructions of the Piazzuola epigraphy highlight one very important point: overall the evidence in this place is sufficiently ambiguous and the archaeological context sufficiently fluid to make the inscriptions speak for a wide range of imaginative schemes, some more farfetched than others, none of them verifiable with any degree of certainty. On the question of a Christian presence in this place, based on the epigraphic evidence and excluding the fish acronym-acrostic, there is nothing here that can be reasonably classified as certain

and very little that falls even within the realm of probability. Carcopino and Cecchelli were guilty of broad speculations at this site, as they were of overintellectualizing the evidence, the same criticism that Nock directed at Cumont in the latter's interpretation of Roman Imperial funerary symbolism; (cf. A. D. Nock, *AJA* 50 [1946], 140–70). A great deal more could be said about the Piazzuola inscriptional evidence and its putative Christian testimony, but in the end Mancini's "sapore cristianeggiante" is still the best brief summary of this complicated puzzle. To be sure, more can be (and has been) claimed, but only with very great difficulty.

Essentially the same is true for the pictorial subjects that are found in the Piazzuola. On the interior of Tomb i, at the first landing of the main stairway that descends to the inner chamber, over the lower doorway there is a splendid scalloped conch (Figure 6.71) decorated with stalks of ivy, acanthus, and lotus leaves, all finely executed in plaster relief. In the center of the conch, executed in low relief, is the image of a peacock facing front, tail coverts erect and shaped in the form of a nimbus that encloses the head and torso of the animal; both the conch and the peacock could be harmonized with Christian intentions, although both are equally at home in pagan contexts.

The interior of Tomb h shows well-executed frescoes including several splendid bird and flower-fruit sequences, a plump and rather Italianate Gorgoneion, a prothesis and a seated figure surrounded by standing figures—each of the latter three subjects is enclosed within its own painted *clipeus*. A fourth painted scene in h shows a standing figure dressed

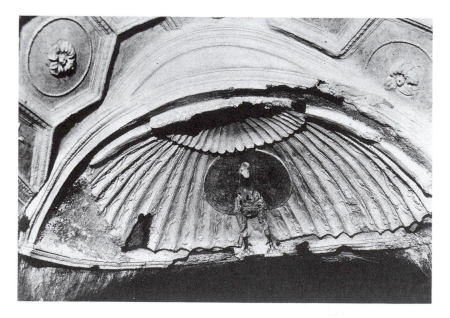

Figure 6.71. Piazzuola. Tomb i. Plaster conch.

in a short tunic and a red chlamys and enclosed within an octagonal frame (Hermes Psychopompos?). But none of the subjects on the interior of Tomb h points in a direction that even evokes, much less requires, a Christian interpretation.

For the latter, the best iconographic evidence is found on the exterior of Tomb h, on its attic above the pedimented brick facade (Figure 6.72). Directly above the apex of the tympanum is a group of standing figures dressed in tunics and mantles (Figure 6.73). Left of center there are grazing sheep and goats, a shepherd-*kriophoros* (Figure 6.74), the animal sitting high on his shoulders, and in the upper far left (west) corner we see two standing figures in short tunics, their arms extended toward the shepherd; they appear to be moving rapidly toward him. Right of center there are four sigma meals (Figure 6.75)—the symposiasts' Nilotic pygmylike visages peer over the sigmas. Two of the latter set off large two-handled kraters (Dölger, ΙΧΘΥΣ 5:513, "Weinkrater"). Below right, to the right of the sigma closest to the center of the attic, there is a group of standing figures moving left and carrying baskets of round breads (Mancini, *NSc* 320 [1923], 53: "una teoria di inservienti vestiti di tunica esomide, e portanti sulle spalle ciascune un cesto vimineo colmo di pani"). And on the very far right edge of the attic's front face there is a group of four standing figures; one of the four, the large figure, appears to be in the foreground (Figure 6.76). The beard that Mancini saw is no longer visible, but otherwise his description is accurate: "Quello che è sul davanti, messo in maggiore evidenze, alto e aitante, è barbato e vestito di tunica e di manto" (Mancini, *NSc* 320 [1923], 53). The figure to the far right of this foursome straddles the corner where the south face of the attic connects with the flanking east face.

On this east lateral face of the attic we see a group of animals, evidently pigs; the torsos of the three or four of them are positioned vertically as if they were falling downward across the face of the east attic (Figure 6.77). In the upper right, one of the pigs is positioned on a horizontal plane and is shown moving—this animal appears to be isolated from the others. Left of center there is a standing figure facing left, arms outstretched (possibly gesticulating to the group just mentioned at the far right of the front face), holding an unidentified object. This is possibly the swineherd (Mancini, *NSc* 320 [1923], 53: "la figura di un servo o pastore in atto di salire sulla destra; è vestito di tunica esomide e porta une specie di bracciale al polso sinistro. Il braccio destro è alzato con la mano tesa; il sinistro è disteso e sembra con la mano reggere un bastone"). More than one commentator has wanted to connect this scene with Mk 5:1–20 par. (the healing of the Gerasene demoniac), a theory that cannot be proved or disproved but is certainly an interesting possibility.

In summary, depending largely on which presuppositions are put into play, one can point the Piazzuola evidence in several different directions. Nothing forbids a Christian interpretation of selected *tituli* or of the iconography on the attic of Tomb h, nor (excepting the fish acronym-acrostic)

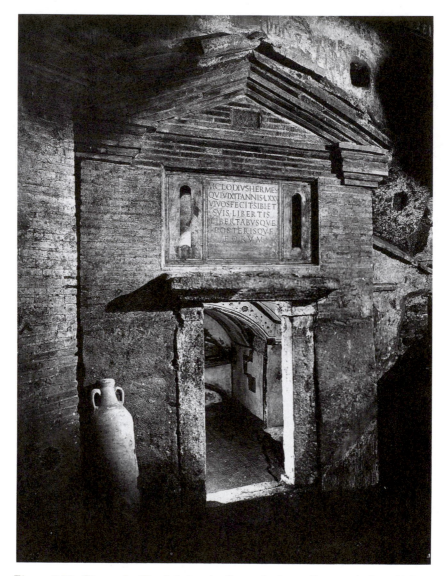

Figure 6.72. Piazzuola. Tomb h facade. Beneath the pediment: titulus of M. Clodius Hermes.

does anything require it. The evidence here is clearly more suggestive than demonstrative of a Christian presence, but in one respect a firm conclusion is justified. This conclusion I would base on the the pattern of deposited evidence rather than on individual pieces. What this pattern suggests is that if there were Christians present in the Piazzuola they were here very likely on an individual basis, as isolated dedicants, donors, or

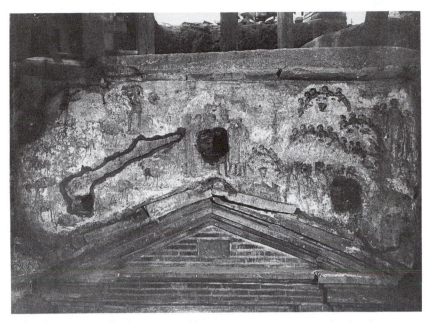

Figure 6.73. Piazzuola. Attic front face above Tomb. h.

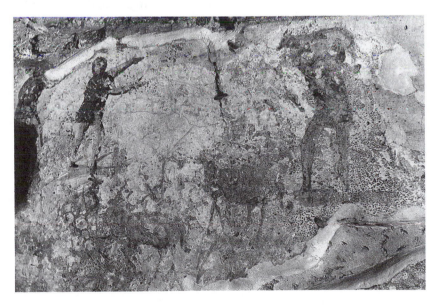

Figure 6.74. Piazzuola. Attic front face of Tomb h, upper left corner.

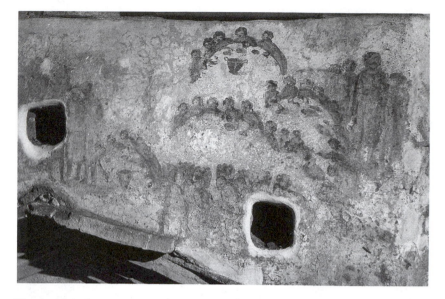

Figure 6.75. Piazzuola. Attic front face of Tomb h, right of center.

honorandi, but not as members an *ekklesia* that had laid claim to this site. There is too much discontinuity here to allow the inference of an *ekklesia* or the kind of communitarian control that is conspicuous, for example, in the oldest Christian nuclei at Callistus. To be sure, Tombs a, i, and h imply groups of people, possibly even funerary colleges (especially likely in the case of Tomb i), but none of these three groups looks Christian. As for the subdial interments in the rock facing of the oval courtyard, as we have seen, on epigraphic grounds some of these could be construed in the light of Christian ideology, but again there is scarcely sufficient cumulative evidence to suggest the presence of an *ekklesia*.

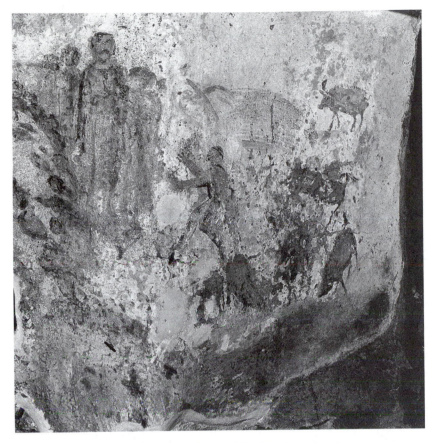

Figure 6.76. Piazzuola. Attic front face of Tomb h, far right of center.

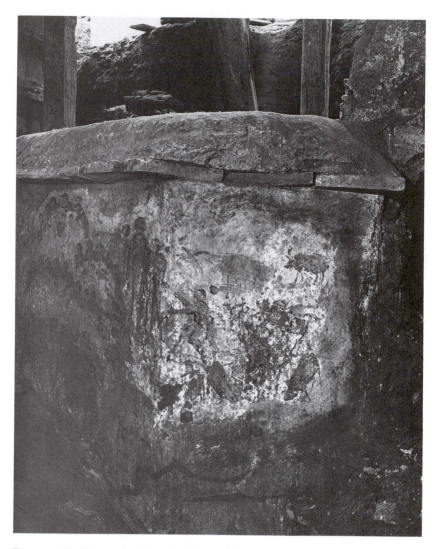

Figure 6.77. Piazzuola. Attic, right lateral face of Tomb h.

APPENDIX 6.2

Painting in the Randanini and Torlonia Catacombs

Between the years 1602 and 1919, six Roman sites (Monteverde Nuovo, Vigna Randanini, Vigna Cimarra, Via Labicana, Via Appia Pignatelli, and Villa Torlonia; for four of the six, see Figure 6.1, nos. 12, 22, 40, 59) were discovered and identified as places containing Jewish interments from the Imperial period—five of these six can be legitimately identified as Jewish; see L. Rutgers, *JbAC* 33 (1990), 140, n. 7 (Rutgers observes correctly that the catacomb in the Appia Pignatelli published by N. Müller, *RM* 1 [1886], 49–56, cannot be called Jewish).

At three sites (Monteverde, Randinini, Torlonia), archaeological reports indicate the presence of wall and ceiling fresco painting, but only at Randanini and Torlonia can these reports be confirmed. Bosio, *RS* 1:143, reported that in 1602 he had seen a painted menorah in the Monteverde catacomb, but the reliability of this report is in question. At Randanini and Torlonia, by contrast, we have a few surviving fresco fragments, although one must admit that, by contrast with the contemporaneous Christian evidence, the extent of surviving Jewish fresco evidence is very modest indeed. Torlonia was excavated to its full extent (preliminary excavation report: R. Paribeni, *NSc* 17 [1920], 143–55) in 1919, the year of its discovery, but Randanini, discovered in 1859, still contains unexcavated sectors. This latter fact has at least four important consequences:

1. The construction history of Randanini cannot be written.
2. The full extent of the complex is unknown.
3. Its material relationship to circumambient funerary installations (both Christian and pagan) is unknown.
4. It is possible that there is more fresco painting (along with other material culture) still preserved within the unexcavated sectors.

Four Randanini cubicula (Goodenough's Painted Rooms I–IV: Goodenough, *Symbols* 2:14–33, 3:737–62) contain wall and ceiling frescoes, three of them at the western end of the complex, one at its eastern end. Architectonically, the Randanini duplex (Painted Rooms I and II) is twice paralleled in Callistus, namely in Area I, cubiculum L1 see (Figures 6.2, 6.3), and in Reekmans's hypogeum alpha, duplex X/Y see (Figures 6.4, 6.5). The decorative ensemble within this Randanini duplex is also paralleled several times over at Callistus in the areas we have already surveyed.

The painting in the Randanini duplex consists in white-ground ceilings and walls overlaid with the familiar red and green linear frames. The rectangular ceiling in the outer room (Painted Room I) consists in a central medallion (Figure 6.78) enclosing eight elliptical line segments attached to the inner side of the central circle. Ringing the central medallion are

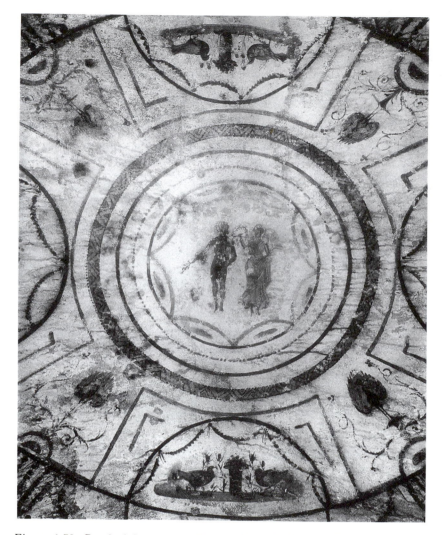

Figure 6.78. Randanini catacomb. Painted Room I. Ceiling. *Rome.*

three concentric bands, the innermost a thin broken line (probably intended as a garland), the middle one thin and continuous, the outermost band broader and marked with a herringbone pattern. Farther out from the center, there is yet another thin concentric band, which marks the outer limit of the first and only annular field. Within the latter, there are four symmetrically arranged lunettes enclosed within quasi-trapezoidal segments and set off by flanking gamma brackets; this conjunction of lunettes within linear segments resembling trapezoids is paralleled in the Callistus ceilings, Area I, A2 (Figures 6.8, 6.9) and L2 (Figure 6.6: with variations). In the ceiling of Area I, A4 (Figures 6.12, 6.13), the large annular zone

surrounding the central medallion is divided into four linear segments resembling trapezoids; these parallel quite closely their counterparts on the ceiling of Painted Room I in Randanini. The linear ceiling frames of Painted Room I continue out to the rectangular perimeter; there are quarter-circle segments at the four ceiling corners, the banded lunettes are continued to the outer perimeter, a medallion flanks each lunette, and where the ceiling intersects the wall there is a banded border.

In Painted Room II at Randanini, the linear ceiling frames (Figure 6.79) have a close parallel in the ceiling of cubiculum C (Figures 6.18, 6.19) situated in Reekmans' Hypogeum beta. In point of fact, overall the parallels in linear frames between the ceilings of the Randanini duplex and the corresponding zones that we have surveyed at Callistus are quite compelling. Since these compositional frames speak primarily to the identity of *officinae*, not of patrons, we are led to conclude that the workshop traditions (and perhaps the workshops themselves) behind Randanini Painted Rooms I and II and the Callistus cubicula were very close in time, place, and status: Severan Rome, middle to lower end of the funerary fresco market.

The iconographic similarities are also close: birds (peacocks, doves?, ducks?), vases nestled on floreated brackets, flower sprays, garlands, hippocampi, and, in Painted Room II, continuous rows of dentilations or embroidery borders on the outer side of the central medallion, on the inner side of the banded frame enclosing the large annular zone surrounding the central medallion, on the outer side of four lunette frames, and on the outer side of the four quarter circles at the corners of the ceiling—these dentilations have conspicuous parallels in Callistus Area I, ceiling A4 (Figures 6.12, 6.13), and in Reekmans' Hypogeum beta, ceiling C (Figures 6.18, 6.19; cf. line drawings of dentilation types at Figure 6.28).

But there are two very significant iconographic differences between the Callistus ceilings and those in the Randanini duplex, and these two happen to appear at the most important place of the two rooms overall, namely at the central apex of the ceiling. In Painted Room I (Figure 6.78), we see two standing figures facing front, the one to the left evidently a naked male holding a flower spray in his right hand, the other a winged female (probably Nike) dressed in a long-flowing, loosely fitted, sleeveless chiton belted at the waist; in her left hand she holds a palm frond, and her raised right hand a wreath (which perhaps she is raising to place on the head of her companion). And in Painted Room II, the central medallion (Figure 6.79) circumscribes a square frame within which we see the same female figure—this time her head is veiled and she carries a cornucopia nestled in her left arm. By derivation, these are traditional Greco-Roman images; what they are intended to convey in this Jewish place, or how their presence is otherwise to be explained, are matters for speculation. Goodenough's brand of the latter (Randanini confirms the existence of a mystical, Hellenized, nonnormative [contra G. F. Moore] Judaism) need not detain us here: a new approach is long overdue.

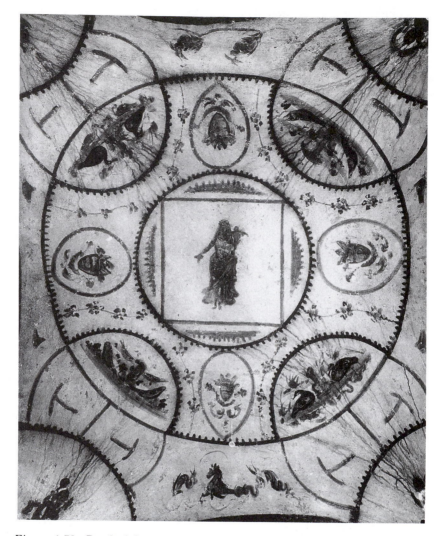

Figure 6.79. Randanini catacomb. Painted Room II. Ceiling.

The same sort of iconography we encounter on the ceilings of the Randanini duplex continues (as one would expect) on the walls of the two chambers. The splendid north wall (Figure 6.80) of Painted Room I, exhibiting both horizontal and vertical tripartition, is pierced by the void of the doorway at its center and framed by panels right and left enclosing opposing peacocks in profile. The one to the left, facing right, is perched on an orb attached to a floreated bracket, and the bird in the panel right of the doorway, striding left on a groundline dotted with flowers, is a tour de force: lively, well proportioned, colorful, and appropriately haughty. On

the opposite south wall (Figure 6.81), similar painted panels flank the doorway and enclose opposing winged horses (Pegasus derivatives) that float free at the center of each panel.

On the east and west walls in Painted Room I, the main feature per wall is a large arcosolium (Figures 6.82, 6.83) set off left and right by flanking panels that frame opposing profile images of birds and a sheep. The corresponding surfaces in Painted Room II show a large arcosolium in the lower register and in the upper a robbed-out large loculus—the painted decoration includes garlands and opposing birds.

The north wall (Figure 6.84) of the inner chamber is largely destroyed. This is where Robert Eisler thought he saw Orpheus, but here (as elsewhere) Eisler was the victim of his own vivid imagination; see *JJA* 5 (1978), 6–15. In short, both rooms display devices that point to an iconography best described as the Greco-Roman lingua franca (generic and broadly conceived). This iconography is the backbone of Romano-Campanian funerary painting. There is nothing here that requires a Jewish interpetation. The *officina* employed here propounded exactly the same sorts of linear compositional frames and iconographic fillers we encounter in the oldest nuclei at Callistus. It is unreasonable and irrational to debate the "Jewishness" of the Randanini Painted Rooms I and II: Judaism is conspicuous here by its absence.

The same is true for the decoration of Randanini Painted Room III—

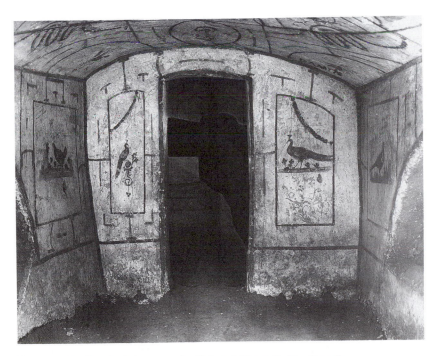

Figure 6.80. Randanini catacomb. Painted Room I. North wall.

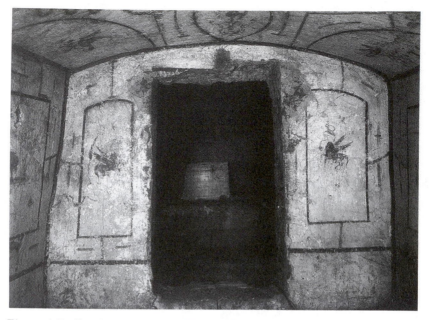

Figure 6.81. Randanini catacomb. Painted Room I. South wall.

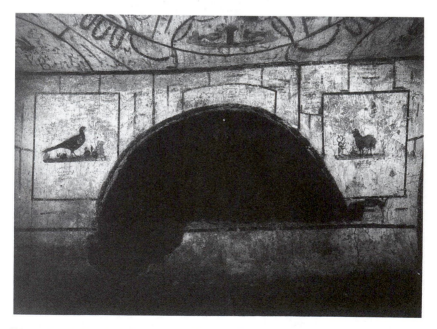

Figure 6.82. Randanini catacomb. Painted Room I. West wall.

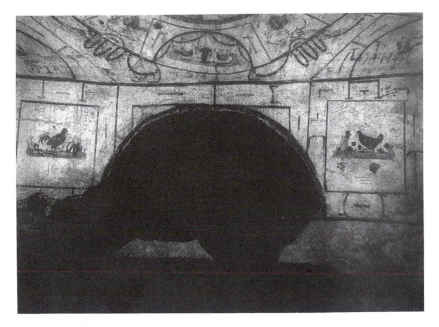

Figure 6.83. Randanini catacomb. Painted Room I. East wall.

at its earliest the painting here dates from the Tetrarchic-Constantinian period, several generations later than the Severan decoration in Painted Rooms I and II. The ceiling of Painted Room III does not survive. Where fragments of the wall painting are still extant (Figure 6.85), the incrustation style (imitating slabs of marble) is conspicuous as a kind of painted dado. On the south wall of the chamber, the west upper register shows a large *kantharos* with plants emerging from its mouth. And in each of the four corners of the room a date palm (see S. Fine, *JSP* 4 [1989], 105–18) snakes its way from floor to ceiling.

On the north wall of Painted Room IV directly above a large arcosolium burial, a painted red menorah (Goodenough, *Symbols* 3:761) is conspicuous. Images of an ethrog, one each per corner quarter circle were once visible on the ceiling of this chamber, or so we are told (Goodenough, *Symbols* 2:21). Ethrogim are no longer visible. Otherwise, excepting the painted menorah and the now invisible ethrogim, Painted Room IV is devoid of Jewish devices.

Overall, the Randanini complex reveals scarcely any evidence of a pictorial tradition shaped by Jewish persons, things, ideas, and events. As for the first of these four, there is no iconography in Randanini to suggest the existence of a Jewish figural tradition. It is only the menorah in Painted Room IV that gives the place any iconographic distinction. One can construe this fact in several ways. A long list of scholars (Garrucci, Frey, Leclercq, Goodenough, Leon, and, most recently, Rutgers; cita-

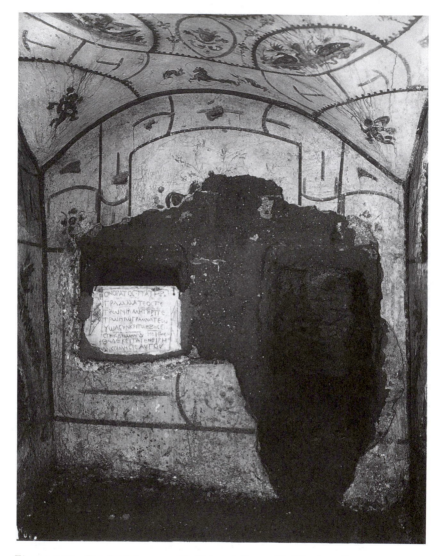

Figure 6.84. Randanini catacomb. Painted Room II. North wall.

tions apud Rutgers, *JbAC* 33 [1990] has already done so, but until the
construction history of the site and its relationship to the other subterra-
nean funerary installations in the region are clarified, it seems to me
pointless to add yet another layer of speculation. The best that can be
achieved at present is to describe the condition of the site and conclude
what is evident to the naked eye: in its present condition of preservation,
this burial complex exhibits a form of fresco painting that is best described
as neutral-generic, the stock-in-trade of third- and fourth-century
Romano-Campanian funerary painting. There is no Jewish figural tradi-

tion at work here and scarcely any other iconographic hints pointing to Judaism.

I hasten to add that the Randanini complex is potentially a place of considerable importance for the study of Roman Jewry in the period of the middle and later Empire, and hence in order to clarify what was going on here, it would be a great service to scholarship if the entire complex were excavated carefully to its full extent and were republished according to contemporary standards of catacomb research. Without new excavation

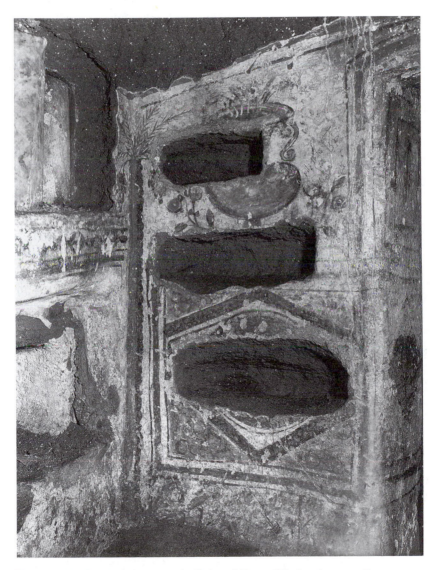

Figure 6.85. Randanini catacomb. Painted Room III. Southeast wall.

and a meticulous reexamination of the already extant evidence (including sarcophagus fragments and epigraphy), it will remain impossible in my view to draw reliable inferences from this fascinating site.

Torlonia and its paintings are better understood than Randanini. This is largely thanks to the basic publication introducing the Torlonia evidence: H. W. Beyer and H. Lietzmann, *Die Jüdische Katakombe der Villa Torlonia in Rom* (Berlin, 1930). This report exhibits all the virtues that the Randanini literature lacks, namely brevity, clarity, simplicity, and accuracy. It would be pointless to rehearse the descriptive passages contained in this volume—the reader can easily locate find spots and other pertinent details in Beyer and Lietzmann. My only purpose here is to evaluate the Torlonia evidence in the light of the previously mentioned (Chapter 6, p. 230) generalization concerning Roman Jewish wall and ceiling painting.

On the upper level of the Torlonia catacomb (Figure 6.86), at its eastern end, cut into the east wall of dromos RU, there is one painted chamber (Beyer and Lietzmann: cubiculum II). Cut into the same gallery on its east and west walls there are two painted arcosolium double-interments (Beyer and Lietzmann: arcosolia III, IV). These three features, cubiculum II and in gallery RU arcosolia III and IV, contain virtually all of the evidence that is significant for an assessment of wall and ceiling painting in this underground cemetery.

The ceiling (Figure 6.87) of cubiculum II presents a concave white canopy overlaid with the familiar white and green nexus of linear frames. At the center and apex of this surface there is a central medallion with one close concentric band and two concentric bands farther out from the center. At the twelve, three, six, and nine o'clock positions there are double-banded half-circles (painted lunettes), and between the latter we see radiating elliptical bands that emanate on a perpendicular course from the periphery of the outermost of the centrally placed concentric circles. These radiating double bands connect with four medallions, each of them enclosed within a concentric frame. Unlike the ceiling in Callistus Area I, L2 (Figures 6.6, 6.7), the radiating bands here do not penetrate to the central medallion and hence, *sensu stricto*, this ceiling combines two compositional traditions: centralized-annular (out to the third concentric band enclosing the central medallion) and converging-transverse (to the outer perimeter of the ceiling).

As for iconography, the central medallion (Figure 6.88) encloses the familiar seven-branched lampstand (sometimes denominated candlestick or candelabrum; on the menorah in the Roman period [mainly diaspora, Greco-Roman evidence], see Goodenough, *Symbols* 13: s.v.; on the Near Eastern background: C. L. Meyers, in *ABD*, s.v. "Lampstand"). The four ceiling lunettes frame dolphins facing left and wound about tridents. And in the four medallions that attach to the radiating transversals, we see a shofar and three heart-shaped, triple-stemmed forms, possibly intended as ethrogim. The four corner medallions are framed by a spindly serpentine vine that originates at each of the ceiling's four corners. It is clear, in other

Figure 6.86. Torlonia catacomb. Plan. *Rome.*

words, that at the center of this ceiling, which is simultaneously the symbolic center of the room overall, the primary semeion is Jewish—the assertion of ethnic and religious identity in this place is beyond debate, although the specific symbolic content envisaged for the menorah is not.

The outer lunette of the east arcosolium in cubiculum II is completely destroyed as is 75 percent of the plaster face of the inner lunette (Figure 6.89): of the latter the only painted sequences that can be made out are the ridge and right face of a roof along with the pedimented upper front end of

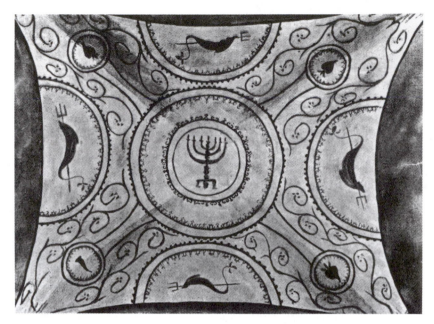

Figure 6.87. Torlonia catacomb. Cubiculum II. Ceiling.

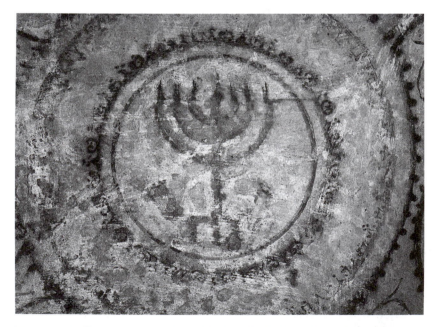

Figure 6.88. Torlonia catacomb. Cubiculum II. Ceiling. Central medallion.

258

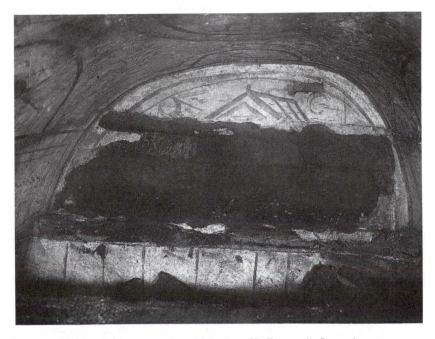

Figure 6.89. Torlonia catacomb. Cubiculum II. East wall. Inner lunette.

an unidentifiable structure. In the field to the right and left there are two sigma-shaped moons.

At the apex of the same arcosolium soffit, framed within a central medallion, there is a painted menorah (Figure 6.90), and the lateral soffit lunettes left and right show a fruit or a flower (Figure 6.91) on a leafy stalk and a scroll (Figure 6.92) rolled tight and depicted in horizontal profile. The embroidery borders (compare dentilations at Figure 6.28) that frame the central soffit medallion and its pendant lunettes are paralleled in the Callistus paintings surveyed earlier. On the north wall of this same cubiculum a second arcosolium soffit exhibits the same compositional and iconographic layout, except that a shofar appears within the left lateral lunette, and the same fruit (possibly a pomegranate) or flower on a leafy stalk appears on the opposite lateral face within the pendant half-circle.

South of cubiculum II, cut into the west wall of dromos RU, there is a double arcosolium (Beyer and Lietzmann: arcosolium IV; see plan at Figure 6.86) with its painted interior lunette (Figure 6.93) substantially intact. At the center of the lunette a pedimented *scrinium* is shown facing front; acroteria dot the upper pediment cornice and within the two-tiered enclosure scrolls are seen piled on end. The *scrinium* sits on a high stylobate decorated with diamonds and roundels. Left and right beyond the front jambs of the enclosure, lateral wings—the doors of the *scrinium*—flare open. A *parapetasma* frames the upper edge of the lunette. Left and

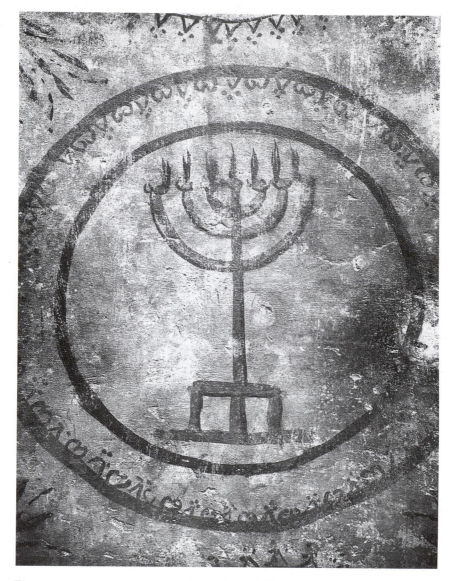

Figure 6.90. Torlonia catacomb. Cubiculum II. East wall. Arcosolium soffit. Central medallion.

right in the field above, a blazing sun and its pendant moon flank the *scrinium* front, and over the circular acroterium at the apex of the pediment there is an eight-pointed star. Left and right, sitting on the same plane as the *scrinium* stylobate, there are flanking menorot. And on this same plane, reading from left to right, we see a palm frond, a fruit or plant on a leafy stem, a two-handled, narrow-necked vessel with a stopper in its mouth, a

shofar, a knife in its sheath, and, at the far right end, an ethrog. This lunette ensemble presents a Torah shrine in a staged setting: front and center within the cosmos, surrounded by the paraphernalia of cult, we are presented with the central symbol of Jewish identity.

There are other sequences of wall and ceiling painting in Torlonia but nothing that adds substantially to the Judaism of the place. In composi-

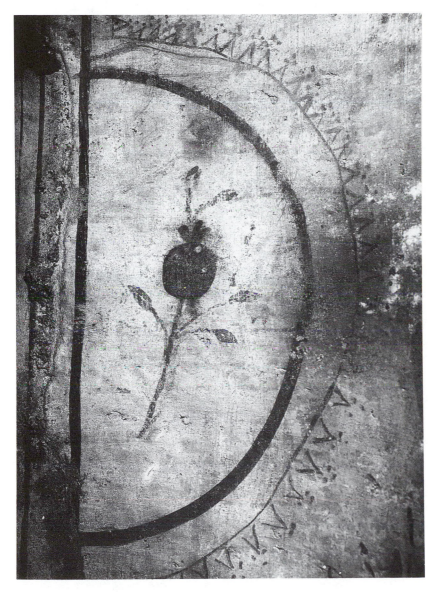

Figure 6.91. Torlonia catacomb. Cubiculum II. East wall. Arcosolium soffit. Left lateral soffit lunette.

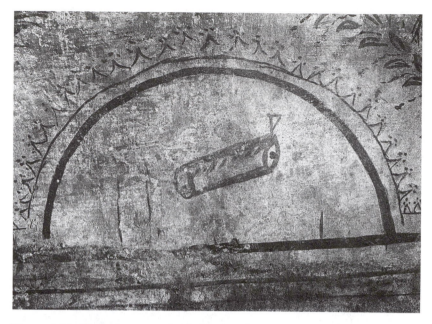

Figure 6.92. Torlonia catacomb. Cubiculum II. East wall. Arcosolium soffit. Right lateral soffit lunette.

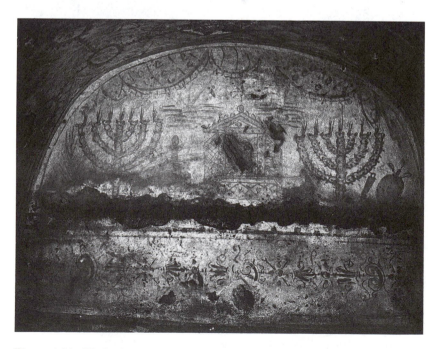

Figure 6.93. Torlonia catacomb. Dromos RU. Arcosolium IV. Inner lunette.

tional conception and iconographic quality, the painting at Torlonia is identical with the painting that survives in the oldest sectors of Callistus. The same is true of Painted Rooms I, II, and III in the Randanini complex. The same *officina* could have been employed in all three places. But at Callistus the journeymen wall painters struggled to bring forth plausible figural subjects, whereas at Randanini and Torlonia, no doubt in conformity with demands set by Jewish patrons, these same (or similar) *parietarii* were spared the embarrassment of displaying their incompetence as figure painters.

Notes

1. In Area I: chambers A1 (painting destroyed), A2, A3, A4, A5, A6, and L2. In hypogeum alpha: chambers X, Y, and C. In Area I the duplex cubiculum L1 (later the crypt of the popes) belongs to the earliest phase of excavation, but it was evidently not decorated with wall and ceiling paintings, probably due to the air well that pierces the barrel-vaulted ceiling (and which thus makes the preservation of frescoes in this place highly problematic); see J. Wilpert, *Die Papstgräber und die Cäciliengruft in der Katakombe des hl. Kallistus* (Freiburg, 1909). For an inventory of the surviving paintings in these oldest chambers within Callistus: A. Nestori, *Repertorio topografico delle pitture delle catacombe romane* (Vatican City, 1975), 99ff.

2. On the oldest nuclei within the Callistus catacomb: H. Brandenburg, *JbAC* 11–12 (1968–1969), 42–54; L. Reekmans, *La tombe du pape Corneille et sa region cémétériale* (Vatican City, 1964); idem, *Boreas* 7 (1984), 242ff. A useful inventory of the paintings in these regions: Nestori, *Repertorio*. On Callistus: Hipp. *Ref.* 9.12; Tert. *Pud.*; *LP* 17 (Duchesne 1.141–42). Still a useful introduction to the life of Callistus: I. Döllinger, *Hippolytus und Kallistus* (Regensburg, 1853), chap. 3; also H. Gülzow, *ZNW* 58 (1967), 102–21.

3. Chronology: L. Reekmans, *RivAC* 49 (1973), 271–91; idem, "Die Situation der Katakombenforschung in Rom," *Rh-Westf.Akad.Vort* G233 (Opladen, 1979); idem, *Boreas* 7 (1984), 242–60; also L. de Bruyne, *RivAC* 44 (1968), 81–113, and H. Brandenburg, "Photogrammetrische Bauaufnahme der Area I der Callistus-Katakombe in Rom," in *Photogrammetrie in der Architektur und Denkmalpflege* (Vienna, 1983), 171–80.

4. *Collegia funeratica, collegia tenuiorum:* J.-P. Waltzing, *Étude historique sur les corporations professionnelles chez les romains,* vol. 1 (Louvain, 1895), 141–53; vol. 4 (Louvain, 1900), 484ff.; and F. de Robertis, *Il diritto associativo romano* (Bari, 1938), 371ff.: Christians forming "collegia tenuiorum religionis causa"; also G. Bovini, *La proprietà ecclesiastica e la condizione giuridica della Chiesa in età precostantiniana* (Milan, 1949), 135ff.

5. Thus Tert., *Apol.* 39.6: Christian churches have a common treasury (*arca*) to which members contribute voluntarily; with the monies collected, they support and bury the poor ("egenis alendis humandisque"); cf. Just., I *Apol.* 14.2 (cf. 15.10–17): on "a common fund [koinon] for distribution to those in need."

6. On the relationship between language and material reality (based on the example of Min., *Oct.* 32.1), see my article in *Boreas* 7 (1984), 214–17.

7. On early Christian painting in the post-Severan period, see my Bibliography at *SC* 6.4 (1987–88), 213–16.

8. Much of Josef Wilpert's long and distinguished career was devoted to

defending a Rome-centered *Monumentaltheologie*. Rome he believed was the true omphalos of Christian art: it all began there, and all the regional manifestations were Roman by derivation. At *ZKT* 45 (1921), 337–69, Wilpert defended this thesis against Strzygowski; similar thoughts are found in *Studi Romani* 3 (1922), 14–34; he summarized his thoughts on this subject in *La fede della chiesa nascente seondo i monumenti dell'arte funeraria antica* (Rome, 1938). E. Weigand's criticism of Wilpert's Rome-centered obsession is still worth reading: *BZ* 41 (1941), 129–46.

9. Parties to the debate: D. V. Ainalov, *The Hellenistic Origins of Byzantine Art* (New Brunswick, N.J., 1961); C. R. Morey, *Early Christian Art*, 2d ed. (Princeton, 1953); J. Strzygowski, *Orient oder Rom* (Leipzig, 1901); idem, *Ursprung der christlichen Kirchenkunst* (Leipzig, 1920). For constructive critical comments, see O. Wulff, *RKW* 34 (1911), 281–314; 35 (1912), 193–240.

10. A columbarium (discovered 1950) with a Jonah cycle painted over an inhumation *a mensa;* cf. A. Nestori, *CIAC. Atti* 7 (1969), 637ff.; also A. Ferrua, *RivAC* 38 (1962), 21ff. Also Nestori, *Repertorio*, 81–82.

11. C. Carletti, *RivAC* 47 (1971), 99ff.; also A. Nestori, *Repertorio*, 8.

12. Best brief discussion: P. Testini, "Cimitile: Antichità Cristiana," in *L'art dans l'Italie Méridionale*, vol. 4, ed. É. Bertaux and A. Prandi (Rome, 1978), 163–76; also D. Korol, *JbAC* Ergbd. 13 (1987) (with the older literature cited).

13. U. M. Fasola, *RendPontAcc* 46 (1973–74) 187–224; idem, *Le catacombe di S. Gennaro a Capodimonte* (Rome, 1975); with P. Testini, *CIAC.Atti* 9.1 (1978), 132: "L'ipogeo con le prime pitture cristiane, tra cui la singolare scena tratta dal Pastore di Erma, è al livello superiore e un po' più tarda [i.e., after 200], ma sempre, crediamo, entro la prima metà del sec. III."

14. Four rock-cut tombs in the Wardian district, one (Tomb III) with paintings, discovered in 1960 and published by H. Riad, *BSRAA* 42 (1967), 89–96. The painting on the east wall of Tomb III shows a reclining male figure resting under a pergola. Christian interpretation: H. Brandenburg, *CIAC.Atti* 9.1 (1978), 342; J. Weitzmann-Fiedler, in *Age of Spirituality*, ed. K. Weitzmann (New York, 1979), no. 250; also A. Barbet, *Colloque historique et historographique. Clio* (Paris, 1980), 391–400. Pagan interpretation: M. S. Venit, *JARCE* 25 (1988), 71ff. Venit's presentation is valuable and well worth reading, but in my view the paintings in Tomb III are Severan, and the reclining figure is Jonah.

15. K. Weitzmann, *MüJb* 3–4 (1952–53), 96–120; idem, *Friend Festschrift* (1955), 112–31; idem, *AJA* 61 (1957), 183–86; idem *JbAC.Ergbd.* 1 (1964), 401–15; also Chapter 3, n. 3.

16. What I envisage here is an informal relationship between the *ekklesia* and its representative, analogous to the (formal) relationship between *mandator* and *mandatarius*, e.g. Iust., *Inst.* 3.26.1ff. (*de mandato*), or, perhaps even more appropriate, analogous to the *negotiorum gestio*, the informal relationship between principal and agent in which there was no contract; on the latter, see A Watson, *Contract of Mandate in Roman Law* (Oxford, 1961), 36ff.

17. Ergasteriarches/officinator: Vitr. 6.8.9; *CIL* 6.43, 44, 298, 1145, 2270, 9715 (*officinatrix*); 8.263c, 22644; 13.10036; 14.5308,27b; 15.1697, 7321; H. Bloch, *CP* 4 (1909), 193; also *AÉ* (1949), 130; cf. D. Mustilli, "Botteghe di scultori, marmorarii, bronzieri e caelatores in Pompei," *Pompeiana* (Naples, 1950), 206–29 (= *Biblioteca della parola del passato* 4).

18. The *institor*, understood as agent for the principal, could be slave or free, thus Ulp., *Dig.* 14.3.1; cf. W. V. Harris, *JRS* 70 (1980), 140–41: *institores* in the Roman pottery industry.

19. Iust., *Inst.* 3.15–21: verbal contract (*stipulatio*); 3.21: written contracts; also 3.22–29. On *stipulatio:* H. F. Jolowicz and B. Nicholas, *Historical Introduction to the Study of the Roman Law*, 3d ed. (Cambridge, 1972), 279ff.

20. Hipp., *Ref* 9.12.1ff.: Callistus had been an οἰκητής in the house of Carpophoros, a Christian man and himself either a slave or a *libertus*, probably of Marcus; cf. *CIL* 6.13040. Carpophoros entrusted Callistus with χρῆμα οὐκ ὀλίγον and instructed him to bring a return on the money (technically an *actio institoria;* on the money entrusted to Callistus as *peculium*, see H. Gülzow, *ZNW* 58 (1967), 105–07). According to Hippolytus, Callistus stole all the money. If there is any truth in this allegation, then despite his experience, Callistus' bad character would have made him a poor choice as agent for the people of the catacomb. Probably, however, this is another Hippolytan smear. Elsewhere (9.12.14) Hippolytus says that Zephyrinus put Callistus in charge εἰς τὸ κοιμητήριον, and *LP* 1.141 attests that Callistus "fecit alium cymiterium via Appia, ubi milti sacerdotes et martyres requiescunt, qui appellatur usque in hodiernum diem cymiterium Calisti." Responsibility for the creation of a new burial property along with the attendant administration of community funds would speak for the probity of Callistus' character.

21. On this subject, see Döllinger, *Hippolytus und Kallistus*, 115–96; also G. Bardy, *DHGE* 11 (1949), 421–24.

22. C. Nordenfalk, *Pantheon* 32 (1974), 225ff. (Cassiodorus' reference to pattern books), and C. Mango, *The Art of the Byzantine Empire 312–1453* (Englewood Cliffs, N.J., 1972), 137ff. (eighth century example); also H. L. Kessler, "L'antica basilica di San Pietro come fonte e ispirazione per la decorazione delle chiese medievali," in *Fragmenta picta*, ed. A. Ghidoli (Rome, 1990), 57: "Ciò sembrerebbe indicare che un libro di modelli sia servito da elemento di intermediazione tra i dipinti antichi e le due repliche del XII secolo. *La Vita Sancti Pancratii*, del' viii secolo, fa cenno a libri di modelli usati per la decorazione di chiese siciliane che svolgevano lo stesso programma iconografico di base delle basiliche romane, . . ."

23. *CIL* 3.802ff. = *Edictum Diocletiani de pretiis rerum venalium*, ed. Th. Mommsen, with commentary by H. Blümner, 2d ed. (Berlin, 1958) 7.8, 9, distinguishing daily wages to be paid to the journeyman wall painter from those to be paid to a figure painter: "[Picto]ri parietario u[t] supra diurni. . . septuagin[ta quinque]" (7.8); "[Pi]ctori imaginario ut supra diurni . . . centu quin[quaginta]" (7.9). Cf. H. von Petrikovits, "Die Spezializierung des römischen Handwerks," in *Das Handwerk in vor- und frühgeschichtlicher Zeit*, vol. 1, ed. H. Jahnkuhn et al. (Göttingen, 1981), 108: *pictor.*

24. From *tego;* at Var., *R* 3.2.9; Vitr. 7.3.10; also Petrikovits, "Die Spezializierung," s.v.

25. P. C. Finney, in *EEC*, s.v. (with the literature cited there); also still valuable: Rossi, *RS* 3.533–43.

26. H. Joyce, *The Decoration of Walls, Ceilings, and Floors in Italy in the Second and Third Centuries A.D.*, *Archaeologica 17* (Rome, 1981).

27. *Cic., Att.* 13.29.I(2). This kind of painting probably represents a wealthier (equestrian) clientele than the Callistus *officina* was accustomed to serve.

28. The growth factor is the key; cf. Chapter 5, n. 43.

29. G. Bovini, *Rassegna degli studi sulle Catacombe e sui cimiteri "sub divo,"* Collezione "Amici delle Catacombe" no. 18 (Rome, 1953).

30. On Callistus aboveground: Rossi, *RS* 3:557ff.; Reekmans, *Tombe.* For a

useful inventory of other subdial, early Christian cemeteries in Rome: P. Testini, *Le catacombe e gli antichi cimiteri cristiani in Roma* (Bologna, 1966), 83–122.

31. A very useful inventory of such devices on *tituli* in the Vatican: P. Bruun, *AIRF* I.2 (1963) 73–166.

32. The Greek term means racecourse or public thoroughfare and is perhaps a bit grandiose for the humble underground corridors of the earliest catacombs. Among the earliest Christian complexes, in the Domitilla catacomb (Figure 6.23a), the main corridor L (Figures 6.22 and 6.23b) of the Hypogeum of the Flavians has more the character of dromos than any of the other early third-century Christian galleries. Romans commonly called an underground corridor joined to a funerary room *crypta* or *crypta arenaria*, the latter designating a funerary complex built out of a previously existing pozzolana quarry. From the mid-third century, Christians were using the term *catacomb* to denote their underground burial places (from the toponym *ad katacumbas* or "near the hollow," a place on the Via Appia near the third milestone where the land dipped down probably due to the late Republican–Augustan pozzolana quarry [*arenarium*], which formed the nucleus of the Piazzuola beneath San Sebastiano); see P. C. Finney, in *EEC*, s.v. "Catacombs." Since *catacomb* and *crypt* are both generic and nondescriptive, I shall continue to employ dromos as the equivalent of gallery or corridor.

33. L, I(1): debouching in a well, I, C, and D belong to the first phase of construction. They were cut from the south to the north—i.e., from dromos B in the direction of A.

34. Containing the funerary *tabulae* of bishops Pontianus (d. 235), Anteros (d. 236), Fabianus (d. 250), Lucius (d. 254), Eutychianus (d. 283). LP 46 (Duchesne 1.234): Sixtus III placed a "platoma in cymiterio Calisti ubi conmemorans nomina episcoporum." This marble *tabula*, which Rossi believed he had found, must have been placed either in L1 or at its entrance; see P. Styger, *Die römischen Katakomben* (Berlin, 1933), 35ff.; also Testini, *Le catacombe*, indici s.v.

35. L. Reekmans, *Tombe*, 187–202.

36. "Double chamber" has an early ancient authority at *ICVR* 4.10183, an inscribed fragment of a marble screen that recounts orders that Deacon Severus received from Bishop Marcellinus (d. 304: *LP* 30 [Duchesne 162]) to construct a double room with arcosolium emplacements and a light well (CVBICVLVM DVPLEX CVM ARCISOLIIS ET LVMINARE . . .).

37. *LP* 22 (Duchesne 1.150–52); *ILCV* 956.a, and b. On the burial of Cornelius: Reekmans, *Tombe*, 208–11: on numismatic and other grounds, it is clear that Cornelius' body was moved from Centumcellae to the Via Appia sometime before 275; Reekmans conjectures that the removal and reinterment could have occurred as early as the episcopacy of Stephen (254–57).

38. Diminutive of *locus:* in the plural commonly a small box or chest divided into compartments and used for storing valuables, esp. a cash box (*OLD*). *Loculus* as a small box containing (valuable) funerary remains, namely Pyrrhus' magic-working big toe (*pollex*): Plin., *Nat.* 7.20 ("hunc cremari cum reliquo corpore non potuisse tradunt, conditumque loculo in templo"); idem, *Nat.* 7.75 (on *loculi* containing the remains of two notable dwarfs). In a lovely, early fourth-century Sicilian inscription (*CIL* 10.7112; *ILCV* I, 1549) to an eighteen-month-old Christian child named Julia Florentina, the father put his daughter's mortal remains to rest in a small coffin: Cuius corpus pro foribus martyrorum cum loculo suo per prosbiterum humatu[m] e[st] IIII non. Oct[o]br[es]." Thus, in common ancient usage the term denoted a small box, including a small coffin. But in archaeological

parlance this usage has been extended to apply to catacomb niches. The common ancient designation was *locus* (*sepulturae*); see *ILCV* III, index XII, s.v.: also *DACL* 9.2, s.v. A niche for a single cadaver: l. *monosomus;* for two, three or four: l. *bisomus, trisomus, quadrisomus,* etc. A burial niche oriented perpendicular to the wall from which it is cut is called a *kokh* (pl. *kokhim*). This is a Palestinian idiosyncracy (N. Avigad, *Beth Shearim* vol. 3 [Jerusalem, 1976]) which carries over to the Jewish catacombs of Rome; see H. Leon, *The Jews of Ancient Rome* (Philadelphia, 1960), 59–60; also R. Hachlili, *HbO* VII.I.2.B/4, 89ff.: this author has not a clue about the nomenclature of interment burials (*forma, loculus, arcosolium, kokh,* and shaft burials) relevant to late Judaism and early Christianity.

39. *ICVR*, n.s., 2.6446 (now illustrated in *EEC*, 353) shows a fossor with a wrapped cadaver lying on the ground in front of him. The *pollinctor* normally had the responsibility of cleaning, oiling and wrapping cadavers, thus Arn., *Pag.* 1.46.18: *pollinctorum uelaminibus.* The *pollinctor* was normally a free employee or a slave of the *libitinarius:* Ulp., *Dig.* 14.3.5,8; cf. K. Schneider, in *RE* (1952), s.v.

40. General survey of second- and third-century mosaics: M. E. Blake, *MAAR* 13 (1936), 67ff., and 17 (1940), 81ff. If the Callistus Christians had been able to afford tessellated floors, we would expect them to have produced figural or perhaps more likely nonfigural floors in black and white tesserae; on which see G. Becatti, *Scavi di Ostia IV: Mosaici e pavimenti marmorei* (Rome, 1961), esp. 277–78: for Hadrianic-Antonine to Severan floors; and for a very brief overview: idem, *La mosaïque gréco-romaine* (Paris, 1965), 15–26; also G. Salies, *BJbb* 174 (1974), 1–178.

41. As argued correctly by Joyce, *Decoration;* see my review, *AB* 67 (1985), 679–81.

42. For archaeological purposes, stratigraphy is normally understood as the study of superimposed strata or horizons deposited over time by human agents (in contrast to the natural sedimentation process). Trenches (shafts, probes, sondages) perpendicular to the earth's surface are cut through to bedrock, and the superimposed, stratified deposits can be "read" in sequence from bottom to top or vice versa. The method of reading is "vertical" in the sense just described. In the catacombs, the fossors cut horizontal galleries that were roughly parallel to the earth's surface. The digger's pickax (*dolabra fossoria* [illustrations, p. 206]; see W. Gaitsch, *ANRW* II.12.3 (1985), 170–204; idem, *AW* 14 [1983], 3–11, Abb. 5) left marks on all exposed surfaces. One can "read" these marks in horizontal sequence, thereby determining, for example, where a dromos originally terminated and then was subsequently extended. Thus the term *horizontal stratigraphy.* On principle one ought to be able to read horizontal stratigraphy from photogrammetric recordings. I have not seen any proof of this so far, but presumably for Callistus Brandenburg's proposed study will provide the evidence; see P. C. Finney, *SC* 6 (1987–1988), 213, VII.4.

43. L. de Bruyne, *RivAC* 44 (1968), 91, fig. 7.

44. B. M. Felletti-Maj, *Le pitture delle case delle Volte Dipinte e delle Pareti Gialle, MPAI* Sez. 3. Ostia/Fasc. 5 (Rome, 1961), 11–17, and Tav. 3.

45. P. H. von Blanckenhagen and Ch. Alexander (G. Papadopoulos), *The Paintings from Boscotrecase, RM* Ergänzungsheft 6 (Heidelberg, 1962).

46. Joyce, *Decoration,* 80–82: Joyce's system IIB: centralized and circular. Her "curved panels" are really annular segments.

47. Joyce, ibid., 82–91: converging systems, which Joyce subdivides into four types: axial, diagonal, curvilinear diagonal, and radial.

48. Joyce, *Decoration* 77ff.

49. P. C. Finney, in *EEC*, s.v. "Cross."

50. Joyce, *Decoration*, geographical index, s.v.; illustrated in B. Andreae, *The Art of Rome* (New York, 1977), Figure 484.

51. Joyce, *Decoration*, geographical index, s.v.

52. Joyce, *Decoration*, subject index.

53. Joyce, *Decoration*, subject index.

54. Centrality as a compositional principle in late antique art: G. Roden-waldt, *AbhBerl.* (1935), 5: "zwei in die Richtung zur Spätantike weisende Tendenzen . . . die Hervorhebung der Mitte und die Rücksicht auf die ideale Bedeutung." Both the central compositional frames of the Callistus ceilings and the images they enclose typify this late antique tendency identified by Rodenwaldt and others.

55. On implict or attributed meanings, see the section on *Tekmeria Theou* in Chapter 7. Bachofen's thoughts on this subject are still provocative and can be applied with profit to the study of early Christian iconography: "Der alte einfache symbolische Glaube, wie ihn Orpheus und die grossen Religionslehrer der frühesten Zeit theils geschaffen, theils überliefert erhalten, kommt im Grabmythus zur Auferstehung in anderer Gestalt. Neue Symbole und neue Mythen erschafft die spätere Zeit nicht. Dazu fehlt ihr die Jugendfrische der ersten Existenz. Aber dem Schatze überlieferter Darstellungen weiss das spätere, mehr auf sein Inneres gerichtete Menschegeschlecht, eine neue vergeistigte Bedeutung unterzulegen"; from J. J. Bachofen, *Versuch über die Gräbersymbolik der Alten* 2d ed. (Basel, 1925), 47.

56. F. J. Dölger (1879–1940) had a lifelong interest in the interpretation of material culture in funerary contexts; his bibliography was published by Th. Klauser, *Franz Joseph Dölger Leben und Werk* (Münster, 1956). Among his pupils, two who made significant contributions in this area of study are Th. Klauser and Johannes Quasten. The former's *Die Cathedra im Totenkult* (Münster, 1927) is a classic. Quasten's several essays on this subject are listed in *Kyriakon*, vol. 2, ed. P. Granfield and J. A. Jungmann (Münster, 1970), 924–38. For a readable and sensible introduction to this subject: I. A. Richmond, *Archaeology, and the After-life in Pagan and Christian Imagery* (Oxford, 1950).

57. A. Stuiber, *Refrigerium Interim. Die Vorstellungen vom Zwischezustand und die frühchristliche Grabeskunst*, Theophaneia 11 (Bonn, 1957); for a thoughtful and intelligent review: J. M. C. Toynbee, *JThS*, n.s., 9 (1958), 141–49.

58. H. Brandenburg, *CIAC.Atti* 9.1 (1978), 331ff.

59. L. de Bruyne, "Les 'lois' de l'art paléochrétien, comme instrument herméneutique," *RivAC* 35 (1959), 105ff.; 39 (1963), 7ff. Monseigneur de Bruyne was one of this century's greatest students of early Christian art; however, in his notion that this art was ruled by "laws" he was not at his best. The same tendency to view the subject from an a priori set of rules characterizes the work of one of de Bruyne's greatest opponents, namely Th. Klauser.

60. A2, second annular field, south lunette: Jonah spewed forth from the mouth of the *ketos;* second annular field, west half-circle: Jonah resting under the pergola. Photo: PCAS (Cal E3). A4, outermost zone, west half-circle: Jonah resting under the pergola; outermost zone, east half-circle: Jonah cast up from the mouth of the *ketos* (on the authority of Garrucci and de Rossi—this image is destroyed). Photo: PCAS (Cal E42). Jonah iconography: P. C. Finney, *SC* 6.4 (1987–1988), x.79–82.

61. Useful inventories of these "neutral" images: P. Bruun, *AIRF* I.2 (1963),

73ff., and H. U. Instinsky, *CIL* 8 Suppl. 5.2 (1955), 240ff.: *anaglypha christiana*.

62. Dölger, *IXΘΥΣ* 2: Sachregister, "Dreifuss"; ibid. 5: s.v. "Dreifuss."

63. On floral iconography in funerary contexts: Th. Klauser, in *RAC* 2 (1954), s.v. "Blume"; floral decoration in Tombs D, G, O, T within the Vatican necropolis: J. Toynbee and J. Ward-Perkins, *The Shrine of St. Peter* . . . (London, 1956), 76–80; P.-A. Février, *CIAC.Atti* 9.1 (1978), 257. On the funerary Feast of Roses (Rosalia/Rosaria): *CIL* 10.3792; also 10.44 (and Plin., *Nat.* 21.11); 6.10234,15: 11 May; 10.3792: 13 May; 6.10239: 21 May; *CIL* I², p. 264: 23 May; 10.444: 20 June; 11.132: 15 July. Roses were especially important, both the painted form and the real thing—on endowments left by the deceased for the purchase of roses as periodical offerings to adorn the grave: J. M. C. Toynbee, *Death and Burial* . . . (London, 1971), 62–63; cf. Min., *Oct.* 38.2–4 (disclaiming the Christian use of garlands, including for funerary purposes). This is a response to Octavius's reproach at 12.6 ("Non floribus caput nectitis . . . coronas etiam sepulcris denegatis), and both the reproach and the response have a highly rhetorical flavor. Aus. *Epita.* 31:

> sparge mero cineres bene olentis et unguine nardi
> hospes, et adde rosis balsame puniceis.
> perpetuum mihi ver agit inlacrimabilis urna
> et commutavi saecula, non obii.

Prud., *Cath.* 10.5.169–72:

> nos tecta fovebimus ossa
> voilis et fronde frequenti,
> titulumque et frigida saxa
> liquido spargemus odore.

cf. A. Ferrua, *RivAC* 46 (1970), 66–67.

64. Garlands in funerary settings: R. Turcan, in *RAC* 11 (1981), s.v. "Girlande."

65. Nilsson, *GGR* 1: 578ff.

66. Pendant marble masks from Pompei: E. J. Dwyer, *RM* 88 (1981), 247–306; also W. Ehlers, in *RE*, s.v.

67. R. Stuveras, *Le putto dans l'art romain* (Brussels, 1969); *erotes:* E. Speier, in *EAA* (1960), s.v., and A. Rumpf, "Eros (Eroten) II (in der Kunst)" in *RAC* 6 (1966), s.v.

68. Darem. and Sag., s.v. "concha"; Dölger, *IXΘΥΣ* 5: Sachregister, "Muschel"; also M. Bratschkowa, *Die Muschel in der antiken Kunst* (Berlin, 1938) = *Bulletin de l'Académie Bulgare. Istvestia* 12 (1932), 2ff. On the *conchae* in the Treasury of Graincourt-les-Havrincourt: Ch. Picard, *RA* (1959), 221–29.

69. Of whom the most distinguished in recent memory is certainly A. D. Nock at *AJA* 50 (1946), 140–70: criticizing Cumont the maximizer. For an earlier version of this debate: H. Lother, *Realismus und Symbolismus in der altchristlichen Kunst*, Sammlung gemeinverständlicher Vorträge und Schriften aus dem Gebiet der Theologie u. Religionsgeschichte 155 (Tübingen, 1931); also idem, *SCD* n.s., 18 (1929): arguing that the peacock is primarily a decorative, ornamental motif in early Christian art.

70. See Chapter 5, n. 70.

71. Th. Klauser, *JbAC* 2 (1959), 115ff.; 3 (1960), 112ff.; 7 (1964), 67ff. General introduction: K. Wessel, *AA* 70 (1955), 315ff.; also F. Matz, *MM* (1968), 300ff.; F.

Bisconti, *VetChr* 17 (1980), 17ff. Unfortunately the only part of Alice Mulhern's unpublished doctoral dissertation (PIAC, 1977) that ever made it into print was her short article, "L'Orante," *Les dossiers de l'archéologie* 18 (September–October 1976), 34–47.

72. Th. M. Mamachi, *Origines et antiquitates christianae* (Rome, 1749–53).

73. G. Marangoni, *Delle cose gentilesche trasportate ad uso ed adornamento delle chiese* (Rome, 1744).

74. L. von Sybel, *Christliche Antike*, 2 vols. (Marburg, 1906, 1909); idem, "Die klassische Archäologie und die altchristliche Kunst," *Rektoratsrede Marburger akademischen Reden* 16 (1906); also *HZ* 106 (1910), 1–38; *RepKu* 39 (1916), 118ff.; (1925), 140ff., 200ff.; and *Frühchristliche Kunst. Leitfaden ihrer Entwicklung* (Munich, 1920).

75. E. Löwy, *JbÖAI* 12 (1910), 243ff.

76. Thus W. Tooley, *NovT* 7 (1964), 15–25; also P. C. Finney, in *EEC*, s.v.

77. To justify his interpretation of the shepherd as a strictly non-Christian image, at Dura Klauser finds himself grasping at straws; see *JbAC* 10 (1967), 106–107: the Dura Christians were baptizing sectarians who did not know the canonical New Testament or who perhaps even fought against it; therefore, they saw God in the image of their shepherd, not Jesus.

78. P. C. Finney, *JJA* 5 (1978), 6–16 (with the literature cited there).

79. For a corpus, incomplete but nonetheless useful: E. R. Panyagua, *Helmantica* 18 (1967), 173ff.; 23 (1972), 83ff., 393ff.; 24 (1973), 433ff.

80. It seems to me that essentially von Sybel got it right, thus *Christliche Antike*, 1:10: "Wo heute zu irgend einem christlichen Typ heidnische Analoga nicht nachweisbar sind, kann sich das Fehlende jeden Tag durch Fund oder Ausgrabung ergänzen."

81. In evaluating the iconography of the Jonah cycle, the most important consideration is the character of the ship, on which we now have a very useful inventory by Irene Pékary, *Boreas* 7 (1984), 172–92; 8 (1985), 111–26.

82. On the formation of the *ketos* type: A. Rumpf, *ASR* 5.1 (1939), Sachregister s.v.; for the Boscotrecase *ketos*, cf. P. von Blanckenhagen and C. Alexander, *RM* Ergbd. 6 (1962).

83. As observed long ago by Désiré Raoul Rochette in his *Discours sur l'origine, le développement et le caractère des types imitatifs qui constituent l'art du Christianisme* (Paris, 1834), and his *Troisième mémoire sur les antiquités chrétiennes des catacombes* (Paris, 1838).

84. LXX: σκηνή. On Roman *pergole:* P. Grimal, *Les jardins romains*, 2d ed. (Paris, 1969), index rerum, s.v.; also Darem. and Sag. s.v.

85. Joyce, *Decoration*, general index, s.v.

86. White and yellow-ochre grounds were the most common; red- and black-ground frescoes are especially conspicuous in the third Pompeian style painting. For Antonine-Severan examples, see Joyce, *Decoration*, general index, s.v.

87. For an informative introduction: A. Barbet, "Les bordures ajourées dans le IVe style de Pompéi, Essai de typologie," *MÉFRA* 93 (1981), 917–98. My thanks to Madame Barbet for an offprint of her very valuable study.

88. E.g., A2 west wall (middle register) and east wall (middle register, right end); A3 east wall (upper register); A6 west wall (middle register, right end); cubiculum Y north wall: left end enclosing the lost central image (the frame echoes the ellipses used to convey the form of the fishes); Y east wall (on the horizontal

strip between the two upper loculi): two elliptical frames enclosing the supine Jonah; also in hypogeum beta, cubiculum C west wall (upper register): ellipses framing a vase nested on floreated brackets.

89. E.g., A3 north wall (middle register, the arc above the central sigma meal) as well as the top and bottom bands framing the pendant fossors; A4 north wall (the arc within the register right of the left orant; also the arcuated register enclosing the orant on the right side of the wall); A6 south wall, west side: the arcuated register enclosing Lazarus and Jesus with his wand; and A6 east wall (middle register, lower half): another arcuated register enclosing a vase nested on a floreated bracket.

90. P. Styger, *PARA.Diss.* 13 (1918), 110.

91. The comparison is G. M. A. Hanfmann's in his *Roman Art* (Greenwich, Conn., 1964), pl. XIII with comments.

92. K. Weitzmann, "Die Illustration der Septuaginta," *Münchner Jb. der bildenen Kunst* 3.3–4 (1952–1953), 96–102; also idem, *Mullus* (Münster, 1964), 401–15. Weitzmann's theory (which represents a combination of Strzygowski and Goodenough redivivi) has met with qualified acceptance and even enthusiastic affirmation in some circles and with neither such response in others. For a critical response: J. Gutmann, *ANRW* II.21.2 (1984), 1313–42. I too remain skeptical: *JJA* 5 (1978), 6ff.

93. Background: E. J. Dwyer, "Pompeian Oscilla Collections," *RM* 88 (1981), 247–306. In Roman wall painting: M. Bieber, in *RE* 14.2 (1930), s.v. "Maske"; also W. Ehlers, in *RE* 18.2 (1942), s.v. "Oscilla."

94. J. Wilpert, *Die Malereien der Katakomben Roms* (Freiburg, 1903), 289; also idem, *Fractio panis* (Freiburg, 1895), 81: "Das Fresko reiht sich . . . von selbst unter die Darstellungen des Speisewunders, des Vorbildes der Eucharistie, ein." Critical discussion: Dölger, *IXΘYΣ* 5:527–33.

95. A. M. Schneider, *RQ* 35 (1927), 287–301; idem, *Refrigerium I. Nach literarischen Quellen und Inschriften* (Freiburg, 1928); also Th. Klauser, "Das altchristliche Totenmahl nach dem heutigen Stande der Forschung," *Theologie und Glaube* 29 (1928), 599–608, and Stuiber, *Refrigerium Interim*, 124–36: one must decide between three possible interpretations, namely *Totenmahl, Eucharistiefeier,* or *Seligenmahl.* Predictably, Stuiber chooses the first (pp. 134, 136): "Alle angeblichen Kriterien für die eucharistische Deutung sind hinfällig. . . . Die Mahlbilder zeigen nicht Verstorbene bereits in der himmlischen Herrlichkeit beim Seligenmahl, sondern irdische Totenmähler als wichtigsten Bestandteil des irdischen Totenkults." Stuiber's assessment of this subject represents hermeneutical orthodoxy in the Dölgerite tradition.

96. Argued again in Wilpert, *La fede della chiesa nascente,* 97–99.

97. A brief, readable survey of Roman funerary rites including visits to the grave site (on the *dies natalis;* on the Kalends, Ides, and Nones of every month; during the feast of the Parentalia [13–21 February] and on 9, 11 and 13 May): Toynbee, *Death and Burial,* 43ff.; also E. Freistedt, *Altchristliche Totengedächtnistage und ihre Beziehung zum Jenseitsglauben und Totenkultus der Antike, LQF* 24 (Münster, 1928).

98. Nestori, *Repertorio,* ad.loc. "delfino"; for a dolphin skewered on an anchor with the *IXΘYΣ* acrostic in the field on an oval gold signet: Dölger, *IXΘYΣ* 1.320, no. 49; also 406 (citing G. B. de Rossi, *BullAC* [1870] 49–73 [well-worth reading]); and *IXΘYΣ* 2 and 5, indices s.v. "Delphin."

99. For Athenaeus in Clement, see *GCS* 39.1 (1934). For a brilliant exposition of Athenaeus in one Clementine passage (*Paed.* III.4,26): Th. Halton, *SC* 6.4 (1987–1988), 193–202.

100. A. Rumpf, *ASR* 5.1 (1939).

101. E.g., cubiculum Y in alpha, south wall, middle register/east: two sheep flanking a *mulctrum*. Bucolic iconography: A. Provoost, "Iconologisch onderzoek van de laat-antieke herders voorstellingen" (diss., Leuven, 1976), and W. Schumacher, *Hirt und guter Hirt, RQ* Suppl. 34 (Freiburg, 1977).

102. Nilsson, *GGR* 1.182–84, on "Seelentiere." On soul birds, see G. Weicker, in Roscher, *Lex,* s.v. "Seirenen." The iconographic type of the siren and the soul bird is the same.

103. The basic monograph on this subject (based on sarcophagus iconography) is still H.-I. Marrou, *ΜΟΥΣΙΚΟΣ ΑΝΗΡ* (Grenoble, 1938); also idem, *RA,* ser. 6, 1 (1933), 163ff.

104. W. Gaitsch, *AW* 14 (1983), 3–11 (Abb. 5); idem, *ANRW* II.12.3 (1985), 170–204; idem, *BAR* 78 (1980). For a reconstruction of the *dolabra fossaria* mounted on a long *pedum* and housed in the Kastell Saalburg Museum, see Gaitsch, *AW* 14 (1983), Taf. IV, VIII.

105. Bosio, *RS* 1:233: "La figura . . . che rappresenta una donna con le mani aperte, in atto di far' oratione, crediamo sia la figura di quella, che forse fù sepellita in quel sepolcro"; cf. J. Wilpert, *Ein Cyclus christologischer Gemälde aus dem Katakombe der heiligen Petrus und Marcellinus* (Freiburg, 1891), 30ff.

106. *RS* 2:322; idem, *BullAC* (1867), 84ff.; (1868), 13; (1869), 33ff.; (1871), 156; (1873), 96; (1874), 88ff., 122ff., 154: Susanna on the Podgoritza plate; (1875), 17–32: Domitilla catacomb, Veneranda arcosolium lunette; (1876), 145ff.; (1877), 131, 141; (1878), 63–64; (1888–1889), 103ff.; (1894), 35ff.; also see L. de Bruyne, *RivAC* 39 (1963), 12ff., and F. Bisconti, *VetChr* 17 (1980), 17ff.

107. Th. Klauser, *JbAC* 2 (1959), 115–45. Here as elsewhere, Klauser's inclination is to stress the continuity of the meaning attributed to the image in a pagan context with the putative meaning attributed in a Christian context.

108. Thus P.-A. Février, *MÉFRA* (1959), 301–19: Février borrowed this term from his mentor, H. I. Marrou. Now see V. Saxer, *RivAC* 67.2 (1991), 435–40.

109. For another view, see J. M. C. Toynbee, *Some Notes on Artists in the Roman World* (Brussels, 1951): a revisionist study arguing that Roman Imperial society did not despise *technitai/artifices* as much as Greek classical society. This, I think, is one of Toynbee's less successful efforts. For a cognate argument with respect to the early Christians: F. M. de Robertis, *Lavoro e lavoratori nel mondo romano* (Bari, 1963), e.g. 42: "Ma alla progressiva demolizione delle concezioni auliche tradizionali dovettero contribuire senza dubbio, e in maniera decisiva, anche l'insegnamento evangelico e le dottrine dei Padri della Chiesa nella esaltazione che vi si contiene—e che derivava direttamente dalla tradizone ebraica— non solo del valore etico-religioso, ma anche della dignità umana e sociale del lavoro e dei lavoratori." This is rubbish: the exact same Greco-Roman prejudice against manual labor and laborers (portrayed as boors, bibbers, and fornicators) is richly attested in early patristic literature (Justin, Tatian, Athenagoras, Theophilus, Tertullian, Minucius, Clement, and Origen). The basic study for the pre-Christian materials is still B. Schweitzer, *NHeidJbb* 2 (1925), 28–132. The classic expressions of antibanausic prejudice: Plut., *Per.* 2, and Luc., *Somn.* 6–9. Banausos: "der kleine Mann mit engem Horizont und dementsprechender Denk-

und Arbeitsweise"; thus K. Brugmann, *RhM* 62 (1907), 634–36; also P. Chantraine, *Melanges . . . à Mgr. Diès* (Paris, 1956), 41–47.

110. D. Nörr, *ZSav*, 82 (1965), 67ff.

111. H. Wölfflin, *Kunstgeschichtliche Grundbegriffe*, 4th ed. (Munich, 1920), 90.

112. Thus F. J. Dölger, *AC* 2 (1930), 97.

113. All three discussed by Dölger, ibid., 96–97.

114. Klauser, *Die Cathedra im Totenkult*, 137.

115. Stuiber, *Refrigerium Interim*, 125.

116. *AC* 2 (1930), 96.

117. On which, see P. van Moorsel, *RivAC* 40 (1964), 221–51.

118. Mk 2:4, 9, 11, 12; Jn 5:8, 9 (healing at the Pool of Bethsaida) uses the variant: κράβαττος.

119. C. H. Kraeling, *The Excavations at Dura Europos. Final Report VIII.2 The Christian Building* (New Haven, 1962), pls. 21, 29.1, 33.1, 40.

120. North lower chamber, southwest corner, upper register seated bearded figure, dressed in a sleeved, clavate tunic, reading from an open scroll; cf. G. Bendinelli, *MonAnt* 28.2a (1922–1923), 343ff., 431ff., fig. 24, Tav. IX; also G. Wilpert, *Atti PARA[serie 3] Mem.* I/II (Rome, 1924), 24ff., fig. 6: Carlo Tabinelli's reconstruction painting of the so-called shepherd shows him surrounded by eleven sheep (*sic:* one is missing), a detail that fits nicely with Wilpert's gnostic-Christian interpretation of the religion of the Aureli. On the putative connection of this so-called shepherd with Bishop Aberkios: H. Strathmann, in *RAC* 1 (1942), 12ff. On iconographic grounds, this seated figure is clearly not a type of a shepherd, but instead of a philosopher or learned person (parallels: Marrou, ΜΟΥΣΙΚΟΣ ΑΝΗΡ). The figure is best described as a seated philosopher set in a sheperding or bucolic context. Carcopino was on the right track in identifying the figure as "le Docteur" (Carcopino, *De Pythagore aus Apôtres*, 155). N. Himmelmann (*AbhMainz* 7 [1975], 18) has also got it right: "bärtiger Philosoph." The exact same attribution belongs to the seated lector on the south wall of A3: this too is a type personifying wisdom and learning. The specific content (if any can be discerned) of the Aureli philosopher's teaching is much disputed, and a great deal of nonsense has been committed to print in the name of this figure.

121. On semiotic connectors: R. Brehmayer, "Zur Pragmatik des Bildes," *LB* 13–14 (1972), 19–57.

122. L. de Bruyne, *RivAC* 20 (1943), 212–47.

123. On which, see A. Hermann, *JbAC* 5 (1962), 60–69. For a fuller discussion of Lazarus iconography, see C. Nauerth, *Vom Tod zum Leben*, *GöO* II.1 (Wiesbaden, 1980), 34–76.

124. Magicians are commonly identified in Greco-Roman iconography by their attribute, the *uirgula*/κηρύκειον; see F. J. M. de Waele, *The Magic Staff or Rod in Graeco-Italian Antiquity* (Gent, 1927). Like Aesclapius, the magician may also be identified by the praxeis he performs. Συνανάχρωσις is a common praxis attributed in both literary sources and in the magical papyri to *goetes/magi*, but I cannot find a corresponding iconographic tradition; see L. Bieler, *ARW* 32 (1935), 228ff., and O. Weinreich, *ARW* 32 (1935), 255ff. The iconography of the magician needs to be carefully distinguished from magical iconography—the latter is a completely different subject. Jesus calling forth Lazarus from the tomb is represented under the iconographic type of the magician—does this have anything to do with the magical images that appear on amulets, intaglios, defixiones, incantation bowls, papyri, and related materia magica?

125. The σκηνή which Jonah made to protect himself against the sun appears at Jon 4.5; its best Latin equivalent is *umbraculum* (cf. *OLD*, s.v.). In painting, Jonah's σκηνή came to be interpreted as a lattice-work trellis (alt: arbor, pergola); on which see F. Fariello, *Architettura dei Giardini* (Rome, 1967), Tav. 8–9 (Pompei: trellis garden architecture in the House of Loreio Tiburtnio); also W. F. Jashemski, *The Gardens of Pompeii* (New Rochelle, N.Y., 1979), index, s.v. "pergola." Painted examples: M. L. Anderson, *Pompeian Frescoes in the Metropolitan Museum of Art* (New York, 1987), 19: archuated pergola in the Boscoreale Bedroom M. For a splendid archuated, lattice-work trellis rendered in mosaic, see G. Gullini, *I Mosaici di Palestrina* (Rome, 1956), Tav. I (set in a Nilotic seascape).

126. See n. 82.

127. Cotta criticizing the Epicureans: "Quod si fingere nobis et iungere formas velimus . . ."

128. *Edictum Diocletiani de pretiis rerum venalium* 7.8, 9: see n. 23.

129. At *Idol.* 8.2 creates "albarius tector," i.e. a *tector* of album (presumably gypsum). *Tector* denotes the plasterer's activity, *albarius* (album) the material that he used. The joining of these two words does not appear elsewhere (*TLL* I.1487, 84ff.), but *albarius* and *tector* are employed separately to convey the same sense: a person who works with plaster. From the description he gives, Tertullian's *albarius tector* is clearly a good deal more than just the fellow who smears plaster on walls with a trowel—his plasterer knows how to execute *cymatia* and *ornamenta*. We have no way of knowing if the Callistus *tectores* could do the same; see J. H. Waszink and J. C. M. Winden, *Tertullianus De Idololatria* (Leiden, 1987), ad loc. An example of *tectores* who knew their stuff and who were contemporaries of the Callistus plasterers is provided by the splendid barrel-vaulted ceiling (hexagonal stuccoed coffers enclosing rosettes, conch and peacock [tail coverts erect] at the lower end) over the stairway leading down to Tomb I (of the Innocentii) in the Piazzuola beneath San Sebastiano (Figure 6.71); see G. Mancini, *NSc* 320 (1923), 3ff.

130. Petrikovits, "Die Spezializierung," s.v. "Tectores et pictores."

131. von Sybel, *Christliche Antike*, 1:9: "wir (i.e., 'we archaeologists') betrachten die altchristliche Kunst auch nicht als die Vorstufe der allgemeinen christlichen, richtiger zu sprechen, der mittleren und neueren Kunst; sondern für den Archäologen ist sie das Ende einer Entwicklung, wenn man will, ihr geschichtliches Ziel, in dem diese sich vollendet, das Ende und Ziel nämlich der Entwicklung und des ganzen Verlaufs der antiken Kunst, worin sie zuletzt auslief. Dem Archäologen ist die altchristliche Kunst das letzte geschichtliches Ergebnis der gesamten Antike; er glaubt, für ihr geschichtlichen Verständnis die wesentlichen Vorbedingungen mitzubringen in seiner methodischen Kenntnis der Antike."

132. H. G. Beyen, *Die pompejanische Wanddekoration vom zweiten bis zum vierten Stil*, vols. 1, 2 (The Hague, 1938, 1960).

133. More than sixty years ago, Nock called for the creation of a corpus of magical images (*JEA* 15 [1929], 219ff.). We still do not have such a corpus; until we do, the full scope and character of magical iconography remains elusive.

134. See P. C. Finney, *CIAC.Atti* 9.1 (1978), 391–405; idem, *Numen* Supp. 41.1 (1980), 434–54.

7

Invisible Divinity and Visible Religion

CL. CALLISTO V. P.[1]
SIVE HILARIO VXOR
ET FILI BENEMERENTI FECER
VIR BONVS ET PRVDENS STVDIIS
IN PACE DECESSIT.[2] NOMEN DICNI
TATIS[3] EXIMIVM LAVDEMQ SVPER
BAM. DEVM VIDERE CVPIENS VIDIT
NEC FRVNITVS OBIIT.[4] SIC SIBI VOLV
IT AC MERITISSVIS FVNVS ORNARI
OMNES FILII BONVM PATREM CLA
MITANT QVERENTES. PARITER ET
VXOR LVGET QVAERET NON IN
VENTVRA QVEM PERDIDIT
QVI VIXIT ANNIS. LXV
D.P.[5] PRID. N. FEB.

 CIL 6.31965
 (*ILCV* 298; *ICVR* 3.8470) (Figure 7.1)

This epitaph, dedicated to the memory of a certain Claudius Callistus (nicknamed[6] Hilarius and otherwise unknown), is one of a large group of Roman *tituli* that came to light in the early nineteenth-century excavations beneath Tenuta di Tor Marancia[7] (Figure 6.23a), in deposits that belonged to the subterranean complex which today we recognize as the Domitilla catacomb. Callistus' tablet has an unusual form: a circular marble slab, seventy-three centimeters in diameter with a pierced hole at the center for the pouring[8] (*profusio: CIL* 5.4990; 10.107) of libations.

 The man died in his sixty-fifth year, probably sometime in the first

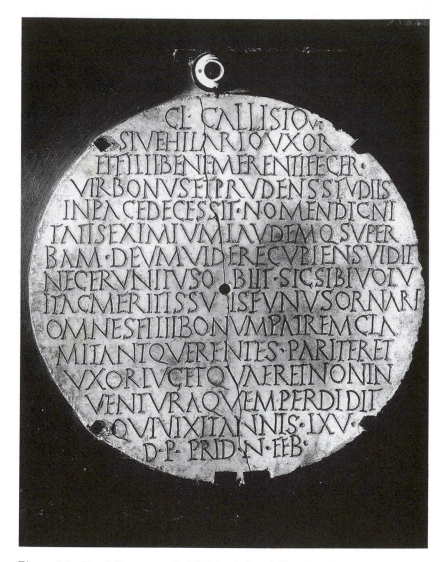

Figure 7.1. Domitilla catacomb. Marble *titulus* of Claudius Callistus. CIL 6.31965. *Rome.*

half of the fourth century. Callistus was *U(ir) P(erfectissimus)*, which on analogy with the title, *U(ir) E(regius)*,[9] could have been intended to denote his membership in the equestrian[10] social class (*ordo*), but which may also be construed as a purely titular epithet bestowed by the Constantinian government on civil servants of varying grades, both during their years of active service and in some cases in their retirement years. All we really can say for sure is that Callistus was some kind of civil servant in the Constantinian (or possibly Tetrarchic) government[11]—whether his position was

high or low we do not know, nor can we identify his *ordo*. As for epigraphic nomenclature, at least two of the usages are formulaic Christian, the one (*in pace decedere*) a euphemism for death, the other (D.P. = *d*[*e*]*p*[*ositus*]) a technical term for the inhumation of a cadaver. In other words, Callistus was a Christian. His wife and sons, dramatically lamenting their loss (". . . filii . . . clamitant querentes . . . uxor luget,[12] quaeret . . ."), remembered their spouse/father as a man who was clever in intellectual matters (*prudens studiis*).

The epitaph says the deceased had desired to see God ("deum uidere cupiens") What does this mean? As just noted, his survivors wanted it known that Callistus was a man of intelligence and learning. We know he was an adult, a mature person, and also an *homme d'affairs:* a Roman bureaucrat inured to the business of government and possessed of a proven track record. Callistus must have been a man with both feet on the ground. But even if he were not a Christian, and indeed even if he were *imprudens studiis*, surely he must have known, based simply on the popular wisdom of the day, that his chances of seeing God were approximately nil. As a Christian he would have realized that his desire was fraught with problems, not the least of them being God's invisibility. Did he somehow flatter himself that he could enjoy what others had been denied? Was this perfect man also *uir deceptus?* None of this seems very likely, although one must hasten to add that this entire line of inquiry is fraught with speculation. Perhaps, the vision of which the inscription speaks is meant in a metaphorical rather than a literal sense. In any case, the epitaph records that Callistus died without enjoying the pleasure of his desire ("nec frunitus obiit"). Under the circumstances, this should come as no great surprise.

Deum Uidere

To return to the discussion that came in the Introduction to this study, what Callistus is said to have desired reminds us of Philip and Autolycus: they too had wanted to see God. Philip asked Jesus to show him and his fellow disciples the Father (Jn 14:8), and Autolycus evidently had put a similar demand on Theophilus (*Autol.* I.2.1ff.: Δεῖξον μοι τὸν θεόν σου). Tat asked his father Hermes to do the same, and in the invented dialogue (*Mem.* 4.3.13–14) that Xenophon created for Socrates and Euthydemus he has the latter asking the same of Socrates.

—Philosophically speaking, this demand is inappropriate[13] (ἀπρεπής), and hence unreasonable. In all of the school contexts (Epicureanism excepted) the desire to be shown the form (εἶδος) of divinity was viewed as an epistemological impropriety. But all of the four offenders just mentioned are little more than straw men—each serves as a literary foil. Philip's request gives Jesus leave to expound the true doctrine of God. Autolycus, Tat, and Euthydemus play the essentially same literary role: they give the hero a pretext for parading his wisdom.

But our fourth-century *uir perfectissimus* was not a straw man. He was a husband and a father, a real flesh-and-blood person inhabiting a distinct time and place in history. Furthermore, he was not just a garden-variety Roman laborer or working man (βάναυσος), but Callistus was evidently a well-placed civil servant in the central government, probably a person of some distinction. Callistus was accustomed to the nuts and bolts of government, politics, economy, and war—he was no Euthydemus. Still, on the face of it, his desire to see God puts him in the same camp with the other invented straw men noteworthy for their naïveté, Philip, Euthydemus, and the rest. Or does it? Actually, the answer to this question (which concerns seeing God) is quite simple, but it brings into play a very large subject that has gone unnoticed in the study of early patristic literature. I can only sketch the contours here. Much more could and should be said.

Of the four literary scenarios just mentioned, Theophilus gives the fullest answer in the most economical form.[14] He tells Autolycus to look within himself (Δεῖξόν μοι τον ἀνθρωπόν σου) thereby to verify that the "eyes of the soul" (τοὺς ὀφθαλμοὺς τῆς ψυχῆς) and the "ears of the heart" (τὰ ὦτα τῆς καρδας) are in good working order (*Autol.* I.2.1). This is Theophilus repeating a Platonizing commonplace, in which the emphasis is on building up the interior life. But in addition he tells Autolycus to look outside himself to the world around him where he will find God "through his works" (διὰ . . . τῶν ἔργων, *Autol.* I.4.12). The literary context of this passage is 2 Macc 7:28 (God makes the heavens and the earth ex nihilo): God is a maker who is "seen" in the things he makes. This is the same Theophilus, in both places, but in the one he stresses a theological epistemology that is individualistic, introspective, and noetic, whereas, in the other he echoes a very different sentiment, namely the Peripatetic-Stoic epistemology, which looks for divinity in external evidence, in the cosmos, in nature, and in history.

Theophilus' appeal to external evidence is paralleled in Jesus' response to Philip: look to the *erga* of the Father. Hermes tells his boy Tat that God is simultaneously invisible (ἀφανὴς) and most manifest (φανερώατος), that the invisible God gives form to all things and appears in all things, even throughout the entire cosmos. He compares God to an artist (δημιουργός) and gives as comparanda the sculptor (ἀνδριαντοποιητής) and the painter (ζωγράφος): in all three examples an image of the maker flows from the things made.[15] And finally, at *Mem.* 4.3.15 there is Xenophon's Socrates who tells Euthydemus that we should not despise invisible reality[16] but rather by acknowledging its power "in the things that it creates" (ἐκ τῶν γιγνομένων) we should come to know and honor god (τιμᾶν τὸ δαιμονιόν).

Briefly, four considerations follow. First, there are two ways to "see" God, the inner noetic path and the outer route, which rests on an appeal to external evidence. Second, in both examples "seeing" is a form of knowing. Augustine put it well:

Ad oculus enim uidere proprie pertinet: utimur autem hoc uerbo etiam in ceteris sensibus, eum eos ad cognoscendum intendimus. (*Conf.* 10.35)

For although, correctly speaking, to see is the proper function of the eyes, we use the word of the other senses too, when we employ them to acquire knowledge.

Uidere with God as its object is clearly a metaphor of cognition, and that is without question the intended meaning in Callistus' epitaph.

Third, visual metaphors of divinity are widely attested in ancient literature, including in the patristic corpus. It is common knowledge that symbolic theologies based on visual metaphors of divinity became a conspicuous feature of patristic literature in the classical period; Ephrem[17] and Augustine,[18] for example, fashioned elaborate symbolic theologies based on things (and beings) seen in the natural world. But what is less well known is the fact that the second-century apologists laid both the literary and intellectual foundations for the great symbolists of the post-Constantian era. Ephrem and Augustine stand on the shoulders of the second- and third-century apologists—without this foundation their symbolic theologies would have been sorely diminished. Furthermore, the early apologists' extensive use of visual metaphors also provided the impulse and the semiotic-symbolic framework for the creation of early Christian art—without the conceptual worlds of Justin and Theophilus and Clement, either there would have been no paintings in the Callistus catacomb, or they would have been of a radically different character.

Fourth and last, "seeing" divinity in later antiquity (alike for Christian, Jew, and pagan) required that one follow the route of indirection. On this subject agreement was widespread: God's essential being was thought to be invisible; hence, direct and unmediated vision of the divine eidos was simply unthinkable. But indirect disclosures mediated through the things and beings that divinity causes to exist (including the human soul) are another matter altogether—mediated visions were judged to be well within the grasp of philosophical mortals desiring to see God. At issue here is an epistemology of signs (σημεῖα), a cognitive exercise that exploits and explains signs pointing to divinity. And, as in all such metaphorical exercises, what really counts is the ability to read the *semeia*.

Within the complex world of later antiquity, this matter of identifying and reading the signs, including those propounded in the artist's workshop, was overall a phenomenon shaped by a strong sensorial (or Epicurean) bias. One of the best ancient guides who illustrates in practical terms what it meant to read the signs is Philodemus[19]—his use of τεκμήριον (token, sign, or symbol) is directly relevant to our subject. Writing on direct and indirect proofs, on probability, sign, and inference, Philodemus says that the sign is peculiar to person who has a particular calling—for example in diseases, the physician; in storms at sea, the captain; and so on. In other words, signs are best identified and intepreted by experienced persons who are trained to read them, and although Phi-

lodemus' concern in this passage is limited to proofs in a rhetorical con-
text, the principle is just as true for theology and art as it is for medicine
and the weather.

Philodemus does not discuss artistic *tekmeria* of divinity, but if he had
they would have been classified among the indirect, artificial, or invented
(ἔντεχνος) signs. In the same manner as with the direct (ἄτεχνος)
indicators, the person one who has training and experience will know how
to read the signs correctly and hence will be able to draw the appropriate
inferences. The one who lacks training and experience in the reading of
artistic *tekmeria* will interpret them inaccurately. Thus, in an art-related
context, *deum uidere* could be construed as a comment on one's ability to
read the τεκμήρια ἔντεχνα, the invented tokens or signs of divinity.
This has no direct relationship to Callistus, whose desire to "see" (as I
have already said) concerns failed cognition and not in any literal sense
failed vision, but this discussion of signitive and semiotic interpretations
does have a direct bearing on the paintings executed for the catacomb
discussed in Chapter 6.

Tekmeria Theou: Early Christian Fresco Paintings

The Callistus paintings reflect a social event, not just a garden-variety
event, but an epoch-making moment, a cultural milestone signaling the
Roman Christian community's coming-of-age as a separate and distinct,
materially defined religious culture. The paintings bespeak the event—
they are signs, its symbolic forms, and as such they embody special mean-
ings for the insiders, the group of people clustered at the Callistus cata-
comb in the early third century, people who as a group were undergoing an
important cultural transformation. We do well to remember Geertz'[20] dic-
tum: social events and the symbolic forms they generate are not "exactly"
the same thing.

Indeed, on the example of the Callistus frescoes, Geertz' qualification
is understated. In fact, the Callistus paintings and the social event that
they represent are completely distinct entities. To be sure, they are
related—were it not for the latter, the former would never have come into
existence. But one can abstract the symbolic forms from the social and
cultural settings that produced them. In other words, one can consider the
frescoes on their own signitive merits and symbolic character. The discus-
sion then turns to the meaning or meanings (apart from the social-cultural
meaning which is given) that these forms were intended to embody. I
have already referred to these meanings as "attributed." Mary Douglas[21]
calls meanings of this sort "implicit." The two epithets are essentially
synonymous.

Without question, this is the most difficult part of interpreting not just
the Callistus paintings but all pre-Constantinian Christian art. After many
generations of study there are still no definitive solutions, and I have no
illusions about the critical difficulties involved in this subject. At the same

time, here as elsewhere one needs to strike a balance, and part of that responsibility means recognizing that we have come far enough in the discussion of meanings to make some very strong claims. I believe they carry the weight of a consensus. There are two fundamental issues that lay the groundwork for all interpretation in this area. One concerns context, understood broadly to include material settings, belief systems, and the emotional climate surrounding the Callistus paintings. The other concerns iconography, specifically the demonstrable thematic uniformity of the images in question.

As for the first, the hypogeal material context is dark, dank or dusty, constricted. The air is close. As for the second, the affective context is best described under words like deprivation, pain, and suffering— Callistus' wife and sons exemplify this mood with some poignancy. The steps at Tor Marancia (Figure 6.23) just as those at the Callistus catacomb lead down to a silent world of death, like Homer's Hades (*Od.* 11.204–22), a "joyless region" (ἀτερπέα χῶρον). The mood is somber. This is a place inhabited by sadness, by tears and sobs brought on by separation, the loss of loved ones, family, and friends. Subterranean Callistus is a warren, bewildering and opaque, a silent black cunicular maze, inhospitable and intimidating—to those of us still living it is a reminder of human frailty and vulnerability. This is a chthonic place. Death dwells here.

There is a thematic thread at Callistus. It ties together the disparate images that happen to survive on the walls and ceilings, and its content is clearly salvational or soteriological: Isaac spared the savagery of his father's knife, Jonah spewed forth from his belly tomb, the paralytic and Lazarus raised from their respective places of defeat, and so on. These are the *tekmeria theou*, the tokens of God's works and deeds, his saving intervention on behalf of his people. These are indirect signs, analogous to Philodemus' proofs in the *entechnoi* category. They are not cult images—they do not make present what they purport to represent. And unlike the devotees of Mithras, the people of the Callistus catacomb did not gather in their underground chambers to reenact a cult event or to worship a cult image of divinity made iconically present. Indeed, with perhaps one exception[22] (Figure 7.2—to be compared with Figure 7.3), the earliest generation of Christians in the Callistus catacomb did not represent God directly in a picture; instead, what they represented was God's *erga* personified in certain key figures who had been the beneficiaries and recipients of God's deeds. The wall and ceiling images are *semeia*, signs or tokens of divine intervention. They served as reminders of God's saving action on behalf of certain representative figures within Israelite and early Christian myth. But these *tekmeria* leave undisclosed and hidden the true *eidos* of divinity.

As has been often remarked, these early Christian signs and symbols come to us in an abbreviated and abstract form.[23] Once again, on the Philodemean analogy, the physician offers a diagnosis based on symptoms that typically reflect only a fraction of the disease, and the sea captain,

Figure 7.2. Callixtus catacomb. Area I, A2, north wall, upper register, large lunette over loculus: boat listing at sea, right end (stern?) upended with rudder (?) exposed, sails furled to the yard—possibly the storm described in Jon 1:4. Left end of vessel: standing orant, facing front, dressed in a belted tunic (*tunica exomis*). Left of the vessel: man overboard, arms flailing in the heavy sea. Upper left: head and one arm of a bust (a divinity, perhaps Helios) enclosed within a *clipeus*—the arm is extended to the head of the *tunicatus* on board the boat: this must be a *diui interuentus*. Rome.

equally dependent on a part of the whole, must interpret larger weather systems based on the microenvironment, the prevailing local winds, the circumambient seas. Without training and experience, the chances that either will get it right are very remote. So also the Callistus Christians— they too were confronted with only a small part of the whole, in the case of a laconic family of signs and symbols redolent of a larger belief system. But without some prior knowledge of the larger narrative context and the matrix of belief that had inspired it, their chances of interpreting these images as they had been intended were not very great. Even today, to the uninitiated outsider the Callistus catacomb frescoes consist in a collection of images that add up to a pictorial scramble. In other words, as abbreviated signs and abstract symbols, as symptoms of a larger whole, the Callistus paintings presume a preexistent catechetical tradition, consisting in the public and private reading of Scripture, in homiletics and instruction in the faith.

It is likely in my view that the Callistus paintings reflect a primitive Christian tradition of funerary prayer,[24] although, given the nature of the evidence, definitive proof is impossible. Scholars have debated this issue

at least since the 1870s, and critical problems perdure, but it is still the best explanation of the probable context in which the earliest cycle of Christian salvation images was first formulated and executed. There is probably an intended correlation between certain of the images at Callistus and selected petitionary paradigms that figure prominently in early Christian prayers offered on behalf of the dead. Unfortunately, due to problems of chronology, it is impossible to prove this connection.

— The petitionary formula of *ordo commendationis animae*,[25] for example, sets forth the demand that God free the soul of the deceased (from the power of death) as in the past he had freed certain paradigmatic figures from death and oppression ("Libera, Domine, animam ejus sicut liberasti . . ."). The figures mentioned in the prayer include Enoch and Elijah, Noah, Abraham, Job, Isaac, Lot, Moses, Daniel, the three youths in the fiery furnace, Susanna, David, Peter and Paul (*de carceribus*), and Thecla. Isaac, Moses, and Daniel appear as salvation types in the Callistus paintings, and in the later third century, Elijah, Noah, the three youths, Susanna, David, and Peter were added to the iconographic repertory. In short, it appears that some of the salvation images on the catacomb walls and ceilings may connect with some of the petitionary paradigms attested in early Christian funerary prayers.

— Chronology is still the main critical problem. None of the petitionary

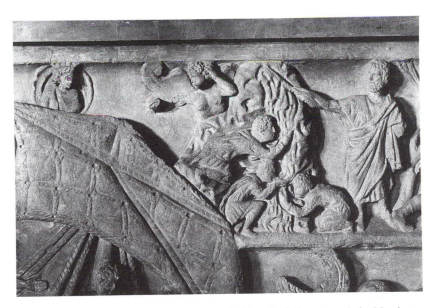

Figure 7.3. Lateran frieze sarcophagus 119. Detail of the upper left side showing (above the sail) the bust of a god (*coronatus:* Helios) enclosed within a *clipeus. Vatican City, Museo Pio Cristiano.*

prayers, whether funerary or nonfunerary, can be dated before the fourth century, at the very earliest. Thus there can be no positive proof of a historical connection between funerary iconography at a place like Callistus and petitionary prayers based on biblical paradigms. One needs to add, however, that the petitionary prayers may well have circulated in a spoken form long before they were committed to writing.

One of the earliest and most intriguing pieces of material evidence attesting the conjunction of the familiar prayer paradigms with accompanying visual images is the famous Podgoritza[26] plate (Figure 7.4), which was found (circa 1870) near the site of Doclea in Dalmatia and is presently in the collection of the Hermitage. At the center of the plate is Abraham's near sacrifice of his son, and above Abraham's head (reading clockwise) the subjects represented include Jonah, Adam and Eve, Lazarus, Moses striking the rock, Daniel, and Susanna. Running round the outer edge of the plate, the accompanying inscription (beginning with Jonah) reads as follows:

> DIVNAN DE VENT/RE QVETI LIBERATVS EST
> ABRAM ETET EV/AM
> DOMNVS/LAIARVM/resuscit/at
> Petrus uirga perq/uouset/fontis cipe/runt quore/re
> DANIEL DE LACO/LEONIS
> TRIS PVERI DE ECNE/CAMI
> SVSANA/DE FALSO CRI/MINE
> *CIL* 3 (Suppl. I–3) 10190; *ILCV* 2426

The date of the Podgoritza plate is not known. The fact that Peter[27] has replaced Moses as the figure striking the rock suggests a post-Constantinian setting. Furthermore, the three youths[28] (*tris* [sic] *pueri*) and Susanna[29] do not appear in the surviving early Christian iconographic repertory until the late Tetrarchic or Constantinian periods. The closest parallel is a glass plate[30] (Figure 7.5) discovered (1866) in Cologne and presently in the British Museum. In format and pictorial subject matter the German example is very similar to the Podgoritza plate, and there can be little doubt but that this parallel piece is the product of a Rhenish glass foundry that was active in the middle or late fourth century. Based on this parallel, it might be reasonable to assign the Dalmatian piece to a fourth-century setting.

It would also be reasonable to connect the Podgoritza plate (like its Rhenish parallel) with a funerary setting. The Dalmatian piece must have been deposited sometime in later antiquity within a protected space (presumably a grave), but for lack of detailed information concerning the findspot and circumstances of discovery, we have no proof. Unlike the Callistus paintings, which due to context demand a funerary interpretation, the Podgoritza plate may or may not have been conceived with funerary purposes foremost in mind. It could also have been used for some nonfunerary purpose during the lifetime of the deceased and then perhaps deposited along with other grave goods at the time of his or her death.

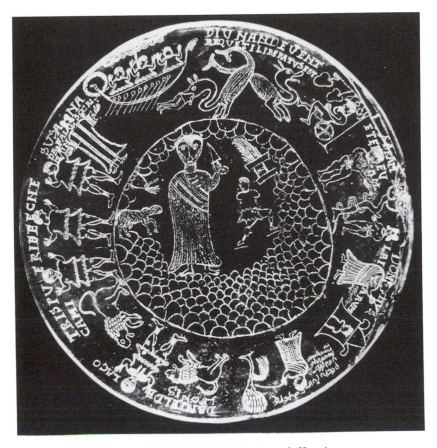

Figure 7.4. Podgoritza plate. Reg. no.ω73. *Leningrad, Hermitage.*

But despite the uncertainties of context in interpreting the Podgoritza plate, the simple conjunction of saving iconography and biblical paradigms cannot be gainsaid. A similar joining of word and image could have occurred earlier than the fourth century, for example at Callistus in the third century. We have no contemporaneous literary proof that it did, but there is equally no good reason to forbid the possibility. As we have already noted, the Callistus paintings come to us in a chthonic world of the dead. Clearly their purpose was to provide meaning for the living, light in the midst of impenetrable darkness. In this sad and forlorn setting, paintings were introduced to give hope to the community of the living. They were conceived as *tekmeria theou,* signs of God's saving power, which he had exhibited in the past by choosing certain representative figures and bestowing on them special forms of deliverance from oppression and death. The function of these paintings was to lift the minds and hearts of the survivors, to provide meaning in a place filled with despair. In short, these

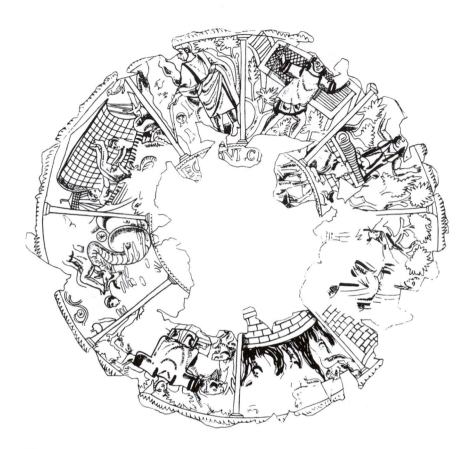

Figure 7.5. Glass plate from the Ursulagartenstrasse, Cologne. Dalton (1901) no. 628. London, *The British Musuem*. Reg. no. S.317.

paintings were designed to give the survivors a glimpse of their living and life-giving God.

Visible Religion

Sometime in the late Antonine–early Severan period Christians began to experiment with expressions of their own distinctive cultural independence. One of the clear indicators that this process had been set in motion is the material definition that Christianity gradually acquired, beginning in the middle Severan period. The process was slow. The initial steps were unquestionably in the nature of an experiment. We cannot be very precise about chronology, but clearly the emergence of Christianity as a materially defined, separate religious culture belongs to the later end of the second century. Based on the archaeological examples we have surveyed (Annius'

shepherd lamps, Wulff 1224, the Callistus paintings), it is evident that Italian Christians conducted their version of this experiment in a highly conservative manner. Their own separate material culture emerged only gradually, indeed almost imperceptibly, and entirely within the framework of already-existing Romano-Campanian workshop traditions.

Based on the cumulative weight of archaeological and literary evidence, it is tempting to draw the inference that during the first six or seven generations of its history Christianity was an intentionally clandestine movement, an underground, somewhat ragtag assemblage of outsiders and assorted misfits who followed the Nazarene despite the dangers, the obstacles, and the dictates of common sense. Celsus' rabbinic source certainly was on target in this degree: Christianity came into the world under a cloud of obscurity, disgrace, and suspicion. Even by Palestinian standards, the founder of the movement was a nonentity, and his arrest, trial, and execution showered disgrace and shame on him, his family, and his friends. Under circumstances such as these, it makes sense that the people who followed Jesus would have wanted to conduct their affairs (especially their religious affairs) in a clandestine manner. The last thing they would have wanted, one would think, was to draw attention to themselves as followers of a man whom the Romans had tried and executed as a common criminal.

There is a cognate development that relates to this matter of intentional secrecy, namely the apologists' portrayal of Christianity as a religion devoted entirely to the interior life, a noetic, spiritual, and philosophical brand of religion. If this were an accurate representation of the real-life setting, then it would tend to complement the intentionally clandestine character of the new religion, or in any case there would be no contradiction. As we have seen, the apologists portrayed themselves and their coreligionists as worshipers of an invisible God, and they represented their form of worship as purely spiritual and interior, devoid of the external paraphernalia and man-made contrivances that characterized traditional religion. The apologists' portrayal of themselves and their coreligionists calls to mind Molinos' and Fénelon's quietistic challenge to the Catholic idea that legitimate forms of religion necessarily involve a public and visible component. If we were to take the apologists at their word, then we might conclude that early Christianity, if not intentionally clandestine, was at least a private, withdrawn, and quietistic form of religiosity, an interior and noetic disposition. As I have already said, this would complement the other picture of the earliest Christians, namely that for the first two centuries of their history they skulked about in the shadows for fear of being found out.

But both of these are caricatures. By first-century, Judean standards Jesus' life circumstances were no doubt obscure, but once he had made the decision to embark on a public career, his behavior was hardly secretive. If he had wanted to hide out, he would have remained in Nazareth: the trip to Jerusalem and his behavior there belie the presumption. Paul

was not what one would call a skulker, and Luke who wrote Acts was
clearly eager to put a public face on the new religion. As for the apologists,
despite the way they characterized themselves and their coreligionists,
they too were primarily concerned to draw Christianity into the public
realm. They sought to make their religion accessible, intelligible, and,
above all, visible. The idea that they were hiding their religion or that they
were promoting a form of religiosity that was secretive, intentionally pri-
vate, withdrawn, and hidden is demonstrably false.

Here a modicum of common sense would help. The apologists made
numerous claims that they then promptly contradicted. They said divinity
could not be described, then they described God. They said divinity could
not be contained or in any way circumscribed, then they proceeded to
elaborate how God is contained in the Logos. They portrayed themselves
as quietists, then set about to put political, judicial, and social demands on
their addressees. They said that no one could see God, but in the same
breath they spun out elaborate visual metaphors describing God's visual
and palpable presence in the world. In short, what was said and what was
meant were often two very different things in the literature of early Chris-
tian apology. For the purposes of further study in the history of the second
and third centuries, it might be helpful to keep this fact in mind. There
can be no doubt, for example, but that the apologists sought to put Chris-
tianity on a public and visible footing. They invited public scrutiny and
sought public respect. Thus on the example of apologetic literature, the
claim that pre-Constantinian Christianity was intentionally clandestine
and invisible makes no historical sense.

Unfortunately, the term *crypto-Christian* (borrowed from the study of
early Christian epigraphy)[31] has now entered the ranks of accepted no-
menclature within the study of early Christian art and archaeology. Con-
trary to Kaufmann[32] (proposing that the term implies only an absence of
distinctively Christian characteristics), crypto-Christian instead suggests
that the new religionists pursued intentionally clandestine, arcane,[33] in-
visible strategies. With application to material culture, crypto-Christian
suggests that the new religionists manipulated their physical environs in
ways that were intentionally secretive and deceptive—for example, by
devising clandestine signs (crosses) and symbols (fishes), acrostics
(ΙΧΘΥΣ), palindromes (SATOR/AREPO),[34] and other esoterica in order to
communicate with one another.

Crypto-Christian is now applied to a wide variety of settings (iconogra-
phy included), but clearly the most common (and so far the most
egregious) applications are in the epigraphic realm. Guarducci's famous
(infamous?) study[35] of the so-called cryptographic graffiti in the Vatican
necropolis is the single best-known example. Testa's lucubrations[36] on
what he styles Jewish-Christian, Palestinian cryptographs and secret signs
also illustrate nicely the indiscretions and excesses to which this genre of
scholarship is prone. As a technical term that purports to describe how and
why Christians gradually formulated their own distinctive material cul-

ture, including their own public inscriptions, signs, and symbols, *crypto-Christian* is a bad one, and the world of scholarship would never miss its disappearance.

Admittedly, Christianity came into this world under obscure (that is, humble) conditions. It also met with opprobrium in several places, not least because it was a religion that lionized a man who was at once a barbarian and a criminal. But the followers of Jesus did not go underground hiding themselves away in obscurantist conventicles. Instead, they made every effort to expose themselves and their teaching to public scrutiny. Pre-Constantinian Christianity was not a mystery religion[37] (with its own "arcane discipline"),[38] and (unlike neo-Pythagoreans, for example) the new religionists did not gather secretly in esoteric or occultist cliques. Catholic Christians were not quietists, gnostics, occultists, or theosophists. It has become become faddish to portray early Christianity in this light (thanks in part to the modern creation of the gnostic industry, with universalist pretenses: "Gnosis als Weltreligion" [*sic*]),[39] and early Christian archaeology, alas, has not escaped this misleading line of thought.

But in fact there is a steady line of development from Jesus through Paul and the apologists in the direction of a continuous early Christian desire for greater visibility and public recognition. For the period that concerns us in this book, the apologists are the main carriers of this line. They were champions of public and visible religion in a time when Christianity was largely an unknown quantity to outsiders. They sought to put a public face on the new religion, and in considerable degree they succeeded. Without the groundwork laid by the apologists, the Eusebian-Constantinian program of making Christianity visible in dramatic architectural and iconographic forms is simply unthinkable.

The birth of Christian art represents one of several late second-century developments heralding the gradual coming of age and emergence of a separate, materially defined religious culture. Prior to the Severan period, Christians were adapted to their physical environment to such a high degree that they were materially invisible. This was not the consequence of a conscious Christian strategy to remain a hidden minority, but instead it was an unintended consequence of the new religionists' social, political, and economic immaturity. In the Antonine-Severan period conditions began to change (in some places dramatically), and as a consequence the new religionists could begin to acquire the kind of material visibility that hitherto they had lacked. Subterranean Callistus is the earliest clear manifestation of this new visibility.

As the new religion gradually emerged from its unintended obscurity, so also the invisible God. The process was slow, the route indirect. From the Hebrew Bible and from their own Scriptures, the new religionists chose to illustrate certain well-known soteriological types. They did not illustrate God the Father, although from the beginning of their iconographic tradition Christians did illustrate God the Logos, albeit under the guise of generic types (shepherds, for example) that were already well

established within the Greco-Roman iconographic repertory. Long before 200 Christians had engaged in the literary production of visual metaphors for God, but now, at the beginning of the third century, they began to fashion the visual counterparts of these metaphorical types.

In the early fourth century, with the added patronage of the State, this process of making Christianity and its God visible was intensified to a degree that had been inconceivable before Constantine. Eusebius' speech (*HE* 10.4.2–72), delivered (circa 315) on the occasion of the dedication of Bishop Paulinus' "temple" (νεώς/ναός) at Tyre, reveals the extraordinary extent to which the invisible God of the Christians was becoming palpable and visible in late Roman society.

Drawing on the Psalmist, Eusebius contrasts God's words (*logoi*), which Christians had heard with their ears (Ps 44:1) and which long ago they had committed to memory, with God's deeds (*erga; HE* 10.4.6), which Christians could now see embodied in the Tyrian temple, Paulinus' basilica. Eusebius then plays on this *logos/ergon* antinomy in the same way that Thucydides[40] had done seven centuries earlier. Both writers invest *logos* with the force of words and opinions, whereas *ergon* suggests deeds and facts. Previously Christians had been privy only to God's words. Now, under the new Christian dispensation, people could see God in action, and Eusebius construes this vision of divinity embodied in a building as a vindication of the truth claims on which Christianity was founded. He is at pains to underscore God's presence in Paulinus' basilica, and to that end he quite consciously invokes pagan architectural nomenclature[41] in order to underscore the visible continuities between the old and new *hiera*. He writes that the new Christian *neos/naos* had replaced all previously existing temples and sanctuaries, that the Son of God had created an edifice (οἰκοδομή) in his own exact image and likeness and that he had bestowed upon this visible edifice the very properties of divinity, including an "immortal, incorporeal, and rational *physis*" (*HE* 10.4.56). In short, what had been denied to Claudius Callistus in early fourth-century Rome was evidently being granted to Constantine and his Caesarean propagandist at the very same time but in a different place, namely the venerable and celebrated Phoenician island-city on the Levantine littoral.

A New Synthesis

With twin roots in Byzantium and Reformation Europe, nineteenth-century scholarship invented a picture of early Christianity as a religion of uncompromising hostility to the representational arts, painting and sculpture. Early Christians were represented as *Bilderfeinde*, iconophobes in theory, aniconic in practice. Absence before 200 of identifiably Christian forms of art was drawn in to support the theory, on the supposition that if Christians produced no art before the third century they must have been opposed to art. Analogies with Jewish iconophobia were also adduced, on the further presumption that whatever went on within the parent stock

must have been continued almost as a kind of second nature within the Christian offspring. Indeed, the absence not just of art but of all identifiably Christian material culture before 200 has become the basis of numerous broad-ranging generalizations and inferences, such as the portrayal of the earliest Christians as spiritual, antimaterialistic, and purely otherworldly persons who eschewed all contact with their physical environment.

My view of this subject is different. The portrayal of early Christianity as a religion on principle hostile to the pictorial arts rests I believe on several misleading assumptions, the most egregious being a literalistic reading of selected passages within early Christian apologetic literature. In fact, absence before 200 of distinctively Christian material culture (art included) says nothing about Christian attitudes toward art. As I suggested in Chapter 5, absence of evidence is just that, no evidence, silence—the latter is always difficult to interpret but should never be confused with negative evidence, which is quite another thing.

It is true that Christians were an obscure group for the first several generations of their history; it is also true that materially speaking they were an invisible community before the early third century. But both of these factors are the unintended consequences of circumstances that were largely beyond the control of the communities involved. Obscurity and invisibility were not goals that Christians pursued either actively or passively at the beginning of their history.

A much stronger case can be made for the opposite point of view, namely that from their earliest Palestinian beginnings Christians sought to put their religion on a public footing, to make it accessible and visible to outsiders. Part of this drive toward greater visibility involved the creation of a distinctive material culture, and art was one of its components. Admittedly, this development came relatively late, as I have argued, almost certainly not before 200. But to repeat, this tardy arrival was an unintended consequence of political, social, and economic factors.

Making their God understandable and visible and public was a large part of the early Christian impulse leading to the creation of distinctive material forms, but at the same time disclosure of this God did not require that Christians compromise the theologoumenon concerning their God's essential invisibility. The signs and symbols that early Christians chose were illative and mediated, not direct and unmediated. Considering the premise, that divinity is absolutely invisible, it is difficult to imagine how things could have turned out otherwise. And given the premise of God's essential invisibility, it is difficult to imagine in what visual form a direct and unmediated disclosure of divinity would have taken place within early Christianity.

The key to interpreting our subject intelligently lies in the comparison and contrast of two principal bodies of evidence, the one apologetic literature, the other wall and ceiling frescoes. The latter constitute the oldest surviving corpus of community-supported and distinctively Chris-

tian pictorial art. At first glance, literature and frescoes seem to have little
in common, but I believe there is more than meets the eye. Efforts to
represent these two as conflicting and contradictory and unrelated are
unconvincing, in my view. Klauser's presumption, for example, that liter-
ature was produced by educated clerymen and paintings by ignorant laity
represents a step backward in our understanding of second- and third-
century history—this is little more than a modern cleric's rearticulation of
an ancient prejudice against people who make or cultivate pictures. Apolo-
getic literature and catacomb paintings are more correctly described as
complementary expressions of the same phenomenon, namely the drive
toward greater public recognition, acceptance, and visibility, together
with the early Christian effort to bring the invisible God out into the open.

As we have seen, the apologists attacked Greek art. To sustain the
argument they created a literary triangle, they and their addressees mak-
ing up the two strong sides of the triangle, the common enemy the weak
third side. The triangle is a literary fiction with a purpose. The apologists
wanted simultaneously to flatter and impress their addressees. Since they
were defending themselves against the charge of superstition, they also
needed an enemy, and the ignorant man-in-the-streets, mired in the muck
of iconic superstition and degradation, served their purposes quite nicely.
So far as I am aware, everything the apologists had to say about Greek art is
a function of this triangular artifice.

The apologists also represented themselves and their coreligionists as
paradigms of philosophical aniconism: they and their cohorts recognized
that true divinity was invisible. In consequence of this theologoumenon,
they portrayed Christians as persons who worshiped God in an interior,
noetic, and purely spiritual manner. This is clearly an idealization. I do not
mean to suggest that the apologists were disingenuous on the subject of
God's invisibility. It seems altogether probable that the apologists took
this teaching with the utmost seriousness and that they were sincere in
their oft-stated conviction that image worship was absurd and image
worshipers pitiable fools. It also happens to be the case that both argu-
ments, the attack on Greek art as well as self-portrayals under the um-
brella of philosophical aniconism, advanced the apologists' cause—this
was no accident. The apologists sought to make Christianity a recognized,
repected, and visible form of Greco-Roman religiosity. How could their
addressees, who espoused the selfsame values, fail to be impressed?

As for the imperial image, possibly it played a minor role in the
formation of early Christian attitudes. But interestingly, this is not a major
item in the apologists' agenda, I suspect because it was such a hot issue.
Caesar's image did play a role in real life. Following Pliny's precedent,
Roman magistrates exploited the imperial bust in judicial *cognitiones* of
Christians. They put it to use specifically to test the loyalty of defendants
who had denied in court their membership in the new religion. This test
of loyalty could have dampened the new religionists' enthusiasm for the
use of portraits in their own religious settings, although I hasten to add

that this is just a theory. In any event, the absence of portraits depicting Jesus or Mary or the disciples is a conspicuous feature of all third-century Christian figural traditions, and one can only speculate about the degree to which Pliny's courtroom behavior may have contributed to this state of affairs.

— Christianity was a late Hellenistic form of religiosity. It was ecumenical and inclusive, its purposes as much public and visible as private and personal. For the first two centuries of its history, the new religion exhibited a high degree of assimilation and adaptation to Greco-Roman culture. At the beginning of its history and for several generations thereafter, Christianity possessed none of the separate ethnic and cultural identity that characterized Judaism. This worked as much for Christianity as it did against it. Because Christianity was not an ethnos and because it lacked a separate cultural identity, the new religion also possessed no distinctive material definition. The latter came about only very slowly over the course of the second century as Christians began to formulate their own separate identity vis-à-vis Greco-Roman culture. The evidence attesting this separation process is extremely fragmentary and difficult to interpret. But it is clear I think that both the apologists and the people of the Callistus catacomb were occupied in varying degrees with a common goal, namely the desire to make people "see" their God and the desire to put the best possible public face on the new religion. Both succeeded. The failure of our *uir perfectissimus* with regard to the first of these goals perdures. It remains an enigma.

Notes

1. This should be read as *U(ir) P(erfectissimus)*, not as is often suggested *U(ir) E(gregius)*. *CIL* and *ILCV* give the latter, which is incorrect; cf. A. Ferrua, *SussSACr* 7 (1981), ad loc. The earliest attestation for *p(erfectissimus) u(ir)* is *CIL* 6.1603 (A.D. 201). By the time of the *Notitia Dignitatum* (early fifth century), the title had disappeared.

2. Christian euphemistic formulas (*in pace abire, cessare, decedere,* etc.) for death, see F. Grossi Gondi, *Trattato di Epigrafia Cristiana* (Rome, 1968), 177–85.

3. I.e., DIGNITATIS.

4. At *ICVR* 3.8470, Antonio Ferrua gives the following paraphrase: "Callistus magnas dignitates uidit (= *adeptus est* [Eng. "attained"]), sed desiderio uidendi dei non frunitus est diu eis et mox obiit"; cf. A. Ferrua, *Epigrammata Damasiana*, *SussSACr* II (Vatican City, 1942), 207, n. 4.

5. *Depositus* = Christian terminus technicus: *ILCV* III, s.v.

6. SIVE HILARO: "Hilarius" was evidently an alternative (presumably a preferred [?]) cognomen, which Mommsen (*Hermes* 37 [1902], 446ff.) dubbed a *signum* (*Schlagname* or *Rufname* but not, he insisted, a *Spitzname*); see E. Diehl, *RhM* 62 (1907), 390ff., esp. 406–20. The phenomenon (alternative cognomina with -*ius*, -*ia* suffixes, commonly attested epigraphically in the genitive, less commonly [as here] in the dative) is widespread among fourth-century Roman aristocrats and bureaucrats, infrequent among *liberti* and not epigraphically attested in the slave population. This is an especially conspicuous idiosyncracy in fourth-century Chris-

tian circles, but its precise significance is still debated; see I. Kajanto, *AIRF* I.2 (1963), 65–66. In place of *sive, qui et* and *signo* are also attested; see *ILCV* 4315 (= *ICVR* 5.14067): "Valeria Calliope que et Anucella"; 4474: "Simplicuus signu Mus[cio]"; *ICVR* 4.12611: "Egnatio Reddito signu Casulio."

7. On the long stairway that leads down from the Tor Marancia property and the Ampliatus cubiculum at the foot of the stairway: P. Styger, *Die Römischen Katakomben* (Berlin, 1933), 95–99. Ampliatus frescoes: A. Nestori, *Repertorio topografico delle pitture delle catacombe romane* (Vatican City, 1975), 125 (cubiculum 49); also P. Testini, *RivAC* 28 (1952), 77ff., and A. Ferrua, *RivAC* 36 (1960), 173ff. For an informative study of the stairway in relation to gallery D on level 2, cf. P. Pergola, *RivAC* 51 (1975), 65–96.

8. Funerary libations in the Vatican necropolis beneath St. Peter's: J. M. C. Toynbee and J. Ward Perkins, *The Shrine of St. Peter* . . . (London, 1956), 61, n. 30; 119, no. xviii; 145–46 and fig. 13.

9. Nomenclature that fell into disuse during the Constantinian period; see O. Hirschfeld, *SbBerl* (1901), 588 = *Kleine Schriften* [Berlin, 1913], 656: A.D. 321 marks the latest use of *uir egregius*.

10. As assumed, for example, by C. Carletti, *Iscrizioni Cristiane di Roma* (Florence, 1986), 84.

11. Hirschfeld, *SbBerl.* (1901), 584–90.

12. *ILCV* 274: "lugit coniux cum liberis, fletib(us) familia prestrepit . . ."

13. Thus Diels and Kranz, *Vorsokr.*, 1.B26 frag. (Xenophanes):

αἰεὶ δ' ἐν ταὐτῶι μίμνει κινούμενος οὐδέν
οὐδὲ μετέρχεσθαί μιν ἐπιπρέπει ἄλλοτε ἄλληι.

At issue here is the idea of theological adequation, the effort to find epithets that are appropriate or adequate to divinity. In the Hellenic world this exercise begins with Xenophanes and has a long afterlife; on the latter, see W. W. Jaeger, *The Theology of the Early Greek Philosophers* (Oxford, 1947), esp. 50ff.; also M. Pohlenz, *GöGN* (1933).

14. For full discussion: K. E. McVey, "The Use of Stoic Cosmogony in Theophilus of Antioch's *Hexaemeron*," in *Biblical Hermeneutics in Historical Perspective: Studies in Honor of Karlfried Froehlich* . . . , ed. M. S. Burrows and P. Rorem (Grand Rapids, Mich., 1991), 30–56.

15. *Corpus Hermeticum*, vol. 1, ed. A. D. Nock and A.-J. Festugière (Paris, 1960), Treatise 5.6–8.

16. Which he had just compared (*Mem.* 4.3.14) to the wind, which one cannot see, although its effects are manifest: καὶ ἄνεμοι αὐτοὶ μὲν οὐχ ὁρῶνται, ἃ δὲ ποιοῦϐι φανερὰ ἡμῖν ἐϐτι καὶ προϐιόντων αὐτῶν αἰϐθανόμεθα.

17. Thus, *Nat.* 1.99, 8.2; *Julian* 2.16; *Virg.* 7.5–15, 30, 31; cf. K. E. McVey, *Ephrem the Syrian Hymns* (New York and Mahwah, N.J., 1989), 36–47.

18. E.g., *Conf.* 13.28–35; see A. Holl, *Die Welt der Zeichen bei Augustinus* (Vienna, 1963).

19. Philod. *Rhet.* I.369, col. 87:

. ᾿Αξιον] δ' ἐπιστ[ά-
σεω[ς] τὰς μὲν ἀτέχν[ους
κοινὰς ἁπάντων ὑπά[ρ-
χε[ι]ν, τῶν δ' ἐντέχνων τ[ὸ
εἰκὸς καὶ τὸ σημεῖον

καὶ τὸ τεκμήριον οὐ-
θέν αὐτοῖς προσήκε[ι]ν, ἀλ-
λὰ τὸ μὲν σημεῖον εἶ-
να[ι] τοῦ παρηκολουθη-
κότος ἴδιον, οἷον τὸ μὲν
ἐν νόσοις ἰατρ[ῶν], τὸ
δ' ἐν τοῖς περὶ τὸ πλεῖν
χ[ειμῶ]σιν κυβερνή-
τον, παραπλησίως [δ]ὲ καὶ
ἐπὶ τῶν ἄλλων· τὸ δ' εἰ-
κὸς [το]ῦ παραθεωρή-
σαν]τος, πῶς τε
. . . . αὐτοῦ προ

On the distinction between Epicurean and Stoic conceptions of *semeion:* Philod. *Sign.* 157ff.

20. C. Geertz, "Religion as a Cultural System," in *Anthropological Approaches to the Study of Religion,* ed. M. Banton (New York, 1965), 1ff., esp. 3–8.

21. M. Douglas, *Implicit Meanings* (London, 1975).

22. In Area I/A2, north wall (upper register) at the upper left end of the storm scene on the large lunette, a bust is enclosed within a *clipeus.* The figure within the *clipeus* reaches across to touch the head of the figure standing on the deck of the listing vessel. This I think must be the visual equivalent of a *diui interuentus/ intercessus* which does not have a literary prototype in the *Jonah* narrative. The *imago clipeata* clearly represents a divinity, quite likely Jonah's God, ʏʜᴡʜ. Within the Callistus corpus this is a hapax; see A. Krücke, *MarbJb* 10 (1937), 1–10. For a parallel in a Tetrarchic (Christian) context, see Lateran 119 (*Rep.* 35; Figure 7.3): at the upper left end of the sail, yet another *imago clipeata*—the figure has a crown sitting on the top of a thick head of hair and may be intended as Helios (?).

23. V. Weidlé, *The Baptism of Art: Notes on the Religion of the Catacomb Paintings* (London, 1950), 10: drawing attention to the "curious curtness" of early Christian art. Weidlé is still worth reading, although his inference (based on the inaccurate assessment of the formal character of early Christian art) that the new religionists were completely indifferent "to art as such" represents an intellectual historian's ignorance of Roman workshop tradition. Mediocre painting, such as survives at Callistus, says nothing about the buyer's like or dislike of painting—it does say something about his pocketbook. The theoretical basis for Weidlé's use of the term *signitive* as a descriptive category (a good one, in my view) of early Christian art is found in his essay, "Über die kunstgeschichtlichen Begriffe 'Stil' und 'Sprache,'" in *Festschrift für Hans Sedlmayr* (Munich, 1962), 102ff. On "die ver-kürtzte Fassung biblisher Themen," Th. Klauser, *JbAC* 4 (1961), 138ff. offered a solution: the abbreviated forms are to be explained as the result of miniature images, which were first executed for intaglios to be worn as fingerrings, e.g. p. 139 (. . . "die Ringgemmen. Sie scheinen uns in der Tat die ursprüngliche Heimat der frühen biblischen Kompositionen der altchristlichen Sepulkralkunst gewesen zu sein"). I shall express my view of this subject in my forthcoming catalogue of intaglios in the British Museum.

24. Scholarship on this subject begins with E. le Blant's *Le sarcophages chré-tiens de la Gaule* (Paris, 1886) and by the same author, *Étude sur le sarcophages chrétiens de la ville d'Arles* (Paris, 1878); also important: D. Kaufmann, *RÉJ* 14

(1887), 33–48, 217–53, and K. Michel, *Gebet und Bild in frühchristlicher Zeit* (Leipzig, 1902). A. Stuiber's *Refrigerium Interim. Die Vorstellungen vom Zwischezustand und die frühchristliche Grabeskunst* (Bonn, 1957) is the most recent discussion of this subject.

25. Stuiber, *Refrigerium Interim*, 169ff.

26. P. Levi, *Heythrop Journal* 4 (1963), 55–60 (with the literature cited there). This object is not a cup but a broad, shallow dish, closer to a *patera* than to a *poculum;* A. Bank, *Byzantine Art in the Collections of the Soviet Museums*, trans. L. Sorokina, 2d ed. (Leningrad, 1985), pls. 26–29: B. correctly identifies it as a *patera*. My sincere thanks to Professor Robert Murray, S.J., of Heythrop College, London for photographs of the plate.

27. E. Dinkler, *MarbJb* 11–12 (1938–1939), 1ff., and P. van Moorsel, *RivAC* 40 (1964), 221ff. For the legend (Acta Petri) of Peter's incarceration in the Mamertine prison and an *interpretatio christiana* of the Tullianum, which flows at the foot of the Capitoline, see Pio F. de Cavalieri, *ST* 22 (1909), 35ff.; also R. A. Lipsius, *Acta Apostolorum Apocrypha* (Leipzig, 1891), 6–7; and idem, *Die Quellen der römischen Petrussage* (Kiel, 1872), 128–29.

28. The earliest catacomb fresco showing this subject is in the so-called *cappella greca* in Priscilla and dates ca. 300; on the dating of the Priscilla complex, see F. Tolotti, *RHE* 73 (1978), 281ff. For a survey of the iconography (frescoes and relief sculpture), see C. Carletti, *I tre giovani ebrei di Babilonia nell'arte christiana antica* (Brescia, 1975).

29. Susanna in the *cappella greca* (Priscilla), see A. Nestori, *Repertorio*, 27 (no. 39); in Peter and Marcellinus, see ibid., 55 (no. 51), 60 (no. 71); in Praetextatus, the Celerina arcosolium, Susanna as a sheep in three-quarter view flanked by confronting wolves, see ibid. 87 (no. 5). Reliefs: *Rep.* 54, 156 and passim; the most important fourth-century relief rendition is found on the sarcophagus of Gerona (Gerundensis in Catalonia): G. Wilpert, *I sarcofagi cristiani antichi*, vol. 1 (Rome 1929–1939), Tav. 196.1; also P. Testini, in *EC*, s.v. "Susanna."

30. Dalton (1901) no. 628.

31. C. M. Kaufmann, *Handbuch de altchristlichen Epigraphik* (Freiburg, 1917), 59ff. Toynbee and Ward-Perkins, *Shrine of St. Peter*, 191, n. 61: "crypto-Christian formulae" in the Piazzuola beneath San Sebastiano. On the Eumeneian formula (ἔσται αὐτῷ πρὸς τὸν θεόν) as a crypto-Christian convention: G. J. Johnson, "Roman Bithynia and Christianity to the mid-fourth century" (Ph.D. diss., University of Michigan, Ann Arbor, 1984), 28ff. But for a fresh breath of air, see W. Wischmeyer, *Griechische und lateinische Inschriften zur Sozialgeschichte der Alten Kirche*, (Gütersloh, 1982). Wischmeyer happily avoids the term altogether.

32. Kaufmann, *Epigraphik*, 59–60: "kryptochristlich, d.h. ohne besondere christliche Kennzeichen."

33. O. Perler, in *RAC* 1 (1950), s.v. "Arkandisziplin."

34. This subject has produced mountains of scholarly gibberish. Still an intelligent introduction: C. D. Gunn, "The Sator-Arepo Palindrome . . ." (Ph.D. diss., Yale University, 1969), with an annotated bibliography. For additional bibliogrphahy and arguments connecting the word square with Mithraism, see W. O. Moeller, *ÉPROER* 38 (1973).

35. M. Guarducci, *I graffiti sotto la Confessione di San Pietro in Vaticano* (Vatican City, 1958); also eadem, *ArchCl* 13 (1961), 183–239, and *ANRW* II.16.2 (1978), 1736–73. Criticism: A. Ferrua, *RivAC* 35 (1959), 231ff.

36. E. Testa, *Il simbolismo dei giudeo-cristiani* (Jerusalem, 1962).

37. This is an old saw, on which see now W. Burkert, *Ancient Mystery Cults* (Cambridge, Mass., 1987), 3ff. (with the literature cited there); also essential: A. D. Nock, "Hellenistic Mysteries and Christian Sacraments," *Mnem* Suppl. 4.5 (1952), 177–213.

38. On which see O. Perler, in *RAC* 1 (1950).

39. Morton Smith, for one, fought valiantly to promote a less pretentious view of gnosticism (with a lower case "g"); see *Numen* Suppl. 41.1 (1980), 806–17. In retrospect, it seems he was fighting a losing battle.

40. E.g. 2.65; on *erga* vs. *epos/logos/mythos* in Thucydides, see E.-A. Bétant, *Lexikon Thucydideum* (Geneva, 1843), s.v.

41. νεώς: *HE* 10.4.1, 39, 40, 41, 42, 44, 45, 63, 65, 69; νηός τοῦ φεοῦ: 10.4.26, 46; βασίλειος οἶκος: 10.4.45, 63; οἶκος βασιλικός: 10.4.65; ἱερόν: 10.4.66; see P. C. Finney, *Boreas* 7 (1984), 193ff.; idem, *HTR* 81 (1988), 319ff. (with the literature cited there).

Selected Bibliography

Altendorf, H. D. "Die Siegelbildvorschläge des Clemens von Alexandrien." *ZNW* 58 (1967).

Attridge, H. "The Philosophical Critique of Religion under the Early Empire." *ANRW* II.16.1 (1978), 45–78.

Augusti, J. C. W. *Beiträge zur christlichen Kunstgeschichte und Liturgik.* Leipzig, 1841.

Bachofen, J. J. *Versuch über die Gräbersymbolik der Alten.* 2d ed. Basel, 1925.

Bagatti, B., and J. T. Milik. *Gli scavi del "Dominus Flevit"* 1. Jerusalem, 1958.

Barbet, A. "Une tombe chrétienne à Alexandrie." In *Colloque historique et historiographique. Clio* (Paris, 1980), 391–400.

———. "Les bordures ajourées dans le IVᵉ style de Pompéi." *MÉFRA* 93 (1981), 917–98.

Barnes, T. D. "Legislation against the Christians." *JRS* 58 (1968), 32–50.

———. "Pre-Decian Acta Martyrum." *JThS*, n.s., 19 (1968), 509–31.

———. *Tertullian: A Historical and Literary Study.* Oxford, 1971.

Baynes, N. "The Icons before Iconoclasm." *HTR* 44 (1951), 93–106.

———. "Idolatry and the Early Church." In *Byzantine Studies and Other Essays,* 116–43. London, 1955.

Becatti, G. *Arte e gusto negli scrittori latini.* Florence, 1956.

Becker, C. *Tertullians Apologeticum. Werden und Leistung.* Munich, 1954.

———. *Der Octavius des Minucius Felix. Heidnische Philosophie und frühchristliche Apologetik.* Munich, 1967.

Bendinelli, G. "Il monumento sepolcrale degli Aureli al viale Manzoni in Roma." *MonAnt* 28.2a (1922–1923), 289–520.

———. *Le pitture del colombario di Villa Pamphili.* Rome, 1941.

Bevan, E. R. "Idolatry." *Edinburgh Review* 243 (1926), 253–72.

———. *Holy Images.* London, 1940.

Beyen, H. G. *Die pompejanische Wanddekoration vom zweiten bis zum vierten Stil.* 2 vols. The Hague, 1938, 1960.

Bianchi-Bandinelli, R. "Continuità ellenistica nella pittura di età medio- e tardo-romana." *RivIstArch* 2 (1953), 77–161.

Bidez, J. *Vie de Porphyre.* Ghent, 1913.

Birt, T. *Laienurtheil über bildenden Kunst bei den Alten.* Marburg, 1902.

Blant, E. le. "Les bas reliefs des sarcophages chrétiens et les liturgies funéraires." *RA* 20–38 (1879), 233–41.

———. "Les actes des martyrs." *AIBL.Mémoires* 30 (1883), 57–347.

Bonner, C. *Studies in Magical Amulets Chiefly Graeco-Egyptian.* Ann Arbor, Mich., 1950.

Borda, M. *La pittura romana.* Milano, 1958.

Borries, B. de. "Quod veteres philosophi de idololatria senserint." Dissertatio. Göttingen, 1918.

Bosio, A. *Roma sotteranea.* Rome, 1632.

Bottari, G. G. *Sculpture e pitture sagre estratte dai cimiterj di Roma.* Rome, 1737–1754.

Bowersock, G. *Greek Sophists in the Roman Empire.* Oxford, 1969.

————, ed. "Approaches to the Second Sophistic." In *APA.Papers,* University Park, Pa., 1974.

Brandenburg, H. "Bellerophon Christianus?" *RQ* 63 (1968), 49–86.

————. "Das Grab des Papstes Cornelius und die Lucinaregion der Callixtus-Katakombe." *JbAC* 11–12 (1968–1969), 42–54.

————. "Überlegungen zum Ursprung der frühchristlichen Bildkunst." *CIAC.Atti* 9.1 (1978), 331–60.

Brenk, B. *Die frühchristlichen Mosaiken in S. Maria Maggiore zu Rom.* Wiesbaden, 1975.

————. *Spätantike und Frühes Christentum.* Frankfurt, 1977.

Brenk, F. E. *In Mist Apparelled: Religious Themes in Plutarch's Moralia and Lives.* Leiden, 1977.

Brunn, P. "Symboles, signes et monogrammes." *AIRF* I.2 (1963), 73–166.

Bruyne, L. de. "Refrigerium interim." *RivAC* 34 (1958), 87–118.

————. "L'importanza degli scavi lateranensi per la cronologia delle prime pitture catacombali." *RivAC* 44 (1968), 81–113.

Buchheit, V. "Tertullian und die Anfänge der christlichen Kunst." *RQ* 69 (1974), 133–42.

Butterworth, G. W. "Clement of Alexandria and Art." *JThS* 17 (1915), 68–76.

Campenhausen, H. von. "Die Bilderfrage als theologisches Problem der alten Kirche." *ZTK* 49 (1952), 33–60.

————. "Die Bilderfrage in der Reformation." *ZKG* 68 (1957), 96–128.

Carcopino, J. *De Pythagore aux Apôtres.* Paris, 1956.

Carena, M. "La critica della mitologia pagana negli apologeti greci del II secolo." *Didaskaleion* 1.2–3 (1923), 23–55.

Casel, O. "Älteste christliche Kunst und Christusmysterium." *JbL* 12 (1932), 1–86.

Carletti, C. *Iscrizioni cristiane di Roma.* Florence, 1986.

Cecchelli, C. *Monumenti cristiano eretici di Roma.* Rome, 1944.

Clerc, C. "Plutarch et la culte des images." *Revue de l'Histoire des Religions* 70 (1914), 107–24.

————. *Les théories relatives aux cultes des images chez les auteurs grecs du IIme siècle après J.C.* Paris, 1915.

Cole, T. *Democritus and the Sources of Greek Anthropology. APA.Philological Monographs* 25. 1967.

Crew, P. M. *Calvinist Preaching and Iconoclasm in the Netherlands 1544–1569.* Cambridge, 1978.

Cumont, F. *Recherches sur le symbolisme funéraire des romains.* Paris, 1942.

Daillé (Dallaeus), J. *De imaginibus.* Leiden, 1642.

Decharme, P. *La critique des traditions religieuses chez les Grecs.* Paris, 1904.

Dinkler, E. *Signum Crucis. Aufsätze zum Neuen Testament und zur Christlichen Archäologie.* Tübingen, 1967.

Dobschütz, E. von. "Christusbilder. Untersuchungen zur christlichen Legende." *TU* 18 (1899).

Dölger, F. J. *IXΘΥΣ* 5 vols. Münster, 1910–1957.

———. *Antike und Christentum.* Münster, 1929–1950.

Dorigo, W. *Pittura tardoromana.* Milan, 1966.

Droge, A. *Homer or Moses? Early Christian Interpretations of the History of Culture.* Tübingen, 1989.

Dvorák, M. "Katakombenmalerie. Die Anfänge der christlichen Kunst." In *Kunstgeschichte als Geistesgeschichte,* 1–40. Ed. M. Dvorák, Munich, 1928.

Duval, Y.-M. *Le livre de Jonas dans la litterature chrétienne grecque et latine.* Paris, 1973.

Eck, J. *De non tollendis Christi et sanctorum imaginibus . . . Decisio. . . .* Ingolstadt, 8 July 1522.

Effenberger, A. *Frühchristliche Kunst und Kultur.* Leipzig, 1986.

Eizenhöfer, L. "Die Siegelbildvorschläge des Clemens von Alexandrien und die älteste christliche Literatur." *JbAC* 3 (1960), 51–69.

Elliger, W. *Die Stellung der alten Christen zu den Bildern in den ersten vier Jahrhunderten. SCD,* n.s. 20. Leipzig, 1930, 1934.

Elmslie, W. A. L. "The Mishna on Idolatry, 'Aboda Zara." *TS* 8.2 (1911).

Eltester, F. W. *EIKON im Neuen Testament.* Berlin, 1958.

Fascher, E. "Deus Invisibilis. Eine Studie zur biblischen Gottesvorstellung." *MarbThSt* 1 (1931), 1–77.

Fasola, U., and P. Testini. "I cimiteri cristiani" *CIAC.Atti* 9.1 (1978), 103–39.

Ferguson, E. "Spiritual Sacrifice in Early Christianity and Its Environment." *ANRW* II.23.2 (1980), 1151–89.

Ferretto, G. *Note storico bibliografiche di archeologia cristiana.* Vatican City, 1942.

Ferrua, A. *Le pitture della nuova catacomba di Via Latina.* Vatican City, 1960.

———. "Paralipomeni di Giona." *RivAC* 38 (1962), 7–69.

Février, P.-A. "Le culte de morts dans les communautes chrétiennes durant le III^e siècle." *CIAC.Atti* 9.1 (1978), 211–74.

Finney, P. C. "Antecedents of Byzantine Iconoclasm: Christian Evidence before Constantine." In *The Image and the Word,* ed. J. Gutmann, 27–47. Missoula, Mont. 1977.

———. "Gnosticism and the Origins of Early Christian Art." *CIAC.Atti* 9.1 (1978), 391–405.

———. "Orpheus-David: A Connection in Iconography between Greco-Roman Judaism and Early Christianity?" *JJA* 5 (1978), 6–15.

———. "Did Gnostics Make Pictures?" In *The Rediscovery of Gnosticism* 1, ed. B. Layton, 434–54. *Numen* Suppl. 41.1. Leiden, 1980.

———. "Alcune note à proposito delle immagini carpocraziane di Gesù." *RivAC* 57 (1981), 35–41.

———. "Idols in Second and Third Century Apology." In *Studia Patristica* 18, ed. E. A. Livingstone, 684–87. Oxford, 1982.

———. "Images on Finger Rings and Early Christian Art." DOP 41 (1987), 181–86.

———. "Early Christian Art and Archaeology I and II (A.D. 200–500): A Selected Bibliography 1945–1985." *SC* 6.1, 4 (1987–1988), 21–42, 203–38.

Fränkel, M. *De verbis potioribus quibus opera statuaria Graeci notabant.* Leipzig, 1873.

Fremiotti, P. *La riforma cattolica del secolo sesto e gli studi di archeologia cristiana.* Rome, 1926.

Freyne, S. *Galilee from Alexander the Great to Hadrian 323 B.C.E. to 135 C.E.* Wilmington, Del., 1980.

Fuchs, H. *Der geistige Widerstand gegen Rom in der antiken Welt.* Berlin, 1938.

Funke, H. "Götterbild." In *RAC* 11 (1981), 659–828.

Garrucci, R. *Storia dell'arte cristiana.* Prato, 1873–1881.

Geffcken, J. "Die altchristliche Apologetik." *Neue Jahrbücher für das klassische Altertum* 15 (1905), 625–66.

———. "Altchristliche Apologetik und griechische Philosophie." *Zeitschrift für das Gymnasialwesen* 60 (1906), 1–13.

———. *Zwei griechischen Apologeten.* Leipzig, 1907.

———. "Der Bilderstreit des heidnischen Altertums." *ARW* 19 (1919), 286–315.

Gerke, F. "Ideengeschichte der ältesten christlichen Kunst." *ZKG* 59 (1940), 1–102.

Goodenough, E. *Jewish Symbols in the Greco-Roman Period.* 13 vols. New York, 1953–1968.

Grabar, A. *Christian Iconography.* Princeton, 1968.

Grant, R. M. "The Chronology of the Greek Apologists." *VC* 9 (1955), 25–34.

Grigg, R. "Aniconic Worship and the Apologetic Tradition: A Note on Canon 36 of the Council of Elvira." *CH* 45 (1976), 428–33.

Guarducci, M. "Valentiniani a Roma: Ricerche epigrafiche ed archeologiche." *RM* 80 (1973), 169–89.

———. "Ancora sui Valentiniani a Roma." *RM* 81 (1974), 341–43.

———. "Dal gioco letterale alla crittografia mistica." *ANRW* II.16.2 (1978), 1736–73.

Gutmann, J. "The 'Second Commandment' and the Image in Judaism." *HUCA* 32 (1961), 161–74.

———. "Early Synagogue and Jewish Catacomb Art and Its Relation to Christian Art." *ANRW* II.21,2 (1984), 1313–42.

———. "The Dura Europos Synagogue Paintings and Their Influence on Later Christian and Jewish Art." *Artibus et Historiae* 17 (1988), 25–29.

Halton, T. "Clement's Lyre: A Broken String, a New Song." *SC* 3.4 (1983), 177–99.

———. "Clement of Alexandria and Athenaeus (Paed. III.4,26)." *SC* 6.4 (1987–1988), 193–202.

Harnack, A. von. "Die Überlieferung der griechischen Apologeten des 2. Jahrhunderts." *TU* 1.1–2. Leipzig, 1882.

Heiler, C. L. *De Tatiani apologetae dicendi genere.* Marburg, 1909.

Henig, M. *The Lewis Collection of Engraved Gemstones in Corpus Christi College,* Cambridge. *BAR* Suppl. 1. Oxford, 1975.

Henrichs, A. "Pagan Ritual and the Alleged Crimes of the Early Christians: A Reconsideration." *Kyriakon* 1 (Münster, 1970), 18–35.

Himmelmann, N. "Das Hypogäum der Aureli am Viale Manzoni." *AbhMainz* 7 (1975), 1–27.

———. *Über Hirtengenre in der antiken Kunst.* Abh Rh-Westf. Akad. 65. Opladen, 1980.

Hock, R. *The Chreia in Ancient Rhetoric.* Atlanta, 1986.

Jaeger, W. W. *The Theology of the Early Greek Philosophers.* Oxford, 1947.

Janssens, J. *Vita e morte del cristiano negli epitaffi di Roma anteriori al secolo VII.* Rome, 1981.

Joyce, H. *The Decoration of Walls, Ceilings, and Floors in Italy in the Second and Third Centuries A.D.* Rome, 1981.

Jucker, H. *Vom Verhältnis der Römer zur bildenden Kunst der Griechen.* Frankfurt am Main, 1950.

Karlstadt (Carolstatt), A. B. von. *Von Abtuhung der Bylder und das keyn Bedtler unther den Christen seyn sollen.* Ed. H. Lietzmann. Bonn, 1911.

Kaufmann, C. M. *Die sepulkralen Jenseitsdenkmäler der Antike und des Urchristentums.* Mainz, 1900.

Kaufmann, D. "Sens et origine des symboles tumulaires de l'Ancien Testament dans l'art chrétien primitif." *RÉJ* 14 (1887), 33–48, 217–53.

Kennedy, G. *The Art of Persuasion in Greece.* Princeton, N.J., 1963.

———. *The Art of Rhetoric in the Roman World 300 BC–AD 300.* Princeton, N.J., 1972.

Keuls, E. *Plato and Greek Painting.* Leiden, 1978.

Kinzig, W. "Der 'Sitz im Leben' der Apologie in der Alten Kirche." *ZKG* 100 (1989), 291–317.

Kitzinger, E. "The Cult of Images in the Age before Iconoclasm." *DOP* 8 (1954), 83–150.

———. *Byzantine Art in the Making.* Cambridge, Mass., 1977.

———. "Christian Imagery: Growth and Impact." In *Age of Spirituality: A Symposium,* ed. K. Weitzmann, 141–63. New York, 1980.

Klauser, T. "Das altchristliche Totelmahl nach dem heutigen Stande der Forschung." *Theologie und Glaube* 20 (1928), 599–608.

———. "Studien zur Entstehungsgeschichte der christlichen Kunst." *JbAC* 1 (1958), 20–51; 2 (1959), 115–45; 3 (1960), 112–33; 4 (1961), 128–45; 5 (1962), 113–24; 6 (1963), 71–100; 7 (1964), 67–76; 8–9 (1965–1966), 126–70; 10 (1967), 82–120.

———. "Der Beitrag der orientalischen Religionen insbesondere des Christentums zur spätantiken und frühmittelalterlichen Kunst." *Atti del Convegno Internazionale sul Tema: Tardo Antico e Alto Medioevo.* Rome, 4–7 April, 1967. *AccadLincei* 365 (1968), 32–89.

Knöpfler, A. "Der angebliche Kunsthass der ersten Christen." In *Festschrift Georg von Hertling . . . ,* 41–48. Munich, 1913.

Koch, H. *Die altchristliche Bilderfrage nach den literarischen Quellen.* FRLANT 27. Göttingen, 1917.

Kollwitz, J. "Christusbild." In *RAC* 3 (1957), 1–23.

———. "Zur Frühgeschichte der Bilderverehrung." *RQ* 48 (1953), 1–20.

———. "Die Malerei der konstantinischen Zeit." *CIAC.Atti* 7.1 (1969), 29–158.

Korol, D. *Die frühchristlichen Wandmalereien aus den Grabbauten in Cimitile/Nola: Zur Entstehung und Ikonographie alttestamentlicher Darstellungen.* Münster, 1987.

Kraus, F. X. *Die Kunst bei den alten Christen.* Frankfurt, 1868.

Landtman, G. "The Origin of Images as Objects of Cult." *ARW* 24 (1926), 196–208.

Latte, K. *Römische Religionsgeschichte.* 2d ed. Munich, 1967.

Lazzati, G. *Gli sviluppi della letteratura sui martiri nei primi quattro secoli.* Turin, 1956.

Leon, J. *The Jews of Ancient Rome.* Philadelphia, 1960.

Lietzmann, H. "Die Entstehung der christlichen Kunst." *IWWKT* 5 (1911), 481–504.

MacMullen, R. *Enemies of the Roman Order.* Cambridge, Mass., 1966.

Mamachi, T. *De' costumi de'primitivi cristiani.* Rome, 1753–1754.

Marangoni, G. *Delle cose gentilesche e profane trasportate ad uso e adornamento delle chiese.* Rome, 1744.

Marrou, H. *ΜΟΥΣΙΚΟΣ ΑΝΗΡ.* Grenoble, 1938.

Martin, E. J. *A History of the Iconoclastic Controversy.* London, n.d.

McVey, K. E. "The Domed Church as Microcosm: Literary Roots of an Architectural Symbol." *DOP* 37 (1983), 91–121.

Michaïlides, G. "Vase en terre cuite portant une inscription philosophique grecque." *Cairo. Institut Français d'Archéologie Orientale. Bulletin* 49 (1950), 23–43.

Michel, K. *Gebet und Bild in frühchristlicher Zeit.* Leipzig, 1902.

Millar, F. *The Emperor in the Roman World 31 BC–AD 337.* Ithaca, N.Y. 1977.

Mommsen, Th. *Römisches Staatsrecht.* 2d ed. Leipzig, 1876–1877.

———. "Der Religionsfrevel nach römischen Recht." *HZ* 64 (1890), 389–429.

———. "Zum römischen Grabrecht." *ZSav* (Rom.Abt.) 16 (1895), 203–20.

———. *Römisches Strafrecht.* Leigzig, 1899.

Monachino, V. "Intentio pratico e propagandistico nell'apologetica greca del II secolo." *Gregorianum* 32 (1951), 5–49, 187–222.

Morey, C. R. *Early Christian Art.* Princeton, N.J., 1942.

Mulhern, H. "L'orante. Vie et mort d'une image." *Les Dossiers de l'Archéologie* 18 (September–October 1976), 34–47.

Musurillo, H. *The Acts of the Christian Martyrs.* Oxford, 1972.

Niedermeyer, H. *Über antike Protokoll-Literatur.* Göttingen, 1918.

Nilsson, M. P. *Geschichte der griechischen Religion.* 3d ed. Munich, 1967.

Nock, A. D. "Cremation and Burial in the Roman Empire." *HTR* 25 (1932), 321–59.

———. "Sarcophagi and Symbolism." *AJA* 50 (1946), 140–70.

Norden, E. *Agnostos Theos. Untersuchungen zur Formgeschichte religiöser Rede.* (Leipzig, 1913).

Opelt, I. "Ciceros Schrift de natura deorum bei den lateinischen Kirchenvätern." *Antike und Abendland* 12.2 (1966), 141–55.

Overbeck, J. A. *Die antiken Schriftquellen zur Geschichte der Bildenden Künste bei den Griechen.* Leipzig, 1868.

Pani Ermini, L. "L'ipogeo detto dei Flavi a Domitilla I and II." *RivAC* 45 (1969), 119–74; 48 (1972), 235–70.

Panofsky, E. *Studies in Iconology.* New York, 1939.

Pease, A. D. "Some Aspects of Invisibility." *HSCP* 53 (1942), 1–36.

Pékary, Th. "Der römische Bilderstreit." *FS* 3 (1969), 13–26.

Pellegrino, M. *Studi sull'antica apologetica.* Rome, 1947.

Pergola, P. "La region dite du bon pasteur dans le cimitière de Domitilla sur l'Ardeatina." *RivAC* 51 (1975), 65–96.

———. "La region dite des Flavii Aurelii dans la catacombe de Domitille." *MÉFRA* 95 (1983), 183–248.

Peterson, E. *ΕΙΣ ΘΕΟΣ.* FRLANT 41. Göttingen, 1926.

Petrikovits, H. von. "Die Spezialisierung des römischen Handwerks." In *Das Handwerk in vor- und frühgeschichtlicher Zeit,* vol. 1, ed. H. Jahnkuhn et al., 63–132. Göttingen, 1981.

―――. "Die Spezializerung . . . II (Spätantike)." *ZPE* 43 (1981), 285–306.

Phillips, J. *The Reformation of Images: Destruction of Art in England 1535–1660.* Berkeley, 1973.

Piana, G. la. "The Roman Church at the End of the Second Century." *HTR* 18 (1925), 201–77.

―――. "Foreign Groups in Rome during the First Centuries of the Empire." *HTR* 20 (1927), 183–203.

Piper, F. *Mythologie und Symbolik der christlichen Kunst.* Weimar, 1847–1851.

―――. *Einleitung in die Monumentaltheologie.* Gotha, 1867.

Pohlenz, M. *Die Stoa. Geschichte einer geistigen Bewegung.* 3d ed. Göttingen, 1948.

Pollitt, J. J. *The Ancient View of Greek Art.* Cambridge, 1990.

Polman, P. *L'élément historique dans la controverse religieuse du XVIᵉ siècle.* Gembloux, 1932.

Poulsen, F. "Die Römer der republikanischer Zeit und ihre Stellung zur Kunst." *Die Antike* 13 (1937), 125–50.

―――. "Talking, Weeping and Bleeding Sculptures." *AcA* 16 (1945), 178–95.

Preuss, H. D. *Verspottung fremder Religionen im Alten Testament.* Stuttgart, 1971.

Price, S. R. F. *Rituals and Power.* Cambridge, 1984.

Provoost, A. "Iconologisch onderzoek van de laat-antieke herdervoorstellingen." 3 vols. Proefschrift, Catholic University of Leuven, 1976.

Puech, A. *Les apologistes grecs du 2ᵉ siècle de notre ère.* Paris, 1912.

Quasten, J. "Die Grabinscrift des Beratius Nikatoras." *RM* 53 (1938), 50–69.

―――. "Vetus Superstitio et Nova Religio. The Problem of the Refrigerium in the Ancient Church of North Africa." *HTR* 33 (1940) 253–66.

―――. "Der gute Hirt in der frühchristlichen Totenliturgie." *ST* 121 (1946), 373–406.

Raoul-Rochette, D. *Discours sur l'origine, le développement, et le caractère des types imitatifs qui constituent l'art de Christianisme.* Paris, 1834.

―――. *Trois mémoires sur l'antiquité chrétienne.* Paris, 1838.

Reekmans, L. *La tombe du pape Corneille et sa région cémétériale.* Vatican City, 1964.

―――. "La chronologie de la peinture paléochrétienne. Notes et refléxions." *RivAC* 49 (1973), 271–92.

―――. "Zur Problematik der römischen Katakombenforschung." *Boreas* 7 (1984), 242–60.

Richmond, I. A. *Archaeology, and the After-Life in Pagan and Christian Imagery.* Oxford, 1950.

Riegl, A. *Die spätrömische Kunstindustrie nach den Funden in Österreich-Ungarn.* Vienna, 1901.

Ritschl, A. *Die Entstehung der altkatholischen Kirche.* Bonn, 1850, 1857.

Rodenwaldt, G. "Eine spätantike Kunstströmung in Rom." *RM* 36–37 (1921–1922), 58–110.

―――. "Zur Kunstgeschichte der Jahre 220 bis 270." *JdI* 51 (1936), 82–113.

Roller, T. *Les catacombes de Rome.* Paris, 1881.

Russell, D. A. *Antonine Literature.* Oxford, 1990.

Santaga, O. *Dom Odo Casel. Contributo monografico per una bibliografia generale delle sue opere.* Vatican City, 1966.

Schoenebeck, H. von. "Altchristliche Grabdenkmäler und antike Grabgebräuche in Rom." *ARW* 34 (1937), 60–80.

Schneider, A.-M. "Mensae oleorum oder Totenspeisetische." *RQ* 35 (1927), 287–301.

————. "Refrigerium I. Nach literarischen Quellen und Inschriften." Habilitationsschrift. Freiburg, 1928.

————. "Die ältesten Denkmäler der römischen Kirche." In *Festschrift zur Feier des zweihundertjährigen Bestehens der Akademie der Wissenschaften in Göttingen 2. AkadGött Phil.-hist. Kl.* (1951), 166–98.

Schüler, I. "A Note on Jewish Gold Glasses." *JGS* 8 (1966), 48–61.

Schultze, V. *Der theologische Ertrag der Katakombenforschung.* Leipzig, 1882.

Schumacher, W. *Hirt und guter Hirt. RQ* Suppl. 34. Rome and Freiburg, 1977.

Schwartz, J. "Philon et l'apologétique chrétienne du second siècle." In *Hommages à André Dupont-Sommer,* ed. A. Caquot and M. Philonenko, 497–507. Paris, 1971.

Schweitzer, B. *Zur Kunst der Antike.* Tübingen, 1963.

Seeliger, H. R. "Christliche Archäologie oder spätantike Kunstgeschichte?" *RivAC* 61 (1985), 167–87.

Sherwin-White, A. N. *Roman Society and Roman Law in the New Testament.* Oxford, 1963.

Sider, R. D. *Ancient Rhetoric and the Art of Tertullian.* Oxford, 1971.

Smith, M. "The Image of God: Notes on the Hellenization of Judaism, with Especial Reference to Goodenough's Work on Jewish Symbols." *BullJRy* 40 (1957–1958), 473–512.

————. *Clement of Alexandria and a Secret Gospel of Mark.* Cambridge, Mass., 1973.

————. *Jesus the Magician.* San Francisco, 1978.

Spanneut, M. *Le stoïcisme des pères de l'église.* Paris, 1957.

Speyer, W. "Zu den Vorwürfen der Heiden gegen die Christen." *JbAC* 6 (1963), 129–35.

Stern, H. "Un nouvel Orphée-David dans une mosaïque du VIᵉ siècle." *AIBL.Comptes Rendus* (1970), 63–79.

Strzygowski, J. *Orient oder Rom?* Leipzig, 1901.

————. *Ursprung der christlichen Kirchenkunst.* Leipzig, 1920.

Stuiber, A. *Refrigerium Interim. Die Vorstellungen vom Zwischenzustand und die frühchristliche Grabeskunst.* Theophaneia II. Bonn, 1957.

Styger, P. *Il monumento apostolico a San Sebastiano sulla Via Appia.* Rome, 1925.

————. *Die altchristliche Grabeskunstein Versuch der einheitlichen Auslegung.* Munich, 1927.

————. *Die römischen Katakomben.* Berlin, 1933.

————. *Römische Märtyrergrüfte.* 2 vols. Berlin, 1935.

————. "Heidnische und christliche Katakomben." In *Pisciculi: Festschrift F. J. Dölger,* 266–75. Münster, 1939.

Sybel, L. von. *Christliche Antike* 1, 2. Marburg, 1906, 1909.

Tcherikover, V. "Jewish Apologetic Literature Reconsidered." *Eos* 48.3 (1956), 169–93.

Theissen, G. *Studien zur Soziologie des Urchristentums.* 3d. ed. Tübingen, 1989.

Testini, P. *Le catacombe e gli antichi cimiteri cristiani in Roma.* Bologna, 1966.

Tolotti, F. *Memorie degli apostoli in catacumbas: Rilievo critico della Basilica Apostolorum al III miglio della Via Appia.* Vatican City, 1953.

Toynbee, J. M. C. *Death and Burial in the Roman World.* London, 1971.

Toynbee, J. M. C., and J. B. Ward Perkins. *The Shrine of St. Peter and the Vatican Excavations.* London, 1956.

Urbach, E. E. "The Rabbinical Laws of Idolatry in Second and Third Centuries in

the Light of Archaeological and Historical Facts." *IEJ* 9 (1959), 149–65, 229–45.

Veyries, M. A. *Les figures criophores dan l'art grec, l'art gréco-romain et l'art chrétien.* Paris, 1884.

Weidlé, W. *The Baptism of Art: Notes on the Religion of the Catacomb Paintings.* London, 1950.

Wendland, P. *Die hellenistisch-römische Kultur in ihren Beziehungen zu Judentum und Christentum.* 4th ed. Tübingen, 1972.

Wickhoff, F. *Römische Kunst.* Berlin, 1912.

Wilpert, J. *Die Malereien der Sakramentskapellen in der Katakombe des hl. Callistus.* Freiburg, 1897.

———. *Le pitture delle catacombe romane.* Rome, 1903.

———. *Die Papstgräber und die Cäciliengruft in der Katakombe des hl. Kallistus.* Freiburg, 1909.

———. *La fede della chiesa nascente secondo i monumenti dell'arte funeraria antica.* Rome, 1938.

Wirth, F. *Römische Wandmalerei vom Untergang Pompejis bis zum Ende des dritten Jahrhunderts.* Berlin, 1934.

Wischmeyer, W. "Die Aberkiosinschrift als Grabepigramm." *JbAC* 23 (1980), 22–47.

———. *Griechische und lateinische Inschriften zur Sozialgeschichte der Alten Kirche.* Gütersloh, 1982.

Wlosok, A. "Römische Religions- und Gottesbegriff in heidnischer und christlicher Zeit." *Antike und Abendland* 16 (1970), 39–53.

Zeegers van der Vorst, N. *Les citations des poetes grecs chez les apologistes chrétiens du II^e siècle.* Louvain, 1972.

Illustration Credits

Figure 4.1. Photo courtesy Deutsches Archäologisches Institut, Rome.

Figures 4.2, 4.3. Photos courtesy Pontificio Commissione di Archeologia Cristiana (Aur A15 & A16).

Figure 5.1. Obverse. Photo courtesy The British Museum.

Figure 5.2. Line drawing by David Goodger. Courtesy the British Museum.

Figure 5.3. Photo courtesy the Boston Museum of Fine Arts.

Figures 5.4, 5.5. Photos courtesy the Staatliche Museen Preussischer Kulturbesitz.

Figure 5.6. From G. P. Bellori and P. S. Bartoli, *Le antiche lucerne sepolcrali figurata raccolte dalle caue sotteranea e grotte di Roma,* pt. 3 (Rome, 1691), pl. 29. Photo courtesy the Marquand Library, Princeton University.

Figure 5.7. Engraving from A. Bosio, *Roma sotteranea* (Rome, 1632), p. 211. Photo courtesy the Marquand Library, Princeton University.

Figures 5.8–5.13. Photos courtesy The British Museum.

Figure 5.14. From S. Loeschcke, *Lampen aus Vindonissa* (Zurich, 1919), Abbildung 7. Photo courtesy the Marquand Library, Princeton University.

Figure 6.1. From Louis Reekmans, "Die Situation der Katakombenforschung in Rom," *Rheinisch-Westfälische Akademie der Wissenschaften. Geisteswissenschaften. Vorträge* G233 (Opladen, 1979). By permission of the author.

Figure 6.2. From Louis Reekmans, *La Tombe du pape Corneille et sa region céméteriale* (Vatican City, 1964), pl. 1. By permission of the author.

Figure 6.3. From Paul Styger, *Die Römischen Katakomben* (Berlin, 1933), Abbildung 10.

Figures 6.4, 6.5. From Reekmans, *Tombe,* pl. XI. By permission of the author.

Figure 6.6. Photo courtesy Pontificio Commissione di Archeologia Cristiana (PCAS) (Cal D25).

Figure 6.7. Line drawing by Gwen Holder.

Figure 6.8. Photo courtesy PCAS (Cal E3).

Figure 6.9. Line drawing by Gwen Holder.

Figure 6.10. Photo courtesy PCAS (Cal E24).

Figure 6.11. Line drawing by Gwen Holder.

Figure 6.12. Photo courtesy PCAS (Cal E42).

Figure 6.13. Line drawing by Gwen Holder.

Figure 6.14. Photo courtesy PCAS (Cal C32).

Figure 6.15. Line drawing by Gwen Holder.

Figure 6.16. Photo courtesy PCAS (Cal C30).

Figure 6.17. Line drawing by Gwen Holder.

Figure 6.18. Photo courtesy PCAS (Cal C37).

Figure 6.19. Line drawing by Gwen Holder.

Figure 6.20. Line drawing by L. Pani Ermini.

Figure 6.21. Photograph taken from O. Marucchi, *Monumenti del cimitero di Domitilla sulla via Ardeatina 2* (*Roma Sotteranea,* n.s.; Rome 1909), Tav. 13–16.

Figure 6.22. Photo courtesy PCAS (Dom D7).

Figure 6.23a,b. Line drawings by Gwen Holder.

Figure 6.24. Photo courtesy PCAS (Dom D14).

Figure 6.25. Photo courtesy PCAS (Cal E2).

Figure 6.26. Photo courtesy PCAS (Cal E23).

Figure 6.27. Line drawing by Henry Pearson. Photo copied from C. H. Kraeling, *The Excavations at Dura Europos. Final Report 8.2: The Christian Building* (New Haven, 1969), pl. 31.

Figure 6.28. Line drawing by Gwen Holder.

Figure 6.29. Photo taken from G. Wilpert, *Le pitture delle catacombe romane* (Rome, 1903), Tav. 24.2.

Figure 6.30. Photo courtesy PCAS (Cal E79).

Figure 6.31. Photo courtesy PCAS (Seb L14).

Figure 6.32. Photo courtesy PCAS (Cal E68).

Figure 6.33. Photo courtesy PCAS (Cal C36).

Figure 6.34. Photo courtesy PCAS (Cal E52).

Figure 6.35. Photo courtesy PCAS (Cal E51).

Figure 6.36. Photo courtesy PCAS (Cal C33).

Figure 6.37. Photo courtesy PCAS (Cal E13).

Figure 6.38. Photo courtesy PCAS (Cal E19).

Figure 6.39. Photo courtesy PCAS (Cal E12).

Figure 6.40. Photo courtesy PCAS (Cal E11).

Figure 6.41. Photo courtesy PCAS (Cal E14).

Figure 6.42. Photo courtesy PCAS (Cal E43).

Figure 6.43. Photo courtesy PCAS (Cal E40).

Figure 6.44. Photo courtesy PCAS (Cal E41).

Figure 6.45. Photo courtesy PCAS (Cal E47).

Figure 6.46. Photo courtesy PCAS (Cal E46).

Figure 6.47. Photo courtesy PCAS (Cal E25).

Figure 6.48. Photo courtesy PCAS (Cal E29).

Figure 6.49. Photo courtesy PCAS (Cal E6).

Figure 6.50. Photo courtesy PCAS (Cal E33).

Figure 6.51. Photo courtesy PCAS (Cal E66).

Figure 6.52. Photo courtesy PCAS (Cal E35).

Figure 6.53. Photo courtesy PCAS (Aur A22).

Figure 6.54. Photo courtesy PCAS (Cal E4).

Figure 6.55. Photo courtesy PCAS (Cal E32).

Figure 6.56. Photo courtesy PCAS (Cal E74).

Figure 6.57. Photo courtesy PCAS (Cal E75).

Figure 6.58. Photo courtesy PCAS (Cal E10).

Figure 6.59. Photo courtesy PCAS (Cal E54).

Figure 6.60. Photo courtesy PCAS (Cal E69).

Figure 6.61. Photo courtesy PCAS (Cal E39).

Figure 6.62. Photo courtesy PCAS (Cal C53).

Figure 6.63. From F. Tolotti, *Memorie degli Apostoli in Catacumbas* (Vatican City, 1953), Tav. III.a.

Figure 6.64. From Tolotti, *Memorie*, text fig. 31.

Figure 6.65. Photo courtesy PCAS (Seb Tl1).

Figure 6.66. Copied from F. J. Dölger, *ΙΧΘΥΣ* 4 (Rome, 1910–57), Taf. 220.1.

Figure 6.67. Photo courtesy PCAS (Seb Tl1).

Figure 6.68. Photo courtesy PCAS (Seb Tl2).

Figure 6.69. Photo courtesy The British Museum, Department of Mediaeval and Later Antiquities.

Figure 6.70. Photo courtesy PCAS (Seb Tg1).

Figure 6.71. Photo courtesy PCAS (Seb N10).

Figure 6.72. Photo courtesy PCAS (Seb N14).

Figure 6.73. Photo courtesy PCAS (Seb N23).

Figure 6.74. Photo courtesy PCAS (Seb N31).

Figure 6.75. Photo courtesy PCAS (Seb N32).

Figure 6.76. Photo courtesy PCAS (Seb N33).

Figure 6.77. Photo courtesy PCAS (Seb N24).

Figure 6.78. Photo courtesy PCAS (Ran B2).

Figure 6.79. Photo courtesy PCAS (Ran B12).

Figure 6.80. Photo courtesy PCAS (Ran B1).

Figure 6.81. Photo courtesy PCAS (Ran B7).

Figure 6.82. Photo courtesy PCAS (Ran B9).

Figure 6.83. Photo courtesy PCAS (Ran B8).

Figure 6.84. Photo courtesy PCAS (Ran B11).

Figure 6.85. Photo courtesy PCAS (Ran A3).

Figure 6.86. From H. W. Beyer and H. Lietzmann, *Die jüdische Katakombe der Villa Torlonia in Rom* (Berlin and Leipzig, 1930), Tafel 31.

Figure 6.87. From *RivAC* 8 (1931).

Figure 6.88. Photo courtesy PCAS (Nom B2).

Figure 6.89. Photo courtesy PCAS (Nom B4).

Figure 6.90. Photo courtesy PCAS (Nom B6).

Figure 6.91. Photo courtesy PCAS (Nom B5).

Figure 6.92. Photo courtesy PCAS (Nom B7).

Figure 6.93. Photo courtesy PCAS (Nom B17).

Figure 7.1. Photo courtesy PCAS (T1 150).

Figure 7.2. Photo courtesy PCAS (Cal E7).

Figure 7.3. Photo courtesy PCAS (La A60).

Figure 7.4. Photo courtesy Robert Murray, S.J.

Figure 7.5. Line drawing by J. M. Farrant. Photo courtesy The British Museum, Department of Mediaeval and Later Antiquities.

Index